T0418765

Silent Film and the Formations of U.S. Literary Culture

Silent Film and the Formations of U.S. Literary Culture

Literature in Motion

SARAH GLEESON-WHITE

OXFORD
UNIVERSITY PRESS

OXFORD
UNIVERSITY PRESS

Oxford University Press is a department of the University of Oxford. It furthers
the University's objective of excellence in research, scholarship, and education
by publishing worldwide. Oxford is a registered trade mark of Oxford University
Press in the UK and certain other countries.

Published in the United States of America by Oxford University Press
198 Madison Avenue, New York, NY 10016, United States of America.

CIP data is on file at the Library of Congress

ISBN 978–0–19–755806–5 (pbk.)
ISBN 978–0–19–755805–8 (hbk.)

DOI: 10.1093/oso/9780197558058.001.0001

i.) a section of Chapter 1 first appeared in Sarah Gleeson-White, "Hamlin Garland,
Multimedia Modern," *Modernism/modernity* Print Plus 2, no. 1 (2017)
[no page numbers], and
ii.) a section of Chapter 4 first appeared in: Sarah Gleeson-White, "Reading Plagiarism:
Charles Chesnutt's The House Behind the Cedars and Oscar Micheaux's *The Masquerade:
An Historical Novel*." *African American Review*, 54.4 (2021): 319–31.

Contents

Acknowledgments

Silent Film and the Formations of US Literary Culture: Literature in Motion, which I began many, many years ago, is, it turns out, a gesture, an act of gratitude for and recognition of archivists, archiving, archives. In some sense, it simply shares what has always been there, owing to the tireless work and care of archivists. It is for this reason I want first and earnestly to thank the archivists who so generously and patiently assisted me with this project over the past decade: Joanne Lammers, Louise Hilton, Genevieve Maxwell, and Rachel Bernstein (Margaret Herrick Library of the Academy of Motion Picture Arts and Sciences); Vicki Catozza (Western Reserve Historical Society Library); Lynne Farrington (University of Pennsylvania Libraries' Kislak Center for Special Collections); Rosemary Hanes and Zoran Sinobad (Library of Congress' Moving Image Research Center); Melinda Hayes (University of Southern California's Doheny Memorial Library); Theresa Hessey (University of Delaware Libraries' Digital Collections and Preservation); Joanna Hulin (University of Reading's Special Collections); Darla Moore (Rollins College's Olin Library); and Bridgett Pride (New York Public Library's Schomburg Center for Research in Black Culture) as well as all those at the New York State Archives' Cultural Education Center, the University of California–Berkeley's Bancroft Library, Boston University's Howard Gotlieb Archival Center, the Huntington Library, Yale University's Beinecke Rare Book and Manuscript Library, and the University of California–Los Angeles' Charles E. Young Research Library. These archivists' enviable skills of detection underpin every sentence and lie behind every image in this book, as does the work of those scholars deeply invested in archival research whose methods provided me with a model of intellectual curiosity and rigor of the highest order—thank you *so* much.

I also want to acknowledge just as much the generosity and labor of those behind the digitized collections I continue to use on an almost daily basis, collections that became invaluable during the pandemic, as they were in the Before Times while residing 15,000 miles from essential materials. I want to thank many of the archivists I have already named, especially Bridgett (Schomburg Center), Theresa (University of Delaware), Joanna

(University of Reading) and the New York State archivists who digitized a bulk of materials for me, and at such short notice. And, too, those extraordinary beings who oversee the Media History Digital Library (I quite seriously could not have written this book without this invaluable resource), the Hathi Trust, the Internet Archive, the Gutenberg Press, and the University of Columbia's Women Film Pioneers Project in addition to my own institution's Fisher Library Interlibrary Loans.

Indeed, this book is the work of so many hands. Not least of all, the wise guiding hand of my editor *extraordinaire* at Oxford University Press, Norm Hirschy; I am so happy we were able to work together again—what a pleasure. And a huge thank you to my graduate student Jessica Masters who wrested the Works Cited (it's long) into shape—twice—and with such diligence and good humor.

I also want to acknowledge so gratefully those institutions still finding worth in, still willing to fund, the humanities—the School of Art, Communication and English at the University of Sydney; the American Philosophical Society; the Huntington Library—so making it possible for me to sit with this project's precious materials. And, too, those institutions as well as individuals who ensured I wrote in some of the most beautiful locations in the world: Ashley Maher and the Research Institute for the Study of Culture at the University of Groningen; Martyn Bone and the Department of English, Germanic and Romance Studies at the University of Copenhagen; and Kim Wilkins and Ketan Joshi and Oslo. And most of all, the Bogliasco Foundation, with its fearless (in situ) leader Ivana Folle, not only for providing a retreat like no other but also for facilitating, within a caring, creative, smart community, extraordinary friendships. Francisco Bustamante, Gahlord Dewald, Bruno Giussani, Maria José Herrada, Leilehua Lanzilotti, Sandra Lapage, Corrie Parks Linda Perkins, Carlos Pileggi, and Fiona Templeton, I hope you know how much your conversation and support meant to me during that final, hard month of writing.

And it turns out that this book is too about friendship—its richly complex enmeshments, its invitations to share and exchange. I'd like to think this is what characterizes all intellectual endeavor. So to acknowledge the handful of generous and brilliant scholars who read (and sometimes reread) with such care and insight draft chapters and more of the book, especially Bud Bynack who read the full manuscript with the sharpest of eyes and a deep understanding, and also David Earle, Marsha Gordon, Tina Lupton, and Adam McKible—thank you all; and too Jordan Brower, always quick to respond to

my pernickety questions and to share work-in-progress; Katherine Fusco, for whom I reserve the biggest thanks I can muster, and for all manner of support and warm friendship; and dear Pardis Dabashi, partner-in-cime in so much, and from whom I continue to learn. I feel privileged not only to have been able to draw on all their prodigious knowledge, but too and perhaps more, their camaraderie.

And then there are the fellow travelers who have encouraged me in all my endeavors over the long years: Bob Jackson, with his Zen-like patience and constancy; Kristin Fujie and Mike Zeitlin, who buoyed me through lockdown after lockdown; and most of all Peter Lurie, much cherished friend who offers seemingly endless supplies of support, understanding and mirth, and who knew exactly how to respond to my *appels au secours* throughout the writing and rewriting of this book. I value these Faulkner-inflected friendships more than I can say; at the very least, they plugged me back into the world at a time when Australia felt remote, especially small.

In the end, though, this book is for my father who continues to set the example, as it is most of all for my points north south east west, Florence and Clementine—astonishing young women who are, quite simply, *everything*.

Introduction

Literature in Motion

"The book . . . is almost everywhere," lamented Henry James in 1899.[1] And so it must have seemed, thanks to recent advances in transport, communications, and printing technologies that together effected an explosion of print that would transform US literary culture across the early decades of the twentieth century and beyond.[2] A radically expanded print culture, underpinned by increased rates of literacy and an aggressive advertising industry, in turn ensured greater access to authorship for those outside of urban centers and the East Coast, and among women and minority groups, along with the increased professionalization of the world of letters.[3] Authorship, as Christopher P. Wilson famously argued, became yet another form of labor, and literature, yet another commodity on the marketplace.[4]

The history of these transformations is now well documented, such as in Carl Kaestle and Janice Radway's 2009 volume *Print in Motion: The Expansion of Publishing and Reading in the United States, 1880–1940*. And yet it remains the case that strikingly absent from this scholarship is the significant contribution of motion pictures, which emerged and developed alongside these rapid and far-reaching transformations within the book and broader print industries. To address this not-insignificant gap in our literary history of the early twentieth century, *Silent Film and the Formations of US Literary Culture* pursues Jan Olsson's acknowledgment of "the ascending leverage of film culture in the world of publishing."[5] And it does so by turning to the first encounters between literary and motion-picture cultures, when authors, agents, and publishers on the one hand, and motion-picture interests on the other, struggled to grasp the complexities and to determine the possibilities of an altered cultural landscape and a marketplace yet in its infancy.

The subtitle of my book, which intentionally plays on the title of Kaestle and Radway's volume, encapsulates what I will be arguing is, simply, that motion pictures set literature in motion: mobilizing it across media and consumers; diffusing it onto the big screen; compacting it into the pages of

Silent Film and the Formations of US Literary Culture. Sarah Gleeson-White, Oxford University Press.
© Oxford University Press 2024. DOI: 10.1093/oso/9780197558058.003.0001

movie magazines; facilitating, or at least promising, social mobility and professional advancement; and moving it into new sites of consumption. As literature began to travel with motion pictures, it moved along their circuits and into their environments, taking on their forms and their audiences.

In some sense, to think about literature in relation to motion—mobility, motion pictures—may not at first seem to offer any particularly new insights into literary culture of this so thoroughly studied period. For we are these days in some ways familiar with observations about the imbrications of motion—including motion pictures—with literature, particularly modernist literature, and particularly when motion is ramped up to speed. Recent scholarship about William Faulkner provides a good case in point. In his formulation of "Faulkner on speed," Jay Watson finds that in his "writings of the early 1930s . . . [Faulkner] was most fully committed to exploring the representational strategies and expressive possibilities of both speed and literary modernism." More recently, Mark Goble finds in *Light in August* "a novel almost preposterously committed to pushing at the very limits of narrative speed."[6] These approaches exemplify a body of work interested more generally in the force of speed in modernity's cultural forms, foundational to which is Enda Duffy's *The Speed Handbook: Velocity, Pleasure, Modernism* (2009). In the context of book and literary history, Kaestle and Radway find it is "the mobility of print forms [that] not only was intensified and sped up but also extended geographically" in response to the train, the telegraph, the telephone, and newspaper syndicates, "which enabled greater production and circulation." But, beyond mention en passant of literature's new ability to "emerge finally in yet another form as a Hollywood film," film, as I have said, receives relatively short shrift in *Print in Motion*, even as it was the single expressive medium uniquely defined by movement.[7]

The relative neglect of motion pictures in the predicament of literary culture around the turn of and into the twentieth century—the work of Katherine Fusco and Michael Wutz is among the notable exceptions—is somewhat surprising for several reasons. We know authors were watching and/or writing about motion pictures and working in or with the industry from its earliest days, as we shall see in Chapters 1 and 2.[8] Frank Norris was among motion pictures' earliest audiences. His brilliant 1899 novel *McTeague* includes a lengthy and closely observed scene of a family outing to "the variety show at the Orpheum": "The feature of the evening, the crowning scientific achievement of the nineteenth century, the kinetoscope . . . fairly took their breaths away," we read. An "awe-struck" McTeague exclaims, "Look at

that horse move his head. . . . Look at that cable car coming—and the man going across the street. See here comes a truck. Well, I never in all my life!"[9] And here is Hamlin Garland's description of a scene from his popular 1903 mountain romance, *Hesper*—published in the same year one of the first motion-picture Westerns, *The Great Train Robbery* (1903), was released—in which the heroine observes the toings and froings of the Colorado mining town in which she finds herself:

> Ann stood at the door watching the miners as they boiled out of saloon doors like bees, and eddied and swirled into knots and close-packed circles. Here and there a man could be heard shouting a command, and horsemen began to clatter up and down the dusty street. It was all so unreal to the city girl, so like a shadowy moving picture, that fear was not awakened in her heart.[10]

The "shadowy moving picture," a Western surely. One final example: Black author and filmmaker Oscar Micheaux's 1915 novel *The Forged Note: A Romance of the Darker Races* depicts not only one of the earliest scenes of moviegoing in Black literature but one of the earliest literary representations of Jim Crow moviegoing—here, a theater in Cincinnati incorporating what was known as the buzzard's roost, the balcony set aside for Black moviegoers. Even this small handful of examples—there are many more I could have included—attests that a range of authors was observing and enthralled by motion pictures and motion-picture-going.[11]

Authors, as well as motion-picture producers, also commented in various public fora on what they perceived to be both the threats and the opportunities in the coming of motion pictures, and in the cross-industry collaborations they at times trailblazed. J. Stuart Blackton, one of the "pioneers in the most wonderful art-science of the age—the motion-picture industry," according to his own account, claimed literature as the very foundation of motion pictures, no doubt in an attempt to flatter and so woo authors to the industry.[12] In 1916, Garland—one of the authors Blackton succeeded in wooing—reported, with a tinge of envy no doubt, that "the rise of great advertising journals [and] the development of motion pictures" had combined "to produce extraordinary and almost bewildering change" to the extent that Charlie Chaplin could now be hailed "a greater artist than Henry James or Joseph Conrad" for the sole reason that he earned $6000 a film.[13] Black film critic Juli Jones Jr., the nom de plume of motion-picture

producer William D. Foster, shared Blackton's view of the potentially productive role of authors in the industry; it would be down to Black authors, he determined, to facilitate a vital Black motion-picture industry.[14] All of this is simply to say that authors and producers alike, from motion pictures' very invention, were observing, thinking hard about, and publicly commenting on the new medium. And yet somehow these authors and producers, and their insights into motion pictures' rise and evolving impact on literary culture, remain largely absent from literary histories. As Meredith McGill recently observed, book history "still hew[s] pretty closely to the story of the development of print, with only sidelong glances at the larger mass media environment."[15]

The treatment of Jack London's career as a means for thinking through the transformations in turn-of-the-twentieth-century literary culture is an object lesson in some remnant indifference to motion pictures. Wilson's and Loren Glass' landmark studies of authorship as well as Jonathan Auerbach's influential biography of London are characteristic in this regard, although all three are keenly interested in London's entrepreneurialism, his engagements with mass culture, and the effects of these on all aspects of his career.[16] In Auerbach's account, London, "more than any of his contemporaries . . . understood how success in twentieth-century magazine and book production so depended on symbolic capital—mass marketing, self-promotion, and the project of an exciting name."[17] Auerbach (like Wilson and Glass, for that matter) pays little heed to the role of motion pictures in these processes despite the fact that London, in his own words, "even in 1909 . . . had . . . begun to see . . . a future for moving-pictures in the way of dramatizing in moving-pictures my own work" and would soon collaborate, and with extraordinary energy, with motion-picture producers such as Hobart Bosworth to disseminate his books more widely, and boost his star power.[18] This is not to say, however, that London's engagements with motion pictures have been ignored. To the contrary, the scholarship of Robert S. Birchard, Owen Clayton, Fusco, and Tony Williams has been crucial in excavating and pondering, to various ends, the significance of London's motion-picture experiences, even as the effects or consequences of these are, for good reasons, anchored in the study of the single author.[19]

The scholarship about London and motion pictures I have cited thus far is only a sampling of a vast body of scholarship to do with the relationship of film and literature more broadly, a relationship that has been approached from a series of different perspectives and with a series of different interests

that include the Hollywood novel, authors in Hollywood (mostly of the studio era, sometimes of the 1920s but rarely earlier), page-to-screen adaptation, authors' writings on motion pictures, and the screenplay.[20] However, it is the scholarship that falls under the rubric of modernism, particularly the New Modernist Studies, that has proved especially consequential in its vertical expansion of literary studies' methods and objects, beyond the narrowly literary. Peter Lurie's *Vision's Immanence: Faulkner, Film, and the Popular Imagination* (2004), Susan McCabe's *Cinematic Modernism: Modernist Poetry and Film* (2005), David Trotter's *Cinema and Modernism* (2007), Laura Marcus' *The Tenth Muse: Writing about Cinema in the Modernist Period* (2007), Julian Murphet's *Multimedia Modernism: Literature and the Anglo-American Avant-Garde* (2009), Andrew Shail's *The Cinema and the Origins of Literary Modernism* (2012), Jonathan Foltz's *The Novel after Film: Modernism and the Decline of Autonomy* (2017), James Stamant's *Competing Stories: Modernist Authors, Newspapers, and the Movies* (2019), Chris Forster's *Modernism and Its Media* (2022), Pardis Dabashi's *Losing the Plot: Film and Feeling in the Modern Novel* (2023), and Jordan Brower's *Classical Hollywood, American Modernism: A Literary History of the Studio System* (2024) are all exemplary here, as they represent the tip of an iceberg.[21] This frequently foundational and sometimes trailblazing work is, at least as far as one can generalize, largely interested in aesthetics and form, and in higher-brow and predominantly white authors.[22] Furthermore, the relationship of the two media and their respective cultures is more often than not figured as a rivalry, a struggle for dominance. Murphet, conceiving of art forms as "information storage technolog[ies]," finds literature's "monopoly" on the media ecology "was uncontested . . . [until] the moment that other data-storage systems became available (photography, telegraphy, phonography, film, etc.)."[23]

Assertions about the scrappy relationship of the two media have their roots in motion pictures' transitional era at least, that is, the period between, roughly, 1908 and 1917 when motion pictures shifted from what Tom Gunning has famously called a cinema of attractions to an established storytelling medium.[24] Popular author Rex Beach figured the interactions of the two industries during this period in just this way. As the inaugural president of the Authors' League of America, a national organization for authors, Beach had reason to keep a close eye on copyright breaches within the worlds of magazine and book publishing, and as such breaches were generated or aggravated by the motion-picture industry. Around the time of the League's

formation in 1912, Beach recalled in his memoir, the motion-picture in-
dustry was yet "so puny that most observers thought it stood small chance of
surviving the hazards of childhood." But soon

> [m]otion pictures outgrew their side-street nickelodeons and moved into
> better quarters: they became a recognized form of entertainment. . . . Yes,
> during this interval the guttersnipe grew into long pants but with them it
> put on the sweater and cap of a hoodlum. It became a neighbourhood nui-
> sance, a disorderly character; it robbed peanut stands, upset pushcarts and
> jeered at the police. No one dreamed that it would ever mend its ways and
> turn decent.

This brash upstart, this menace to the literary world, with its alleged greater
capacity for narrative enthrallment and photographic realism, "had come to
stay" and, importantly, "a wide-awake author could get more out of it than a
case of eyestrain."[25]

A significant portion of *Silent Film and the Formations of US Literary
Culture* uncovers exactly what such "wide-awake" authors like Beach him-
self, as well as Micheaux, Garland, and London, among many others not
yet mentioned, "got out of" the motion-picture industry. As I find in the
chapters to follow, literary culture's contact with the industry was in fact
largely generative, if at times ambivalent. Authors approached the motion-
picture industry with a considerable degree of openness, interest, and ea-
gerness, as they did also with a degree of caution and suspicion, and just
as much, they quickly recognized in it, as we shall see in Chapters 1 and
2, opportunities for both professional and social advancement. As Nancy
Bentley has written of the interactions of literary culture with mass culture
more generally,

> turn-of-the-century artists and intellectuals distrusted mass culture. . . . But
> the more open and incisive thinkers . . . confronted this antagonist with
> real intellectual curiosity. . . . And competition also produces kinship. . . .
> American artists and intellectuals learned from and, indeed, even imitated
> elements of the rival mass culture they also subjected to sharp critical
> analysis.[26]

Bentley's project in *Frantic Panoramas*, from which this insight is
taken, is to discover "the uneven, conflicted intersection of the bourgeois

public sphere with the emergent publics"—in theaters, amusement parks, museums—that occurred as a consequence of the Progressive Era "encounter between literary culture and mass culture."[27] My own project focuses on one aspect of that intersection. Guided by discoveries in author, studio, publisher, and press archives, and in particular by what I term "motion-picture print culture," that is, the vast array of print materials— scenarios and synopses, contracts and correspondence, fan and industry magazines, film reviews and related newspaper and magazine inclusions, and posters and lobby cards—generated by this upstart industry, *Silent Film and the Formations of US Literary Culture* tracks down and describes the actual activities authors engaged in and generated when confronted with motion pictures. In place of a battlefield, it discovers a flourishing scene of cross-industrial commerce. And in so doing, it addresses a series of absences or oversights in the broader scholarship about the interactions of motion-picture and literary cultures. The first of these concerns the significant collaborative contributions of Black motion-picture producers and authors to an increasingly complex cultural landscape, an oversight that is particularly remarkable when we recall that race film and the Black literary flourishing known as the Harlem Renaissance arose simultaneously. Second, in my choice of materials, I do not limit myself to a series of canonical texts or authors, or particularly distinguish between high and low cultural artifacts. That is to say, all manner of texts—scenarios and magazine film stories; modernist, romance, and pulp fiction—are up for grabs in the process of reconstructing the cross-industrial transactions I argue were so critical to early twentieth-century literary culture. Third, I ponder the new forms, such as screen-to-page remediations, that the encounter of literature and motion pictures spawned, and not simply as ends in themselves but as means to begin to understand how literature could now circulate and how readers came to navigate this "postliterary" landscape.[28] Fourth, I focus on the decades immediately following motion pictures' emergence, that is, the silent-film period that scholars more broadly interested in the relations of film and literature often overlook in favor of the sound and studio eras, or they focus on the late silent era—the mid-1920s, by which time narrative film was well established—at the expense of the first twenty-five years or so of motion pictures' development.

There may be good reason for the relative neglect of the early silent-film era in the scholarship for it may not, on first consideration, seem particularly conducive to cultures of writing even though scenarios, or at least "intentional

uses of written 'plans' for films," were in use as early as 1897, and Biograph had a discrete story department as astonishingly early as 1898.[29] And yet it was only on the consolidation of classical Hollywood film form and the establishment of the studio system that modernists like Faulkner, F. Scott Fitzgerald and other high-brow authors made their way to Hollywood to write for the movies. Their sometimes dazzling contributions to motion-picture history have largely taken precedence over those of the popular authors of the earlier decades of the century, so many of whom are forgotten today but who early on tested the limits and promise of the new narrative medium. It is also my sense that because modernist studies, new and otherwise, has dominated the study of early twentieth-century culture, and to the extent that it continues to do so, it has obscured many of the cultural activities and expressive forms of the early silent-film era in which I am interested here. That is to say, experimental high-modernist objects can continue to absorb scholars' attention at the expense of the larger literary scene, one comprising realism, popular fiction and its various print forms, in addition to much else. We still need to ponder, with Faye Hammill, "What becomes of writing which cannot be easily accommodated to the paradigms of . . . high modernism?"[30] *Silent Film and the Formations of US Literary Culture* makes, I hope, a contribution to the rich discussions and expanding scholarship "against modernism," to take the gauntlet-throwing title of Patrick Collier's roundtable at the 2015 Modernist Studies Association convention, to recuperate and attend to the vast array of early twentieth-century literary forms.[31]

A strangely overlooked short film of the 1920s provides a useful sketch of the kind of approach, materials and concerns of *Silent Film and the Formations of US Literary Culture* as a whole. *Camille, or the Fate of a Coquette* is *New Yorker* illustrator Ralph Barton's 1926 "picturization," in the parlance of the day, of Alexandre Dumas fils' 1848 novel *La dame aux camélias* (*The Lady of the Camellias*).[32] Here is a mere sampling of the rather astonishing cast list of Barton's film:

Paul Robeson
Sinclair Lewis
Anita Loos
Theodore Dreiser
Sherwood Anderson
George Jean Nathan
Alfred A. Knopf

H. L. Mencken
Charlie Chaplin
Ethel Barrymore
John Emerson
Rex Ingram
Dorothy Gish

To be screened at one of his home-movie *soirées*, Barton compiled this four-reel feature by splicing together bits of the home movies he had produced since 1925 of the friends and acquaintances—among them the most celebrated littérateurs and motion-picture personalities of the early twentieth century—who had passed through his home and studio.[33] "We never took it too seriously," Barton recalled, "and didn't bother too much about costumes and scenery, simply taking a show whenever people were at the house and the mood was on."[34] Indeed, without the intertitles (which bear no relation to Dumas' text, incidentally), a retroactive attempt to stitch the scenes together, there would be very little to structure Barton's thirty-minute-plus narrative.

Filmed mostly indoors, with several shots of the Manhattan skyline, Central Park, and a rotating image of the Statue of Liberty—all of which was to pass for Paris—*Camille* opens with a close-up of Paul Robeson, by this time something of a celebrity subsequent to his critically acclaimed performance in the London production of Eugene O'Neill's *The Emperor Jones*, and he had made his motion-picture debut the previous year in Micheaux's film *Body and Soul*. Here, in *Camille*, he plays Dumas, dressed in a smoking jacket and, when we first see him, seated at a small writing desk. Immediately following this opening scene, no other than Sinclair Lewis appears, adorned in generously applied eyebrow pencil, and black and white drapes while engaging in all sorts of expressive movements to conjure, as an intertitle explains, the "elements that control the Destiny of Man": love, hate, despair, adultery, greed, and motherhood. Following Lewis' wonderfully bizarre performance, an intertitle invites us to "linger no longer at the threshold—let us knock—and enter the magic door." We then cross to shots of a series of hands knocking on that magic door, and the story proper begins.

What plot there is, is pretty straightforward. Loos, who wrote *Camille's* scenario and whose novel *Gentlemen Prefer Blondes*, illustrated by Barton, had recently been published, stars as Camille. Ruined by a "degenerate arch roué" played by her husband John Emerson, and condemned to life as a "bird

in a gilded cage for MEN . . . from the four corners of the earth," as another intertitle informs us, Camille becomes pregnant, is visited by the Virgin Mary, and subsequently kills herself. *Camille* is, in short, a madcap, loose, to say the least, version of Dumas' novel.

Barton's home movie should be of great interest to anyone concerned with early twentieth-century cultural history, not least of all for the pure pleasure of watching Lewis' slightly insane performance, as well as Charlie Chaplin— as Mike, the piano player—restaging his famous "Bread Roll Dance" from his 1925 film *Gold Rush. Camille* also happens to be one of the earliest extant examples of amateur film, emerging in the mid-1920s with the development of 16mm film, on which Barton shot this home movie. But of particular interest and significance to the concerns of *Silent Film and the Formations of US Literary Culture* is the way *Camille* manifests so efficiently and compellingly the imbrications of literary with motion-picture cultures, particularly in terms of the way motion pictures facilitated new experiences of and encounters with the literary, and as these were displaced to motion-picture formations. Barton's *Camille* introduces several matters I take up in the pages to follow: the entanglements of literary celebrity with motion-picture stardom, and a series of both structured and less structured collaborations across the two industries.

Barton's *Camille* is also, of course, an adaptation—even if of a wild sort. As we know, motion pictures' narrative turn during the transitional era resulted in a greater demand for story material, and hence the turn to source literature and to page-to-screen adaptation. Prior to the 1912 Townsend Amendment to the copyright law, motion-picture rights did not inhere in the copyrighted property. An additional and enduring benefit of page-to-screen (and stage-to-screen, for that matter) adaptation was that the product, that is, the source text, had already been tried and tested in the marketplace. The arrangement also suited authors, and not simply for the commercial gains arising from the sale of subsidiary rights. As Blackton wrote in 1914, there would also emerge opportunities for authors to write specifically for the movies: "a gripping, compelling story, hitherto unknown and unpublished, properly picturized, and bearing the name of the best-known writers of modern fiction, would be a greater success artistically and financially than a revived popular play or 'Best-Seller.' "[35] Adaptations, timed carefully with or near the release of the literary text on which they were based, could also be deployed to cross-promote both motion picture and book. Bosworth, who committed to

adapting to the screen London's oeuvre during the author's lifetime, as I have said, scheduled his adaptation of London's 1903 novel *The Sea-Wolf*, which premiered in October 1913, to coincide with the novel's republication by Macmillan.[36] And the following year, there were plans afoot to run *The Sea-Wolf* "in Philadelphia daily papers concurrently with Sea Wolf film exhibition" in an early form of serial tie-in.[37]

Silent Film and the Formations of US Literary Culture, however, is more interested in the way a broader literary culture—one that encompasses literary objects (books, magazines) as well as authors, publishers, and other personnel—participated in motion pictures' practices of exhibition and consumption, rather than in adaptation or adaptation studies, or in screenplays or screenplay studies, or with other modes of film writing such as the intertitle, although it will touch on these at points. Adaptation studies, a popular and well-mined field, has contributed to, I suggest, the obfuscation of the many, and many significant, additional ways that literary and motion-picture cultures have interacted, and have menaced and benefited each other over the past hundred years and more. Indeed, as Jan Baetens more boldly puts it, adaptation studies does little to advance "the intelligent dialogue or exchange between different forms and media."[38]

Barton's *Camille* registers or at least gestures toward the interests of *Silent Film and the Formations of US Literary Culture* in other ways, particularly in terms of the various roles authors came to play in motion pictures, both on and behind the screen and in very hands-on ways, as well as in terms of the increasing enmeshment of authorship with motion-picture stardom. Here, in Barton's home movie, real authors (among other luminaries) fill the cast, and Robeson plays the role of a real author. The film opens with Dumas writing—perhaps writing the very story (Dumas'? Loos'?) we are about to see enacted on the screen. This brief scene of authorship acknowledges—and perhaps parodies—a practice that the motion-picture industry instituted in collaboration with authors and their publishers in the early teens: the incorporation, at the start (and sometimes at the close) of a film, of moving images of its source text's author. Author cameos, as I call them, not only remind us of authors' direct involvement in motion pictures; they are also more broadly indicative of the extent to which motion pictures became increasingly responsible for generating, maintaining, or expanding literary celebrity.

Authorship was only one of several practices transformed by literary and motion-picture cultures' earliest encounters. The circulation of literary narratives, and the sites and manner of their consumption, are others. It is these kinds of practices and experiences—rather than individual authors, bundles of texts, or chronology—that organize *Silent Film and the Formations of US Literary Culture*. It is the task of Chapters 1 and 2 to examine the changes in authorship—both white and Black—as wrought by its proximity to and co-opting of and by motion pictures. Chapter 1, "Starring the Author: Literary Celebrity and Popular Authorship" begins by establishing this book's broader approach to motion-picture history, that is, one that "looks past the screen," to paraphrase the title of Jon Lewis and Eric Smoodin's 2007 volume.[39] Films themselves are only at times the object of interest or focus in the chapters to follow, for it was a more capacious motion-picture industry and culture—that included as well as exceeded films—that shaped the literary field in all its aspects. It is also the case that so few silent films have survived, a fact necessitating an approach to early motion-picture history that is somewhat aslant. The principal method I deploy here attends to, as it unearths, a dense motion-picture print culture.

Drawing on these kinds of resources—scenarios, studio contracts, along with those other motion-picture print materials I earlier listed—Chapter 1 traces the transformations in authorship as it shifted out of the study, into the studio and onto the screen, which were engineered by its encounters with motion pictures. While, as we shall see, the Authors' League may have facilitated and overseen the earliest collaborations of authors with motion-picture producers by, for instance, providing tips about motion-picture writing, it was increasingly the case that it was less the authors' craft that so appealed to the studios than, in the case of the popular authors at least, their reputation and the cultural capital that accrued to literary authorship, which the studios hoped to exploit. The studios began to market authors in the same way they came to market stars. Indeed, Samuel Goldwyn was convinced, in all of 1919, that the star system was on its way out, to be superseded by an *author*-star system. Barring Marsha Orgeron's work on London, and Hammill's about popular British women authors, literary historians are more likely to consider literary celebrity as it emerged from the mid-nineteenth century in the context of the mass-magazine revolution, parallel developments in technologies of photography and illustration, and/or the lecture circuit, which substituted for forms of patronage more common in the United Kingdom and Europe.[40] But authors and their publishers, as well as motion-picture producers, also exploited motion pictures in the pursuit of

celebrity, and the archive I have over some years gathered of the many moving images of authors on screen is crucial here.[41] I conclude this chapter with an investigation of the career of Gertrude Atherton, one of the most popular authors of the period yet largely forgotten today, as a means to conjure more concretely the transformations in authorship after film I track here.

Chapter 2, "Black Authorship at the Movies: Oscar Micheaux, Paul Laurence Dunbar, Wallace Thurman," is likewise interested in authors and authorship as these collided with the motion-picture industry but this time in the parallel realms of race film—all-Black-cast films largely produced and consumed by African Americans—and early twentieth-century Black literature, realms only very rarely brought into conversation although there were significant exchanges between the two media and industries, and although there is a huge body of scholarship about early twentieth-century Black literature, particularly most of all the Harlem Renaissance, and a more recent upsurge of interest in race film. Chapter 2 discovers that it was motion pictures, maybe surprisingly, that provided Black authors as diverse as Micheaux, Paul Laurence Dunbar, Alice Dunbar Nelson and Wallace Thurman a means to navigate the gnarly terrain of Black authorship across the early decades of the twentieth century, caught as it seemed to be between the demands or expectations of "propaganda" (W. E. B. Du Bois) and "pure literature" (James Weldon Johnson) and between those of literary and vernacular forms—or, as Bentley writes in the context of Dunbar's career,

> the divide between blocked ambitions for higher cultural expression and the profits from popular art; between a middle-class "dignity" always out of reach and a vital urban aesthetic that risked shame and stigma from its proximity to the low; and between the inhospitable conventions of high forms and the euphoric beauty of a street life that could also bring grief.[42]

Micheaux, acknowledged as the pioneer of race film, was also a prolific novelist across the full span of his career. Chapter 2 opens with a brief consideration of the depiction in his autobiographical *Künstlerromane* of the promise of the nascent race-film industry to support Black authorship and literary ambition.[43] As Jones wrote in a 1915 *Chicago Defender* column, "without one question of a doubt the moving picture business offers today the biggest field in the world to the American Negro to make money . . . to show their real talent to the whole world."[44] The careers of Dunbar and Thurman urge a more extensive consideration of the affordances of motion pictures in the

Black literary realm, and not only as means to index Black achievement "to the whole world." Two of Dunbar's prose works, "The Scapegoat" and *The Sport of the Gods*, in all likelihood the first African American–authored literary works adapted to the screen, played a significant role in extending his legacy through the 1920s. But at least as importantly, his cinematic afterlife registers the strain of Black authorship and literary reputation in a period during which the categories and conceptualizations of Black literature and the Black author were under considerable pressure from, among other factors, the exigencies of a new Black mass cultural marketplace. And in a serendipitous twist, tracking Dunbar's afterlife through the race-film industry happens to take us directly to his widow Alice Dunbar Nelson's efforts to break into motion pictures, an aspect of her career that has received next to no attention.

Chapter 2 concludes by deploying film as a method to reconsider Thurman's entire opus—and not just his well-studied novels *The Blacker the Berry: A Novel of Negro Life* (1929) and *Infants of the Spring* (1932)—from the perspective, through the lens, of his two end-of-career Hollywood scenarios, a move that invites an altered understanding of this brilliant but "failed" Black satirist and modernist. It is also a move that exceeds or bypasses what Johnson deemed the "dilemma of the Negro author"—for whom should the Black author write?—which in some ways continues to shape and inform today the critical reception of this idiosyncratic Black author, seemingly unable to fulfill his great promise.[45]

A final note about Chapter 2. Although the chronology of *Silent Film and the Formations of US Literary Culture* spans the silent era, this chapter pushes into the early 1930s, that is, into the early sound era, in order to present a compelling sampling of the earliest rumblings of these Black cross-media transactions, which occurred somewhat belatedly by comparison with their white counterparts due to the various and wide-ranging Jim Crow restrictions on every aspect of Black life. In this expanded timeline, I follow several scholars of Black cinema who have argued for a different Black film chronology. For one, the silent era of Black motion-picture production extended beyond the almost mythical year of 1927 when *The Jazz Singer*, hailed as the first sound film, was released, for Black motion-picture producers came later to sound, thanks to the prohibitive costs of the necessary sound technologies, including in the slow refitting of theaters.[46] As far as film historians have been able to ascertain, the first Black-produced sound film—Micheaux's *The Exile*—was not released until 1931. For this

reason, Jane Gaines "date[s] 1931 as the end of the silent era in race movies to call attention to the difference between black and white silent eras."[47] I share Gaines' commitment to a greater awareness of the variations within different motion-picture cultures and histories.

Having considered the exigencies of authorship alongside and after film in Chapters 1 and 2, the second half of *Silent Film and the Formations of US Literary Culture* takes a particular literary form—the novelization—forged out of literature's encounter with motion pictures, as a means to consider the novel ways in which literature could now circulate among, and be encountered and experienced by, both readers and filmgoers. Novelization, as I use it here, is something of an umbrella term that captures an array of closely related print forms that narrativize in different literary modes—novel, short story, poem—motion-picture stories. These print forms include motion-picture tie-ins, which were typically serial narratives appearing simultaneously on screen and in the popular press (newspapers, general interest magazines, motion-picture fan magazines), short-story narrativizations of film stories, screen-to-page adaptations (original motion-picture stories or adaptations of literary narratives) published as discrete books, and photoplay (motion-picture) editions of novels or short stories that included stills and other paratexts pertaining to the motion picture they remediated and at times underpinned. Chapters 3 and 4 continue to unravel one of the central tenets of *Silent Film and the Formations of US Literary Culture*, and this is that the motion-picture industry introduced literature into its own series of circuits, and its own practices of exhibition and consumption.

Building on Baetens' and Foltz's important work on novelizations, Chapter 3, "Novel Forms: Rose Atwood's "A Man's Duty," Oscar Micheaux's *The Masquerade: An Historical Novel*, Willa Cather's *A Lost Lady*," focuses on three quite different examples of these:[48] Rose Atwood's short-story narrativization, in the pages of the Black periodical *The Competitor*, of *A Man's Duty* (1919), a film produced by Lincoln Motion Pictures, one of the earliest race-film companies; *The Masquerade: An Historical Novel* (1947), Micheaux's novelization of his own silent and early-sound adaptations of Charles Chesnutt's novel *The House Behind the Cedars*; and finally, the Grosset and Dunlap photoplay edition of Warner Bros.' 1924 adaptation of Willa Cather's gorgeous 1923 novel *A Lost Lady*. All three novelizations adopt, draw on, or appeal to various features of motion pictures—narratives, print modes, audiences—to circulate literature and literary form among a moviegoing readership. Atwood's efforts in this regard signal the way literature—here, the

short story—could be co-opted to "uplift" motion pictures by repackaging its narratives in literary form, and in a respectable forum, in this instance *The Competitor*, which, its opening editorial claimed, was "replete with matter calculated to inspire the race to its bests efforts in everything American."[49] Micheaux, I argue, composed his strange and highly complex novelization, *The Masquerade*, in an attempt to kick-start his stalled career. To do so, he recycled literary (Chesnutt's) and silent-film (his own) materials, and, in contradistinction to *The Competitor*'s lofty aspirations, repackaged these in the most lurid, pulpy way, no doubt in an effort to attract a readership of Black filmgoers to whom his motion pictures had once so appealed. As with Atwood's and Micheaux's novelization, the novelization—photoplay edition—of *A Lost Lady*, in which Cather had no direct hand, exploited the routes motion pictures had newly opened up to literature, but more strenuously so. Importantly, this edition reminds us of yet another way literature—high literary culture—could now mass-circulate beyond the "big" magazines and page-to-screen adaptation. But, as I will argue, to read a literary narrative in the form of a photoplay edition has the unexpected effect of altering our understanding of it. In this instance, I find in the Grosset and Dunlap edition of this Midwestern *Mme. Bovary*, with its motion-picture paratexts, *A Lost Lady*'s otherwise submerged engagements with motion pictures, especially in terms of its fascination with stardom and an accompanying fan culture.

Novelizations had the beneficial—or detrimental, depending on whose views we seek—effect of expanding literature's readership into motion-picture audiences and worse (according to Cather at least), motion-picture fans. Chapter 4, Readerly Pleasures: Screen Reading, and *The Motion Picture Story Magazine*," picks up on this insight to seek out the ways readers responded to and navigated literature's new forms and materials generated out of its encounters with motion pictures. To do so, it begins by considering what I argue are motion pictures' invitations to read, a strategy of motion-picture address that refers to, draws on, recasts, or incorporates literary features in addition to the on-screen author cameos mentioned above. These include the inclusion of on-screen literary quotations as well as literary objects such as books and manuscript fragments. An awareness of such invitations can provide us with a good indication of how motion-picture producers wished filmgoers to engage with motion-picture narratives. But motion-pictures' print forms such as short-story novelizations, as well as readers' letters-to-the-editor and similarly interactive columns and features that appeared in the motion-picture fan magazines of the time—here, the

full run during the 1910s of *The Motion Picture Story Magazine*—can also aid in constructing an account of the ways in which readers responded to and engaged with these new experiences of and encounters with literature beyond its more conventional sites and print objects. In sum, Chapter 4 aims to discover how motion pictures may have generated, contributed to, or altered habits of literary reading—and, just as importantly, what pleasures motion-picture reading, whether it occurred on screen or in the pages of the fan magazines, promised it readers.

The Afterword, Roaming with Vachel Lindsay and Oscar Micheaux reflects one last time upon the movement—the transportation—of literature through the postliterary landscape. To do so, it ponders the near-contemporaneous cross-country wanderings—door-to-door, tramping, riding the rails—of Vachel Lindsay, poet and film theorist, and Oscar Micheaux, novelist and motion-picture producer, as they sold or bartered their wares—poetry, novels, film stock—in a manner Lindsay described as "Higher Vaudeville." I find in Micheaux's and Lindsay's wanderings, and their respective accounts of these, an invitation and a template of sorts to think once more about the new networks for literature that motion pictures mobilized, rendering it more volatile, more permeable—and indeed expansive.

It is the task of *Silent Film and the Formations of US Literary Culture* to uncover a comprehensive range of interactions of motion-picture and literary cultures from the emergence of motion pictures through to the early sound era, and in particular to reveal the significant contributions motion pictures made to the transformations within literary culture of the early twentieth century. Indeed, my claim is that it is impossible to think and write about early twentieth-century US literary culture without a consideration of motion pictures, which came to inform and underpin its very infrastructure. As Bentley has written, "Whether analyzing dime novels or the cerebral fiction of a Henry James, we need additional compass points: cinema as well as print."[50] While it is not possible here to explore the full range of the collaborations across motion-picture and literary cultures, the chapters that follow focus on enough of these to demonstrate, I hope, that the literary history of the twentieth century is motion-picture history, and motion-picture history, literary history.

1

Starring the Author: Literary Celebrity and Popular Authorship

On February 14, 1914, members of the recently formed Authors' League of America gathered in New York City's Biltmore Hotel for the league's inaugural annual banquet. The Vitagraph Company, both "the movie nursery and kindergarten" and "at the forefront of the industry's wooing of the middle class, especially with its recourse to prestigious sources," was invited to host the event in tandem with the league.[1] Included in the festivities was a program of short films in which several of the league's members—popular authors George Ade, Rex Beach, Ellis Parker Butler, George Barr McCutcheon, Amelie Rives, Ida Tarbell, Booth Tarkington and Louis Joseph Vance—were depicted writing at their desk or reading from one of their books. (Beach later disclosed the book that the filmmakers presented to him for this purpose was actually *Diseases among School Children*.) Under the auspices of J. Stuart Blackton, one of Vitagraph's founders who also happened to be a life member of the league, the scenes were filmed "over several days" at "the plant in Brooklyn," and were to be screened for "the second time at the Hotel Plaza on the afternoon of Feb. 19" with in-person readings by several authors, including Jack London and Rupert Hughes.

The league's collaboration with Vitagraph on this February evening in 1914 ushered in, as a *New York Times* columnist explained, what would become the league's efforts "to secure better recognition for the unknown writer, and better protection for all writers under the copyright law, which was drawn before the days of serial, dramatic, and moving picture rights."[2] However, the broader implications of the banquet resonates beyond the league's immediate and worthy objective of promoting "The Case of the Poor Author."[3] It also signaled literary culture's evolving interactions and allegiances with the motion-picture industry.

The joint banquet was of course not the first such interaction of literary and motion-picture interests. Adaptations of literary texts had been something of a staple since motion pictures' emergence, two of the earliest being *Trilby*

Silent Film and the Formations of US Literary Culture. Sarah Gleeson-White, Oxford University Press.
© Oxford University Press 2024. DOI: 10.1093/oso/9780197558058.003.0002

and Little Billee (1896), adapted from George Du Maurier's *Trilby* (1894), and *The Death of Nancy Sykes* (1897), adapted from Charles Dickens' *Oliver Twist* (1838). By the early 1910s, it was evident that narrative film—the multireel feature—rather than a cinema of attractions, which preceded and developed alongside it, would become the motion-picture industry's preeminent mode. Turning to literary texts for the source of motion-picture stories made good business sense for motion-picture producers. Viewers' prior familiarity with the story could to some extent be relied upon at a time when dialogue conveying plot information was limited to whatever could be squeezed into intertitles. Stage and screen actor Hobart Bosworth early on recognized the financial and artistic wisdom of page-to-screen adaptation. In 1913, he established Hobart Bosworth Productions Company for the sole purpose of adapting to the screen the works of London, the most celebrated author of the day. London was in turn quick to take advantage of the opportunities that motion pictures seemed to offer for greater renown and an end to the "financial hole" into which he so often fell.[4]

The commerce between motion-picture and literary cultures during the early twentieth century extended well beyond the adaptation of literary texts to film. And that topic has been well covered by others.[5] The rise and consolidation of narrative cinema during the 1910s and 1920s more comprehensively transformed literary culture, particularly, as we will see, in terms of authorship, a practice that was becoming increasingly collaborative as authors went to work for motion-picture production companies. Authorship was also becoming an increasingly public endeavor, a spectacle staged for an audience of consumers, and a valuable marketable commodity. As Beach concluded in the memoir he published in 1940, "Of all the phenomena I have witnessed none has been more startling than the growth, development and conversion to respectability of motion pictures. It interested me deeply . . . because it so profoundly influenced the profession of writing."[6]

From Study to Studio

The motion-picture footage of members of the league screened during that 1914 banquet depicted authors at work: writing, reading. These scenes were neither filmed in these authors' studies nor in comparable private domestic spaces. They were, rather, created on set in Vitagraph's Brooklyn studio amid, as the *New York Times* reported, "a vast assemblage of Mexicans,

soldiers, and frontiersmen, who had come to watch from the other studios."[7] Not only were these scenes and sites of authorship staged; they were also public, in their manner of production and reception and, for that reason, diverge considerably from the ideal "fittingly circumstanced" Victorian study known "at least from the opening of the present genteel period" and which William Dean Howells conjured so evocatively in his very first "Editor's Study" column for *Harper's Monthly* in 1886. Here, he invites his readers to imagine "the unreal editor, the airy elusive abstraction" whose study is decorated with "Heavy rugs [that] silence the foot upon his floor; nothing but the costliest masterpieces gleam from his walls; the best of the old literatures, in a subtly chorded harmony of bindings, make music to the eye from his shelves, and the freshest of the new load his richly carved mahogany table." Howells' fanciful study functions as a refuge from a cultural sphere now menaced by the "Grub Street traditions of literature," that is, from the mass and cheaply produced hack work which would in a decade's or so time include that produced by both popular and higher-brow authors working in the motion-picture industry.[8] Associated with a life of contemplation and "interiority," the world of the study was clearly "antithetical to the world of popular spectacle."[9]

But it was exactly the world of popular spectacle that soon transformed the site of literary production. The emergence of a new mass marketplace from the late nineteenth century, thanks in part to the magazine revolution of the 1880s, had already begun to alter such sites, as Howells' reference to Grub Street indicates. As part of such transformations, Nancy Bentley writes, "the author's private study became a site of concentrated interest for tourists and celebrity seekers as well as literary devotees," with "public tours and magazine photos" showcasing authors' intimate places of writing. "The privacy of the private study could have an almost irresistible mass appeal."[10] And it was an appeal from which many authors increasingly sought to profit.

Motion pictures offered a way to both archive and achieve—record— that appeal. Many of the most popular authors of the day worked closely with or directly in the motion-picture industry. However, very few cultural histories of the early twentieth century acknowledge, let alone examine, these cross-media collaborations. Even in the many excellent accounts of the transformations that took place in the literary realm across the late nineteenth century and into the earliest decades of the twentieth, the role of motion pictures in new forms of authorship authorship—the focus of

this chapter and the next—has been somewhat neglected. Paying attention to the new sites of authorship that emerged as the relations between the motion-picture industry and authors developed can tell us a little more about a major turning point in the history of authorship, and this is its move, as so many scholars have found, from gentlemanly pastime to paid profession. Considering the place and work of authors on the studio lot is a good place to begin gauging more fully the increasingly collaborative, public and spectacular nature of authorship in the wake of motion pictures.

In the earliest years of the twentieth century, even before they took their narrative turn, motion pictures were beginning to play a significant role in the changing literary landscape. Several authors, like London, identified opportunities that only in the late 1910s would emerge more concretely in terms of subsidiary rights, employment opportunities in the industry itself, and in terms of the lure of greater renown or lucre that the mass circulation of literary narratives promised. Beach, Thomas Dixon, Hamlin Garland, Gertrude Atherton, Elinor Glyn, London, Frank Norris, Tarkington, and Edith Wharton are representative here; they were among the first authors to discover exactly what the upstart industry—motion pictures—might have to offer them. As Marsha Orgeron has written of London, "Although not the first, [he] was among those writers on the cutting edge of [the] transitional phenomenon of selling stories to the [motion-picture] industry."[11] And according to Michael Wutz, Norris' novels were, around 1914, "among the first to be considered for film."[12]

Several famous authors, deeply invested in the industry beyond the sale of the rights to their fiction the studios, had sustained hands-on involvement in various stages of motion-picture production. Some set up their own companies "during the adolescent age of the movie industry" to adapt their own works to the screen. In 1914, L. Frank Baum formed the Oz Film Manufacturing Company, which "released . . . Oz films . . . scripted by Baum." Before that, in 1910, and through the Selig Polyscope Company, he "released four one-reelers, three based on the Oz stories and all scripted by Baum himself."[13] Beach would follow suit; in 1917 he established Rex Beach Pictures Company with producer Benjamin B. Hampton to manufacture adaptations of his novels, such as his 1914 *The Auction Block: A Novel of New York Life*. As he later recalled, "I edited and re-wrote scripts, hired casts, supervised productions, helped cut and title the film."[14]

Other popular authors collaborated with in-house scenarists. Irving S. Cobb, Zane Grey and Hughes teamed with Universal's scenarists on the

forty-reel, twenty-episode serial *Graft* (1915; lost). Others, such as Beach and Atherton, wrote original film stories that in-house scenarists then converted into scenarios. And Hughes and Atherton, among others, oversaw the scenarios adapted from their fiction, and supervised the final editing of the motion pictures made of these. Hughes was also "invited to retitle and re-arrange other people's pictures" and at times acted "as a director, of a sort."[15] Anzia Yezierska, in the process of supervising Goldwyn Picture Corporation's 1922 adaptation of her short-story collection *Hungry Hearts*, discussed the project with "members of the scenario department."[16]

Hamlin Garland's experiences provide a particularly useful case in point in terms of the hands-on ways authors from very early on in the development of motion pictures began to engage with the industry. He first investigated its potential as early as 1913 when "a California moving picture company" expressed interest in his "short stories and . . . a novel."[17] The following year, he met with Jesse L. Lasky and William N. Selig about adapting to the screen his 1901 novel *The Captain of the Gray-Horse Troop*. Although nothing came of these early inquiries, "the motion-picture bug had bitten" him.[18] But it would be another two years before he entered into what turned out to be successful negotiations with the Vitagraph Company, the studio that was integral to altering perceptions of motion pictures with its attempts to become "the most prolific producer of 'high art' subjects."[19] Under contract to Vitagraph from 1916 to 1918, Garland wrote synopses, titles and scene lists, and frequently attended rehearsals to provide advice about the shooting of the films of four of his novels: *Hesper of the Mountains* (1916), *The Captain of the Gray Horse Troop* (1917), *Money Magic* (1917), and *Cavanaugh of the Forest Rangers* (1918).

Bert Ennis, Vitagraph's press agent and music supervisor, and Clara Beranger, a Vitagraph scenarist, wrote illuminating accounts of the role of writers in preproduction during this period. A writer would produce a treatment or synopsis of the novel, play or story to be adapted; that same or a different writer would then compose a list of scenes from the treatment; the titles and inserts (images of letters or newspapers, for example) would subsequently be composed if required; and only then were technical directions such as fades added. According to Beranger, it was during this final stage that the writer would confer with art and technical directors to create the final scenario that was "pretty nearly as you see the picture on the screen."[20]

Garland was involved in every one of these stages. For the filming of *Money Magic*, he even composed instructions for color tinting;[21] he believed "tinting . . . would add greatly to the charm of the piece. . . . Such treatment . . . would relieve the monotony of that gray-white effect which is ghastly on the face of the actors."[22] He also had significant input as regards the location for each of his productions. And he would read and revise scenarios that, once he had composed the story treatments, were written by Vitagraph's in-house "hack writers," as he termed them. The scenarios of each of the four adaptations were sent to Garland for "additions and corrections," and the revised scenarios were then used as the final shooting scripts.[23] For *Money Magic*, Garland ended up writing the scenario himself after his "little hack scenario writer" was "taken off the property."[24] The shooting of Garland's last Vitagraph property, *Cavanaugh of the Forest Rangers*, was delayed to provide Garland as much time as possible to make revisions to its scenario.[25] Garland's seeming willingness to submit his works to the studio's own writers was conditioned by a clause in his contract with Vitagraph, stipulating "Any change from the story of the book will be submitted to you and all scenarios will be submitted for your approval before being placed in rehearsal."[26]

One of the most significant new sites for authorial labor, a site far from Howells' ideal study, was the motion-picture story department, and "one of the first moves toward a regularly constituted scenario department [was] the employment, in 1900, of [author] Roy McCardell as a scenarist for Biograph."[27] The emergence of narrative film generated a demand for more complex scenarios, and these very quickly became central to motion-picture production, so requiring dedicated space on the lot.[28] Indeed, story departments became the norm from around 1912, and writers were hired for the express purpose of producing scenarios. Screenwriting guides, in book form and in the trade papers, proliferated during the 1910s; what had once been a field open to amateurs became a professional practice.[29] Inside the shared spaces of the story department, in story-conference rooms, on set and on location, authorship became increasingly public. Even the transient spaces of hotels were often transformed into gathering places for authors in the motion-picture industry. It was to the Hollywood Hotel in 1920 "that Samuel Goldwyn brought . . . such celebrities as Rex Beach, Rupert Hughes" and "Sir Gilbert Parker, Edward Knoblock and even the great Somerset Maugham himself. Elinor Glyn . . . arrived at about the same time."[30] Atherton, who also

stayed at the Hollywood Hotel during her tenure with Goldwyn Pictures, remembered it as "the headquarters of all that was most interesting in Hollywood. It was interesting, no doubt of that, that nonentities came from the East every winter to sit on its piazza and in its large dining-room to stare at the celebrities. Not only did many of the screen folk live in that truly abominable hotel . . . but at this particular time nearly all the authors had been herded into it."[31]Authors, when not working alone in their apartments, hotel rooms, and bungalows, were also found working on site—often "in an ugly little office in a noisy rackety-packetty building"[32]— with scenarists, editors, directors, producers, actors and others in the industry as they simultaneously learned to compose new print forms such as intertitles, synopses and scenarios.

The Authors' League and the Eminent Authors Inc.

Indicative of the new and more direct forms of authorial collaboration with the motion-picture industry was the increasingly significant role of the Authors' League of America, threatened, as its members felt themselves to be, by a consolidating motion-picture industry. Although the league's principal objective was to keep in check what it considered to be the often dubious and sometimes exploitative copyright practices and oversights of the publishing industry, it quickly sensed the intermediary role it would need to play in an altered cultural landscape on which had burst a potentially disruptive mass storytelling medium.

The league set out its purpose in the first—April 1913—issue of its monthly publication, *The Authors' League Bulletin*: "the mutual protection and information of authors in their dealings with publishers. It is a purely business and technical organization, for the purpose of advising writers as to their legal rights and answering practical commercial questions relating to their profession."[33] This statement omits any mention of motion pictures. However, an editor's note in this same issue briefly ponders the possible effects of motion pictures on authorship. And an article by Beach, the league's president, considers "a new and comparatively untried field," that is, motion-picture rights. There needs to be, Beach writes,

more thorough and intelligent co-operation between members [of the league] and the [motion-picture] producers. Moving pictures are no

longer an experiment, they are an institution; they have attained to a dig-
nity equalling that of the drama, with the result that a demand has risen
for good material. This demand has increased steadily, as the public taste
has improved under the commendable efforts of the manufacturers, and
promises to continue to increase.

Motion-picture adaptations of "famous plays" and "literary masterpieces,"
Beach continues, in addition to "a market for good plots" and the forma-
tion of "several agencies" have together given rise to "departments for the
exclusive handling of moving-picture plays."[34] In other words, although
not set out in its original statement of purpose, the league did in fact take
a keen interest in motion pictures from its founding, identifying in them
opportunities—not only risks—for its members and, implicitly, literary cul-
ture more widely.

In the second issue of the *Bulletin*, published in June 1913, Beach again
takes up the subject of motion pictures. Since 1911, he writes, authors have
found a good source of revenue in selling the rights to their short stories
for one-reel feature films. But the recent development of multireel features
has engendered "a demand for more pretentious photoplays," and "many
famous books . . . are being photographed."[35] Beach urges the members
of the league to familiarize themselves with these developments, and to
learn to market their books to the studios. However, in his 1940 memoir
Personal Exposures, Beach recalled less sanguinely the opportunities the
industry seemed to offer authors in the 1910s. In addition to the alleged
abuses perpetrated by "wily and unscrupulous" magazine editors and
"human barracuda"—publishers—"who preyed upon fingerling authors"
thanks to a copyright law that was "loosely drawn, ineffective and unfair,"
authors now also had the motion-picture industry with which to contend,
which, although "still in diapers . . . showed such precocious criminal
tendencies that it needed watching."[36] One of the first copyright suits the
league sponsored was London's against the Balboa Amusement Producing
Company in 1913.[37]

The *Bulletin* also provided a forum for the motion-picture industry to
plead its case and to court authors. In his 1914 article, "Literature and the
Motion Picture—A Message," essentially a plea to authors to have their
work "properly picturized," Blackton claimed that "Literature is literally the
basic foundation upon which the already gigantic edifice of Picturedom has
risen." Of particular interest to authors who might have been weighing up

the advantages and disadvantages of motion-picture collaboration must have been Blackton's claim that

> Millions upon millions of men, women and children all over the world look upon this form of entertainment as their principal recreation and, incidentally, are being unconsciously educated to understand and appreciate the higher forms of art and culture. . . . In fact, the greatest advertising a novel could receive would be a preliminary exhibition all over the world in pictures. . . . In addition to reproducing well-known plays and successful books, there is a need for big original features, specially written for pictorial presentation.[38]

The "need" to which Blackton here refers arose out of the marked changes the motion-picture industry experienced during its transitional era when, beginning around 1913, one-reeler films were increasingly replaced by two- to four-reeler feature films. According to film critic Epes W. Sargent in 1913, "Nine-tenths of the real demand to-day is for two-reel photoplay stories."[39] Copyright laws had also changed. The studios could no longer freely adapt works from literature and other media; they "needed to obtain permission in order to adapt works for the screen." One consequence, as Peter Decherney writes, was that "the exclusive relationship between publishers, theater companies, and movie studios became a staple of the new film market."[40] In other words, the studios needed to work closely and collaboratively with publishers and authors in the search for and securing of works for adaptation.

Another factor in the ascendancy of the feature film in motion-picture production was the effort by exhibitors to elevate the status of moviegoing and a broader motion-picture culture by exploiting the prestige of literary works—an effort in which many authors were willing to participate. And, as Miriam Hansen finds, from the mid-1910s the downtown picture palace increased admission fees to attract a better-paying middle class—not the working class who until then had been the principal patrons of the nickelodeon and cinema of attractions. One consequence of the industry's "bid for cultural respectability"—from production through to exhibition—and of "the rise to hegemony of the narrative film" was that producers began to direct their attention to scenarists and scenarios.[41] Edison Inc. produced guidelines for would-be scenarists, and the Mutual Film Corporation, "in its effort to raise the standard of moving pictures . . . contracted for the stories by

many of the most prominent authors of novels and magazine stories [to be] condensed into scenario form and produced upon the lighted screen under the direction of D. W. Griffith, the Mutual's famous director."[42]

It was exactly this shifting cultural landscape the Authors' League aimed to negotiate on behalf of its members. On the whole, the league, via its *Bulletin*, continued to urge authors to profit from the new medium. To aid in this, it included tips for writing scenarios, advertisements for scenario-writing competitions run by the studios, sample scenarios, advice about rights and copyright, advice on how to negotiate motion-picture contracts, and studio announcements seeking writers of original scenarios. But the *Bulletin* also contained warnings to those members considering crossing over in some capacity to motion pictures. It published several letters from members complaining that the studios had destroyed their scenarios, converting quality to trash. The *Bulletin* also published opinion pieces warning authors to stay away from motion pictures altogether, to stick to what they do best: literary authorship. (One motion-picture representative, pushing back against this kind of criticism, claimed it was only the weakest authors whom motion pictures attracted.)[43] A 1916 issue of the *Bulletin* reprinted from the motion-picture fan magazine *Photoplay*, "An Author in Blunderland," a short story about an author seduced—by a serpent no less—to write for motion pictures, with the lure of large financial rewards.[44] On the whole, however, the *Bulletin* encouraged members to embrace the new opportunities motion pictures offered for greater, and new and larger audiences for their fiction.

But many authors identified more high-minded opportunities arising from closer collaboration with the motion-picture industry. Producers such as Griffith had already recognized in motion pictures' capacity to reach a mass audience the potential to educate and thus "elevate" the American people spread across a vast continent. He opined in 1914, "the great writers of the present day and the great authors of the years to come will deliver their messages to the waiting world by means of the photoplay."[45]

Many authors echoed such earnest calls. For London, motion pictures were a means to distribute "knowledge in a language that all may understand."[46] Garland's comparable faith in the democratic potential of motion pictures aligned with his theories of an indigenous American literature, as set out in his 1894 essay collection, *Crumbling Idols*. Accordingly, the comprehensive circulation of an indigenous literature would forge and bind the imagined nation. Concerned that "America is not yet democratic in

art, whatever it may claim to be in politics," Garland foretold its coming; it would be born "not of drawing-room culture, nor of imitation, nor of fear of masters, nor will it come from homes of great wealth. It will come from the average American home, in the city as well as in the country."[47] And indeed—and perhaps ironically for this author whose writings mourn a prelapsarian world embodied in its regions—it would be motion pictures that would not only create a broader imagined community but, as Griffith also saw it, disseminate the greatest works of literature, including Garland's own, to the American people, and in that way consolidate and circulate, even beyond the reach of print culture's expanding market, a self-consciously American culture.

Thomas Dixon articulated a more radical conception of the mass circulation of motion pictures and their salutary function in his rather odd, and unproduced to this day, 1924 one-act play—a nine-page "sketch"—"The Hope of the World: A New Language of Men—the Motion Picture," whose cast of three, Thomas Edison, an unnamed young boy and his unnamed mother, are gathered in Edison's laboratory. Mother and son ask Edison how another world war might be avoided. Edison's (and presumably Dixon's) answer is education—via the older technology of the Kinetoscope, and the exemplar of the notorious adaptation of Dixon's own novel, *The Clansman: A Historical Romance of the Ku Klux Klan* (1905):

> In 1915 Mr. Griffith produced "The Birth of a Nation," the first great Photoplay of history. In this epoch-making achievement we showed that the motion picture is a new universal language of Man, expressing thought with a thousand times the power of printed page or spoken word. . . . Its language is universal. Through it we can speak to Europe, Asia, Africa, America, and every island of the Seas, the same message—and, it's the hope of the world.

Dixon's Edison encourages the mother to "gather the greatest authors, artists and musicians [to] create masterpieces of our new language" in order to "teach millions through the new universal language of film."[48] His eccentric vision of the function of motion pictures placed authors in a central didactic role.

Rex Beach was also quick to grasp the potential of motion pictures for authors, as we have seen, but he was more interested in the personal reputational and concomitant financial benefits that would surely accrue. As he writes in his

memoir, "I predicted that the day would come when fiction-writers would find their motion-picture rights to be as valuable as their magazine, book, or stage rights, therefore it behooved them to pay attention to the flicker drama."[49] Thus, when in 1914 the league established a Photoplay Committee (renamed the Motion-Picture Committee the following year) expressly to advise members about motion-picture rights, he seemed the obvious choice to chair it.[50] There was clearly a need for such a committee, that is, a body within the league tasked with keeping a close eye on motion-picture-industry practices. According to a 1915 letter from a member of the league's Executive Committee to Theodore Dreiser, the league "receive[d] many complaints during the course of a year made by authors and directed against publishers, managers and moving picture concerns."[51] And as London had noted rather bitterly in the foreword to his posthumously published novel *Hearts of Three*,

> In a year a single producing company, with a score of directors, is capable of filming the entire literary output of the entire lives of Shakespeare, Balzac, Dickens, Scott, Zola, Tolstoy, and of dozens of less voluminous writers. . . . The film rights in all novels, short stories, and plays that were still covered by copyright were bought or contracted for, while all similar raw material on which copyright had expired was being screened as swiftly as sailors on a placer beach would pick up nuggets. Thousands of scenario writers . . . pirated through all literature (copyright or otherwise), and snatched the magazines hot from the press to steal any new scene or plot hit upon by their writing brethren.[52]

In the 1915 "Report of Motion-Picture Committee" that he composed for the league's membership, Beach acknowledges that motion pictures were becoming the most significant factor affecting copyright. The report strongly urges authors "to lease their rights on a royalty basis and not to sell them outright." To that end, the committee drafted "a photoplay contract under the terms of which the author's rights will be plainly set forth." But Beach also took pains, in this report, to underscore the great opportunities that motion pictures' narrative turn would provide authors. He remarks in particular on "the increase in popularity of the feature film as distinguished from the short film, and its improvement in quality," citing as evidence "[t]he excellence of the high-grade feature, its wide general appeal and the dignity of its method of portrayal," all of which "is particularly gratifying to the author."[53] Beach, then, became something of a spokesperson for authors,

advocating on their behalf as he worked to ensure they played a central role in the new industry. Indeed, according to Hampton, "Authors in all lands owe a debt of gratitude to Rex Beach. He has done more than any one man to create conditions under which novelists can work with [motion-picture] producers."[54]

The benefits that could accrue to authors and producers worked both ways. Samuel Goldwyn clearly saw in Beach something of an ally as well as an effective mediator when he chose him in 1919 to head up his Eminent Authors Inc., a studio-based stable of famous authors contracted to "film their own works, under the guidance of Beach."[55] Studios had begun to court authors since at least 1914 when, according to a *Moving Picture News* column, Universal announced that it would now be "corralling many of the big well-known writers and securing the exclusive rights to produce in photoplay from their best works."[56] But Goldwyn's Eminent Authors was the largest and most structured such attempt, and certainly became the best known.[57]

Goldwyn, according to Beach, "was the first mogul in the business to recognize the importance of writers and to offer them real encouragement."[58] And Rupert Hughes recalled that Goldwyn "had given authors their own way" rather than having them "shut out as a useless nuisance whose opinions are not worth even consideration."[59] What was particularly novel about Goldwyn's initiative was that "While all of the writers . . . have had some stories filmed, none of them has ever been seriously consulted regarding the method of screen treatment of their stories, nor have they been allowed that intimate co-operation and supervision which prevails in and is vital to the author"—which was not quite the case, however, as Garland's experiences at Vitagraph indicate.[60] By contrast, the Eminent Authors were to oversee the "picturization" of their works, which included approving (or otherwise) the scenarios adapted from their fiction by in-house scenarists. Convinced that the future of motion-picture production lay with the author, Goldwyn was adamant that "every picture . . . will not be offered for release until the author has given his personal approval to it. The picture must pass the severest critic that it will ever meet—the author of the story."[61]

As a branch of Goldwyn Pictures, which Goldwyn had formed in 1916, the Eminent Authors comprised an original group of seven famous authors: Atherton, Beach, Hughes, Basil King, Gouverneur Morris, Mary Roberts Rinehart, and Leroy Scott (Figure 1.1). (Authors who would a little later have contractual and other arrangements with the Eminent Authors

Figure 1.1 From "Eminent Authors Pictures Formed," *Moving Picture World*,
June 7, 1919, p. 1469.
Courtesy of the Media History Digital Library.

Figure 1.2 From "Announcing Eminent Authors' Pictures," *Moving Picture
World*, July 12, 1919, n.p.
Courtesy of the Media History Digital Library.

include Roy Cohen, Glyn, Belgian playwright Maurice Maeterlinck, Alice
Duer Miller, Elmer Rice, Tarkington, and Yezierska.) To announce his in-
itiative, Goldwyn, among other promotional activities, took out sixteen-
page spreads in the July 12, 1919 issues of *Moving Picture World* and *Motion
Picture News* (Figure 1.2). The announcement included two pages devoted to

Figure 1.3 "Gertrude Atherton," from "Announcing Eminent Authors' Pictures," *Moving Picture World*, July 12, 1919, n.p.
Courtesy of the Media History Digital Library.

each of the authors, accompanied by a nearly full-page photographic portrait of each. Here are Atherton's pages (Figure 1.3). "I have always believed in the future of the motion picture. I am delighted at the opportunity to reach new millions," Atherton is quoted here as saying. Her 1932 memoir, *Adventures of a Novelist*, details the nature of the contracts she and her fellow Eminent Authors signed with Goldwyn Pictures. Goldwyn had "the privilege of using anything [the Eminent Authors] had ever written or might publish during the three years" they were under contract; "we were to be paid a certain stipulated sum during the term of our contracts, whether our work were acceptable or not." Goldwyn Pictures then "would have ninety days to decide whether or not they wanted to film the work. If they did, the author would receive a $10,000 advance against one third of the film's earnings"—an attractive deal. Atherton concluded, "Whether we liked our first experience with Hollywood methods or not, one thing must be said for these 'Studios': their remuneration was extremely generous and equally assured.... As far as I was concerned, this agreement was faithfully kept."[62] Yezierska, having traveled to Hollywood in 1921 to join the Eminent Authors to oversee the production of *Hungry Hearts*, was less impressed by the conditions, and indeed left

Hollywood in disgust: "She resented the successful Hollywood writers who wanted to earn as much money as possible," that is, the "Hollywood gods" Hughes, Atherton, and Glyn who "had all put love, pity, integrity behind them and were expecting her to do the same.... Everyone in Hollywood was crowded about the cream bowl."[63]

Several factors, including "wrong-headed investments ... and ... the economic crisis of the post-World War 1 period," ensured the Eminent Authors Inc. was short-lived.[64] But Goldwyn's "[l]ofty literary ambitions" contributed to its demise also. Take, for example, the 1920 adaptation of Atherton's hugely popular novel *The Tower of Ivory* (1910) as *Out of the Storm*, one of the Eminent Authors' first productions (Figure 1.4). Although several industry magazines were convinced Goldwyn had a hit on its hand, thanks to Atherton's fame and popularity that would ideally "cover up the rather

Figure 1.4 A full-page advertisement for Goldwyn Pictures' *Out of the Storm* (1920) with Gertrude Atherton's name prominently featured. *Motion Picture News*, May 1, 1920, p. 3802.
Courtesy of the Media History Digital Library.

trite plot," as *Wid's Daily* had it, *Out of the Storm* received mixed reviews.[65] Atherton herself was displeased with this adaptation of what she declared to be her favorite novel; "[t]hey had introduced as *deux ex machina* an escaped convict."[66] Indeed, it was "because it was thought to contain too many tips on jail-breaking" that the motion picture was banned in Philadelphia.[67] This was just one of many disappointments for Goldwyn's author initiative. Operating at considerable financial loss, the Eminent Authors was disbanded in 1922 after first Goldwyn's resignation from Goldwyn Pictures in 1921 and then Beach's resignation from the Eminent Authors in 1922. Soon after Goldwyn's departure, Beach published a letter in *Moving Picture World* in which he acknowledged the producer's exceptional vision:

> I hold you accountable for this: For being the first powerful producer to give real recognition to the author and to afford him not only the opportunity of presenting his stories upon the screen with the same freedom he enjoys in putting them upon the page or the stage, but also for encouraging him in so doing. . . . You opened the studio door to authors and I hope I am not presumptuous in venturing to thank you on behalf of the whole writing fraternity.[68]

It is likely the Eminent Authors would have been dissolved regardless of Goldwyn's or Beach's departure for, although Goldwyn claimed the Eminent Authors "the greatest American novelists of today . . . [and] are known to every reading individual," this was not in fact the case.[69] As Hampton insightfully observed in 1921, "the fame of a novelist reaches only a short distance into the social and intellectual scale. The appeal of motion pictures is to all classes, from the lowest stratum of society to the highest. Somewhere around the upper middle and higher strata are found the book readers, but below them there is an enormous audience with little or no knowledge of famous authors."[70] In other words, the bulk of moviegoers—the "enormous audience"—had likely never heard of any of the Eminent Authors. Many of these popular authors would also have been unknown to the cultural elite. In attempting to convince Maeterlinck, one of the most acclaimed authors of the day, to join the organization, Goldwyn named Rinehart and Atherton as authors already contracted to the Eminent Authors. However, as Goldwyn lamented in his memoir, "mention of all the writers we had assembled called from [Maeterlinck] only that vacant smile, that politely groping gaze of a man being addressed in Choctaw or Sanskrit. It is

sad but it is true that the eminence of our Eminent Authors had never been detected by M. Maeterlinck. He had not heard of a single name on our list."[71] (Maeterlinck, under a different contract to Goldwyn Pictures, and barely speaking English, went for months without writing a word. His first scenario, "The Power of Light," was about a boy and a mattress; his second opened with a Native American woman emerging from a sewer in Paris, gripping a knife between her teeth. That was the end of Maeterlinck's motion-picture career.[72])

But the failure of the "enormous audience" to recognize the names of the Eminent Authors could not alone account for the organization's failure. While Beach's and Hughes' contributions were largely successful, in Goldwyn's view, the other Authors were unable to make the transition from literature to motion pictures, and preferred to return to doing what they knew best. Goldwyn explained the failure of the Eminent Authors in terms of "the tradition of the pen [running] athwart the tradition of the screen. . . . The great trouble with the usual author is that he approaches the camera with some fixed literary ideal and he can not compromise with the motion-picture view-point. . . . This attitude brought many of the writers whom I had assembled into almost immediate conflict with our scenario department."[73] Perhaps W. Somerset Maugham, among Famous Players-Lasky's stable of authors in 1921, was right: because the screen "is a technique of its own, with its own conventions, its own limitations, and its own effects," authors were not yet at this point quite able, or indeed prepared, to make the shift.[74] Nonetheless, as one of Goldwyn's salesmen, Arthur Mayer, recalled, "if neither Goldwyn nor the screen was permanently enriched by their [the Eminent Authors'] writings, no one could deny that Goldwyn had not classed up the industry."[75]

The Author as Star

In any case, it was not simply famous authors' skills of writing that producers were seeking or from which they were most to benefit. They were at least as interested in exploiting author reputations. This arrangement was not lost on authors of course, as a clause in the Eminent Authors Inc. contract indicates: adaptations were to "prominently state the name of the Author in connection with the main title of every of the said motion pictures" both on the screen and in all promotional materials.[76] And it is here the commerce between motion pictures and literature produced one of its most dramatic

effects: the transformation of authorship into a brand—and a highly visible, performative one at that. London described his collaboration with Bosworth Productions from 1913 in this kind of way: "I am not an actor. . . . And I never plan to be. My connection with the motion pictures will be solely as author and advisor for their productions"—"although I may pose at my desk," he added.[77] A "pose," of course, requires or depends upon an audience, that is to say, not (only) a reader but (too) a *spectator*.

London, a master of self-promotion and an adherent of the Rooseveltian strenuous life, not only sought locations alternative to the Howellsian study in which to write but ensured there were visual records of these. To that end, in August 1913, Bosworth filmed London at his northern California ranch in Glen Ellen with the aim of incorporating this footage into his film, *The Sea Wolf*. London in turn supplied Bosworth with "a bunch of my photographs."[78] While several photographs in London's private collection capture the study he shared with his "mate-woman" Charmian London, the photographs he chose to publicize, in addition to the footage Bosworth shot, depict him at work outdoors: writing at a table on a balcony, reading in the garden, and reading on board the *Roamer* and the *Snark*.[79] (London wrote in a 1915 letter, "I keep on with my novel-writing" during "the trip through the Canal."[80]) It was important to London's self-fashioning that he depict himself in such spaces to "mythologize this aspiring writer into a rough-hewn proletariat tutored mainly by experience while relatively unskilled in literary ways— an Adamic man of words, a literary frontiersman," as Christopher Wilson puts it.[81] A photograph found on the first page of a four-page promotional pamphlet for Bosworth's (lost) six-reel 1914 adaptation of London's 1913 memoir *John Barleycorn* depicts London seated at the wheel of the *Roamer* with an open journal in which he appears to be writing (it is just possible to make out a writing implement in his right hand) and looking up as if mid-sentence (Figure 1.5).[82] This pamphlet concludes with the following infor-mation for theater managers: "When the play [photoplay] begins we see Mr. London writing the opening lines. It closes as he writes the concluding caption, while speaking the words, easily read, 'And this is my message.'"[83] Bosworth explained to the Londons the value of including in his adapta-tion images of London himself, not as an actor but as author—as if London needed instructing in the work of publicity.

> I think you will be surprised and pleased at the enormously increased value of the play as well as the message resulting from your two scenes beginning

Figure 1.5 Bosworth Inc. Presents John Barleycorn, promotional booklet for *John Barleycorn* (dir. Bosworth, 1914).
Courtesy of the Huntington Library.

and ending the film, made aboard the Roamer. We were all enormously thrilled as the scenes came on and you will be surprised yourself at the strength and earnestness as well as the beauty of your face. Your expression particularly in the last scene, where you say 'And that is my message', is really wonderfully beautiful, and [in] a way sacred, because it seems to express all the force of conviction that you put into the book.[84]

Bosworth was evidently "surprised and pleased" with *John Barleycorn*'s inclusion of moving-picture footage of London, staged as the author of both the book and the motion picture based on it, since this became something of a staple for his London productions. He also incorporated footage of London in his 1914 adaptation of his—London's—1909 autobiographical novel *Martin Eden*. The film, of which only four of six reels survive, includes near its opening, thirteen seconds of footage of London, this time reading

in the garden in Glen Ellen. The camera then moves in for a close-up of his smiling face. Other of Bosworth's adaptations of London works—*The Sea-Wolf* as well as *The Valley of the Moon*—were likewise "headed by a motion picture of himself at work with a pen."[85] Bosworth, in promoting this author as laborer-celebrity, recognized what Bentley describes, in her account of the era's fascination with the private space of the study, as "a quiet glamour that is never directly claimed but everywhere implied: the disavowed glamour we call authority. And in modernity, where there is glamour, there is likely to be iconic display—in other words, spectacle."[86]

London's appearance in several of Bosworth's films is only the tip of the iceberg in terms of the author cameos that began to appear in screen adaptations of literary works during the 1910s and into the 1920s, and that embody, as Mark Goble writes of the cameo more generally, "an intersection of private lives and public spheres in American media culture."[87] These early-film author cameos served both to authenticate the literary provenance of the adaptation and to promote an author's name as a reliable marker for consumers to identify, if they were in the know, and to direct their ticket-purchasing dollars accordingly. As I have said, London's cameos are certainly not the sole (or earliest) example. However, because so few films of the silent era survive and because those that do are not readily available, held in archives as they mostly are, this important early motion-picture practice has received little scholarly attention, and none by literary historians.

According to Joceline Andersen, the term "cameo" used in relation to motion pictures emerged in the early 1910s when "small roles were described as cameos. . . . Most notably, the phrase 'stand out like a cameo' appears occasionally in early newspaper reviews of vaudeville and cinema from the turn of the century to the 1920s to describe distinctive or especially noteworthy performances by individuals within larger acts that offered performers the chance to 'cameo' themselves."[88] Those film historians interested in such inclusions concur that Vitagraph's 1912 two-reel film, *A Vitagraph Romance*, incorporates the first motion-picture cameo in the sense we would typically understand that today, that is, as a walk-on appearance by some (visually) recognizable personality (Figure 1.6).[89] Andersen's important and overdue history of the cameo, *Stars and Silhouettes*, does not, however, consider the author cameo. Jan Olsson does, in addressing what he terms "cameo introductions" among a range of "rhetorical manners of preparing the spectators for the story," and "as a quality seal to bridge the transposition

Figure 1.6 The Vitagraph Company's founders, William "Pop" Rock, Albert
E. Smith, and J. Stuart Blackton as themselves in *A Vitagraph Romance* (1912).
Courtesy Eye Filmmuseum

from text to film text . . . ostensibly warrant[ing] a hoped-for seamless trans-
position from novel or play to screen." Olsson's brief analysis of these author
cameos includes consideration of the on-screen impersonation by actors of
authors long dead, for example, the "complex introduction of Edgar Allan
Poe in a prolog featuring several generations of ancestors," which opens
Essanay's adaptation of *The Raven* (1915).[90] But cameos came to play an im-
portant role in, as they are also an indication of, the transformation of the
status of authorship in the early years of the twentieth century.

Several years prior to Bosworth's visit to Glen Ellen to film London "at
work with a pen," Edison, at that point producing shorts out of the Edison
Manufacturing Company, was on a similar mission when in 1909 he trav-
eled out to Stormfield, the Connecticut home of Mark Twain, to shoot
footage of one of the first authors "to achieve both mass cultural celebrity
and canonical literary status."[91] Unlike London as shot by Bosworth in Glen
Ellen, Twain was not filmed writing—in his study or elsewhere—but rather
strolling through the gardens of his mansion and taking tea with his daugh-
ters, Clara and Jean Clemens, a poignant inclusion since the footage was shot
only months before Jean's premature death at the age of twenty-nine. Edison
included this footage in his 1909 two-reel adaptation of Twain's 1881 novel

The Prince and the Pauper. Since only the documentary footage of Twain survives, and not the screen adaptation of this novel, we can only speculate about the role and placement of this footage in the adaptation. But it is likely this footage introduced—and perhaps also concluded—the narrative in the way that moving-picture footage of London introduced, and sometimes bookended, Bosworth's adaptations of his works.

There are good reasons why filmmakers such as Bosworth and Edison began to include in their films footage of the author of the adapted narrative. One of the most pressing of these, at least at the time of Bosworth's and Edison's respective London and Twain adaptations, pertained to copyright. A Hobart Bosworth Productions Company publicity release from around 1913, and as its adaptation of *The Sea-Wolf* was in production, announced, "The London films will be presented under the film name 'Bosworth,' and at the beginning of each film, as definite authentication, will be run short 20-foot scenes of London himself" who will be "characterized as," a 1913 *Tribune* column noted, "a man in a wide sombrero and a negligee shirt."[92] Why would Bosworth be concerned with "definite authentication"? The 1912 Townsend Amendment meant that in considerations of subsidiary rights, motion pictures were now included in the revised 1909 Copyright Act. Prior to the amendment, as Peter Decherney writes, "film companies freely adapted works from other media (literature, theater, comic strips, etc.) without permission."[93] But Bosworth clearly believed there was still need in 1913 for some form of authentication—here, the "20-foot scenes of London himself"—to safeguard his productions from piracy. An authenticating signature made sense then. London, always alert to "fake Jack London Movies," was embroiled in copyright battles with motion-picture producers almost for the duration of his motion-picture forays, most notoriously with the Balboa Amusement Producing Company from 1913, and with the support of the Authors' League of America, which maintained a record of the case:[94]

> Jack London gave to the Balboa Amusement Producing Company . . . the right to produce several of his books. . . . The contract . . . contained a time clause which provided that if the production were not accomplished at a certain date the right should revert to the author. The pictures were not produced by that date, whereupon Mr. London notified the Balboa Company that the contract had become void. Nevertheless, the Balboa Company finished and produced this film [*The Sea Wolf*]. Mr. London sued for an infringement of copyright, asking incidentally for an injunction. . . .

To the surprise of Mr. London [*sic*] attorneys, the Balboa Company attacked the validity of his copyright. They claimed that when a novel or short story . . . is copyrighted in a magazine, the copyright becomes invalid so far as other forms of publication are concerned—that upon the expiration of serial publication any one is at liberty to republish the work, to dramatize it, or to produce it in moving-pictures.[95]

In the midst of this legal battle, Bosworth telegrammed (to whom is not clear), "GENUINE PICTURE OF SEA-WOLF SEVEN REELS BEARS NAME BOSWORTH INCORPORATED SHOWS LONDON SIGNATURE MEDALLION AND TWENTY FIVE FEET OF MR LONDON IN MOVING PICTURES. HORKEHEIMER THREE REELS. NO SUCH AUTHENTICATION."[96] The medallion that Bosworth here mentions is a reference to the still image of London beneath which appeared his signature: "the autograph and medallion" that would "preface all the Bosworth-London productions" (Figure 1.7).[97]

Figure 1.7 Autograph and "medallion" of Jack London, from *Martin Eden* (dir. Bosworth, 1914).
Courtesy Library of Congress Moving Image Section.

It is fair to say that anxieties and legal battles concerning infringements of and changes to copyright played a significant role in the emergence of the motion-picture author cameo. The author medallion-plus-autograph would shortly give way to the author cameo—literally, in the case of the opening scenes of Bosworth's screen adaptations of London's works, in which the medallion of London is followed by moving footage of London, at least in *Martin Eden*, the one Bosworth–London motion picture that is (mostly) extant. In other words, once there were no longer any pressing copyright reasons for producers to include the author's "medallion and autograph" on screen, they nonetheless continued, or began, to include moving pictures of authors to open and/or close the adaptation, as both Bosworth and Edison had been doing. This little-studied tendency of narrative film of the silent era provides for some greater insight into the role and activities of authors in motion pictures, including the way authors marketed themselves, or at least wished to be marketed, in motion pictures, and the forms of authorship such a practice produced.

Twain and London were among the most popular authors of their day. It is no wonder Edison and Bosworth, canny entrepreneurs that they were, wished to channel and profit from their fame. Indeed, as already mentioned, Bosworth was shrewd enough to set up an entire production company whose sole purpose was to adapt to the screen the works of London. It is true also that producing works of famous authors was, in theory at least, a low-risk enterprise since their product had already been tested on the market. There was, too, the expectation that in so closely aligning themselves with literary culture, motion pictures would attract and absorb some of its higher-cultural aura.

William Selig of the Selig Polyscope Company had long been alert to the benefits of just such literary association, having engaged in 1905 John Pribyl "who had experience in the publishing industry, to purchase motion picture material from the field of literary production. Through Pribyl, Selig acquired the work of [Oliver] Curwood, Beach, and 'many other contemporary writers of star fame' for trivial sums, which in subsequent years proved lucrative resale commodities."[98] Much later, in 1916, Selig traveled from Los Angeles to Indianapolis to shoot footage of another hugely popular author of the day, James Whitcomb Riley (who would die only months later) as part of a larger documentary film project commissioned by the Inter-State Historical Pictures Corporation to mark Indiana's centenary of statehood.[99] When Selig embarked on a series of adaptations of Riley's work two years later, in 1918,

perhaps inspired by the examples of Bosworth and Edison, he incorporated this footage into the first two of these adaptations, *A Hoosier Romance* (1918; no longer extant) and *Little Orphant Annie* (1918). The latter, fortunately extant, includes the entire footage of the moving images of Riley that Selig Polyscope shot that day in Indianapolis.

Little Orphant Annie opens with Selig's footage of Riley seated in the front garden of his home, holding a small dog on his lap. The next moving image depicts him, now standing, reciting what are the opening lines of his 1885 poem, "Little Orphant Annie" (on which the motion picture was based), so casting the story we see unfold upon the screen as an unmediated reading of the poem by no less than the poet himself. An intertitle then announces, '"Inscribed, with All Faith and Affection: To all the little children: —the happy ones; and sad ones; The sober and the silent ones; the boisterous and glad ones; The good ones—Yes, the good ones, too; and all the lovely bad ones." A second intertitle—"The Poet's Afternoon at Home"—prefaces Riley's reappearance. A group of children enter through the garden gate and gather about Riley, once more seated (Figure 1.8).

Figure 1.8 Footage of James Whitcomb Riley taken for Indiana's centennial, and incorporated into the Selig Polyscope Company's *Little Orphant Annie* (1918).

Another intertitle—"I will tell you children the story of . . ."—introduces a close-up still of the cover of the Bobbs-Merrill Company's 1908 edition of "Little Orphant Annie." The next shot depicts this book opening to reveal the first page of the poem, shown in close-up before the narrative proper begins. These opening scenes—of Riley, the children, the book—absorb a remarkably lengthy three and half minutes. In the film's final minutes, we return to the opening footage of Riley seated in his garden. The children wave him farewell as they exit through the garden gate, and a still of the last page of the Bobbs-Merrill edition fills the screen before closing.

As with Edison's documentary presentation of Twain, we do not witness Riley at work either writing or reading. What Edison's footage of Riley does document are some of the ways in which literature could circulate—via live recitation, the published book and, as with any screen adaptation of a literary work, motion pictures—and the role of the author in these. But bookending *Little Orphant Annie* with footage of Riley was a clever marketing strategy. By the 1910s, Riley was "one of the most recognizable men in America . . . and manufacturers used his image to sell a number of different products," including "the James Whitcomb Riley cigar. 'Hoosier Poet' also became a brand name for canned fruits, vegetables, and coffee. Greeting cards and postcards were available containing lines from his poems."[100] If the Hoosier Bard, as he was named on the cigar packaging, could sell such commodities—and such an array of them—then why not motion pictures? In other words, although motion-picture producers—as well as authors—no longer had any pressing need to include an author "medallion and autograph" as a means to authenticate an adaptation, the practice of the author cameo continued and indeed expanded because what mattered to the producer was the author's renown. Famous authors came with a ready-made audience, after all, just as an author could hope for significantly greater (visual) recognition, and from a new audience: the moviegoer.

Beach and Glyn, famous during the 1910s and 1920s, made similar cameo appearances in adaptations of their work.[101] In these examples, both authors are filmed at work—writing—in the seeming privacy of the study, much in the way members of the Authors' League appeared in the Vitagraph shorts screened at that 1914 New York banquet.[102] Beach and Glyn—and Selig Polyscope and Principal Pictures, which produced the cameo appearances in question—likely wished to promote a more sophisticated mode of authorship, one that might set these authors apart from the swashbuckling ethos of London's cameos, or the down-home hokeyness of Edison's footage

of Twain, and Selig's of Riley. Beach, an extremely successful author at this time but frequently tagged as the poor man's Jack London, may well have wanted—and indeed needed—to distinguish himself from his hugely successful rival.[103] And the elegant and cosmopolitan British-born Glyn, the only woman author to my knowledge who made such cameo appearances on screen, likely found in motion pictures, as surely did Selig Polyscope itself, "the unique opportunity for which I had always longed of helping to spread the ideals and the atmosphere of romance and glamour into the humblest homes."[104]

What we know of Beach's cameo appearance derives from what we can glean from the surviving print materials that pertain to the motion picture in question, Selig Polyscope's 1916 rerelease of its 1914 adaptation of Beach's hugely popular novel, *The Spoilers* (for which Beach contributed a one-page synopsis), no longer extant.[105] According to the American Film Institute's catalogue notes about this 1916 rerelease, "Because of [its] great popularity . . . in its original nine reel version, Selig shot additional scenes for the film in 1915 and released it in a twelve reel version in early 1916. This version opened with shots of Beach in his study once the characters had been introduced. According to *MPN* [*Motion Picture News*], this was Beach's only screen appearance."[106]

The study in which Beach appeared near the opening of the 1916 *The Spoilers* may well be the study located in his New Jersey summer home, which he owned from 1911 until 1916 and in which he is seen writing in a 1913 photograph used to promote his novel, *The Iron Trail* (1913) (Figure 1.9). Beach's study is a world away from the ideal study Howells evoked in his first "Editor's Study" column. Its large rustic hearth and uncarpeted floors are appropriate to a rural retreat or hunting lodge—a fitting study for this "Author at Ease," as his short screened at the 1914 Authors' League banquet was titled. But on show too are scattered piles of books, a typewriter and, in the distance on the left-hand-side wall, a poster of the cover of his 1911 book *The Ne'er Do Well* (of which he would go on to write the screenplay in 1923)—and, of course, he is shown at work writing, as Rex Beach the author.

Glyn, best remembered today as the creator of "It," that *je ne sais quoi* quality that guaranteed Clara Bow's fame as the era's "It" girl—itself a kind of brand—likewise appears at work in Principal Productions' 1922 *The World's a Stage*, and in a study that is more feminine parlor than masculine den. *The World's a Stage*, opens with Glyn seemingly absorbed writing at a desk cluttered with inkstand and strewn papers in this sumptuously decorated

Figure 1.9 Rex Beach at his desk, Lake Hopatcong, NJ, in 1913.

room. *The World's a Stage* is not an adaptation of one of Glyn's literary works; it's an original film narrative, of which she wrote its synopsis. These are the motion picture's opening credits:

Principal Pictures
presents
Dorothy Phillips
In
"The World's a Stage"
by
Elinor Glyn

Adaptation and Scenario
by
Colin Campbell
and
George Bertholon

The credits render ambiguous Glyn's role in the film; "by Elinor Glyn" tells us very little. The producers likely hoped the audience would suppose the motion picture an adaptation of one of the famous author's novels, and in that way endow it with greater value and heft.

The ambiguity found in the credits tells us something about Principal's assumptions concerning its audience—attracted by Glyn's fame rather than to her works perhaps—as well as the way authorship was beginning to be conditioned and to operate as a brand rather than as a form of shorthand or synecdoche for a literary corpus. Immediately following the credits of *The World's a Stage* and the brief moving footage of Glyn writing at her desk, a handwritten—maybe designed to mimic Glyn's own handwriting—intertitle appears: "What curious existence is that of the actor! Half of it is spent in a realm of magic make-believe—the other half in a world of cold reality, made commonplace by contrast." In the way the credits encourage us to assume that what we are about to watch is a Glyn adaptation, the footage depicting Glyn at her desk, along with the handwritten intertitle that follows it, hoodwink the viewer into thinking that it is an adaptation of a (nonexistent) Glyn novel entitled *The World's a Stage*. For surely we are here not being invited into the intimate space—albeit larger than life, blown up as it is on the big screen—of famous author Glyn's parlor-study simply to witness her composing a "mere" synopsis. Glyn's thirty-second cameo participates in the film's disingenuous literary alignment as it both reveals—and risks—its literary aspirations.

Glyn also made cameo appearances in other films, such as *The Affairs of Anatol* (dir. DeMille, 1921), in which she had a walk-on part as a recognizable but uncredited extra, and in *Show People* (dir. Vidor, 1928).[107] In the latter, Glyn appears not as the author who introduces her filmed narrative; rather, she is incorporated—as herself, as the famous author Elinor Glyn—into the fabric of the story that *Show People* narrates, as are Hollywood stars Charlie Chaplin and Lew Cody, and the director himself, King Vidor. Glyn is shown in the foyer of the suggestively named High Art Studio, carrying a copy of her wildly popular 1926 novella, *It*.[108] (In another memorable scene, Marion Davies, who stars as *Show People*'s movie-struck Peggy Pepper, encounters Davies the real-life film star; Peggy is less than impressed with her.) A popular author here both lends the cachet of literature—along with popular culture credibility—to a film about film people that makes claims about film as art, and performs on screen the association of authorship and filmmaking via the presence of the author among the film world's stars.

Glyn's appearance suggests that to be a well-known author is to be part of the show.

Glyn again appears as herself, in Paramount's 1927 adaptation of *It*, for which she is credited with "story and adaptation"; she is also credited in the list of players as Madame Elinor Glyn. According to draft synopses of the adaptation, as Lisa Stead has found, Glyn was originally to feature in another opening cameo, sitting "at her desk and writ[ing] her definition of IT."[109] Instead, in the adaptation that was produced, it is the first intertitle that provides a definition of "It"—"that quality possessed by some which draws all others with its magnetic force"—which is finished with Glyn's signature. While Glyn carries *It* in book form in *Show People*, in the film *It*, the protagonist Monty picks up to read not the book but the issue of *Cosmopolitan* magazine in which the story was first serialized in two 1927 installments.[110] When Monty opens the magazine to the first page of Glyn's story, a close-up allows us to read its opening passage, a reworking of the earlier intertitle's definition of "it": " 'IT' is that peculiar quality which some persons possess, which attracts others of the opposite sex. The possessor of 'IT' must be absolutely un-selfconscious, and must have that magnetic 'sex appeal' which is irresistible."[111] And so Monty begins his mission to find an "IT" girl. Sometime later in the film, Monty's friend Cyrus T. Waltham dines with his wealthy girlfriend Adela and her mother at a fashionable restaurant. During the dinner, they discuss "Elinor Glyn's latest story, 'IT' " since Monty "was raving about it today. What *is* 'IT'?" Adela wonders via an intertitle. Just at that moment, an intertitle announces, "Here's Elinor Glyn herself! Let's ask her to tell us something about 'IT.' " Glyn, looking regal in an elegant floor-length black dress, passes their table as Cyrus stops her: "Madame Glyn, we've been talking about your latest story. Just what *is* this 'IT'?" Glyn replies: "Self-confidence and indifference as to whether you are pleasing or not—and something in you that gives the impression that you are not all cold. That's 'IT'!"

What we see in the various cameo appearances I here describe is a style of authorship generated by motion pictures that is increasingly dependent on not only visibility but visual recognition, even as it fostered that recognition, something we might more readily equate with the picture personality, as motion-picture stars were originally known. This dynamic—authorship bordering on stardom—is undoubtedly most pronounced in the cameo appearances of the legendarily glamorous Glyn. Just as elegantly attired in *The World's a Stage* and *Show People*, costumed, as she is in *It*, in a long-sleeved

black gown accessorized with a knotted string of pearls and hair braided around her head in such a way to resemble a crown, Glyn mingles comfortably with the real-life stars she encounters in the Higher Art Studio in *Show People*—and, indeed, on the very sets on which that film, *The World's a Stage* and *It* were filmed.

Motion-picture audiences must surely have experienced some thrill in their ability to put a face to a (famous) name—London, Twain, Riley, Beach, Glyn—and gaining what must have seemed an intimate glimpse into and seemingly establishing a relationship with a famous and perhaps favorite author. These cameos may also have had the effect of "express[ing] all the force of conviction" that an author "put into the book," as Bosworth wrote of London's cameos.[112] Author cameos also tell us a little about moviegoers during the 1910s and 1920s, or at least the type of moviegoer producers were now trying to attract: avid or aspirational readers. Andersen has written that the cameo appearance of motion-picture stars from the 1910s "establish[ed] the cameo as a potentially cinephilic moment that studios could exploit to engage audiences."[113] What the *author* cameo facilitates is not only a parallel bibliophilic moment but indeed a bibliophilic rupture of the motion picture's diegesis, a rupture that renders authorship part of the show, and its posed, as London might say, labors visible, indeed larger than life—spectacular.

So, although structured studio initiatives such as the Eminent Authors Inc. may have failed in their efforts to employ authors as *writers*, it was still the case that from the early twentieth century, authors could elevate and sell motion pictures—to class up the industry, as Mayer had put it[114]—and seemingly in response to the moviegoing public's eagerness to know something about the author. As a fan wrote to the editor of *The Motion Picture Story Magazine* in 1913, "You are making us acquainted with the players; now make us acquainted with the authors.... Who are they?"[115]

Author cameo appearances were not the only strategy motion-picture producers deployed in this regard. Print materials designed to promote adaptations had named the adaptation's famed author—as opposed to or in addition to the players—at least since 1909, when the Edison Company "advertis[ed] the famous writers who contribut[ed] stories for its films."[116] As an article announcing the Eminent Authors in 1919 proclaimed, "Screen personalities alone cannot hold [the] industry up, for no matter how big or popular that personality, picture audiences expect and demand a story back of him or her, and a story, moreover, big enough to match the star's

personality and prestige."[117] Beach's were clearly assumed "big enough," even prior to his engagement by Goldwyn. Promotional materials appearing in industry magazines for the 1917 adaptation of his novel *Pardners* (1905), in which his name appears immediately beneath the film's title (even if it is not as prominent as the star Charlotte Walker's), urges, "This WALKER-MUTUAL Photoplay by Rex Beach offers unlimited possibilities for box-office receipts" (Figure 1.10).[118]

Later that year, as earlier mentioned, Beach, with Hampton, set up a production company bearing his name: Rex Beach Pictures. It was, Hampton claimed in a 1921 column in *The Bookman*, "the first company ever organized to make photodramas from the works of a novelist and to 'star' the novelist instead of a player."[119] (This was not in fact true, as the example of London and Bosworth's collaboration, from 1913, indicates.) In response to the company's first production—an adaptation of Beach's *The Barrier* (1907)—a column in *The Moving Picture World* acknowledged the

Figure 1.10 Advertisement for Mutual Film's *Pardners* (1917), *Moving Picture World*, February 3, 1917, p. 168.

inherent risks of "putting over a photoplay without a star in these days" but concluded, with great insight, *The Barrier* would nonetheless be a success thanks to the "strength and popularity of Beach as an author and 'The Barrier' as a literary magnet."[120] We can already see the shift in the strategies used to advertise the two films—from *Pardners* to *The Barrier*—all of one month apart: while Mutual names Beach in the poster for *Pardners*, it is the player Charlotte Walker who is given star billing. With *The Barrier*, Beach is its star (Figure 1.11).

And so, when Metro-Goldwyn-Mayer released a remake of *The Barrier* in 1926, a column in *Film Daily* reminded its industry readers that "Rex Beach's name as the author of a famous best-seller is the best tie-up you have. It will draw in the average house."[121] While his own producer at Rex Beach Pictures Company, Hampton, had concluded that "book readers" constituted only "somewhere around the upper middle and higher strata" of society, Beach continued to believe that at least "movie audiences were made up, largely, of people who can, and do, read and that an author's name which can be used

Figure 1.11 Poster for Rex Beach Pictures' *The Barrier* (1917).

to sell books and magazines can be used to sell theater tickets"—as well as books.[122] In *Personal Exposures*, he briefly describes his attendance at various national screenings of a United Artists motion picture adapted from one of his novels—either *The Iron Trail* in 1921 (based on his eponymous 1913 novel) or *Fair Lady* in 1922 (based on his 1912 novel *The Net*); he does not specify which here. "It was a novelty for an author to make a personal appearance. . . . I could make a . . . multitude of new readers, by agreeing to the arrangement. Why, no author ever had such an opportunity. Thousands of my auditors would choose the nearest exit—in a rush for bookstores. Think of seeing my name a-glowing in Neon lights in Baltimore, Buffalo, Cleveland, Detroit, St. Louis and points West."[123]

Given its faith in popular regard for authors, Goldwyn's Eminent Authors Inc. likewise promoted its authors in these ways. To ensure "[t]he vast audiences that these authors command by their written word will be able to identify these pictures. . ., each one will carry the name of the author" so that "[t]hey will look for 'a Rupert Hughes picture' or 'a Mary Roberts Rinehart picture.'"[124] Goldwyn went further again. He began to incorporate not only the names but also the *images* of his authors into posters, and newspaper and magazine advertisements designed to promote the films to which Atherton, Beach, Hughes et al. were attached. A 1919 *Film Fun* column, "Feature the Author," was skeptical of Goldwyn's ambitions to feature the author rather than the actor. "Easier said than done," opines this columnist; "No one would be the least bit interested in seeing the authors' pictures in the paper, nor would the movie fan."[125] Nonetheless, Goldwyn ambi pursued his ambitious vision. Remarkably, he planned "billboards in all parts of the country. By [the fall of 1919] hundreds of Goldwyn billboards will be in position. . . . Each billboard will show the likeness of one of the seven eminent authors . . . and one Goldwyn star, Geraldine Farrar, Madge Kennedy, Tom Moore, Mabel Normand, or Will Rogers."[126] While to my knowledge no visual record of these billboards remains, they did apparently eventuate; Hughes recalled "Great twenty-four-sheet placards . . . speared on the billboards across the continent. On one side was a beautiful actor or actress, on the other an eminent author or authoress."[127]

Such intermingling of images of picture personalities and famous authors was not limited to advertising at such scale. As Orgeron notes, the motion-picture fan magazines also began to equate "the status of authorship with that of on-screen celebrity." She takes the example of Fox Entertainments' full-page advertisement in the November 1919 issue of *Picture-Play Magazine*,

Figure 1.12 *Picture-Play Magazine*, 11, no.3 (November 9, 1919).
Courtesy of the Media History Digital Library.

with its indiscriminate mixing of authors and stars—among them Henry Wadsworth Longfellow, Zane Grey, Twain, Pearl White, William Farnum, and Tom Mix—to promote its page-to-screen adaptations (Figure 1.12).[128] Goldwyn arranged a four-page spread in *The Morning Telegraph*, headed "Well Known Artists of Stage and Screen," in which authors and stars similarly shared space. The advertisement includes photographs not only of the Eminent Authors—Atherton, Beach, Hughes, King, Morris, Scott, Rinehart, now tagged "screen artists," perhaps to promote their active engagement on site and, at times, on set in the process of the adaptation of their works— but also of Goldwyn stars Harry Beaumont, Jack Pickford, Geraldine Farrar, Made Kennedy, Pauline Frederick, Will Rogers, Mabel Normand, and Tom Moore (Figure 1.13).[129] Here, drawing on Andersen's useful distinction between the celebrated and celebrities, whereby "[c]elebrated figures may be known to many but their physical appearance recognized by few," we could say that in promoting the Eminent Authors in this way, that is alongside

WELL KNOWN ARTISTS OF STAGE AND SCREEN

Figure 1.13 "Well Known Artists of Stage and Screen," *Morning Telegraph*, Christmas Number, December 21, 1919: section iii, part 7, vol. 94, no. 174.

picture personalities, Goldwyn was creating or at least hoping to create celebrity authors out of celebrated authors, that is, to inject his famous authors, now "screen artists," with a star power arising out of visual rather than mere name recognition.[130] Goldwyn was evidently tapping into what he sensed was the public's possible "tiring of the star"—and at the very moment of the consolidation of the star system.[131] Indeed, as Orgeron has argued, the very fact that authors began to appear in motion-picture fan magazines at all already signaled the proximity of "authorship with that of on-screen celebrity," thereby only ramping up, as Loren Glass writes in a different context, "the unpleasant possibility that literary value inheres not in the text but in the public perception of the author."[132]

To put this slightly differently, confronted with the new visual narrative medium, authorship was no longer limited to *authoring*. Take

the case of Canadian novelist Winnifred Eaton who, between 1921 and 1930, was contracted to Universal and Metro-Goldwyn-Mayer in various capacities: "screenwriter [*False Kisses* (1921)], title writer, literary advisor, and scenario editor." As Vito Adriaensens has for good reason speculated, it seems Eaton was hired "not only for her literary talent"[133]—or, perhaps, for her literary talent at all. A column in a 1925 issue of *Exhibitors Trade Review* reported that Eaton, "the author of some twenty best sellers" and now head of Universal's East Coast scenario department, "has sent out a letter to every well known author in the United States," such as Irvin S. Cobb, urging "the author to write directly for the screen."[134] What the studio valued, it seems, was Eaton's "large network of personal contacts."[135]

The Case of Gertrude Atherton

Gertrude Atherton, one of Goldwyn's original Eminent Authors, and whose focused pursuit of fame, Windy Counsell Petrie finds, informed her decision to become an author, had been alert to the opportunities motion pictures' narrative turn afforded authors even before Goldwyn came calling. Her career epitomizes the transformation of author into celebrity that this chapter has tracked—an author whose status was defined by her public image, by the spectacle of authorship, and by her credibility as a brand.[136] Atherton's experiences with the motion-picture industry across the 1910s and into the 1930s, and the series of portraits that circulated in her novels, on screen and in motion-picture publicity, trace that transformation: from the solitary author at work in the study, to a brand in a marketplace' and finally to a logo, an image signifying "author." Barely remembered today, if at all, Atherton was hugely famous in the first half of the twentieth century. Whether she was as famous as Edith Wharton, as she believed, she was "arguably the most read woman writer of her generation."[137] She must have been thrilled when the members of the Authors' League voted her "America's American Author" in 1918.[138] No wonder Goldwyn was keen to sign her up to his Eminent Authors the following year.

Atherton had begun to sell the motion-picture rights to her fiction from 1917, when the Mutual Film Corporation bought the rights to *Mrs. Balfame*

(1916). A Mutual advertisement proclaimed her among "the foremost writers of the land," and a column in the trade journal, *Motography*, noted that she would "be a good drawing card for the film."[139] Indeed, her contract with Mutual insisted her name "appear as the author of the said 'MRS. BALFAME,' upon all films, announcements, printing, programmes, and all other forms of publicity."[140] However, at this stage of her career, Atherton was still seen and still saw herself as a traditional author, and so was leery of collaboration with the industry in any more hands-on way. Selling the motion-picture rights to her fiction seemed to suffice. Indeed, in April 1919 she declared that to write for the movies "would be more or less in the nature of hack work!"[141] However, Goldwyn's invitation to join his Eminent Authors Inc. was clearly too enticing for on May 22, 1919, that is, only one month after she had written off motion-picture-writing as hack work, she signed her contract with his Eminent Authors. According to her contract, Goldwyn and Beach

> [desire] to acquire the exclusive rights to use the copyright material of the Author [Atherton] in all literary works of the Author ["except such as the motion picture rights to which may have been heretofore disposed of"], heretofore written and certain of those which may be hereafter written by her during the fixed terms of this agreement, except those above expressly excluded; and [desire] to secure the exclusive right to make motion pictures of or adapted from or based upon such of the said material as may be deemed adaptable for motion pictures.

The contract additionally stipulated that Atherton was "to assist the Producer [Goldwyn and Beach] in so far as she may be able . . . in making successful motion pictures of and from the aforesaid works, subject however to the control and in accordance with the policy of the Producer, through its technical staff." And finally, Goldwyn and Beach will

> make the said motion picture adaptations of the said literary works . . . in a first class manner, under the general supervision of the persons constituting the Producer, from scenarios approved by the Author, and with such title and sub-titles as may be approved by the Author; and to prominently state the name of the Author in connection with the main title of every of the said motion pictures; and that every one of the motion pictures made from a literary work of the Author shall state that the name is a 'GERTRUDE ATHERTON PICTURE': and to cause the name of the Author to be stated

on all trade advertising matter and wherever practicable on all other advertising matter connected with every of the said motion pictures; to make no change without the written consent of the Author in the scenarios [*sic*] titles or subtitles . . . except such as the exigencies of the production of the said motion pictures may require in which case the judgment of the Producer shall govern.

Atherton was to be paid royalties to the sum of 33.33 percent of the net profits derived from the film adaptation during the fixed term of the agreement ("three years from the last day of June, 1919"), or a minimum of $10,000 each year.[142]

Upon arriving in Los Angeles on August 9, 1919, Atherton's first assignment as an Eminent Author was to oversee the screen adaptation of her 1910 novel *Tower of Ivory*, released, as earlier mentioned, as *Out of the Storm* in 1920.[143] Her next project, "Noblesse Oblige," was an original synopsis—"I never attempted to write a scenario," she wrote in her memoir—the film of which was released as *Don't Neglect Your Wife* in 1921.[144] A half-page column in *Motion Picture News* advised exhibitors, "you have the author's [Atherton's] name and what it means to literature, to put forth in special advertising. Tell them it is her initial contribution to the screen, and carries the same novel and interesting situations and characters as are found in her novels. Play up her name in big letters. Then tell something of the remarkable cast."[145]

Goldwyn's gamble was that moviegoers would set greater, or at least as much, store by Atherton they would than the film's players: only "*then* tell something of the remarkable cast" (emphasis added). The gamble did not pay off. While one of the trade papers predicted that *Don't Neglect Your Wife* would be "a box-office title if ever there was one," it was not.[146] The film was poorly reviewed in *Motion Picture News*. To begin with, "The story is told entirely by titles of which there are a multitude"—it is true that Atherton includes a fair amount of dialogue in her synopsis, but surely it was the responsibility of the professional in-house scenarist to remedy this. Second, "There is no plot complication, the whole story being episodic narrative." (Not the case with the synopsis at least.) The reviewer was, however, approving of the story's "revolutionary" twist—"having a heroine as a divorcee"—something Atherton's readers would have likely expected from this author, renowned for broaching risqué subjects particularly as these pertained to women's independence and sexuality.[147] A more generous review of *Don't Neglect Your Wife* appeared in the *New York Times*. This

reviewer, remarking the discrepancy between the film's working title—"Noblesse Oblige"—and the title of the completed film, concludes, "the story seems to have undergone certain alteration and adaptation calculated to make its final title more fitting than the name Mrs. Atherton gave it." In other words, the reviewer wonders what interventions must have occurred that meant a compelling historical narrative of 1860s San Francisco—a stock Atherton setting—became "an uninspired movie melodrama, incredible, homiletic and conventional."[148]

Atherton too complained: "My picture was given [this] awful title. They got into a panic because it was a period picture . . . and they feared the public was wedded to the present and gave it a title that is modern to excess."[149] Goldwyn must have approved the scenarist's alterations to her synopsis; Eminent Authors' contracts allowed for "the judgment of the Producer [to] govern" under certain conditions.[150] If this was the case, then it suggests, in this instance at least, that Goldwyn did not quite grasp the full value of his own project to center the author in motion-picture production and promotion. That is to say, he seems to have failed to grasp what an audience of Atherton readers, and indeed fans, on whom his Eminent Authors initiative surely relied, might want and expect.

Either way, "Noblesse Oblige" was Atherton's last and sole experience of motion-picture writing, and her last project with Goldwyn's Eminent Authors Inc. Indeed, she wished to forget altogether her experiences on the Goldwyn lot. While choosing in her memoir not to "dwell upon that experience in Hollywood," she does include brief recollections of more agreeable moments of her tenure, such as her encounters with other writers—W. Somerset Maugham, Glyn, Rinehart and Hughes, among others—as well as the authors' healthy remuneration.[151]

It would be well over a decade before Atherton again had any professional involvement in the motion-picture industry, beyond continuing to sell the screen rights to her fiction, such as *Black Oxen* in 1923. But then in 1933, she contributed to *The Woman Accused*, a multi-author serial, sound-film tie-in jointly produced by *Liberty* magazine and Paramount Publix (Figure 1.14). "Ten of the world's greatest authors"—in addition to Atherton, these included Hughes, Grey, Cobb and Ursula Parrott, among others—each produced one of the ten installments *Liberty* published over five weeks between January 21 and February 18, 1933.[152] Atherton composed the serial's sixth installment, "Chains of the Past." The motion picture that tied in with the magazine serial, and which starred Nancy Carroll and

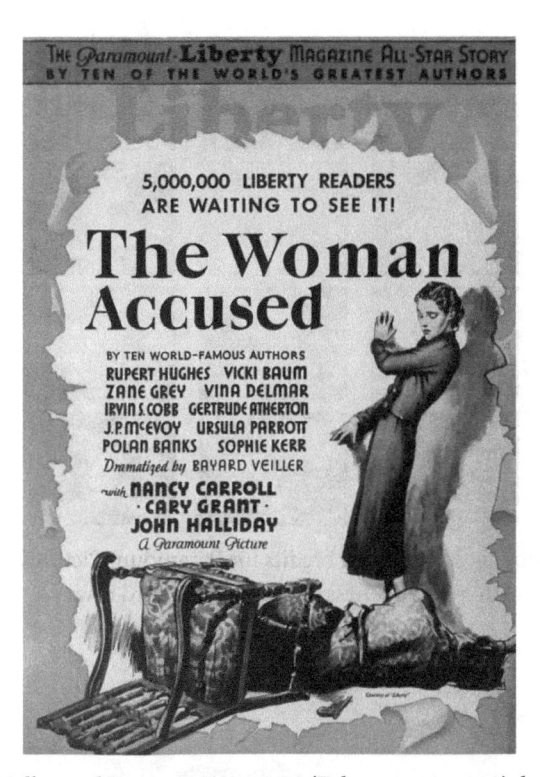

Figure 1.14 *Hollywood Reporter*, 13, no. 21 (February 13, 1933): back cover
Courtesy of the Media History Digital Library.

Cary Grant, was released on February 17, 1933 to coincide with the story's final magazine installment. The opening credits of the film include moving images of nine of these "ten . . . greatest authors"—but not of Atherton. Her credit comprises footage depicting the hand of an artist adding what was likely meant to be the finishing touches to a sketch of her famous sitter's famous profile (Figure 1.15).

Atherton was notoriously controlling of her public image. According to her biographer Emily Leider, she "loved posing for her portrait," and "tried to dictate from what angle and through which lens she should be viewed by the public, loudly protesting the use of any publicity photograph of herself she considered unflattering."[153] Her "cameo-like profile and erect carriage were celebrated. So was her crown of fair hair. . . . She loved to display her alabaster shoulders when she posed for artists and photographers."[154] In short, as Petrie concludes, "[look] and style were an important part of [her brand]."[155]

Figure 1.15 Sequence of opening credits for Paramount Pictures' *The Woman Accused* (1933). Atherton's likeness appears in the third row.

Figure 1.16 Gertrude Atherton in 1890, frontispiece to her novel *The Doomswoman: An Historical Romance of Old California* (J .B. Lippincott Co., 1892).

Figure 1.17 Atherton photographed in 1901.

Figure 1.18 Atherton c. 1901.

Courtesy of Emily Leider, " 'Your Picture Hangs in My Salon': The Letters of Gertrude Atherton to Ambrose Bierce," *California History* 60, no. 4 (1981): 340.

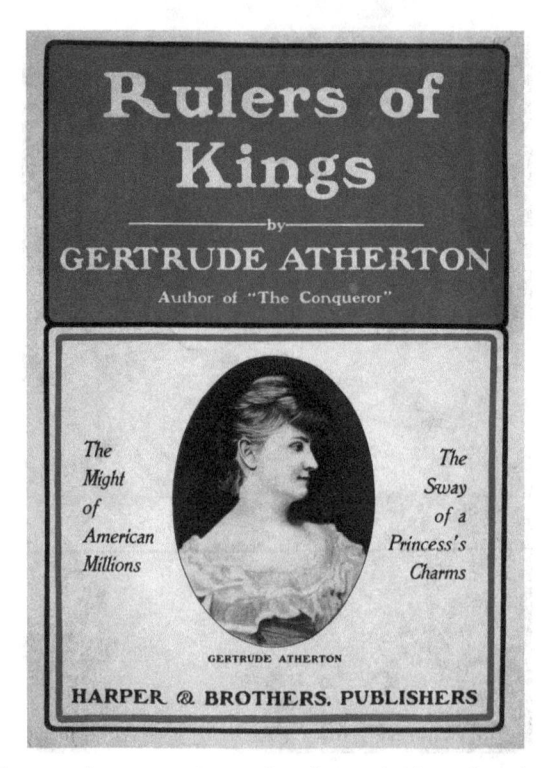

Figure 1.19 Poster advertising Gertrude Atherton's *The Ruler of Kings* (Harper and Brothers, 1904).
Courtesy of Alamy Stock Photo

As this series of portraits from 1890 to 1903 indicate, Atherton preferred, and likely ensured, that she was almost exclusively photographed in profile—and from her favored right-hand-side (Figures 1.16–1.19). The latter two portraits appear within oval-shaped frames, effectively presenting Atherton's likeness in the form of a cameo and signaling her preliminary transformation into a stylized visual object. These are photographic likenesses. It was actor and motion-picture producer Dorothy Donnelly who, in 1925, made the sketch of Atherton—this time of her left-hand-side profile—that appears in the opening credits of *The Woman Accused* (Figure 1.20). Atherton evidently liked the sketch; she had already chosen it, or at least sanctioned it, as the frontispiece to her 1932 autobiography—as well as a heavily shaded version of it to introduce the installment she contributed to *The Woman Accused* serialization in *Liberty* magazine—and, finally, projected on the big screen, larger than life, in the opening credits of *The Woman Accused* (Figures 1.21 and 1.22).

GERTRUDE ATHERTON
(1925)
from the sketch by Dorothy Donnelly

Figure 1.20 Dorothy Donnelly's 1925 sketch of Gertrude Atherton, which formed the frontispiece to Atherton's memoir, *Adventures of a Novelist* (Liveright, 1932).

Atherton's likeness stands out as an anomaly here (Figure 1.15) amid the moving-picture footage that credits each of the nine other famous authors. A small column in *The Hollywood Reporter* explained the production of these images: "Paramount has photographed the ten authors who wrote chapters of 'The Woman Accused,' and will spot the introductions in an early sequence of the picture. Three of the writers faced the cameras here, five were shot in New York, one in San Francisco and Paramount cabled Zane Grey to send on his own from the South Seas."[156] That makes ten. Atherton might have been the author shot in San Francisco (where she lived) but she obviously managed to have her way, preferring the Donnelly sketch over whatever documentary footage the studio may have shot. The image as it appears in these opening credits is an oversized cameo, a portrait distilled "to the minimal elements needed for recognition," reminiscent of an author—London's— medallion.[157] Across the various modes of Atherton's (profile) portraiture,

tinued. "Under my responsibilities it is within my power to keep you confined here until this cruise is ended. And if, furthermore, I should deem it necessary to insure against any attempt by you to escape from custody or to do yourself an injury, it becomes not only my right but my duty to put these shackles on you."

"BUT only yesterday," she protested, "when I came to you and told you who I was and what I had done, you pledged your word—"

"That was yesterday," he broke in. "Today is another story. For just a little while ago I received that radio from the New York Police Department saying you were suspected of the killing of Leo Young and asking whether you were aboard. And I wirelessed back that you were aboard, which means I have guaranteed that you still will be aboard when we return."

"But, captain," she pleaded desperately, "I promised you that I would surrender myself. I only asked for these few days—this little taste of paradise before I walked down into hell. And now— Oh, God! Oh, God, have mercy on me, a sinner!"

"What you promised—I recall your words—was that if you *were still a passenger on this ship* when we docked, you would surrender. That might mean—well, almost anything." And he stared hard into her brimming eyes.

"Jeffrey," she murmured, shaken by an added distress; "you've told him, then?"

"No, not yet. Whether I tell him may depend altogether on you."

"But when you pen me up here like a caged animal— when you chain my hands—"

"I haven't actually said I meant to do those things. I only have shown you what in my discretion I can do, and what in my best judgment I may yet have to do."

Now there came a discreet knocking on the door.

Chapter Six
Chains of the Past

By

GERTRUDE ATHERTON

GERTRUDE ATHERTON *was born in San Francisco and still makes that city her home, although she has lived abroad much of the time. She was educated in private schools and by tutors, and is the author of numerous novels. She was given the Legion of Honor in 1925.*

LIFE had made an accomplished actress of Glenda Cromwell; more particularly her life with Leo Young. After the novelty of luxury had worn thin, and she had penetrated with disillusioned eyes the vile character of the man who had rescued her, the gaudy night life, the senseless pursuit of excitement in which bad liquor and jazz bands were the main factors had soon inspired ennui and disgust.

Honest and aspiring by nature, if fate had been kinder she would, no doubt, have found an outlet for the adventurousness of youth —which amounts to little more than a desire for change—either in society or travel. It was this longing for adventure, combined with resentment against the monotonies of small-town life and

Figure 1.21 The profile of Gertrude Atherton sketched by Dorothy Donnelly, which prefaced Atherton's contribution, "Chains of the Past," to *The Woman Accused, Liberty* 10, no. 5 (February 4, 1933): 24.

Figure 1.22 The profile of Gertrude Atherton sketched by Dorothy Donnelly, used in the opening credits of Paramount Pictures' *The Woman Accused* (1933).

from photograph to oval-framed photograph to sketch, from photographic realism to (shaded) outline, and at a range of scales, we witness the increasing abstraction, the aestheticization of Atherton into something more akin to a maquette or logo designed simply to *connote* "Atherton." As Atherton's photographic likeness recedes, the more visible, the more visually recognizable, she becomes.[158]

A couple of years after the appearance of *The Woman Accused* and Atherton's hugely successful memoir, *Adventures of a Novelist*, her friend Gertrude Stein composed one of her few plays, the little-known and -performed, *A Play Called Not and Now*. Stein and Atherton had first met in Paris in 1925, having been introduced by Carl Van Vechten, and on the evidence admired each other greatly; Atherton "had been my youthful idol," Stein wrote in *The Autobiography of Alice B. Toklas* (1933).[159] *A Play Called Not and Now* was evidently inspired by a Hollywood cocktail party held in Stein's honor in April 1935. In attendance were celebrities of both page and screen: Chaplin, Paulette Goddard, Anita Loos, Dashiell Hammett, John Emerson, Lillian Hellman—and Atherton.[160] Stein's playscript opens conventionally enough with a list of its dramatis personae who, for the duration of the short play, mix and mingle at a party. Among them—artists, authors, actors, socialites—is "A woman who looks like Gertrude Atherton":

CHARACTERS
A man who looks like Dashiell Hammett
A man who looks like Picasso
A man who looks like Charlie Chaplin
A man who looks like Lord Berners
and a man who looks like David Green.

WOMEN
A woman who looks like Anita Loos
A woman who looks like Gertrude Atherton
A woman who looks like Lady Diana Grey
A woman who looks like Katharine Cornell
A woman who looks like Daisy Fellowes
A woman who looks like Mrs. Andrew Greene.[161]

The play's effect—its plot and characterizations, what little of each there is in Stein's play—is almost entirely dependent upon visual recognition: in the

transactions between the characters, and in the relationship of audience to actor. The audience would need to recognize Atherton in—she would need to be recognizable as—the "woman who looks like Gertrude Atherton," which would first require Atherton to be recognizable to Stein's audience. Stein's intriguing play cracks open, gets at, the *spectacular* authorship that Atherton came to embody and which she finessed through her long association with and work in the motion-picture industry from the late 1910s through the early 1930s.

Immediately following the list of dramatis personae in *A Play Called Not and Now*, we read, "These are the characters and this is what they do": what they "do" is look like a celebrity, be it Hammett, Picasso, Chaplin, Loos or Atherton. In some sense, this might also describe the work or role of the famous author in motion pictures, the mode of authorship that motion-picture collaboration now generated. What Atherton "did" in the movies was look like "Gertrude Atherton"—in the pages of industry papers and fan magazines, and on billboards and on screen—as London had posed at his desk. Under pressure from, seduced by and emulating motion pictures and their stars, authors began to *look* like authors, and authorship, like authorship.

2

Black Authorship at the Movies: Oscar Micheaux, Paul Laurence Dunbar, Wallace Thurman

Only three weeks prior to the Supreme Court's 1896 ruling on *Plessy v. Ferguson*, Thomas Edison's Vitascope debuted at Koster and Bial's Music Hall in New York City. Scholars such as Robert C. Allen, Cara Caddoo, Peter Lurie and Alice Maurice have found in these coeval events—one ushering in a system of Jim Crow segregation that would condition Black American life at least until the civil rights era, and the other instituting what would become the new century's most popular mass entertainment—a way to begin to think through what they argue is the fundamental entanglement of race with US motion-picture cultures. As Allen reminds us, "For nearly 70 years . . . the history of moviegoing and the history of racial segregation in the US, particularly in the south, are not only co-terminus but conjoined."[1]

This was also the year in which the so-called dean of American letters, William Dean Howells, proclaimed Charles W. Chesnutt's "fiction . . . remarkable above many, above most short stories by people entirely white, and . . . worthy of unusual notice if they were not the work of a man not entirely white" and, the following year, Paul Laurence Dunbar "the first of his race to put his race into poetry" as race leaders were advocating more vociferously for a Black-authored literature.[2] For author-activists such as Victoria Earle Matthews, the production of what she termed "Race Literature" would "serve as [a counterirritant] against all such writing as shall stand, having as an aim the supplying of influential and accurate information on all subjects relating to the Negro and his environments, to inform the American mind at least, for literary purposes."[3] While Matthews identified a corrective purpose to the formation of a race literature, W. E. B. Du Bois, writing in 1913, understood "the rise of the Negro novelist and poet with national recognition" from the 1890s on, and the continuing "stream of Negro writing" since 1900, an index of the progress and worth of the race achieved in the face of "economic stress" and "racial persecution."[4]

Silent Film and the Formations of US Literary Culture. Sarah Gleeson-White, Oxford University Press.
© Oxford University Press 2024. DOI: 10.1093/oso/9780197558058.003.0003

What is little remarked upon in the scholarship about African American cultural history is that such calls for and the emergence of a self-conscious Black literature occurred alongside the emergence of the new medium of cinema, including what is known as race film—that is, motion pictures with (largely) all-Black casts, produced (largely) by African Americans, and targeted at a (largely) Black audience—which flourished in tandem with the Harlem Renaissance, and made a significant contribution to the New Negro movement. The relative scholarly neglect of the coincidence and entanglements, as we will see, of the at times breathtaking Black literary and cinema formations of the 1920s and beyond is particularly striking and indeed odd when we recall how keenly scholars of the Harlem Renaissance have uncovered and considered the relationship of the period's prodigious literary output and its other visual cultural forms: art, theater, photography. But not motion pictures. In other words, we continue to keep at arm's length these significant parallel movements. There may be good reasons for this. To begin with, race film emerged largely in the Midwest, and the Black literary "renaissance" largely in the East, in New York's Harlem. These developments were also distinct in terms of their respective milieux. As Jane Gaines has pointed out, "In contrast with New York's cultured black elite, the race movie pioneers were by and large alien to the new middle class," who were more closely associated with "the world of hucksterism and ballyhoo." This meant each appealed to or attracted a different audience: "Access to the works of the New Negro was limited to the literate public, white as well as black, and whites were the exception not the rule in the race movie audience," which was constituted of "lower class urban blacks in the North and rural blacks in some parts of the south, only a few whites, and perhaps a handful of the elite blacks in the Harlem Renaissance circle, a group who never took these films seriously enough to write about them."[5]

While the race-film industry and the Harlem Renaissance have been somewhat sequestered the one from the other, it is also the case that the latter has garnered far greater scholarly attention. Clyde Taylor's 2001 essay "Oscar Micheaux and the Harlem Renaissance," a rare and important exception in its joint consideration of Black film and literature of the 1920s, makes a similar observation to that of Gaines in terms of the relative neglect of race film—by mainstream audiences of the teens and 1920s and by film scholars today. In operating well outside the developing Hollywood studio system, Taylor argues, race film's target audience was not, and was never intended to be, white, unlike that of the work of the major authors of the

Harlem Renaissance such as Jean Toomer, Langston Hughes, and Wallace Thurman, all of whom were published by mainstream (white) publishing houses catering to a white readership. In short, we could say that the Harlem Renaissance appealed to a white and Black bourgeois readership, and race film, to "the unsorted populace."[6]

Here, I argue that Black authors turned to the motion-picture industry as a potentially critical piece of infrastructure to support Black literary culture during a period characterized by, as Elizabeth McHenry writes, "the *unsettledness* of the category of Black literature" arising out of "the complicated, qualifying questions about Black authorship and the reach and possibilities of African American literature."[7] The little-known *Künstlerromane* of Oscar Micheaux are invaluable in providing insights into exactly this precarious state of Black authorship as they also reveal Black literary culture's investments in and advocacy of motion pictures as both an index of and a means to realize Black literary ambition—or quite simply, in the case also of Chesnutt's and Alice Dunbar Nelson's respective forays into race film, as a means to kickstart a stalled literary career. Furthermore, these authors' negotiations with and experiences in the nascent race-film industry reveal the incongruities and particular challenges in exploiting a mass entertainment to facilitate literary ambition and nurture literary reputation. It is this very tension, between a Black vernacular and a higher-brow culture, with which the earliest African American–authored narratives adapted to the screen—Dunbar's "The Scapegoat" and *The Sport of the Gods*—struggle as they move out of the world of letters and into the new mass cultural sphere.

The final section of this chapter deploys motion pictures a little differently to reorient and so to reread Wallace Thurman's brief but brilliant career by placing at its center what I discover are his lifelong interests in and engagements with motion pictures, including his little-known late-career turn to motion-picture writing. While Thurman's career may well be apiece with what Michael Nowlin finds to be a "tradition of failure, misguidedness or highly qualified success" in "African American literature from Chesnutt and Dunbar to Ellison and James Baldwin"—we might add Micheaux and Dunbar Nelson here—importantly, it is also a tradition that "keeps presenting its ambitious beneficiaries with a fresh opportunity."[8] I find in Thurman's failure—which his good friend Langston Hughes and others since have understood as a selling-out—a means to navigate the shoals of Black authorship this chapter traces. Or, as Thurman himself put it, as a means to "transcend the *Zeitgeist* and forge out a new path for himself."[9]

The *Künstlerromane* of Oscar Micheaux

Before Micheaux became a trailblazing filmmaker—J. Hoberman is absolutely right to declare him "the forebear of American independent cinema" and therefore "one of the most significant American filmmakers"[10]—he was a relatively prolific author, having published three novels before the appearance in 1919 of his first film, *The Homesteader*, an adaptation of his eponymous 1917 novel. Altogether, between 1913 and 1947, Micheaux authored seven novels, the bulk of which he published himself, and four of which are retellings of his life as a—the only, he would sometimes claim—Black homesteader in South Dakota.

Micheaux never produced novels and films simultaneously; he oscillated between periods of literary authorship and periods of motion-picture production, and many of his films, such as *The Homesteader* (1919), *The Exile* (1931) and *The Betrayal* (1948), are adaptations of his autobiographical novels. Of especial significance for anyone interested in the history of authorship in the twentieth century or African American cultural history is that so many of Micheaux's novels evince a keen interest in authorship, particularly as a means of social advancement for the "darker races."[11] This is not a particularly novel observation to make about authorship and advancement—Jack London's career is a renowned and well-documented instance of this dynamic and, as I will go on to note, not something lost on Micheaux. While for the young Chesnutt, "what made the literary field attractively anomalous was the extent to which it appeared to function like a truly free market: one could compete in it 'without capital,' it rewarded 'the successful,' and—this went without saying—racial barriers might prove less likely to block entry," Micheaux and many other aspiring Black authors saw it differently.[12] For, in addition to "economic stress," "racial persecution" was "too bitter to allow the leisure and the poise for which literature calls," as Du Bois wrote in 1913. The stakes of Black authorship as a means of self-advancement were exceedingly high[13]—as their failures were especially devastating.

Micheaux was one of the first Black authors to venture into race film to discover how it could be deployed to advance the cause of Black authorship and literature. He documented these experiences across several of his autobiographical novels and the adaptations he made of these, as well as in late-career detective narratives in which appear a series of Black authors and/or race-film producers: Jean Baptiste in the 1913 novel *The Conquest* and its 1931 adaptation *The Exile*, and in the 1917 novel and its 1919 adaptation *The*

Homesteader; Martin Eden in the 1941 novel *The Wind from Nowhere* and the 1948 film *The Betrayal*; and Sidney Wyeth in the, respectively, 1915, 1944, and 1946 novels *The Forged Note, The Case of Mrs. Wingate*, and *The Story of Dorothy Stanfield*, as well as in the 1921 film *The Gunsaulus Mystery*. Several of these *Künstlerromane* depict authorship as a viable path to Black middle-class respectability. In *The Story of Dorothy Stanfield*, Sidney Wyeth supports his studies in the law through his fiction writing; authorship for Wyeth is simply an instrumental means to an end. The upward trajectory that author-ship facilitates—Wyeth is able to complete his studies—is more pronounced in the case of the author-homesteader Jean Baptiste of Micheaux's much earlier autobiographical novel, *The Homesteader*. Here, it is only Baptiste's earnings from his fiction that can fend off the dual threats of foreclosure and "poverty accompanied by crop failures."[14]

Like all Micheaux's dogged author figures, Baptiste institutes a grueling writing schedule modeled on, we read, Jack London's own strenuous habits of composition. In fact, the author protagonist of *The Wind from Nowhere* is named Martin Eden, after London's author protagonist of his own auto-biographical novel, *Martin Eden* (1909).[15] ("I was Martin Eden," London would later declare.[16]) Micheaux was a keen admirer of London, likely recognizing in him—and in his Martin Eden—a kindred soul. Both men were autodidacts who gained "an education in the University of the World," and both had "no mentor but myself."[17] Micheaux explicitly names not only Martin Eden but also London in *The Wind from Nowhere* as well as in *The Homesteader*. Aspiring to London's commercial success, Micheaux's fictional authors emulate the exhaustive writing practice that fueled London's trajec-tory from "hoodlum and sailor" to celebrity author, and which is traced in *Martin Eden*. London's Eden devises a three-part formula for his "machine-made storiettes" on which he works over nineteen hours a day. "In quan-tity, the formula prescribed twelve hundred words minimum dose, fifteen hundred words maximum dose."[18] Martin Eden's writing practices capture the attention of Micheaux's Eden in *The Wind from Nowhere*: "Said London, the way to write was just to get a pencil and paper and start writing; some-thing that somebody might read." With *Martin Eden* as his writing manual, Micheaux's Eden quickly embarks upon his "literary education":

> Martin Eden bought himself a thick tablet . . . and he sat him down and
> started to write. Jack London, he recalled again and again, had written that
> was the way to write, by just writing.

> He kept in mind that Jack London wrote 10,000 words a day. So Martin
> Eden wrote 10,000 words the first day too. . . . And he wrote and wrote and
> wrote and re-wrote until he finally completes his novel.[19]

However, Micheaux's Eden, for all his ten thousand words-a-day writing schedule, does not produce a bestseller—just as Micheaux did not. In Micheaux's Künstlerromane—as in his own life—authorship as a means of middle-class access fails. No matter the extent to which his author figures might emulate London's Eden—even when named Eden—they are not and never could become Eden, as Micheaux could be no London. Even an author such as Micheaux, who strove for commercial success rather than to achieve "the literary standards of the world," and in that, embraced a more instrumental model of authorship, encountered exclusion and erasure—indeed, erasure from a bourgeois Black literary culture that tended to privilege Black literature published by white publishers and read by white readers.[20] Unable to secure the kind of white patronage many writers of the Harlem Renaissance would come to enjoy—and, before them, Dunbar and Chesnutt—Micheaux, like his fictional authors, established his own publishing company, the Western Book Supply Company, in 1915. Only in that way was he able to see his novels into print.

Micheaux reflects at some length on the impediments to Black authorship in his 1915 novel The Forged Note. Wyeth, now an established author, tours the South to promote and sell copies of his latest novel. But "it seemed almost an impossibility to interest those at the south in a subject of literature." One reason for this, he is convinced, is the Jim Crow restrictions on libraries, which should ideally function as vehicles of uplift to create and sustain an educated, cultured Black middle class. Another is that Black southerners do not have the financial resources to purchase books.[21] Such insights about the racialization of reading—access to it—are picked up by Jean Baptiste in Micheaux's next autobiographical novel, The Homesteader, when he opines, "ours is a race of notoriously poor readers" thanks to "separate schools": "Mix the Negro children daily with the whites, and they are sure to become enamored of their ways."[22]

No wonder then that Wyeth, by the time of his appearance in Micheaux's 1944 novel The Case of Mrs. Wingate, and hewing more closely to his creator's trajectory, has shuffled back and forth between motion-picture production and authorship in an attempt to identify the most viable and direct path to commercial success and upward mobility. When Wyeth first enters the

narrative, he is writing a novel "to make a living." But confronted with what James Weldon Johnson deemed "the dilemma of the Negro author," Wyeth "learned . . . that if I hope to interest the white people who review books for the Metropolitan dailies . . . I've got to write a shocker"—like *The Case of Mrs. Wingate*, in fact—rather than a novel of "modern, intelligent Negro life." Unwilling to produce shockers, Wyeth abandons novel-writing entirely to return to motion-picture production, which he had pioneered, we read, "twenty years before" and which "he had been forced to suspend the production of . . . for lack of funds."[23]

Wyeth's—like Micheaux's—efforts to carve out a financially viable career and, as a consequence, a life of middle-class respectability by moving back and forth between literary and motion-picture production are indicative of the particular challenges—including those to do with audience—that African Americans faced in breaking into the cultural marketplace and activating it as a means of social advancement. More than this, and more specifically, the uneven trajectory of filmmaker-cum-novelist-cum-filmmaker Wyeth, much like his creator's, registers the failed promise of motion pictures for the advancement of Black literary culture, particularly as these—motion pictures—might address the obstacles to authorship Wyeth discovers on his southern literary tour in *The Forged Note*.

The earliest writings about race film trusted that the new medium would yield just such opportunities for Black authors and the expansion of the field of Black literature. Race-filmmaker William Foster, writing as Juli Jones, Jr., published an article in *The Chicago Defender* in 1915 in which he implores African Americans to consider working in the motion-picture industry, not only as a successful commercial adventure but in order to "show their real talent to the whole world."[24] Several years later, in 1919, Micheaux and Jones published film criticism in quick succession in *Half-Century Magazine*. Both men advocated the central role of writing—whether original scenarios or novels and stories suitable for adaptation—in Black motion-picture production. A thriving Black motion-picture industry would provide professional opportunities for the more entrepreneurial members of the race, they hoped, as it had the potential to counteract the obscene images of Black life that mainstream cinema continued so widely to circulate.

Micheaux's column "The Negro and the Photoplay" proposed that "the fewness of Negro photoplays" is largely referable to the fact that "the race has written only a small number of novels as well as magazine stories." He urges that "before we expect to see ourselves featured on the silver screen as we live,

hope, act and think today, men and women must write original stories of Negro life."[25] Jones likewise promoted the role of authors—to produce first-class scenarios—in the establishment of a Black motion-picture industry as a means to advance the race. In his own 1919 *Half-Century* column, published two months after Micheaux's, Jones, appreciating that the success of a Black motion-picture industry depended upon "educating young men and women who with a little practical training would be able to write the necessary scenarios," singles out Chesnutt and Johnson, in addition to Micheaux who at that point had already published three novels, as Black authors of "rare literary talent" who would form "a splendid corps of writers" for the screen.[26]

Jones' vision resonates with the ambitions of mainstream motion-picture companies that likewise sought to engage popular authors of the day, as we saw in Chapter 1. Notably, Jones' call here for a corps of Black authors to contribute to the formation of a Black motion-picture industry appeared in print a month or so prior to Goldwyn's announcement of his Eminent Authors Inc., However, very few Black authors even attempted to follow Micheaux's lead—or to answer his and Jones' call. Chesnutt is something of a striking exception; he entered negotiations with Micheaux in the early 1920s about adapting his fiction to the screen—something I return to at greater length in the following chapter.

Alice Dunbar Nelson wished to collaborate with Micheaux. Her diary entry from September 1921 reveals, "I gently hinted to Micheaux that I'd like to collaborate with him. Showed him [her short story] 'The Goodness of St Roque.' He did not bite so readily, however."[27] Micheaux was equally indifferent to collaborating with Black motion-picture producers, as indicated by his well-documented rebuffing of Lincoln Motion Pictures co-founder, George Johnson's invitation in 1918 to collaborate on an adaptation of *The Homesteader*. Micheaux ended up producing the adaptation himself, a turn that famously kickstarted his brilliant filmmaking career. We are left only to speculate then about the direction Black cultural history might have taken were Micheaux to have entered into the kinds of collaborative, cross-industrial partnerships that Chapter 1 tracks. Indeed, as Phyllis Klotman has wondered, "What amazing productions might have taken place had Micheaux been able or willing to collaborate with the African-American writers Hollywood found so easily expendable."[28]

It is not difficult to imagine at least some of the reasons Black authors chose not to follow Micheaux into motion pictures. It is true that motion pictures promised a new and expanded audience to authors just as, on the other side

of the coin, alignment with the literary realm would afford race-filmmakers some greater cultural legitimacy. While Jones had confidently declared, in 1915, "moving pictures . . . the greatest opportunity to the American Negro in the history of the race from every point of view," by 1919 he feared "Our people . . . have not learned the commercial value of the motion picture game."[29] But it is also the case that the Black film industry of the teens and early 1920s was extremely short-lived. It peaked almost as it emerged, falling into rapid decline with the coming of sound film. As one of Micheaux's Black author figures Kermit Early (based on Du Bois) observes in *The Case of Mrs. Wingate*, white east coast producers "jumped into making colored pictures, with more money to spend on them at their command than Wyeth had or could perhaps get"; they "hired white scenario writers in Hollywood" who "started out to write stories about Negroes with as much knowledge regarding the innerlife [*sic*] of the Negro, as they had about the inner life of Chinese in Chungking."[30] Of course, Black authors, like the broader Black community, had good reason to be more generally wary of the new medium. While motion pictures had the very real potential to generate and distribute in the marketplace of early twentieth-century Black cultural life images of Black respectability, race progress, and so forth—what Allyson Field terms "uplift cinema"[31]—from their very emergence, they had also depicted Black subjects and communities in the most pernicious ways, and with the alarming capacity to do so at significant scale.

It is also the case that there was really nothing in the Black cultural realm equivalent to the Authors' League of America, an organization that, as we have seen, not only endeavored to protect its author members from predatory and unscrupulous motion-picture producers and industry practices but also encouraged authors to engage with producers, frequently assisting them in doing so. The National Association for the Advancement of Colored People (NAACP) might well have played a comparable role in supervising and mediating the interactions of Black film and literary interests. It had already exerted efforts to promote a broader Black culture, as Jenny Woodley makes clear in *Art for Equality: The NAACP's Cultural Campaign for Civil Rights* (2014). We know, for instance, that Walter White supported several authors associated with the Harlem Renaissance, and the NAACP had famously coordinated nationwide protests in response to the first screenings of *The Birth of a Nation*, and set up a scenario committee in 1915, overseen by Du Bois and others, to organize a cinematic response to D. W. Griffith's vicious blockbuster.[32] But as far as I have been able to tell, the NAACP did

not oversee or encourage specific collaborations between authors and (Black) motion-picture interests in the way that, say, the Authors' League had sought to do with its members and the studios. Indeed, as Gaines has argued, the NAACP's "focus on [Griffith's] film was at the expense of focus on films produced by African Americans themselves."[33] Nor did any of the race-film companies, such as Micheaux Book and Film, set up any organization—"a splendid corps of writers"—of the kind Jones called for and that Goldwyn managed to do with his Eminent Authors Inc. In effect, there were few opportunities for Black authors and indeed little support or encouragement provided to any who may have considered entering into some form of collaboration with motion-picture interests.

This situation is all the more striking when we consider the many scenes of filmgoing in Black-authored literature that began to emerge in the mid-teens. I take such inclusions as sound evidence that Black authors were at least intrigued by what was occurring in a broader Black motion-picture culture as they closely observed it. There is not the space here to offer more than a cursory overview—or mention—of such scenes. It was Micheaux who authored the first scene, or certainly one of the first scenes, of Black filmgoing. In *The Forged Note*, Mildred Latham, Wyeth's great admirer, bitterly recalls her experience in a Cincinnati theater that catered to both Black and white patrons: "A great motion picture drama . . . was disturbed by the gallery, where only the *black* people were allowed to sit. They were assigned this portion because so few understood or made any effort to understand the play. These were the facts in the lives of her people, which exposed the Negro to the contempt of the white race."[34] While the uneducated Black riffraff humiliate Mildred under the white gaze, a comparable scene in Jessie Fauset's *Plum Bun: A Novel Without a Moral* (1928) treats the experience of Jim Crow moviegoing as a violence enacted upon African Americans. Early in the novel, the light-skinned Angela is taken to "a little gem of a theatre" with her darker-skinned admirer, Matthew. She understands that "Philadelphia theatres . . . could be very unpleasant to would-be coloured patrons," and this theater, although patronized by both Black and white moviegoers, is no exception; because it comprises only "one-storey," it does not have a gallery, the buzzard's roost where Black spectators were sequestered. The attendant cruelly informs Matthew, "she [Angela] can go in, but you can't. . . . Go over there and get your refund."[35]

Dorothy West's story, "Odyssey of an Egg," dwells with considerable irony, unlike Micheaux's *The Forged Note*, on the moral risks inherent in

filmgoing. Porky Tynes, a fan of motion pictures screened at "cheap movie house[s]" depicting "Gangsters, and gats, and gun molls," comes to "self-identify" with these gangsters: "The feature picture came on. Porky forgot his hunger and hunched forward, licking his lips a little. Yeh, this was the biz, all right. This was the way the big shots did it. Self-identification made him shiver with joy."[36] Porky is arrested for unwittingly participating in a forgery racket to which his emulation of movie gangsters leads him. Thurman's remarkable 1926 short story "Cordelia the Crude," to which I return later in this chapter, is yet another instance of Black-authored fiction incorporating scenes of Black moviegoing. Even this cursory overview of such scenes provides a sense, at least, of the extent to which Black authors were watching closely, were intrigued—frequently captivated—by, as they were also wary of, motion pictures and moviegoing.

Paul Laurence Dunbar at Frederick Douglass Film Company and Reol Productions

Just as Black authors were keenly watching, or were at the very least aware of, a broader motion-picture culture—moviegoing and its spaces, most notably—several early race-film companies actively sought to attach themselves to the literary realm, if reluctant to collaborate with authors themselves, perhaps heeding Micheaux's and Jones' shared conviction that the way to advance Black filmmaking, and by implication the race, was to place writing front and center at every stage of motion-picture production. It was Dunbar, the most popular Black author of the day, who first attracted the attention of race-filmmakers. In 1917, over ten years after his untimely death from tuberculosis, the Frederick Douglass Film Company adapted to the screen his short story "The Scapegoat" (1904); and then several years later, in 1921, Reol Productions adapted his novel *The Sport of the Gods* (1902). Curiously, both narratives, as rendered on the page and on the screen, resist, or at least fail in any endeavor to support, the discourse of uplift and the politics of respectability for which critics such as Micheaux and Jones advocated in race-film production. In other words, these two Dunbar narratives are a rather odd choice for race-film production. "The Scapegoat" depicts intraracial conflict between a white-sponsored Black middle class and the Black masses, and *The Sport of the Gods* resists its own already laboring critique of Black vernacular culture to narrate the very

tensions that informed modern Black life—tensions that race film came to embody in, on the one hand, its efforts at edification and respectability and, on the other, its production and circulation of mass spectacle for the unruly crowd.[37]

Notwithstanding the ambiguous intent of both "The Scapegoat" and *The Sport of the Gods*, that it was Dunbar who paved the way, even if posthumously, for adaptations of African American–authored narratives is perhaps not surprising. To begin with, Dunbar is considered the first Black *littérateur* to earn a living from writing. He had also "received high praise from the Hoosier Poet, James Whitcomb Reilly" and received, as had Chesnutt, the support of Howells, who declared him "the first instance of an American negro who had evinced innate distinction in literature."[38] Dunbar's work appeared in higher-brow mainstream magazines such as the *Century*, the *Atlantic Monthly* and the *Saturday Evening Post*, as well as with the prestige publishing house Dodd, Mead and Company, which published his 1896 volume *Lyrics of Lowly Life* and the bulk of his output subsequent to it. According to Valerie Babb, Dodd, Mead had "built its reputation on fine editions of English literature and scholarly volumes on the fine arts, and each of their Dunbar editions had handsome cover art." Dunbar's inclusion in the publisher's list is particularly striking because "To date, the majority of black novels were often self-published," as were Micheaux's, or serialized, as were Chesnutt's and indeed Dunbar's *The Uncalled* (in *Lippincott's Monthly Magazine*) "so Dodd Mead's attention to the presentation of Dunbar's work was notable."[39] In other words, Dunbar's writings had been well tested in the literary marketplace by the time race-film producers began looking around for literary works to adapt to the screen. Crossing the publishing color line in the way that it did, and in such convincing fashion, it is no wonder Dunbar's work, and his name, appealed to early race-filmmakers in pursuit of both the sure-fire hit and cultural legitimacy.[40]

The New Jersey–based Frederick Douglass Film Company, run by "many of New Jersey's prominent Negro business and professional men," operated between 1916 and 1919, and produced three feature-length films.[41] "One of the best organized of the early black independent companies," Douglass Film shared the objectives of most early race-film companies, particularly, but not exclusively, in the wake of *The Birth of a Nation*, "to offset the evil effects of certain photo plays that have labeled the Negro and criticized his friends. To bring about a better and more friendly understanding between the white and colored races. To show the better side of negro life [and] to inspire the

negro a desire to climb higher in good citizenship, business, education, and religion."[42]

In May 1917, the company released its second film, the short *The Scapegoat* (no longer extant), an adaptation of Dunbar's eponymous short story, which had first appeared in his 1904 volume of stories *The Heart of Happy Hollow*, published by Dodd, Mead. As I have said, *The Scapegoat* may well be the first screen adaptation of an African American–authored literary narrative, one that predates Micheaux's first adaptation, *The Homesteader*, by a couple of years. Dunbar's story tells of the wily Robinson Asbury's retribution as he turns the tables on the Black elite of the fictional southern town of Cadgers. The respectable Black community, bitterly envious of Robinson's rapid rise from bootblack to barber to lawyer, is angered and affronted by his decision to remain living and working among "the rude coarse people of the low quarter" rather than moving uptown to join their ranks; "I will never desert the people who have done so much to elevate me," Robinson announces.[43] Because Douglass Film's adaptation is no longer extant, it is impossible to determine how closely it hewed to Dunbar's story. But contemporary reviews suggest that it did. Lester Walton reviewed the film at some length in *The New York Age*. Reporting that it "lacks a certain cohesiveness," he concluded this was also the case, however, with Dunbar's story, "which brings about radical changes in the twinkling of an eye—with the stroke of [his] pen."[44] Indeed. Asbury's rapid rise from bootblack to lawyer, narrated over the space of all of one page in Dunbar's story, is only one such example of a "radical change" told "in the twinkling of an eye."

While Walton may have tolerated the film's uneven editing, perhaps for the reason that in doing so it remained faithful to Dunbar's story, this was not the case with the film's Black vernacular speech, inscribed on its intertitles, which Douglass Film not only introduced into Dunbar's narrative, in which there is none at all—likely because none of the residents of the "Negro quarter" is assigned any dialogue at all—but ascribed to all its characters, including those of the Black middle class, a move that Walton felt a Black film company should avoid at all costs. It is hard to account for Douglass Film's decision to include dialect when there is none in Dunbar's story. According to Walton, "Putting dialect into the mouths of our doctors (or near doctors) and ministers seems to be the rage among writers of the drama and photo plays, although these race representatives are supposed to be classed among the 'intellectuals' of the race. I find it difficult to become converted to this 'modern view,' especially when the picture is made by a

colored firm and principally for colored theatres."[45] We can only speculate why the company chose to characterize Dunbar's Black middle class in this way. Either it wished to show its Black audience—drawn from the full spectrum of the community—that an uneducated Black man too could climb the social ladder, or it hoped the dialect might appeal to the film's less sophisticated spectators who may have had little to no familiarity with this new medium and its mode of narration. Or the addition of dialect could have been a concession to the white members of its audience—"the film is being booked by white and colored motion picture houses," a column in the June 14, 1917, *New York Age* advised—to avoid alienating a white audience leery, and worse, of "uppity" Black folk.[46] But, of course, it is also true that Dunbar was renowned for his dialect verse; the filmmakers may have felt they were producing a more authentic or at least recognizable Dunbar narrative by ascribing dialect indiscriminately to its Black characters, thus doing "Dunbar" better than Dunbar himself.[47] Nonetheless—and in addition to what he adjudged were sloppy intertitles ("the misuse of the word 'their' for 'there' . . . and the misspelling of 'susceptible'")—Walton concludes his review by pronouncing *The Scapegoat* the "best [Negro photo play] to date."[48]

And yet anyone familiar with Dunbar's story would probably agree that it is, as I have suggested, a rather unusual choice for adaptation by a race-film company whose objective was, among others, "To show the better side of negro life." While both Dunbar's story and its adaptation provide in Asbury Robinson a model of advancement through a combination of aspiration, wiliness and education, these segments of the plot in Dunbar's tale are passed over in a matter of a few opening pages; and it seems, from what we can glean from Walton's review at least—and his comment that the film endeavors "to be consistent with the story of the author"—the film likewise resisted or was indifferent to drawing out the plot of or filling in the gaps in Robinson's trajectory from bootblack to barber-lawyer and wily political operator. Instead, Dunbar's narrative focuses on the conflict between a Black middle class aspiring to validate white cultural norms, and the Black folk. Indeed, it provides a rather fierce critique of Black respectability in its abandonment of the folk and in its concomitant alignment with white interests, which in turn exposes the "uppity Black" to chicanery and corruption.

The Sport of the Gods, the second Dunbar narrative adapted to the screen, is an equally odd choice, again in the context of what we know of race-film companies' aspirations to "produce 'high-class pictures.'" Reol Productions, which adapted Dunbar's novel, was in operation from 1921

until 1926 and headed up by white entrepreneur Robert Levy. One of its strengths, and the likely reason it endured for a relatively long period in the context of early race-film companies, was its association with the Lafayette Players, the successful Harlem-based all-Black stock theater company to which "Levy purchased the management rights" in 1916.[49] Levy had secured from Dunbar's mother, Mrs. Mathilda Dunbar, and from his widow and beneficiary of his estate, Dunbar Nelson, the motion-picture rights to two of his works—*The Sport of the Gods* and *The Uncalled* (never produced)—for a total of $1000, "the largest sum Dunbar ever earned (albeit posthumously) for his writing."[50] To put this in perspective, that same year Micheaux offered Chesnutt $500 for the rights to *The House Behind the Cedars*. Chesnutt replied that Houghton Mifflin, the novel's publisher, "think [Micheaux's] offer of $500.00 for the motion picture rights is small in comparison with prices offered by other firms, but at the same time they realize that the market for such a film is somewhat restricted, and are willing to leave that matter to me."[51]

Thanks to the University of Delaware's Dodd, Mead and Company archive, we know it was Levy who first approached Dunbar's publisher in January 1921 to initiate negotiations over the motion-picture rights to *The Sport of the Gods* and *The Uncalled*. Dunbar Nelson and Mathilda Dunbar, on behalf of whom Dodd, Mead was acting, agreed almost immediately to Levy's offer and the terms according to which he would adapt these novels. Sensing an opportunity both to safeguard and to expand Dunbar's legacy— as well as her erstwhile mother-in-law's and her own income—Dunbar Nelson approached Levy herself to suggest that he produce Dunbar's second novel, *The Love of Landry* (1900). While nothing came of that, the successful negotiations over *The Sport of the Gods* and *The Uncalled* prompted Dunbar Nelson to contact "Real" (as she misspells Reol throughout her diaries) about making "a deal with them for picture plots. I'll send them that serial," she recorded on September 25, 1921.[52] And she did. "That serial" was "Nine-Nineteen-Nine ('9-19-'09): Motion Picture Play in Eleven Episodes," "an unabashed melodrama of the *Perils of Pauline* type popularized by movie serials,"[53] which she packaged up with another motion-picture prospect, a two-reel comedy, "Frances [*sic*] Party Dress," of which a seven-page synopsis remains. A rather delightful story, in some ways reminiscent of Anita Loos or F. Scott Fitzgerald, "Frances Party Dress" tells of an orphaned schoolgirl caught in a muddle-up over a suitably demure white dress and a *décolleté* feathered dress, which she mistakenly ends up wearing to a ball held at the

"miniature Tuskegee" (the only indication the community of the story is Black) to which she is briefly sent. Reol was not interested.[54] After watching another of Reol's films, *The Burden of the Race* (1921; lost), about the upward trajectory of a young educated Black man, Dunbar Nelson recorded in her diary that she appreciated only "now what kind of stuff the Real [*sic*] people want, and I realize I can hardly hope to come up to their standard."[55]

Chesnutt, whose more serious works were better suited to Reol's tastes and agenda, also negotiated with Levy about adapting his work—*The Marrow of Tradition*—to the screen shortly before the company's successful negotiations over the rights to *Sport of the Gods* and around the same time he embarked on a rather drawn-out collaboration with Micheaux that finally put *The House Behind the Cedars* on the screen in 1927. Acknowledging to his publisher at Houghton Mifflin that an adaptation by Reol of the controversial and, admittedly, poorly received *The Marrow of Tradition* would "be of no value to you as publishers and would produce nothing for me in the way of royalties," Chesnutt nonetheless hoped it would at least "produce a sufficient demand to justify the printing of at least another small edition" of that novel.[56] In other words, a motion-picture adaptation just might resuscitate his career. But the film was never produced. It seems negotiations came to a halt at the point of the contract, according to which Reol would purchase the rights for $500 and all advertising for the film, "and . . . the film itself" would clearly state "that the film is based on 'The Marrow of Tradition' by Charles W. Chesnutt, by special arrangement with the publishers, Houghton Mifflin Company." Chesnutt enquired of Levy in March 1912, "What is the trouble"?[57] Surviving materials indicate he received no reply (or at least none that can be located). We can presume that Levy concluded that this "bitter, bitter" narrative of Black–white relations, as Howells had condemned *The Marrow of Tradition*, was too much of a gamble to pursue.

It made better sense for Reol to turn to Dunbar. Although *The Sport of the Gods* was censured by one contemporary critic for its "unrelieved woefulness," it did not provoke the kind of outcry that accompanied the publication of *The Marrow of Tradition*, which effectively put an end to Chesnutt's critical and financial fortunes.[58] Dunbar's short novel tells of the trials and tribulations of the Hamiltons, a "good-living" southern Black family "struggling to rise."[59] Following Berry Hamilton's incarceration on his conviction for a theft he did not commit, his wife Fannie, and their two grown children Joe and Kit, migrate North to New York City's Tenderloin district. The family is soon introduced to the city's "Negro bohemia," to use James

Weldon Johnson's term, which in the novel takes the form of nightclubs and "coon shows."[60] Seduced by its twin promises of community and pleasure, their lives rapidly spiral out of control. Fannie, under the misapprehension "dat a pen'tentiary sentence is de same as a divo'ce," marries the abusive Mr. Gibson; Kit becomes a second-rate chorine; and Joe is imprisoned for the murder of his on-again, off-again lover.[61]

Dunbar's novel might seem a relatively straightforward cautionary tale about the temptations and degradations of Black urban life and the cultural forms and sites that now generated. As Dunbar's narrator gravely announces, "Whom the Gods wish to destroy they first make mad. The first sign of the demoralization of the provincial who comes to New York is his pride at his insensibility to certain impressions which used to influence him at home. . . . After that he goes to the devil very cheerfully."[62] In an 1898 essay, Dunbar is likewise damning of the "Negroes of the Tenderloin" newly arrived from the South, with no care for a moral life or for their children.[63] James Smethurst describes the Hamilton family's actual and moral trajectory as "a journey into a new kind of slavery to mass culture and the evils of modernity."[64]

However, there is something else, something more at work in Dunbar's depictions of Black urban popular culture in this, his final, novel, something more along the lines of what Johnson also recognized in the Tenderloin: "an alluring world, a tempting world, a world of greatly lessened restraints, a world of fascinating perils; but, above all, a world of tremendous artistic potentialities."[65] It is true that it entices the Hamiltons away from "good living"—the "good living" that, we would do well to recall, resulted, if indirectly, in Berry's incarceration in the first place, leaving his family with little option but to flee North.[66] But it also generates community. The Banner Club, which Joe and Kitty frequent, "stood to the stranger and the man and woman without connections for the whole social life. It was a substitute—poor, it must be confessed—to many youths for the home life which is so lacking among certain classes in New York."[67] At least as importantly, in its formation of a Black public sphere over which the "coloured people in the audience . . . seemed to take proprietary interest," the club, as motion pictures would come to do, introduces to the community "mystery and glamor" and "scene[s] of beauty"—in other words, aesthetic and imaginative possibility: "It is strange how the glare of the footlights succeeds in deceiving so many people who are able to see through other delusions. The cheap dresses on the street had not fooled Kitty for an instant, but take the

same cheese-cloth, put a little water starch into it, and put it on the stage, and she could see only chiffon." Why not see chiffon where there is cheesecloth? Similarly, Mrs. Hamilton, visiting a different club not long after the family's arrival in the city, finds that the chorus "gave almost a semblance of dignity to the tawdry music and inane words," and so she soon "came around to the idea that . . . she . . . had always been wrong in putting too low a value on really worthy things."[68]

Reol's production of Dunbar's novel was evidently similarly transfixed, and more, by the Black bohemian culture it depicted. As Christina Petersen has found, "Judging by still photographs from the film, *The Sport of the Gods* looks to have transformed the novel's Harlem Banner Club, 'a social cesspool, generating a poisonous miasma and reeking with the stench of decayed and rotten moralities' into a swinging all-Black cabaret," capable of seducing not only the younger Hamiltons but the very narrative in which they appear, as well as its viewers.[69] So again, *The Sport of the Gods* would seem an unlikely choice for the project of uplift cinema. However, what Levy could not have done with Chesnutt, whose reputation was somewhat in tatters, he was able to do with Dunbar: mine, with Alice Dunbar Nelson, the reputation that Dunbar had forged during his lifetime and that continued to flourish in the decades following his death.

Levy had a background in mainstream motion pictures—he had started out as the general manager of The Ideal Company of Hollywood (also known as Features Ideal, Inc.) in 1914—and thus was more than likely abreast of the promotional practices of mainstream studios, including their deployment of famous authors to sell their product.[70] He would also have been aware of the similar tactics of Micheaux, from whose Film and Book Company he set out with very clear intent to distinguish Reol.[71] Micheaux, as did several of the studios discussed in Chapter 1, placed the author—himself in this case—front and center of much of his motion-picture advertising. In the newspaper advertisement for his first film, adapted from his novel *The Homesteader*, he includes his own image among the "All-Star Negro Cast," of which he is apparently now a member (Figure 2.1). Significantly, the caption beneath his image reads "author" than, or rather in addition to, director, scenarist and/ or producer, all of which he also was. There was good reason for this. *The Homesteader* was Micheaux's first motion-picture production, whereas he had published by this point three novels. It made sense then to draw on his reputation—what he had yet established of it—as an author in order to sell his films.

Figure 2.1 Advertisement for *The Homesteader* (dir. Micheaux, 1919), *Kansas City Sun*, March 1, 1919.
Courtesy of Library of Congress

Exactly how closely Levy followed Micheaux's career is hard to say, but he seemed to emulate Micheaux's strategies when he placed Dunbar at the center of promotional materials for Reol's adaptation of *The Sport of the Gods*. By contrast, what we can tell from the few materials that remain, only one newspaper advertisement for Frederick Douglass Film's *The Scapegoat* includes any mention of "America's Greatest Negro Poet" whose name appears in upper-case font above the film's cast of "famous colored stars" (Figure 2.2). By the time Reol came to market *The Sport of the Gods* several years later, Dunbar played a central role. Unlike in the advertisement for *The Homesteader*, Dunbar's is the only portrait that appears in advertisements for this adaptation. The "all-star cast of colored artists" is only named, and in significantly smaller font; the film is hailed as a "Dunbar feature" and the work of the "Shakespeare of the race" and "the Race's greatest poet (Figure 2.3)."[72] Rather intriguingly, there is evidence Reol planned a novelization to tie in with the film of *The Sport of the Gods*. According to a March 1921 *Chicago Defender* column, "a complete story of this play will be published in these columns in the near future."[73] Unfortunately, this does not seem to have eventuated; at least no record of it remains.

Figure 2.2 Advertisement for the Frederick Douglass Film Company's *The Scapegoat* (1917), *Philadelphia Tribune*, July 7, 1917, 4.
Courtesy Proquest Historical Newspapers.

Reol's, and to a lesser extent Douglass Film's, strategies to market their respective adaptations of Dunbar's fiction once more register the importance of the author to "sell theater tickets," as Rex Beach would put it.[74] But as we also saw in Chapter 1, authors had themselves much to gain from attaching themselves and/or their work to the industry as a means to promote their work—and themselves—and thus their fortunes, critical and otherwise. As already mentioned, both Dunbar Nelson and Mathilda Dunbar leaped at the chance to have Dunbar's fiction adapted to the screen, evidently recognizing in such

Figure 2.3 Advertisement for Reol Productions' *The Sport of the Gods* (1921), *Chicago Defender*, February 19, 1921, 5.
Courtesy Proquest Historical Newspapers.

an undertaking an additional means of contributing to, indeed expanding on, Dunbar Nelson's larger project of safekeeping and promoting Dunbar's posthumous reputation, a project that became increasingly important in generating income. While Lillian S. Robinson and Greg Robinson are correct that Dunbar's "symbolic presence as an exemplar of Black achievement—the first Black *professional* writer—swiftly eclipsed what he actually wrote," the Dunbar brand began to lose some of its heft in the 1920s when a new generation of Black authors with different investments in and visions for Black literary culture found Dunbar's work "mediocre or politically compromised."[75] One particularly outspoken critic of Dunbar's creative capacities was Wallace Thurman, who believed Dunbar "far from being a great poet" and that his "novels are of no value whatsoever, being poorly conceived, poorly executed and poorly written."[76] Thurman singled out *The Sport of the Gods* for censure; "I don't like Dunbar's novel. It is quite bad. . . . It is dated for one thing," he wrote in mid-1929 to his (white) friend and sometime collaborator, playwright William Jourdan Rapp.[77] We know Thurman had indeed read Dunbar's novel for Levy had invited him to adapt it to the stage for the Lafayette Players in the wake of Reol's demise.[78] While this venture did not

proceed, it meant Thurman was now aware, if he had not already been, that "these people [Levy's Quality Amusement Corporation] own the dramatic and movie rights to Dunbar's works."[79]

B Movies and Pulp Fiction: Wallace Thurman

It might be tempting to conclude that it was this awareness that prompted Thurman to pursue his own engagements with motion pictures as a scenarist or via the sale of subsidiary rights to his fiction. But he was already in Los Angeles at this point—the summer of 1929—doing just this, that is, attempting to launch himself into Hollywood as the smallest handful of Black authors had done several years earlier with varying success. Walter White had tried to interest Cecil B. DeMille in producing his novel *The Fire in the Flint* (1924) and entertained hopes of writing the scenario himself; and in the late 1920s, Claude McKay had read for director Rex Ingram in Metro-Goldwyn-Mayer's Victorine Studios in Nice.[80]

Thanks to the survival of Thurman's lively correspondence with Rapp and with Langston Hughes, we know quite a bit about his initial efforts to break into mainstream motion pictures. Aged twenty-seven and basking in the success of his first novel *The Blacker the Berry* (1929), Thurman traveled out West in the hope of riding the wave of what he termed, in the context of the Broadway theater world at least, "Negromania."[81] While the race-film industry was now in its last gasps due to, among other factors, the prohibitive costs of the new sound-film technologies, the higher-paying Hollywood studios, hoping to emulate the success of King Vidor's "marvelous" 1929 Black-cast screen musical *Hallelujah*, began to lure Black actors away from that industry. So with "Negro movies . . . at a complete standstill," Thurman turned first to Paramount's James Cruze and to RKO to gauge their interest in adapting to the screen Rapp and his co-authored play *Harlem: A Melodrama of Negro Life in Harlem* (1929).[82] He also pitched original motion-picture stories—slated for Evelyn Preer and Nina Mae McKinney—to Cruze as well as to MGM while at the same time attempting to secure work "doing some dialogue for colored talking pictures. Both Fox and Lasky are specializing in Negro two-reel films." However, he received "final 'noes' from M.G.M., Pathé, Fox and James Cruze," and that was that—because, as he wrote to Rapp, "They did not mind me being a Negro, oh, no, it was just that I was too obviously one," a reference to his dark

complexion.[83] Thurman would have to wait another five years or so before successfully breaking into Hollywood when, only months before his death, Bryan Foy Productions contracted him to write two original scenarios, *Tomorrow's Children* and *High School Girl*.

And yet Thurman had exhibited an interest in motion pictures well before the summer of 1929. In 1926 he published "Cordelia the Crude," that superbly irreverent story of Black moviegoing and its attendant moral risks, in the sole issue of *Fire!! A Quarterly Devoted to the Younger Negro Artists*, a short-lived collaborative venture of which he was editor-in-chief. The story, which he would develop with Rapp into their successful Broadway play *Harlem*—and which was accompanied by Richard Bruce Nugent's black-ink drawing of a voluptuous naked woman leaning against a coconut tree, conjuring all the sensuality and exotica of the tropics—includes an attentive description of

> New York City's Roosevelt Motion Picture Theatre on Seventh Avenue near 145th Street. Thrice weekly the program changed, and thrice weekly Cordelia would plunk down the necessary twenty-five cents evening ad-mission fee, and saunter gaily into the foul-smelling depths of her favorite cinema shrine. The Roosevelt Theatre presented all of the latest pictures, also, twice weekly, treated its audiences to a vaudeville bill.[84]

In narrating the moviegoing experiences of sixteen-year-old Cordelia, a Black southern transplant who is "physically . . . a potential prostitute," Thurman's story delights in its lampooning of the concerns shared by both Black and white moral guardians about the capacity of motion pictures, moviegoing, and the motion-picture palace to corrupt young women in par-ticular. Cordelia—or Thurman—pushes such moral panic to its limits so that there is little to distinguish the picture palace from dens of vice such as the speakeasy, and the Black woman moviegoer from the "prostitute."

But there is another Thurman text, composed around the same time he was seeking motion-picture employment in 1929, that is of greater signif-icance in my film-oriented reconsideration of Thurman's literary career. As motion pictures and the motion-picture industry were on his mind, he completed what would become the posthumously published collection of essays *Aunt Hagar's Children*, which included what he described as "a sketch of himself as a young colored lad anxious to enter a literary career." This essay, "Notes on a Stepchild," is, as Nowlin has written, "the best testimony we have to Thurman's literary ambition."[85]

Particularly striking about this oddly third-person account of his youthful literary stirrings is that Thurman situates motion pictures at their very foundation. After noting his "rabid" movie fandom as a young boy, he recalls writing his "first novel" at the tender age of ten. What Nowlin omits in his otherwise brilliant account of Thurman's essay is that the plot of this first novel is "centered around a stereopticon movie he [the young Thurman] had seen of Dante's *Inferno*. It concerned the agony of a certain blonde woman."[86] Thurman also recalls that at the age of twelve, he took to rewriting "the contemporary serial thrillers and was more prodigious with death defying escapades for his heroes and heroines, than the fertile Hollywood scenarists."[87]

I find in Nowlin's account of this brief but highly significant passage, and indeed of Thurman's essay generally, a resistance to the attraction motion pictures clearly held for him, including—especially—its B-movie plots, an attraction that infuses Thurman's recollection of his nascent literary aspirations, and in a recollection he seems to have composed, we would do well to remember, as he was seeking employment in Hollywood. Reminiscent of the "tremendous artistic potentialities" Johnson saw in New York's "Negro bohemia" and of the similarly creative energies embodied in *The Sport of the Gods'* Banner Club, the "fertile" imagination of the Hollywood scenarists inspires the "prodigious" reimaginings of the young Thurman (at least as far as these are constructed by the older Thurman) in ways that exceed Nowlin's dismissive description of these as "imitation movie scenarios."[88] Nowlin also overlooks the genre of the serial films that Thurman watched, probably as Saturday matinees, and that he rewrote: thrillers.

While it is true we cannot take this keen ironist at face value, it is still the case that Thurman's account of his literary beginnings, composed at the very apex of his career—he had just published *The Blacker the Berry* and staged *Harlem*—is filtered through the prism of motion pictures, specifically the B-movie genre of the thriller. It is worth taking seriously Thurman's retrospective account of his career, likewise to privilege or at least foreground motion pictures as a means to reconsider it, from his 1926 short story "Grist in the Mill" through his final novel *The Interne* (1932), co-authored with A. L. (Abraham Loew) Furman, and lastly, the Hollywood scenarios he completed not long before his death in 1934. Reading Thurman in this way, that is, through the critical lens of motion pictures, addresses anew or provides a different perspective on the conundrum, the tragedy even, of this singular author who, as Hughes understood it, longed "to be a very great writer" but

"felt that he was merely a journalistic writer."[89] And to do so, I begin at the end, with the scenarios.

Thurman composed *High School Girl* and *Tomorrow's Children* for Bryan Foy Productions in 1934, not long before his death that same year. Both films were produced and released and, because of their provocative content and mode—Micheaux's Sidney Wyeth might have designated them "shockers"— attracted the attention of the censors. This means that, although Thurman's scenarios are lost, we have the dialogue sheets—transcriptions of the dialogue as produced—of both films; these are among the mass of paperwork held in the State of New York's archives in Albany, generated by the censorship cases concerning the two films. One preliminary clarification or note about these two properties: the print of the film of *High School Girl* in circulation today includes the alterations the censors required, but the print of *Tomorrow's Children* in circulation is unexpurgated; it includes all the scenes and dialogue the New York censors slated for excision.

Known as "the keeper of the B's," Foy had previously overseen Warner Bros.' B-unit, mass-producing the sort of motion pictures usually exhibited ahead of the classier film screened as part of the double-feature format. According to Jeremy Geltzer, "Leaving highfalutin production values to the well-funded film factories, Foy's expertise became grind-house films, tailored to teen audiences." *Tomorrow's Children* and *High School Girl* were no exception.[90] Both *Variety* and the *Hollywood Reporter* announced the arrival of Thurman—this "noted negro writer"—in Los Angeles on March 12, 1934.[91] Thurman must have worked extraordinarily quickly, for *High School Girl* was released in April 1934 and *Tomorrow's Children* in July 1934, the very month in which Thurman was admitted to New York's City Hospital on Welfare Island (now Roosevelt Island) for the tuberculosis that would kill him only five months later. Thurman told Harold Jackman he was "working night and day" for Foy.[92] And according to his dear friend Dorothy West, "The story sessions were mad, and Thurman's nerves were shot. He hated the long, drawn out, senseless discussions. On one occasion he became violently ill through sheer physical revolt at the antics of his colleagues."[93] While he felt he had "been sold down the river to Hollywood," it was also the case he was "learning a lot, [and making] swell contacts and nice money."[94] The *Pittsburgh Courier* reported he was receiving "a stipend in excess of $250 a week, perhaps the highest salary paid a Negro in America." Maybe. But this was roughly half of what, according to Richard Fine, (white) Hollywood screenwriters would typically earn at this time.[95] To put this into some

further perspective, William Faulkner, writing screenplays for Twentieth Century-Fox the following year, drew a weekly salary of $1000.[96]

Both *Tomorrow's Children* and *High School Girl* were directed by silent-film actor (he had starred in *The Perils of Pauline*)-cum-director Crane Wilbur, and both are "white life" narratives as well as medical melodramas, so capitalizing on the emergence—indeed the explosion—of a motion-picture genre concerned with the romances and trials and tribulations of doctors, nurses, and patients.[97] According to Susan Lederer, "The popularity of such films as *Men in White, Women in White, The White Parade*, and *The White Angel* made it seem as though anything 'in white' was good for box-office returns."[98] *Tomorrow's Children* and *High School Girl* are also "in white" films; set largely in hospitals and adjacent medical environments, they deal with such hot-button issues as teenage pregnancy and sexual hygiene, women's reproductive rights, and, especially controversially, state-mandated sterilization and eugenics. The *Hollywood Reporter* provides a useful synopsis of *High School Girl*: the film

> tells of an unsophisticated school girl [Beth], neglected by her clubwoman mother. Involved in a puppy-love affair [with Phil], she asks for instruction, only to be told that she is too young to know about such things. The inevitable occurs and the girl is taken away by her understanding older brother to have her baby secretly. . . . Throughout the plot wanders the character of a biology professor who preaches the doctrine of frankness.[99]

Indeed, Mr. Bryson, the high-school science teacher played by Wilbur, is fired for instructing his students in moral hygiene, the "scientific facts explaining all the functions of the human body."[100] As this reviewer, evidenced by the plot summary above, is rather coy in the face of teenage sexual intercourse and pregnancy, so is the version of the film we watch today. Beth and Phil's sexual encounter is only gestured at, as is Beth's pregnancy, which culminates in the loss of the baby during labor (which may in fact be an abortion) but also, happily, in a proposal of marriage from Phil.

Although *High School Girl* includes several scenes depicting "the agony of a ... blonde woman"—to take from Thurman's "Notes on a Stepchild"; here, the platinum-blonde Beth's near breakdown as she is confronted with the shame of her predicament—the print of *High School Girl* that circulates today, as I have said, bears the alterations required by the New York State

Department to clean it up. In this sanitized rewriting of the film's narrative, it is impossible to discern exactly what the procedure is that Beth undergoes when, toward the end of the film, she is whisked away by her brother and the science teacher to a hospital in another town: an abortion? induced labor? delivery of the baby who is then put up for adoption? The censors also required that "much of the hospital sequences" be "eliminated." While Beth never exhibits any signs of pregnancy, there is also no mention of the baby at any point, including after Beth's apparently urgent, life-saving procedure. Other scenes were cut altogether on the direction of the department, for instance, "the scene of love-making in the field."[101] Today we only witness Beth and Phil briefly seated in a leafy bower during a barn dance. The camera straightaway cuts away from the bower back to the barn dance, and then, all of a sudden, we are back in the classroom, far enough into the future, the sharp viewer will ascertain, for Beth now to be pregnant.

The saucier dialogue has likewise been cut. Among the materials in the New York State archives is a list of the dialogue the board slated for excision, for example:

> REEL 1: Eliminate underlined words in spoken sub-titles in dialogue:
> "Hy [sic] there fellow—what's the matter, <u>couldn't you make the grade with the girl friend?</u>"
> "Her name's Susie Hecht and she has a twin sister, too. Her old man runs a bakery. <u>What a fine pair of strawberry tarts he turned out.</u>"
> "Don't give him so much credit. <u>There [sic] not much opposition this year among the girls.</u>"
> "Dames are like everything else—<u>you've just got to know how to handle them.</u>"

Irwin Esmond, the director of New York State's Film Censorship Office, determined that such scenes and dialogue were "'Indecent.' 'Immoral.' 'Would tend to corrupt morals.'"[102] As one moral guardian at the time concluded, even in revised form, the film was simply "too sexy."[103]

While a *Hollywood Reporter* reviewer pronounced *High School Girl* "dull" owing to, or despite—it is not made clear—Foy's "taking a leaf out of Ivan Abramson's notebook"[104] (Abramson was a silent-film director of the "social problem" film), another *Hollywood Reporter* reviewer found much to praise about the film: its production values distinguish it from the "moralizing picture of the sort . . . designed to play the ten cent houses in our cities' 'Main

Streets,' coupled with flamboyant 'Men Only" and 'Women Only' advertising." It does not contain "an offensive second in the entire hour of its running time," and "if there must be screen preachments of the kind, this could hardly be improved." And although this reviewer does not name Thurman, they find "the writing entirely in good taste."[105] Dorothy West recalled the film "had a fair run at the Astor" in Los Angeles.[106]

Tomorrow's Children, whose working title was "Sterilization," encountered far greater problems with the censors. As it had done with *High School Girl*, the New York State Department of Education declared *Tomorrow's Children* "Immoral" and that it "Will Tend to Corrupt Morals"—with the addendum that it "Will Tend to Incite Crime."[107] According to Ewa Luczak, *Tomorrow's Children* "was the only Hollywood production that had the ambition to draw attention to the problem of eugenic sterilizations and to warn against the abuses of a restrictive reproduction policy," and it did so at a time when no fewer than twenty-seven US states allowed for the forced sterilization of those designated unfit—for reason of alleged intellectual, physical, or criminal incapacity—to bear children.[108] More explicit, more sensational in its handling of medical themes, and significantly grittier in its milieu than *High School Girl*, *Tomorrow's Children* switches back and forth between scenes of an impoverished "house full of idiots and cripples" (in the words of the film's Dr. Brooks), a busy county hospital and its operating theaters, and the courtroom in which those sentenced to sterilization petition the rulings. *Tomorrow's Children*'s setting is a far cry from the respectable middle-class families and locales of the small town, school, and crisp and efficient hospital of *High School Girl*. The often chaotic scenes in the busy hospital of *Tomorrow's Children* are also more numerous and protracted than equivalent scenes in *High School Girl*, and include quite explicit scenes of medical consultation and in operating theaters. It is no wonder *Tomorrow's Children* became the subject of even more prolonged censorship battles.[109]

Tomorrow's Children tells of "a drunkard and his poverty stricken feebleminded family, with its sick, crippled, and criminal members, and a normal attractive" daughter, Alice who, we find out very much later in the film, is the Adams' foster, rather than biological, daughter, a last-minute disclosure that saves Alice from the forced sterilization the rest of her family is subjected to, a reprieve that also facilitates her marriage to Jim to begin a family of her own.[110] The film's surviving revised dialogue sheet, dated November 24, 1934, includes the offending sections, struck through. In the following brief scene, to take one example slated for excision, Dr. Brooks explains the

procedure of sterilization for women to Spike, a convicted thief ordered to undergo a vasectomy to "cut a little bit of the bad from me":[111]

> BROOKS: In the case of a female, of course, a general anesthetic is necessary. And the operation consists of the removal of part of the Fallopian tubes. These are reached directly through the abdomen by an incision. The operation is not dangerous. I should say, it's comparable to the removal of the appendix."[112]

Worth noting is that the quite detailed explanation of a vasectomy Dr. Brooks goes on to provide Spike was not slated for excision—only that of a woman's tubal ligation. Eroticized by the censors, the procedure was deemed too risqué to remain in the film. (Both these scenes, in which Brooks explains to Spike the procedures involved "in the case of a female" and male, remain in the film print we watch today.) Oddly, two graphic scenes of the near rape of two women—Alice, by a hobo riding the rails, and a nurse, whose uniform is ripped off by a senator's son as he awaits his sterilization verdict—were not marked for excision. As Felicia Feaster argues of *Tomorrow's Children*, the "scandal seems to lie largely in the sexual connotations of sterilization"; "the film's thematic concern with sex and sexual surgery suggested the possibility of even a non-representational sex"—specifically in terms of male sexualization of women's bodies.[113] As the New York State Supreme Court had determined in March 1938, "the teaching and demonstration of many facts may be necessary to the classroom of the law school, the medical school and clinic, the research laboratory, the doctor's office, and even the theological school, which are not proper subject matter for the screen."[114] And so the film was denied release in New York. According to the state's commissioner of education, Frank P. Graves, "The reproductive organs are the theme, and their perversion is the topic of the picture."[115]

I do not here pursue, as several scholars have so profitably done, *Tomorrow's Children*'s censorship entanglements or its eugenic themes, especially significant in the context of Thurman's well-documented self-loathing arising from the color of his skin.[116] Rather, it is the risqué plots of these sensationalist films that are of interest here since these encourage us to seek out Thurman's corresponding "B" commitments as a career-long author of pulp fiction.[117] In other words, in approaching Thurman's career from the perspective of motion pictures—his writings for and about the industry and medium—as he himself did in his 1929 "sketch of himself as a young colored lad," we discover

that it is not only bookended but also profoundly informed by a low-brow sensationalism, by "shockers," a through line that reaches all the way back to "Grist in the Mill" and forward to *High School Girl* and *Tomorrow's Children*.

For one reviewer, the weakness of *Tomorrow's Children* was that it was not explicit *enough* in its depictions or scrutinization of the controversial matter of sterilization: the film "isn't given much help by the screen play by Wallace Thurman who evidently read about such things in a newspaper and decided it was a timely subject, and then let it take care of itself."[118] This was in fact far from the case—Thurman was deeply knowledgeable of medical matters as a result of his own experiences of ill health as well as of his handling of "such things" across his opus, as we will see. Sickly throughout most of his life, suffering from a heart condition, he had been admitted on at least one occasion to New York's City Hospital, where he would also see out his final months. He had, furthermore, been a premedical student at the University of Utah from 1919 to 1920; and, as Jess Waggoner rightly reminds us, "Thurman addresses a striking range of medical, biopolitical, and eugenic themes throughout his corpus. *The Blacker the Berry* (1929) is not only a critique of intracommunity colorism, but also utilizes discourses around colorism and the presence of intellectual disability to trouble eugenic thought in uplift discourses."[119] Even *Infants of the Spring*, Thurman's novel of the Harlem Renaissance, includes hospital scenes: Raymond is admitted briefly to Bellevue after experiencing some kind of breakdown where he is attended by an intern and a nurse, and Eustace Savoy is admitted to a city hospital as a result of "physical and mental apathy."[120]

In fact, medical settings and plots, and as "B-movie" or pulpy as those in his scenarios, appear across the full span of Thurman's career, beginning with his very first story, the hilarious, brilliant "Grist in the Mill," a farcical narrative about Black-to-white blood transfusion, published in *The Messenger* in June 1926 when Thurman was employed there not long after his arrival in Harlem. "Grist in the Mill" tells of the wised-up Black northerner, Zacharia Davis who, as a result of a series of misdemeanors, finds himself in Louisiana. Wishing to return North but lacking the financial wherewithal to do so, he eventually finds an opportunity in "an anachronistic relic from pre–civil war days," Colonel Charles Summers, and his—the colonel's—need of a lifesaving blood transfusion. Zacharia becomes "drawn into the little comedy in which Colonel Summers was to play the star role." He donates his blood to this "true reborn Confederate," gleefully apprising the colonel of this transaction only after the fact. Driven to insanity at the very thought of Black blood

running through his veins, the colonel' "began to revolt against this dusky intruder, began to writhe and wriggle upon the floor, began to twitch and turn, trying to rub [him]self clean, trying to shed this superimposed cloak, but the blackness could not be shed—it was sprouting from the inside, and being fertilized by the night" until a Poe-esque "black crow . . . cawed out . . . to the dying maniac on the floor, it seemed to caw, 'nigaw, nigaw, nigaw—.' "[121]

So when Thurman joined the editorial staff of the Macfadden Publishing Company in late 1928, he certainly had something to contribute as he also continued his apprenticeship in "shockers," including medical shockers. Bernarr Macfadden's media empire was, as Shanon Fitzpatrick has recently explained, "a sensational 'pulp empire' of muscles and magazines, known for its interactive content, broad reach, and massive circulations," founded on the success of *Physical Culture*, not only "one of the world's first popular fitness periodicals and the most prominent and successful English-language publication of its kind" but, too, notorious for its candid discussions of sexual and related matters.[122] In addition to its physical culture publications, the Macfadden Publishing Company published romance, trade (movie, radio, advertising), and—perhaps Macfadden's greatest innovation—confessional magazines, all of which were distinguished by their sensationalism, raciness (the inclusion of images of scantily clad men and women, for instance), as well as advocacy of sex education. It was inevitable, then, that Macfadden would run afoul of the censors (he was arrested on several occasions), including the US postal inspector Anthony Comstock, then head of the New York Society for the Suppression of Vice. The most popular, and best-known, of Macfadden's confessionals was the illustrated magazine *True Story*, which Thurman's collaborator Rapp edited between 1926 and 1943 and which attracted a mighty readership of around two million; according to David Earle, it was "the third-most-popular magazine in America, and the best-selling magazine on newsstands."[123] What was distinctive about *True Story* was its incorporation of readers' stories, confessions, combining "sex and adventure"—in other words, exactly the kind of "sensationalized 'factual' narratives" of the sort Thurman had himself begun to write and would continue to write.[124]

While the magazine's readers may have contributed the bulk of the content of *True Story*, its "longer serials were written by staff writers," among them, Thurman. "Of course Mr. MacFadden [sic] had no idea I was doing this work," he wrote to Hughes in early 1932. "But Mr. Rapp couldn't do it. He having taken on more jobs than one human could possibly handle. So in stepped

little Wallie . . . the ghost editor."[125] Hughes recalls Thurman writing "under all sorts of fantastic names, like Ethel Belle Mandrake and Patrick Casey" to compose "Irish and Jewish and Catholic 'true confessions.'"[126] Earle, one of the very few scholars who has pursued Thurman's career at Macfadden, explains that in addition to *Physical Culture* and confessionals such as *True Story*, Macfadden published other "pulp (and pulpish) magazines like *Ghost Stories, Red-Blooded Stories, Thrills of the Jungle*, and *Flying Stories*." Earle, speculating that Thurman ghostwrote for these too, is particularly taken with the prospect of Thurman's ghostwriting for *Ghost Stories* magazine: "it seems symbolic of the ethereal specter of black writers haunting the pulps." However, "ultimately, it is impossible to know because [such stories] would have been written under a house name or pseudonym"—like Ethel Belle Mandrake or Patrick Casey.[127] Notably, Macfadden also published motion-picture fan magazines, including, from 1921, *Movie Weekly*. Who is to say Thurman, a "rabid movie fan" from an early age, did not ghostwrite for it too?[128]

Thurman was still ghostwriting for Rapp at *True Story* "from six until ten [p.m.]" when, in 1932, he commenced "from nine until five at Macaulay's," which, in addition to his own novels—*The Blacker the Berry* (1929), *Infants in the Spring* (1932), and *The Interne* (with Furman; 1932)—published "histories, poetry, criticism, literary translations" as well as "inexpensive popular literature"—like *The Interne*.[129] Starting out as a reader at the Macaulay Company, he was very quickly promoted, in September 1932, to editor-in-chief, an appointment significant enough to be announced in *The Crisis*.[130] As Dorothy West remembered it, Thurman's role at the publishing house was "successfully turning out 'popular fiction'"—perhaps even medical-themed, such as doctor-cum-popular author Frederick G. Eberhard's 1930s sensationalist mysteries *The Secret of the Morgue* (1932) and *The Skeleton Talks* (1933). We don't know.

But we can, I think, safely assume Thurman learned much from his employment at both Macfadden and Macaulay. To begin, and as he himself wrote of his tenure at Macfadden, "actually editing, *True Story* magazine . . . [ha]s been a great experience. I have learned something about magazines, about public tastes, about many technical problems, and about American moronity at its best(?)."[131] He must also have learned the successful formula for the particular mode of popular fiction, combining didacticism and sensationalism, in which Macfadden's publications specialized, and building on his own experiences of producing more purely sensational or raucous narratives

like "Grist in the Mill" and "Cordelia the Crude." And, although Macfadden does not appear to have published a magazine devoted specifically to medical stories, the tables of contents of many issues of *Physical Culture* and *True Confessions* reveal, especially in the former, a large number of sensationally titled articles about health and medical culture. As Fitzpatrick has found, "Having always considered frank discussion of sex and reproduction a necessary cornerstone of physical culture, Macfadden remained committed to supplying the sexual knowledge industry and influencing public attitudes about interpersonal relationships and family formation."[132] It is also the case that the hospital romance was a fairly recognizable plot in the love pulps and in confession magazines, plots which "Thurman would surely have known of given his being a reader for Macfadden."[133] Take, for example, *High School Girl*, with its own risqué plot overlaid with educational intention. It resonates quite forcefully with an editorial Macfadden himself contributed to a 1925 issue of *True Story*, in which he regrets the refusal of the American public "to satisfy youthful curiosity by giving them the truth properly and reverently presented"—as the film's science teacher Mr. Bryson had attempted to do—resulting in "a hell on earth for literally millions of poor victims," like the film's Beth, "who have been reared amidst falsehoods."[134] And while, West insightfully observed, "Thurman's work with MacFadden [*sic*] publications had taught him what a large part of the public wanted," at Macaulay's "he was successfully turning out popular fiction," including his own (*The Interne*).[135] It was these experiences, West continues, along with "Thurman's engaging personality" that had "sold him to [Bryan] Foy," a friend of Furman, Thurman's colleague and, soon enough, co-author; Furman also oversaw Macaulay's pulp-fiction publications as he himself wrote pulp. All of this is to say that Thurman was poised for the next—what would turn out to be the final—stage of his career.

Among Thurman's papers held in the Beinecke Library's James Weldon Johnson Collection are several pages comprising Thurman's handwritten notes that appear to be the result of or in aid of research he was evidently undertaking in a sanitorium for "the care and cure of pulmonary tuberculosis." These notes include descriptions of the patients on "Male X," "at once a rectangular ward and an elongated corridor through which continually passed a variegated procession of septic people and antiseptic paraphernalia." He finds among the patients here "the most indigent of the proletariat" who are "worthy of a novel": "Poor Irish, ghetto Italians," "European peasants, and a few Negroes and Porto [*sic*] Ricans."[136] While the Beinecke Library dates these

notes as "ca. 1934," it is more than likely Thurman composed them somewhat earlier, as part of the research he undertook to cowrite with Furman his last novel, *The Interne*, which Macaulay published in late 1932.[137] Thurman had told Hughes in January 1932 that he was "turning out this hospital novel" at the same time that he was ghostwriting for Rapp at Macfadden and working at Macaulay. And according to West, "Thurman's scrapbooks"—which may have included notes of the kind he composed about Male X—"give mute testimony to the materials collected" as he prepared to cowrite this novel, as no doubt did his visit to Welfare Island (Memorial Hospital in the novel), likely the location of Male X, which, West recalled, "shocked and horrified him. He came away loud and bitter in his denunciation, and with the avowal never to set foot again in the place."[138]

It seems *The Interne* started out as a play. Thurman wrote to Granville Hicks in January 1932 that he had "been commissioned to novelize a play of mine. I don't know what kind of novel it is going to be. It concerns the experiences of a sensitive young medical graduate who enters a city hospital to interne for a year. I don't know how much you know about city hospitals. But conditions are appalling. And the interne who leaves college filled with ideals and ethics has a rude awakening." And "this is my first attempt to do something which does not concern Negroes. It may be my last." (It wasn't; the two scenarios were.) "The hospital play may be bought any minute by [Broadway producer] Wm. A. Brady. He has been considering it for weeks."[139] The play was not bought by Brady or anyone else for that matter, and indeed, there is no surviving play script of *The Interne*.

According to a 1932 letter from Thurman to Hicks, Thurman had been "commissioned" to write *The Interne*[140]—by Macaulay most likely, or maybe even by Bryan Foy who, as I have said, was a friend of Furman, Thurman's co-author. According to West, Furman had introduced Foy and Thurman in early 1932, that is, around the time of this commission. Two years later, a rather perplexing announcement in the *Hollywood Reporter* announced, "Bryan Foy has just sold the latest novel of Wallace Thurman, 'The Interne,' to Macauley [*sic*] for publication. Thurman, former U.S.C, athlete, wrote 'Sterilization' [the working title of *Tomorrow's Children*] and is now collaborating with Crane Wilbur on 'High School Girl.'"[141] While this intriguing notice suggests that Foy had a significant hand in *The Interne*, it does not make chronological sense—*The Interne* was long published at this point. Nonetheless, the reporter's error prompts us more fully to apprehend the extent to which Thurman's late work is informed by intricate

transactions between B movies and pulp fiction: *Tomorrow's Children*, *High School Girl*, and *The Interne* form a suite of sorts, a knotted relationship of such ambiguity and resemblance as to be jumbled by this *Hollywood Reporter* journalist.[142]

The principal setting of *The Interne* is Memorial Hospital—the narrative rarely strays from it, perhaps due to its origins as a stage play. More *Tomorrow's Children*'s hectic charity hospital than *High School Girl*'s well-ordered retreat, Memorial Hospital's catchment covers "the more flagrant slum neighborhoods . . . in which were isolated the poorer Jews, Italians, Negroes, and Shanty Irish," that is, exactly the population "worthy of a novel" Thurman found on Male X.[143] Dedicated to "Dr A. A. S. and the thousands of internes in public hospitals who conscientiously devote their hearts and minds to ease human suffering," *The Interne* is in some ways, as are the two scenarios Thurman would shortly write for Foy, an exposé, in the manner of Upton Sinclair or Theodore Dreiser, of the intolerable conditions in which young medical interns and nurses work, and the sordid conditions their patients, like those in *Tomorrow's Children*—"the most indigent of the proletariat," as Thurman wrote in his notes[144]—must endure. Like his two scenarios, then, *The Interne* contains an important and earnest social message.

What little scholarship there is about *The Interne* approaches it in exactly this way: as a well-intended exposé of the parlous state of the public hospital system in which Carl Armstrong, the idealistic young interne of the title, is thrust.[145] It is true the novel, according to its prefatory blurb, "reveal[s] an appalling situation—fire trap hospital buildings, insanitary wards, lack of men and equipment, administration riddled with politics, internes hardened to callousness, living a reckless life of drinking, gambling and woman chasing, and launched on racketeering careers." Carl is horrified at what he witnesses immediately on his arrival:

> A patient signing his own autopsy affidavit! A policeman beating an insane woman over the head with his night stick! An interne finishing out a hand of bridge while his patient was reported bleeding to death! All the impressions he had previously gained of the hospital came surging back. He remembered the gruesome possibilities of the maternity ward, the foul odors and the pathetic overcrowding of the other wards through which he had passed, the dinginess of the hospital's interior and the drabness of its exterior.[146]

But like *Tomorrow's Children* especially, *The Interne* is also a "shocker," thanks to its frequently gratuitous sensational scenes and subplots. It may very well be the case that it was Thurman who wrote the muckraking segments of the novel—we know he felt passionately about the conditions of public hospitals, as his research notes and West's recollection of this period of his life indicate. And because Furman supervised the production of popular fiction at Macaulay and authored his own popular narratives—ghost stories, and mystery and detective stories—it could very well have been Furman who composed *The Interne*'s more salacious scenes. We cannot know. But, as we have seen, there is plenty about Thurman's career up to this point to indicate that it was just as likely he who contributed the novel's more risqué elements.

Either way, the novel does read as the work of two different authors, as two quite different novels: one, a social problem or "message" novel, and the other, a pulpy narrative indulging in the city's seedy Prohibition-era underbelly. At times, these different modes merge. Take this scene, for instance, in which Nora Grant, "night nurse in charge of the male and female emergency wards" and Carl's on-again, off-again lover, describes to his other lover, the wealthy ingenue Annabelle—"the little blonde girl, who had been his first patient"— the life of a nurse at Welfare:

> "Where shall I begin?"
> "Any place."
> "Does rape interest you?"
> "Rape?"
> "Well, maybe rape is a strong word. Let's say seduction."
> Annabelle was justifiably mystified. "I ... I ... don't understand."
> "Didn't you know?" Nora asked in shocked surprise. "Why that's the first
> thing a nurse learns."
> "What?"
> "How to avoid seductions," Nora answered calmly.
> "Oh," Annabelle's interest began to subside. She felt herself entertaining a
> growing dislike for this nurse who talked so strangely.
> "Hospital beds," Nora continued inexorably, "seem always
> to ... well ... should I say ... make men ambitious? Really, it's awful. You
> give a man a bed pan and no matter how many pains he has, when you
> move the bed pan, he wants you to take its place."[147]

At other times, *The Interne* descends into the kind of straightforward smuttiness Thurman would introduce into *Tomorrow's Children*, and that characterized the "girlie pulps"—such as *Harlem Stories*. Rather tantalizingly, Earle has found that "the only identifiable author who published in *Harlem Stories . . .* had been [an] editor [at] MacFadden's [*sic*] . . . in 1927, while Wallace Thurman ghost wrote for it. . . . What are the chances that either Thurman had been involved in *Harlem Stories*, either as a ghost writer or editor?"[148] Threaded throughout *The Interne* are scenes of the relentless sexual pursuit of nurses by interns (including Carl) in morgues, on ambulance stretchers and "behind the laundry chute."[149] Some of the scenes depicting doctor–patient consultation or surgery serve only as extensions of or variations of these more titillating scenes. Carl, aroused by her torn stockings and "shapely white flesh," becomes instantly infatuated with "the petite and blonde" Annabelle, the "dizzy dame" in his charge while on late-night ambulance duty. Populated also by escaped convicts, bootleggers, "gangster moll[s]," and "street flooz[ies]," the novel includes scenes depicting sex between patients, drunken parties at which the interns sexually harass "[p]retty patients and sex starved nurses" and so forth, scenes that fail to offer the kind of critique in which Nora engages in her conversation with Annabelle.[150] It was no doubt for these—multiple—inclusions, noted only very cursorily here, that West described *The Interne* as having "little to offer save its over-sensational exposé of conditions on Welfare Island. It was cheap and poorly written."[151] Critics have largely lined up with West; *The Interne* has been out of print since its first printing, and, to my knowledge, very few scholars have exhibited much interest in it.[152]

Thurman's final projects then—three white life medical melodramas, all collaboratively composed for a mass audience—are in many ways the natural culmination of his career. To put this slightly differently, together they disclose an otherwise submerged pattern or mode that suffuses his entire opus. Thurman's sensationalist, pulpy interests, spanning the full arc of his career and across different media, may well have provided him a means to manage and even break free of the constraints of Black authorship—economic stress and racial persecution (Du Bois), the "unsettledness" emerging out of the uncertain "possibilities of African American literature" (McHenry)—caught as it was between conflicting demands for popular "propaganda" and what Johnson called "pure literature," the very conflicts that Bentley sees at work in Dunbar's *The Sport of the Gods*: "the divide between blocked ambition for

higher cultural expression and the profits from popular art . . . and between the inhospitable conventions of high forms and the euphoric beauty of a street life that could also bring grief."[153] As Hughes recalled it, Thurman

> wanted to be a *very* great writer, like Gorki or Thomas Mann, and he felt he was merely a journalistic writer. His critical mind, comparing his pages to the thousands of other pages he had read, by Proust, Melville, Tolstoy, Galsworthy, Dostoyevski, Henry James, Sainte-Beuve, Taine, Anatole France, found his own pages vastly wanting. So he contented himself by writing a great deal for money, laughing bitterly at his fabulously concocted "true stories," creating two bad motion pictures of the "Adults Only" type for Hollywood.[154]

In other words, as Nowlin argues, "idealizing 'Literature' led [Thurman] to devalue his own writing and cynically take up hackwork."[155] However, where Nowlin finds Thurman's "literary ambition . . . inseparable from 'literature'"—an association that shapes entirely Nowlin's project to "reexamine the literary trajectory Thurman followed under the inspiration of his readings in modern literature"—I find it also deeply imbricated with popular forms and themes. It may have been the case that Thurman wrote "a great deal for money," as Hughes put it, in order to underwrite "a tremendous idea for another Negro novel," which Thurman mentions in a letter to Hicks in early 1932.[156] In the novel Thurman *did* go on to (co)write—*The Interne*—Carl, a "poet, dressed up in a starched, bloody uniform," is confronted with a conundrum comparable to Thurman's own: should he accept an offer of relatively easy work at a private abortion clinic in order to "acquire sufficient money to enable him to follow the true dictates of his mind [his own practice]? Carl, the artist, was considering hack work, so that his masterpieces could be evolved without economic strictures."[157] This is an approach to, a way of accounting for, the artist-poet's hack work that is all too familiar, especially in the plentiful scholarship that frames the Hollywood experiences of high-modernist authors like Faulkner as failure and/or as a mere means to underwrite the real work, that is, the literature. Such an accounting dismisses an author's "B"-side or, at best, holds it at bay from that supposed real work. But reading Thurman as I do here, that is, from the perspective of motion pictures, encourages us to reconsider his failure—his fall into "true stories" and "Adults Only"—as generative. For, as Earle also finds, "rather than a failure, the New Negro movement led—at least for some writers—to a populist pulp form rather than a rarefied modernist one."[158]

3

Novel Forms: Rose Atwood's "A Man's Duty," Oscar Micheaux's *The Masquerade: An Historical Novel*, Willa Cather's *A Lost Lady*

Chapters 1 and 2 focused on the various ways authors came to participate in the motion-picture industry, and the transformations in authorship—its modes and its practices—these effected. Chapter 2 was particularly attuned to the affordances (and otherwise) such a series of interactions offered in terms of mobilizing a mass cultural form to legitimate or index Black authorship and shape literary achievement. This chapter is once more interested in the instability or porosity of literary culture exposed to motion pictures but this time in the context of a particular literary artifact, one that emerged along the new circuits motion pictures opened up: the novelization.[1] While the transactions between motion-picture and literary cultures produced new writing and written forms, among them the film review, the scenario and subtitles, novelizations more closely resembled literature, taking recognizably literary form. Screen-to-page narrativizations of original film stories or of films adapted from novels, short stories, short-story cycles and plays, novelizations first appeared around 1911 as narrative film came to absorb the bulk of motion-picture production. And they could take various forms. Some were discrete short stories (which, for the sake of clarity, I designate "storyizations" from here on) published in motion-picture fan magazines such as *The Motion Picture Story Magazine* and *Photoplay*. Other novelizations were published as installments in monthly magazines or in the syndicated press to coincide with the release of the motion-picture serial they narrativized. Another form of novelization was the photoplay—movie—edition, which emerged in the mid-1910s and to which I return later in this chapter. Still others, such as Jack London's *Hearts of Three* (1916), on which he collaborated with scenarist Charles Goddard, appeared in the form of a novel.[2] Regardless of the shape

Silent Film and the Formations of US Literary Culture. Sarah Gleeson-White, Oxford University Press.
© Oxford University Press 2024. DOI: 10.1093/oso/9780197558058.003.0004

that novelizations took, their principal function was cross-promotion: to prolong the life, and so increase sales, of the magazine or newspaper or book in which these appeared, as well as of the motion picture from which they derived. These days, novelizations from the silent and early-sound eras perform considerable preservation work. For, almost without exception, they incorporate various motion-picture paratexts such as stills from the motion picture they novelize. This means they are more often than not all that remain of the many thousands of silent films presumed forever lost.

The novelization is, as Jan Baetens claims, "one of the least-known aspects of literary production over the last century or more," even as it is crucial "for anyone wishing to grasp the dynamics of the literary object in the complex media environment now surrounding it."[3] To date, novelizations have largely been the preserve of film historiography. In "Fiction Tie-ins and Narrative Intelligibility, 1911–1918," film historian Ben Singer argues that this new print form reveals something about "the difficulty of early cinema's efforts to transform itself into a story-telling medium." For—and this is something Chapter 4 considers at greater length—novelizations aided a motion-picture audience in following what were at times early film's unintelligible plots.[4] More closely aligned to my own interests here is Jonathan Foltz's recent article, "The Writing of Circumstance: Novelization, Modernism and Generic Distress," which situates novelizations—in this instance, Bob Brown's 1913 novelization of the 1912 motion-picture and magazine serial *What Happened to Mary*—within a more narrowly literary-historical framework to discover "the relations between the novelization and the idea of the conventional novel whose shape it takes, as well as its unstable position between novel and film."[5] This chapter makes a comparable claim on the novelization for literary history in its consideration of three rather unusual examples of it: African American writer Rose Atwood's "A Man's Duty," a short-story narrativization of the eponymous 1919 Lincoln Motion Pictures' film; Oscar Micheaux's *The Masquerade: An Historical Novel*, his late-career novelization of one of the two adaptations he produced of Charles Chesnutt's 1900 novel *The House Behind the Cedars*; and finally, the photoplay edition of a high-literary novel, Willa Cather's 1923 *A Lost Lady*. I find in "A Man's Duty" and in the photoplay edition of *A Lost Lady* the efforts of "respectable" print and high-literary cultures to exploit and simultaneously keep at arm's length, or at least refine, the brash new medium of film. *The Masquerade*, meanwhile, appears to have been a last-ditch effort on Micheaux's behalf to revive a particular mode—race melodrama—in which both he and Chesnutt had worked across different media, and to which they had hitched their careers. Tracking this odd form—the novelization—across several of its manifestations

offers some further insights into the contributions the motion-picture industry made to literature's dissemination beyond the realms of both the "little" and "big" magazines, and beyond adaptation, about which we already know much.[6]

Rose Atwood's "A Man's Duty" and the Urge to Reform

One way better to understand novelizations and the role they came to play in literature's wider circulation after film is in terms of remediation, a concept taken from media studies and according to which, as Jay David Bolter and Richard Grusin have written, one "medium promises to reform its predecessors by offering a more immediate or authentic experience."[7] There may be limits to this formulation in the context of film, which, as Mary Hammond reminds us and as we have seen, "had to fight long and hard for cultural acceptance as an art form, and for some years did so by relying on— and even aping—earlier, more 'legitimate' media such as literature."[8] And yet remediation as reform, in its dual senses of reshaping *and* edification, nonetheless usefully describes the dynamics of a rare example of a Black-authored storyization. But what Atwood's "A Man's Duty" (1920) in the end, and rather ironically, discloses is the very fragility or instability of novelization as a method of doing just this, that is, of garnering cultural legitimacy.

Reform as uplift animated much of the discourse around race film and Black print culture across the early decades of the twentieth century. As we have seen, the Black press campaigned to encourage Black filmmakers to produce motion pictures that would depict exemplary forms of Black identity and experience, recognizing in the new medium a particularly powerful means to counteract those troubling images and narratives of Black life that circulated in mainstream cinema. The *Baltimore Afro-American*'s entertainment column, Spotlight, urged readers in 1926 to provide "sensible support of Negro producers like Micheaux" since "[m]oving pictures cannot be made without money. . . . These pictures are shown in houses catering to colored patrons only; from them must come the means that will determine whether the industry will live. To bear with such men as Oscar Micheaux and other pioneers today means bigger and better pictures tomorrow. Make it your slogan to see these pictues [*sic*] if it hurts."[9]

Novelizations would appear a perfect strategy in this project of uplift cinema, which, as Alysson Field writes, aimed to promote "the interests of African Americans and [convey] the possibilities of Black citizenship for both Black and white spectators."[10] Novelizations had the potential to elevate the cultural status of motion pictures by transforming, or rather extending, them into more

respectable literary form. They were a particularly ideal mode of promoting and recirculating Black motion-picture narratives since they were themselves a very index of Black (literary) achievement. And yet Atwood's storyization of the Lincoln Motion Picture Company's *A Man's Duty* remains the only example of a Black-authored novelization I have been able to locate—barring, as we shall see, the rather unconventional instance of Micheaux's *The Masquerade*.

Lincoln Motion Pictures, established in 1916 by Black screen actor Noble Johnson and his brother George (who had, in 1918, hoped to adapt Micheaux's novel, *The Homesteader*), was the first motion-picture company, according to the *Chicago Defender*, "owned, operated and financed by our people only—not a white person even being allowed to own one share of stock. . . . [T]he entire casts are people of Color, and the remarkable manner in which these dramas were acted was a revelation to those who had the idea that if our folks didn't cork up and pull a lot of rotten, so-called comedy, there was no chance of success."[11] As part of its program of uplift, Lincoln produced across the span of its short life five twenty-minute melodramas depicting Black progress and endurance within the Black middle class: *The Realization of a Negro's Ambition* (1916), *Trooper of Troop K* (1917), *The Law of Nature* (1917), *A Man's Duty* (1919), and *By Right of Birth* (1921).[12] According to the *California Eagle*, Lincoln Motion Pictures promised that "all pictures featured and delineated by this company will be of the highest order: depicting the Negro only in his natural habitat. All application and references will be true to the life and character of the Negro."[13] Unable to "maintain the high costs and demanding labor of producing, advertising, and especially distributing Black-cast films," Lincoln folded in 1923.[14]

A Man's Duty was the fourth of Lincoln's productions. All that remains of this five-reel melodrama is its one-page synopsis, held in UCLA's George P. Johnson Negro Film Collection. From this, we know the motion picture narrated the romantic misfortunes and eventual fortunes of Richard Beverly (played by Clarence Brooks), a member of an older Black settler family with "social prestige and reputation," and a favorite of the "exclusive social set."[15] One evening, Richard's rival in love, the villainous Hubert Gordon, gets Richard intoxicated and takes him to a house of ill repute. The damage to Richard's reputation is done, and a fight between the two men ensues. Convinced he has fatally wounded his rival in love, Richard flees to an unnamed city where he meets Merriam Givens, a young woman who, like Richard, is a victim of rumor. It transpires that Richard has not in fact committed murder; Hubert still lives. Doubts about Merriam's reputation are similarly cleared up, and she and Richard are united in love.

A Man's Duty screened to full houses around the country. The owner of the States Theater in Chicago claimed "this feature . . . has done more business in our four days run . . . than any feature we have ever had for the same number of days. . . . We smashed all attendance records."[16] It received favorable reviews in the Black press.[17] The *Chicago Defender* proclaimed it "without a doubt the greatest of 'All Race' productions, and is right up there with the finest output of any of the large companies, regardless of color."[18]

It is not surprising *A Man's Duty* caught the attention of Robert L. Vann, the founder and editor of the short-lived Pittsburgh-based monthly magazine *The Competitor* (1920–1921). Lincoln Motion Pictures' ambitions were compatible with *The Competitor's*. According to the magazine's statement of purpose, its objective was "to inspire the race to its best efforts in everything American" by promoting, among other things, the production of a "clean and wholesome literature."[19] Printed on glossy paper and illustrated with photographic images, *The Competitor* published some of the most important and popular Black and white authors of the day—James Weldon Johnson, Rupert Hughes—and Alice Dunbar Nelson was one of its "associates." Just as Lincoln Motion Pictures did, it targeted a Black middle-class audience with aspirations to cultural respectability.

An editorial note in the magazine's first issue announced its scope: "Editorial, Contributors, Reviews, Feature Articles, Woman's Department, Short Stories, The Stage, The Screen, Art, Athletics, Wit and Humor." Most of these departments and columns did appear regularly across the life span of the magazine—with the notable exception of The Screen. *The Competitor*, it seems, was reluctant to engage with the by now thriving race-film culture. "A Man's Duty" is the only novelization the magazine published, and the column Moral and Movies (1920), by the *Chicago Defender's* "dramatic critic" Tony Langston, was its only column about motion pictures. In this article, Langston defends motion pictures against their detractors, largely by reference to the work of the nationwide censor boards that ensured "every picture shown carries it's [sic] own individual moral lesson, and it is true that some of the most impressive and uplifting sermons imaginable are daily being preached by the silent figures on the screen."[20] However, Vann's views regarding the value or role of motion pictures must have diverged from Langston's. The relative absence of motion-picture discourse from *The Competitor* is somewhat striking when we discover its inclusion in other Black newspapers and magazines of the day, such as the *New York Age*, Vann's own *Pittsburgh Courier*, the *New York Amsterdam News* (the latter

two had dedicated entertainment sections) and the *Chicago Defender*, as well as the glossier magazines such as *Half Century* and *Opportunity*. Like *The Competitor*, these were all directed to a Black middle-class reader who needed, they were convinced, to understand the operations of the motion-picture industry if it were to be supported.

Very little is known about Atwood, this storyization's author, except that she worked as a sportswriter for the *Pittsburgh Courier* during the 1920s, and contributed short fiction and general-interest stories to *The Competitor*. The only other trace of Atwood I have been able to find is as the author of a twenty-installment serial, "Sheik Husbands," which appeared in *The Pittsburgh Courier* between July 25 and December 19, 1925 (although this last issue concludes with "Continued Next Week"); as far as I can tell, it has no connection to any motion picture of the day. "A Man's Duty," which includes the byline "Novelized by Rose Atwood," follows to the letter the plot of Lincoln's film—at least as set out in the film's synopsis—as it also announces, immediately beneath the byline, "This Story Has Been Filmed by the Lincoln Motion Picture Company and Is Now showing throughout the United States," making clear its role in Lincoln Motion Pictures' marketing strategy.

As the storyization straightaway advertises the motion picture, it at the same time transforms it into literary form, into a short story. Indeed, Anna Everett finds that because "A Man's Duty" does not include any contextualizing "prefatory comments or prologue" or "references to visual cues such as camera positioning and spatial and temporal settings . . . it creates a separate narrative experience from the film itself," even as its subtitle "reaffirms the idea that despite the specific narrative distinctions and demands, the basic 'story' of both the film and [Atwood's] 'novelized' treatment remains constant."[21] The actual placement of the storyization also sets it at a respectable distance from its motion-picture source. Immediately following "A Man's Duty," there appears an "Offer," to "young men and women of the country . . . of our group [who] have attempted work of this kind, but have been discouraged because there was no ready outlet for their product," to submit their fiction for possible publication in the magazine. "Irwin Cobb [*sic*], Mary Roberts Rhinehart [*sic*], and other successful writers of fiction and short stories had a beginning as humble, perhaps, as yours." It may be a coincidence that the only two authors cited in this offer—Irvin S. Cobb and Mary Roberts Rinehart—found their way into motion pictures, Rinehart as one of Goldwyn's Eminent Authors, and Cobb as a contributing writer of the 1915 serial *Graft* and, much later, of *The Woman Accused* (1933). Either way,

this announcement's close proximity to Atwood's "A Man's Duty" is an indication, as implicit as that may be, that novelizations were one possible means by which motion pictures facilitated and expanded literary access to aspiring women and minority authors like Atwood without previous "ready outlet" in the literary field.[22]

While "A Man's Duty" may, as Everett has argued, form a discrete entity, distinct from the motion picture it storyizes, there are several points at which it is in fact unable fully to reform its filmic origins. First of all, it includes five asterisked breaks or divisions, each of which signals a cut from one setting to another. These divisions, hardly necessary in a narrative of such brevity (the storyization is not quite six pages) would seem to mimic the scene breaks of a scenario continuity. More striking is the storyization's inclusion of three stills from Lincoln's motion picture, each of which is captioned with text taken from Atwood's narrative. These stills, more so than the asterisked intervals, contribute to some disruption of the movement of the narrative. The second and third stills bear no relation whatsoever to the surrounding text they should ideally illustrate. The second still, which was also used in the film's promotional materials, depicts the fistfight between Richard and his nemesis, Hubert (Figure 3.1). But *The Competitor* has placed this still two pages prior to the event the storyization narrates, and for that reason this still proves something of a spoiler. But then again, the reader of any novelization would in all likelihood already have watched the motion picture it narrativized. In some sense, then, the plot in novelization is already spoiled. (This is a feature of reading literature within motion-picture environments Chapter 4 considers at great length.) The third still, which depicts Merriam with her young niece, appears at a point in the story at which neither has yet been introduced. And indeed, we do not learn that the little girl is the unwed Merriam's niece—rather than, and more controversially, her daughter—until the very last page.[23] The stills then do not serve Atwood's narrative in any way. They are, as Foltz writes more generally of stills in novelizations, only "reminders of the absent version of a story," that is, the motion picture.[24] But this is surely the point. "A Man's Duty," and cognate motion-picture print forms such as reviews, demonstrated to a Black middle-class readership the potential of motion pictures to contribute to the project of uplift.

We could say then that the stills' seemingly random placement in "A Man's Duty" disrupts its pretentions to literary form as they promote the Lincoln Motion Picture production. The narrative and generic ambiguity generated by the inclusion of stills here is characteristic of novelizations more generally

Figure 3.1 Promotional material for *A Man's Duty* (Lincoln Motion Picture Company, 1919).

Courtesy of the Norman Studios, Jacksonville, FL.

and contributes to what Foltz terms their "complexity of address," a feature that made for some rather dizzying reading experiences.[25] A fine example is the Grosset and Dunlap photoplay edition of Rupert Hughes' short-story collection *The Patent Leather Kid and Several Others*, the title page of which announces that it is "illustrated with scenes from the First National Picture. Starring Richard Barthelmess." Hughes' short story, "The Patent Leather Kid," was first published in the February 1926 issue of *Cosmopolitan* magazine.[26]

Set during wartime, it tells of a young cabaret dancer, Fay Poplin—the Patent Leather Kid of the title—and her professional-boxer beau, Curley Boyle who, having done all in his power to avoid the draft, finally enlists in order to follow the Kid to the western front where she has traveled to entertain the troops. As a result of an uncharacteristic act of bravery, Curley is wounded and consequently confined to a wheelchair for the foreseeable future. He and the Kid reunite as his patriotic fires are finally stoked.

Hughes' story was adapted to the screen the following year and was widely viewed and well received.[27] But National Pictures introduced one striking alteration to Hughes' story: the Patent Leather Kid of the film's title is now *Curley*, not Fay; and Fay—Hughes' Kid—is renamed Curley Boyle, a radical gender reversal only underscored by the 1927 Grosset and Dunlap photoplay edition. (Where Hughes' Kid earns her moniker from her patent-leather cabaret costume, the film's Kid earns his as a result of his slicked black hair and the black leather coat he frequently wears.) The photoplay edition's text is a straightforward reprint of Hughes' story but the motion-picture stills that illustrate it depict the gender-altered Kid. The captions only contribute to this narrative perplexity. A still of the boxer (the film's Patent Leather Kid) with the cabaret dancer (the film's Curley Boyle) is captioned "Curly [*sic*] Boyle was a prize-fighter who had a way with him."

This kind of conflict between image and text, which occurs throughout the photoplay edition of *The Patent Leather Kid and Several Others*, makes for distracting, uneasy reading, an experience that would only have been exacerbated for its contemporary readers who in all likelihood would have seen the film before reading the book, and thus would have known Curley as its female lead. In an attempt to thwart any such narrative confusion, the photoplay edition includes a prefatory note, "Before You Begin," ascribed to a "W. F. E.," probably of Grosset and Dunlap. It accounts for the motion picture's surprising gender swap in terms of a response to the by now well-established star system:

> the name of Richard Barthelmess came to those responsible for the production as the ideal actor for the part of Curly Boyle; and this was responsible for about the only change made in the transferal [*sic*] of the story from print to screen. Owing to the prominence of Barthelmess as a star and actor the title rôle was changed from the female character (as portrayed in the story) to the more picturesque male lead in the picture.[28]

This is announced as if it were by no means a hugely disruptive alteration, one that affected the narrative's very sense.

In his consideration of the function of stills in novelizations published between 1911 and 1918, Singer writes,

> filmmakers and spectators alike might indeed have relied on tie-ins [such as novelizations] to compensate for the limitations of cinematic story-telling. . . . Since they tried to stay very close to the film image, fiction tie-ins were well suited to be used by spectators as a tool to assure narrative comprehension. . . . [W]hen one looks at particular examples of films with tie-ins, it seems almost inconceivable that spectators could have made any sense of the film without an elucidating intertext, and it seems likely that the film-makers assumed their audience would have the benefit of such a supplementary guide.

This makes good sense of the 1910s but we can assume that by 1927, the year in which *The Patent Leather Kid* was released, filmmakers had a much better grasp of the mechanics of storytelling—and First National's production is in fact intelligible. However, this may not have been the case with Lincoln's 1919 *A Man's Duty*, which may yet have struggled with the challenge of film narration, something particularly likely when we recall the reduced budgets of Black film companies and thus their relatively limited access to increasingly sophisticated production and editing technologies. Because nothing beyond the synopsis and a small handful of reviews of *A Man's Duty* survives, it is difficult to determine whether its narrative required the type of print supplementation Singer describes. But a review in the *Chicago Defender* singles out for praise the film's intelligibility: "It is a fact that the photography is the best ever seen in a photoplay of the sort, and details are taken care of in the most careful way."[29] Furthermore, that the film broke business records, according to another *Chicago Defender* column, might also indicate that the film's narrative intelligibility was not at issue.[30]

The purpose of Atwood's "A Man's Duty" and the reason for its inclusion in a magazine such as *The Competitor* would appear then to lie elsewhere. Its important cultural work may well have been to educate a Black middle-class readership about motion pictures, particularly their ability to tell and mass-circulate stories that would represent, in Micheaux's words, "Negro life as lived by Negroes in that age or period, or day."[31] In its depiction of a Black

middle-class milieu—the triumph of respectability and love over moral corruption and dissipation—Atwood's storyization promoted the new medium as a force for uplift as it was itself a narrative of uplift.

But the fact remains that "A Man's Duty" was the only novelization *The Competitor* published across its thirteen or so issues. The magazine, and by extrapolation its readers, must have remained uneasy about the place of motion pictures—even such a one as *A Man's Duty*—in African American life and their role in the project of uplift. The scarcity and indeed nearly complete absence of novelizations in African American literary history may also be indicative of the Black film industry's prolonged stuttering beginnings. And at this point—1920—it appears that a respectable Black print culture could not quite re-form race film into digestible literary form.

Novelization and the Second Chance: Micheaux's House Behind the Cedars

Atwood's novelization may well have failed in this task. But Elizabeth McHenry, in her recent consideration of failure in the context of turn-of-the-twentieth-century Black literature, encourages us to incorporate into literary historiography exactly "those texts, genres, institutions, and forms of authorship that we have dismissed as unsuccessful, unproductive, unconventional, anomalous, or irrelevant . . . as a means of expanding and supplementing our knowledge of the complex literary landscape" of Black authorship.[32] Another comparable "failed" enterprise that can do just this is *The Masquerade: An Historical Novel*, Micheaux's strange 1947 novelization, published by his own Book Supply Company, of two motion pictures he produced—one in the late 1920s and the other, the early 1930s—and in which he had invested hopes for the revitalization of his career. *The Masquerade* provided him with the opportunity not only to revisit, to reattach himself to, these earlier, relatively successful motion-picture projects but also to the reputation of Chesnutt, once one of the most celebrated Black authors.

The Masquerade is, to say the least, a hugely complex narrative, a fact that becomes immediately apparent from its opening Acknowledgment. There, Micheaux describes his modus operandi in the composition of the three novels—*The Wind from Nowhere* (1944), *The Case of Mrs. Wingate* (1945), and *The Story of Dorothy Stanfield* (1946)—he wrote prior to *The Masquerade*

and on his retirement from motion-picture production. He explains that to devise these novels' plots,

> I was able to select very successfully from among the stories I filmed while making pictures some years ago. I had merely to select and rewrite whatever one of the old stories I liked best, which in fact, was not nearly so arduous as creating a new theme entirely, and, due to the fact that the story had been worked out very carefully when it was filmed, I found that it made a better and more convincing novel after I had worked it back to story form.

The apparent ease with which these three narratives migrated across texts and media is characteristic of Micheaux's creative practice throughout his dual motion-picture and literary careers.

The Masquerade emerged out of a similar practice of recycling, a practice that, as the passage quoted above indicates, appeared to function as a clarifying exercise for Micheaux in the process of creative composition. To write *The Masquerade*, "after deciding to do an historical novel as my next publication, I went back to my old file of motion picture scenarios and found one that just fitted my purpose: a scenario from a novel by Chas. W. Chesnutt, published almost fifty years ago. I had filmed the novel twice. First, as a silent picture in the twenties, and as a talking picture early in the thirties."[33] The two films to which Micheaux here alludes are *The House Behind the Cedars* (silent, 1924, lost) and *Veiled Aristocrats* (sound, 1932, extant), both adaptations of Chesnutt's 1900 novel *The House Behind the Cedars*, which tells of the mixed-race Rena Walden who, on her brother John's urging, passes for white. After a series of misadventures and ill luck in love, she succumbs to the all too familiar fate of the "tragic mulatta."

Although *The Masquerade* does not include any stills from either of Micheaux's motion-picture adaptations, I consider it a novelization since, as Micheaux explains, it novelizes one of the motion pictures he made of Chesnutt's novel. He does not specify which of these, which scenario, he drew upon; but from what remains of his film, *The House Behind the Cedars*, in contemporary reviews and correspondence, the inability to determine exactly which scenario he novelized does not really matter since it would appear that beyond the significant addition of a soundtrack, *Veiled Aristocrats* is very close in spirit and plot—as well as setting, in Micheaux's present—to this earlier silent-film adaptation.[34]

In his Acknowledgment, Micheaux also notes "with gratitude, the assistance provided by [Chesnutt's] book . . . which I have drawn upon in the rounding out and completion of this novel." If ever there were an instance of audacious understatement, then here it is, for *The Masquerade* in fact reproduces verbatim—*verbatim*—Chesnutt's novel. The relationship of Chesnutt's novel to Micheaux's novelization is hardly one of "assistance" or of "draw[ing] upon" then. It is true that Micheaux at least names Chesnutt (if not Chesnutt's *The House Behind the Cedars*) in this Acknowledgment as he also mentions "his"—Micheaux's—Walden family's house behind the cedars throughout the narrative itself. Nowhere in his novelization, however, does Micheaux attempt to clarify where Chesnutt's words end and his begin, and vice versa. *The Masquerade* in fact contains very little that is original to Micheaux. Indeed, *The Masquerade* is "*radically* unoriginal."[35] It is no doubt for this reason scholars have dismissed it as a quirky footnote to or an embarrassing blemish upon African American literary history. One of Micheaux's biographers writes that "Of all the questionable things he had done to survive and keep going, this was the worst."[36] But here, we can think of the novelization as Micheaux's opportunity to return to earlier work—both Chesnutt's and his own—to revise and recirculate it to a new readership. In this way we can move this novelization beyond the impasse of plagiarism to gauge the formally and politically radical nature of this, Micheaux's final, work.

In January 1921, the ever-opportunistic Micheaux approached Chesnutt with the aim of purchasing the rights to what had been his highly acclaimed and relatively commercially successful fiction, including *The House Behind the Cedars*. Chesnutt must have welcomed Micheaux's overtures. As previously noted, the publication of *The Marrow of Tradition* had compromised his status as "the best known novelist and short story writer of the race," and he struggled to revive his fortunes for the remainder of his life.[37] Failing to find a publisher for the novels he composed during the 1920s—*The Quarry* and *Paul Marchand, FMC*, both of which remained unpublished until only recently—Chesnutt became reconciled to the fact that he was now "perhaps . . . too old to write another live book, but if some of my first ones could be revived, that would be something."[38] As it turned out, the revival of one of his "first ones" did occur but not until 1947, long after his death; and this took the rather unusual form of Micheaux's novelization. Chesnutt's passing narrative had first appeared in serial form between August 1900 and February 1901 in *Self-Culture Magazine* and then as a book with Houghton Mifflin in October 1900. Between 1920 and 1921, it was serialized in *The*

Chicago Defender, thus reaching a quite different readership from Houghton Mifflin's. This is likely where Micheaux first encountered *The House Behind the Cedars*; he had already published several articles and advertised his 1917 novel, *The Homesteader*, in the paper.[39] It was at the point of *The Chicago Defender*'s serialization of *The House Behind the Cedars* that the entrepreneurial Micheaux initiated negotiations with Chesnutt to purchase the rights to his fiction.[40]

As part of the initial negotiations over Chesnutt's novel, Micheaux promised to produce "the most perfect Negro Drama ever shown on the screen."[41] We know that Chesnutt had by this time viewed at least one of Micheaux's films—*The Homesteader* (released February 20, 1919), *Within Our Gates* (released January 12, 1920), *The Brute* (released August 16, 1920) or *The Symbol of the Unconquered* (released November 29, 1920)—and concluded "it wasn't all bad."[42] We also know that shortly after entering negotiations over *The House Behind the Cedars*, Chesnutt watched Micheaux's *The Gunsaulus Mystery*, which first screened in April 1921. He told Micheaux that he "enjoyed it very much. The picture was well made, and gives me reason to feel confident that the 'House Behind the Cedars' will not suffer at your hands."[43] Several years later, Chesnutt watched another of Micheaux's motion pictures, *Birthright*, released in January 1924, which he also thought "very well done, and [it] was certainly extremely realistic."[44] And yet he was unhappy with Micheaux's first—the silent—adaptation of *The House Behind the Cedars*, lamenting in *The Crisis* in 1926, "My most popular novel was distorted and mangled by a colored moving picture producer."[45] In the process of negotiations over the rights, Micheaux had made clear to Chesnutt that he intended to introduce several changes to the narrative in order to ensure "the story [would be] accepted and appreciated more thoroughly by those who would be most likely to see it, and whom in the realm of our business we must consider when contemplating a play which we are to offer them."[46] As a novelist-cum-filmmaker, Micheaux must have recognized that literature and motion pictures attracted quite different audiences, and so he set out to make his *The House Behind the Cedars* accordingly. Roughly fifteen years after his second screen adaptation of *The House Behind the Cedars*, and in an attempt to revive his stalled career as a novelist, Micheaux decided "to do an historical novel as my next publication," as he wrote in its Acknowledgment.

In composing *The Masquerade*, Micheaux made two significant alterations to Chesnutt's narrative—in addition to moving the action to the present—alterations that are consistent with the plot of his surviving 1932 adaptation

of it, *Veiled Aristocrats*. The first of *The Masquerade*'s revisions pertains to one of the central characters, Frank Fowler, whom Chesnutt depicts as a member of the folk: he is "dark brown," and while his features may be "indicative of . . . intelligence," he speaks in dialect and exhibits little ambition.[47] Micheaux explained to Chesnutt that having "Frank more intelligent [and] permitting him to study and improve himself" would make him a more appropriate suitor for the light-skinned, educated Rena.[48] Accordingly, the Frank of *The Masquerade* (as in *Veiled Aristocrats*) speaks a decidedly formal American English and works as a successful and ambitious builder-contractor. Importantly, Micheaux's Frank remains "dark brown." (In *Veiled Aristocrats*, he was played by the dark-skinned actor Carl Mahon.) In making this decision, Micheaux resisted intraracial imperatives and prejudices about skin color and, on the assumption his silent-film adaptation made the same statement, at the very point at which W. E. B. Du Bois was waging a battle over the kinds of Blackness that could—and should—be depicted on the cover of *The Crisis*. In his Opinion column of October 1920, Du Bois expressed his exasperation at those African Americans ashamed of dark skin:

[T]hey are afraid to see the types which the white world has caricatured. The whites obviously seldom picture brown and yellow folk, but for five centuries they have exhausted every ingenuity of trick, of ridicule and caricature on black folk: "grinning" Negroes, "happy" Negroes, "gold dust twins", "Aunt Jemimas", "solid" headed tacks—everything and anything to make Negroes ridiculous. As a result if THE CRISIS puts a black face on its cover our 500,000 colored readers do not see the actual picture—they see the caricature that white folks intend when *they* make a black face

rather than the reality of "that which we love in life." Micheaux's dark-skinned *and* respectable Frank appeared to be one way of combatting such "thought-chains and inchoate soul-shrinkings."[49]

Frank's altered characterization bears on a more significant revision Micheaux makes to Chesnutt's *The House Behind the Cedars*, and this is in terms of the passing narrative's ending. Micheaux explained to Chesnutt that to "have Rena's heart go out to [Frank] in the end as his reward, would, I am sure, in so far as our people are concerned, send them out of the theatre . . . with the feeling that good must triumph in the end," which "would result much more profitably from a financial point of view."[50] Near the conclusion of Chesnutt's novel, Rena's white suitor George Tryon abandons her on

discovering the secret of her "blood work," an event that informs her decision to devote the rest of her life to the betterment of the race.[51] She accepts the lecherous Jeff Wain's invitation to teach at his school for Black children "'way down in Sampson County."[52] Walking home one evening, she arrives at "a juncture of the two paths. . . . The route she had been following was the most direct way home, but led for quite a distance through the forest, which she did not care to traverse alone." She soon becomes

> aware that a man was approaching her from each of the two paths. In one she recognized the eager and excited face of George Tryon, flushed with an- ticipation of their meeting and yet grave with uncertainty of his reception. Advancing confidently along the other path she saw the face of Jeff Wain, drawn, as she imagined in her anguish, with evil passions which would stop at nothing. What should she do?

Unable to determine the best course of action, she eschews both paths, both men, to flee into the forest.[53] Melissa Rauterkus locates at the point of Rena's flight a modal shift in Chesnutt's novel, from melodrama to bitter realism:

> On the one hand is George, the would-be noble knight, and on the other, Wain the mulatto scoundrel. The former represents the white romantic fan- tasy, while the latter epitomizes the dark reality of [Rena's] current social position. . . . Rena's race and gender place her in a vicious double bind, a moral quagmire that Chesnutt literalizes in the swamp sequence.[54]

This sequence, of course, concludes with Rena's death. (The most wretched statement in Chesnutt's *The House Behind the Cedars* is surely this: "There was a doctor within five miles, but no one thought of sending for him.")[55]

Nearly fifty years after the publication of Chesnutt's novel, Micheaux offered Rena a path out of the swamp, a third option. In the final chapter of *The House Behind the Cedars*, Frank, en route to rescue Rena from the clutches of the "liar and . . . scoundrel" Wain, discovers her lying uncon- scious in the swamp, and he transports her home to Patesville to be cared for by her mother, Miss Molly.[56] It is at this point *The Masquerade* departs radically from the narrative to which it has until now so closely adhered— indeed, reproduced. Whereas in Chesnutt's *The House Behind the Cedars*, Frank's "reverie was broken by a slight noise from the thicket," which turns out to be Rena's moaning, in *The Masquerade*, Frank's "reverie was broken

by a noise ahead of him," which turns out to be "A wretched looking old Negro woman," a conjure woman.[57] The conjure woman informs Frank that "A putty young gal is at mah house, sick, terribly sick. I found her on the edge of the swamp."[58] He takes Rena home to Fayetteville (as Patesville becomes in *The Masquerade*; Fayetteville in North Carolina was Chesnutt's hometown). The doctor is summoned. This time Rena recovers, declares her undying love for Frank, and accepts both his proposal of marriage and his suggestion they leave the South for Chicago ("color discrimination and the caste system among Negroes . . . didn't exist there") where he will set up a construction business for which she will work as the bookkeeper.[59] (*Veiled Aristocrats* concludes with Rena and Frank, the light-skinned woman and her dark-skinned lover, quite literally driving off into the sunset.)

Such are the significant revisions Micheaux's novelization makes to *The House Behind the Cedars*, all of which are largely referable to his wish to make Chesnutt's narrative more palatable, more appealing to a postwar Black readership. Jane Gaines' insight into Micheaux's earlier silent-film adaptation of *The House Behind the Cedars* also helps to make sense of these intertwined revisions to Chesnutt's novel: "In the narrative rewritten by Micheaux . . . both brother and the mother press the marriage [to a white man] on the light-skinned sister, who prefers a man 'of her own race.' . . . [T]he Negro couple [Frank and Rena] rebukes the conniving relatives who would marry the mulatta to a white man rather than a black one."[60] But of course, and again, Micheaux's Frank is not simply *any* man "of her own race." In the process of passing from Chesnutt's novel to Micheaux's film(s), Frank is transformed into a "veiled aristocrat" as Rena is rewarded for her loyalty to the race—more correctly, to a respectable version of Blackness. Micheaux's novelization, as *Veiled Aristocrats* had done, thus inserts into Chesnutt's race melodrama what Gaines calls the "opportunity narrative." Such a narrative, she writes, reflects "new post-Reconstruction concerns having to do with education, respectability, community, and opportunity" whereby "the concern with respectability is gradually displacing the appeal to sentiment." In revising race melodrama in this way, opportunity narratives shift from the evocation of "heart-wrenching sentiment" for a "sympathetic white lady" to accounts of African American achievement, and in that way appeal to "the African-American aspiring classes."[61]

In fact, Micheaux's own tempering of race melodrama amplifies in quite interesting ways a concern already taken up in Chesnutt's novel. As Richard Brodhead has observed in his reading of *The House Behind the Cedars*, it is

the library of the Walden siblings' absent white father, with its volumes of Fielding, Scott, Milton, Shakespeare and others, that provides Rena's brother John with "the portal of a new world, peopled with strange and marvelous beings. . . . Sometimes he read or repeated the simpler stories to" Rena until "The blood of his white fathers . . . cried out for its own, and after the manner of that blood set about getting the object of its desire."[62] It is John's reading of the literary canon that contributes to his decision to pass for white—the object of his white blood's desire—and enter the (white) middle class. However, Micheaux's reforming of Frank updates the project of uplift—metonymized by Chesnutt as "the quaintly carved walnut bookcase"—for the New Negro audience that, as Micheaux notes in a letter to Chesnutt, had emerged over the course of the twenty years "since the writing of your story."[63] What was required in the current age were, in the words of Jean Voltaire Smith, one of the few Black women writing about film at this time, "films of the clean, helpful sort, that will uplift."[64]

The Masquerade retains most of the changes to plot and characterization that the film(s) it novelizes first staged. And yet, as I have mentioned, Micheaux's novelization also duplicates huge slabs of Chesnutt's novel. Indeed, almost the entire second half of *The Masquerade* repeats verbatim Chesnutt's novel. To put this slightly differently, twenty-one of its forty-eight chapters (chapters 27–47) are, quite simply, Chesnutt's, a phenomenon that, among much else, draws out the irony of *The Masquerade*'s own copyright notice: "Copyright, 1947. By Oscar Micheaux . . . All rights reserved. No part of this book may be reproduced in any form without the permission of the author." A mere handful of examples can provide a sense of the extent of Micheaux's brazenness: *The Masquerade*'s chapter 27 repeats verbatim chapter 10 of Chesnutt's *The House Behind the Cedars*; chapter 28, Chesnutt's chapter 11; chapter 29, Chesnutt's chapter 12; chapter 30, Chesnutt's chapter 13; chapter 31, Chesnutt's chapter 14; and so on and so on until chapter 47, which combines the text of Chesnutt's chapters 33 and 32 (in that order) before rerouting, right toward its conclusion, to an invented narrative—invented in the context of Chesnutt's original house-behind-the-cedars narrative—about Frank Fowler's encounter with the conjure woman.[65]

In recent years, scholars have begun to push past a knee-jerk moralistic response to plagiarism (a response epitomized by that aforementioned biographer's observation) to consider it instead as a strategic form of revision, one aligned with Black expressive practices such as signifying, sampling and other forms of creative repetition that authors and scholars such as Zora

Neale Hurston, James Snead, and Henry Louis Gates have argued structure so much African American cultural expression.[66] As Richard Yarborough has recently remarked, "The literary politics of such questions"—the "discomfort attaching" to "Is this or is this not plagiarism?"—"can hardly be more fraught, with roots extending at least as far back as Thomas Jefferson's condescending dismissal of Phillis Wheatley in *Notes on the State of Virginia*, and his broader contention that blacks are incapable of true creativity."[67] The particular challenge of thinking about *The Masquerade* in terms of plagiarism is that its verbatim replication of Chesnutt's *The House Behind the Cedars* is overt even as Micheaux, if rather nonchalantly, acknowledges "the assistance provided by [Chesnutt's] book." And while Micheaux may neglect to name the book in his Acknowledgment, the ensuing narrative does so by reference, almost twenty times, to the Walden family's house behind the cedars. To understand what Micheaux is doing in this novelization, it is useful to consider the motivation behind his decision to appropriate so entirely the work of his erstwhile collaborator, an author whose critical reputation would not be restored until after the civil rights movement.

By the time he came to write *The Masquerade*, Micheaux had not made a film in some years—since 1940's *The Notorious Elinor Lee*, a boxing film that, according to Thomas Cripps, "In the largest black city in the world . . . earned no more than a split week."[68] And his most recent novels—*The Wind from Nowhere, The Case of Mrs. Wingate* and *The Story of Dorothy Stanfield*—had not sold well. It is not unreasonable to conclude that Micheaux hoped to revive his reduced fortunes at this stage of his career by close association with one of the most significant names in Black cultural life. And yet Chesnutt, long dead by the time of *The Masquerade*'s publication, had himself fallen out of critical favor some years earlier. At the turn of the century, with prestigious publishing interests such as the *Atlantic Monthly* and Houghton Mifflin producing his early works, including *The Conjure Woman* and *The House Behind the Cedars*, and with patrons of the ilk of William Dean Howells, Chesnutt became the first African American author to attract extensive national attention.[69] However, as we have seen, his fortunes fell into some decline. Micheaux's interest in the rights to his fiction in the early 1920s must have been most welcome, to say the least.

To understand why an out-of-luck author and filmmaker would not only turn to but also *plagiarize* a by now neglected author in an attempt to revive his critical and commercial fortunes, it is helpful to recall that *The Masquerade* redacts not only Chesnutt's novel but also one of Micheaux's

adaptations of it, either *The House Behind the Cedars* or *Veiled Aristocrats*. He may well have believed that returning to a narrative from a more successful period of his own career might be one means by which to renew his fortunes. His 1946 novel, *The Story of Dorothy Stanfield*, offers some insights into his ambitions at this point, particularly in terms of his relative neglect by the market.

In a scene near the beginning of *The Story of Dorothy Stanfield*, Dorothy and her investigator beau, Walter Le Baron, consider the relative merits of two major Black authors of the day, Sidney Wyeth, a thinly disguised Micheaux, who is an erstwhile motion-picture producer, and author of *The Homesteader* (the title of Micheaux's 1917 novel, of course) and Frank Knight, a thinly disguised Richard Wright, whose acclaimed 1940 novel, *Native Son,* had recently become the first African American novel nominated by the Book of the Month Club.[70] Dorothy and Walter agree that of the two, Wyeth is the superior author: "He is about the only Negro author who writes about us colored people as we are living and thinking today; about the only writer who puts the love and romance of our lives into his stories." They accuse Knight of disloyalty to the race in playing to a voyeuristic white readership with his sensationalist depictions of black "poverty and misery," and of hypocrisy in marrying a white woman, particularly remarkable, they agree, in the case of an author such as Knight so engaged in his fiction with white-on-Black racism. An odd three-page preface to *The Story of Dorothy Stanfield*, entitled "Patterns and 'Thou Shalt Not': In a Democratic and Free Country" and ascribed to "The Publishers," that is, Micheaux's own Book Supply Company, attempts to account for Micheaux's lack of critical acclaim. He "dared reverse the old order" to write of meaningful relationships between white women and Black men, and thus challenged "the pattern" of "hundreds of novels" that "[s]ince long before the Civil War . . . have featured as the main theme, colored women, mostly beautiful ones, as the concubines of white men, from which association through the years has sprung hundreds and thousands of mulattoes, and nobody seems to think anything about it!"[71] We begin, then, to gain a better sense of the reasons Micheaux may have returned to the Rena narrative—Chesnutt's and his own—to renew his fortunes.

While he chose to novelize—no doubt, to cash in on—a race melodrama according to the "pattern" of "hundreds of novels," he also found a way to radically revise or reframe that "theme" to which he so objected: by bringing to the fore the tumultuous events against which the Rena narrative takes place, which are almost entirely obscured in Chesnutt's novel and in his own

adaptations of it. For *The Masquerade* does not plagiarize Chesnutt's novel exclusively. It also recirculates—by reproducing, citing, paraphrasing—a series of historical documents pertaining to the institution of slavery, abolition, secession, the Civil War and emancipation. In the Acknowledgment that prefaces his novel, Micheaux reveals that his decision to include such documents was motivated by Chesnutt's omitting mention of "Abraham Lincoln, the Dred Scott case, John Brown or the Civil War"—as he himself had done in *Veiled Aristocrats*. (In fact, Chesnutt mentions Dred Scott by name once in his novel and the Civil War on several occasions.) His own "scenario from a novel by Chas. W. Chesnutt," Micheaux continues, "provided a splendid background to work in these characters and events as I saw fit." At the opening of chapter 18 of *The Masquerade*, a Micheaux-like first-person narrator, who intervenes into the narrative three times throughout the book to host us through its plot twists and turns, reappears this time to remind the reader that "It was the author's intention at the outset . . . to make the war, leading to the issuance of the Emancipation Proclamation, a part of the story" of the Walden family.[72] It is this historicizing of Chesnutt's romance that Micheaux must have felt earned *The Masquerade* its subtitle, *An Historical Novel*. On the four hundred or so pages that lie between the covers of *The Masquerade*, Micheaux has transcribed *The House Behind the Cedars* only to transform it into "a splendid background to work in . . . characters and events"—in addition to clippings and excerpts.[73]

Chesnutt's novel opens with the visit of John Warwick (*né* Walden) to his mother after a ten-year absence, during which visit he proposes that his light-skinned sister Rena pass into white society and eventual marriage to a white man. Although John's visit is what generates the narrative's central passing plot, this scene does not appear in *The Masquerade* until the very end of chapter 18—that is, over a third of the way through this lengthy novelization. *The Masquerade* instead opens with a disquisition about the 1857 Dred Scott case and citations from the decision, as well as what passes as direct quotation from, but is rather creative paraphrase of, Lincoln's and various senators' responses to that decision. Other insertions throughout the novelization comprise quotations and paraphrase in connection with John Brown's final speech, delivered in 1859 (chapter 9); the 1860 presidential campaigns of Lincoln and Stephen Douglas, and excerpts from Lincoln's letters (chapter 10); South Carolina's secession in 1860 (chapter 11); the "Declaration of the Immediate Causes Which Induce and Justify the Secession of South Carolina from the Federal Union" (chapter 13); Lincoln's First Inaugural

Address of March 4, 1861, verbatim and in its entirety (chapter 14); Horace Greeley's August 20, 1862 *New York Tribune* editorial, "The Prayer of Twenty Millions," and Lincoln's August 24, 1862 response to it (chapter 16); and finally, in chapter 17, the Emancipation Proclamation, also in its entirety, in addition to the Illinois Democrats' January 7, 1863 response to it. In other words, to arrive at Chesnutt's passing narrative, the reader of *The Masquerade* has first to wade through no less than eighteen chapters of historical account and documentation, sometimes produced verbatim, sometimes paraphrased and, at other times, as narrative or reportage.

The reader of this novelization is surely struck not only by Micheaux's erudition but too the display (the showmanship) of it, something in some part referable surely to the "lingering scepticism about the authority of [Black authors'] literacy" of which Karla Holloway writes—and which Micheaux may have felt particularly keenly because of his "unprivileged background in intellectual matters."[74] To write *The Masquerade*, Micheaux must have worked—and worked closely—with the many documents he either quotes at such length or paraphrases with such familiarity. He must have had these sources to hand in some form or other.

Brian Cremins, in the only sustained consideration of *The Masquerade* to date, argues that its inclusion of these historical documents—speeches, newspaper articles, legal cases, letters and so forth—functions to interrogate the workings of history, which is here presented as "a series of anecdotes and scattered documents lacking coherent meaning until sequenced and manipulated by a writer, director, or editor." He additionally argues that the novelization's process of "splicing" these documents and authorial comments into the plot signals its affinities with filmmaking practices: it bears "the marks of a film scenarist and script writer accustomed to thinking and writing in scenes, action, plot, and sub-plot" and of the editor and director.[75] These insertions, which have the effect of stalling or freezing the narrative, are also analogous with the historical tableaux frequently deployed in early motion pictures, most notoriously in D. W. Griffith's *The Birth of a Nation* (1915). As Katherine Fusco has explained, "Historical tableaux were typically single-shot films, filmed from one camera position that depicted a well-known scene from history or scripture." In *The Birth of a Nation*, such tableaux function as "footnotes to the tale of the Stonemans and Camerons," something that also makes sense of the use to which Micheaux puts various historical documents in the process of providing context to the Walden family romance.[76]

Just as Griffith sought to write "history with lightning," Micheaux, in films such as his 1920 feature *Within Our Gates* as well as in *The Masquerade*, deploys archival artifacts in order to historicize and contextualize the quotidian or, as he might have put it, the *romance*, of African American life.[77] *Within Our Gates*, his blistering response to *The Birth of a Nation*, which notoriously manipulated historical documents to maximum propagandist and spectacular effect, incorporates letters, a copy of the *Literary Digest* and newspaper articles. Micheaux's comparable deployment of historical documents in *The Masquerade* reminds us that the function of the archive is not only to preserve—an unanticipated boon of more conventional novelizations with their inclusion of motion-picture stills, as I have said—but also to serve as a significant repository of materials to be reused, recycled. In anchoring its romance narrative firmly in the turbulence of the period in which it is set, *The Masquerade* is able to resist the ahistoricism of the race melodrama it appropriates from Chesnutt's and his own (motion-picture, present-set) Rena narrative. The documentary inclusions resituate the private narrative of passing and intraracial love within the history of US slavery and its attendant institutions, practices, and legacies.

How and where might Micheaux have gained access to these documents in order to have transcribed and paraphrased them so closely we can only speculate. One possible source for these might have been *The Journal of Negro History*, produced by the Association for the Study of Negro Life and History whose objective was, as Clare Corbould has explained, "to make an archive of black history available to researchers and especially black schoolteachers."[78] He may also have consulted any of the multivolume histories of the United States popular at the time, and other anthologies, encyclopedias, and newspapers held at the New York Public Library's midtown and Harlem branches. Or he may very well have visited the African National Memorial Bookstore, Harlem's largest bookstore, run by Micheaux's near-namesake Lewis Michaux (who may or may not have been a cousin, depending on who is doing the recalling). But what we do know is that Micheaux was very much plugged in to a broad print culture. In his first autobiographical novel, *The Conquest: The Story of a Negro Pioneer* (1913), the Black homesteading narrator, the pseudonymous Oscar Devereaux (his real name, Devereaux confides, "is a peculiar name that ends with an 'eaux'") declares that he "received much literature in the way of newspapers and magazines and read lots of copy-right books," including *Othello*, and "my closest companion was the magazines," the muckraking *Everybody's Magazine*, *McClure's*, and the *American Magazine*.[79]

Whichever the manner of Micheaux's access to the various materials he records in *The Masquerade*, his novel forms an important document in amateur Black historiography, a consequence of his decision to foreground the turbulent events against which Chesnutt's Rena narrative takes place and which are relatively obscured in *The House Behind the Cedars*. It is worth recalling that Micheaux undertook this project at a time during which there remained in place "Jim Crow restrictions on black scholars' access to archival materials . . . when the records on slavery were often found in southern repositories and the majority of slave narratives remained out of print."[80] *The Masquerade*, then, is as much archive as it is romance. While it may not preserve the visual traces of the silent films it novelizes, it preserves and circulates anew materials, including Chesnutt's novel, absolutely central to Black American cultural, social, and political histories.

Just as Micheaux's novelization becomes a fascinating—and unexpected—means for Chesnutt's and his two motion-picture narratives, as well as so many historical artifacts, to recirculate, so is it interested in circulation itself. Its very opening lines are remarkable for this reason: "It is the year 1857. Ever since '*Uncle Tom's Cabin*,' a novel by Harriet Beecher Stowe, exposing the horror and cruelty of slavery began publication in 1851 as a serial story in the *National Era*, America had begun to grow more restless than before regarding the institution of slavery."[81] The additional and seemingly unnecessary detail of *Uncle Tom's Cabin*'s original manner of publication in serial form—in *The National Era* in 1851, prior to its publication as a book—which attracted an astonishing fifty thousand or so readers, registers Micheaux's keen attention to the routes via which literature and other reading materials travel. There are a couple of points to make here. As Micheaux takes care to describe where print materials appear and how they circulate in this passing narrative and in the documents that punctuate it, *The Masquerade* is itself a vehicle for the circulation—the *recirculation*—of a vast number and range of materials via Micheaux's acts of transcription and related practices of citation, and at a point in time, to repeat, of "legalized forms of black exclusion from public life."[82] Most obviously, it recirculates—thanks to its extensive plagiarism—a long out-of-print novel by a once critically acclaimed Black author whose books had become "more written about and read about than they are read or ever were read by colored people," as Chesnutt wrote in 1926 of his evident decline in fortunes.[83] There is a good case to be made that Micheaux's recycling of *The House Behind the Cedars* marks the stammering

posthumous return of the "first Negro novelist" as well as his own—motion picture? literary?—career.[84]

And yet *The Masquerade*'s original dust jacket, with its lurid portrait of Rena bedecked with ornate earrings and a blue-beaded necklace, and wearing a bright orange dress so sheer that it leaves little to the imagination, would seem to belie these more earnest ambitions (Figure 3.2). We know Micheaux took great care with the design of his novels—just like his proxy, Sidney Wyeth, of whose books "there is . . . more in the way they are gotten up, with beauty and care . . . than in most books."[85] And while Micheaux often employed renowned African American illustrator Elton Fax to design his covers, we do not know who designed the cover of his novelization. But Patrick McGilligan is surely right that Micheaux's decision to include such a garish palette was likely intended "to evoke his glory years as a race-picture pioneer" by incorporating " 'the same yellows, the same blues, the same reds

Imaged by Heritage Auctions, HA.com

Figure 3.2 The brightly-colored dust jacket of Oscar Micheaux's *The Masquerade: An Historical Novel* (Book Supply Company, 1947). Collection of the author.

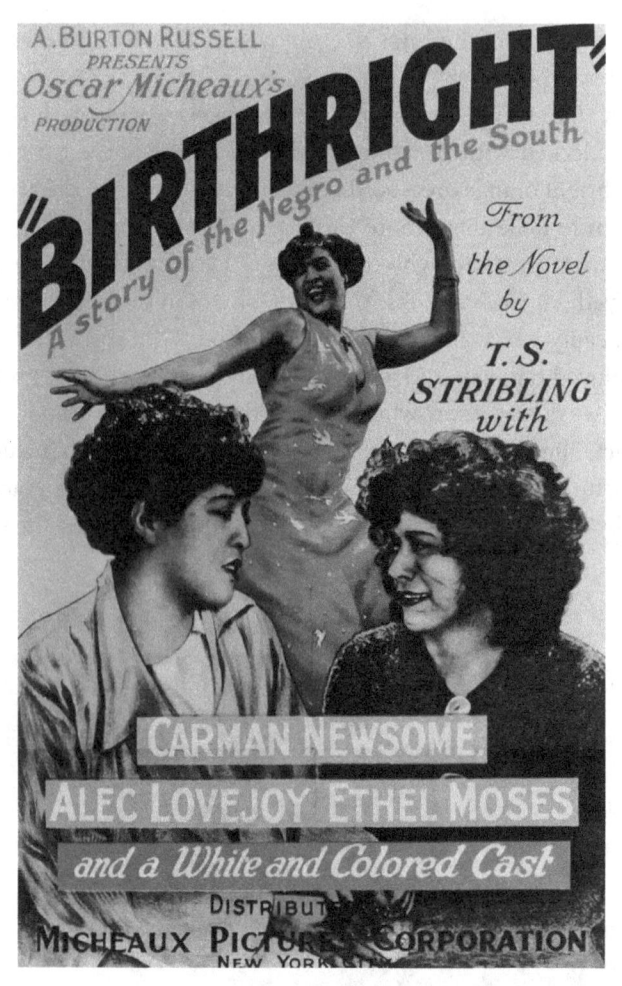

Figure 3.3 Poster, in lurid reds and yellows, for Oscar Micheaux's lost 1939 film, *Birthright*.
IMDB.

that went into those old lobby cards' for his many films" (Figure 3.3).[86] This vampish Rena, a character more at home in almost any of Micheaux's sound-era films such as *The Notorious Elinor Lee*, about a gangster's moll, bears absolutely no resemblance whatsoever to Chesnutt's or for that matter Micheaux's own various Renas, all of whom remain modest. Even the promotional materials for a more overtly commercial enterprise such as *Veiled Aristocrats* includes nothing so lurid. Indeed, the still chosen to market that film shows John and his mother deep in seemingly grave conversation (Figure 3.4).

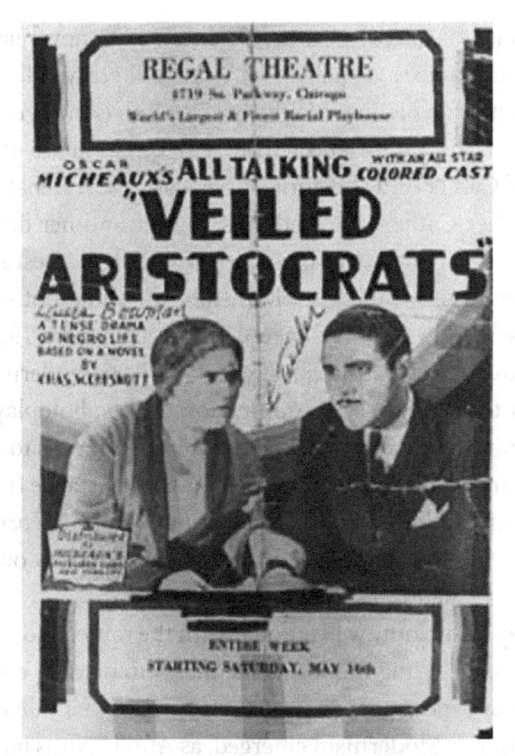

Figure 3.4 Black-and-white promotional material for *Veiled Aristocrats*, Oscar Micheaux's 1932 film adaptation of Charles Chesnutt's *The House Behind the Cedars* (1900).

In repackaging the Rena narrative in such lurid fashion, Micheaux may have hoped to target a more low-brow readership, one arguably more at home in the motion-picture palace and with his racier films, even as he aimed to tap into a prestige market associated with Chesnutt—a marketing conundrum that, as we will see, the photoplay edition of Cather's *A Lost Lady* encountered head-on.

Of Personality and Fans: Photoplay Editions and Willa Cather's *A Lost Lady*

Photoplay editions were another form of novelization that opened up new avenues for literature's dissemination, especially in their—their publishers'—efforts to transform motion-picture fans into readers (and vice versa),

a vexatious, as it transpired, turn that Cather's 1923 novel narrates and its photoplay edition indexes. What was at stake in literary culture's increasing attachments to motion pictures via the novelization is thrown into especially sharp relief when the author and narrative in question are of the high cultural caliber of Cather and the gorgeous *A Lost Lady*. Debate continues to rage as to whether Cather is a modernist author and her opus modernist. My own view is that it largely is, owing to its abiding interest in the production and dynamics of meaning itself, in the "the thing not named," as she famously wrote in "The Novel Demeublé," her much-cited 1922 essay about the modern novel.[87] While the question of Cather's modernism is not exactly pertinent to the following examination of the photoplay edition of *A Lost Lady*, I understand her novel as modernist as a means to signal its high literary status, and thus to set it at some productive distance from the mostly popular texts and authors on which *Silent Film and the Formations of US Literary Culture* has thus far focused, and in that way draw out more boldly exactly the stakes I mention above.

It is fair to say we are now well familiar with the routes and venues of high-literary culture's, including modernism's, mass circulation, especially in the big magazines and newspapers, and via paperback editions and motion-picture adaptation.[88] Modernism emerged, as Ann L. Ardis has argued, "in a publishing ecosystem that was far richer, and far more complexly diversified, than the first several generations of bibliographic scholarship on modernism recognized."[89] However, a significant component of this ecosystem remains relatively unacknowledged in both literary and film studies, although it bears directly upon literature's interactions with the mass-cultural marketplace, and this is the photoplay edition. Other than the invaluable bibliographies compiled by dedicated collectors such as Emil Petaja, Rick Miller and Thomas Mann, scholarship about this odd object remains scant, as does its archive.[90] To date, there are only two essays that take photoplay editions as a worthwhile scholarly endeavor. Marija Dalbello considers the photoplay editions of Anzia Yezierska's narratives of immigration, *Hungry Hearts* and *Salome of the Tenements*, in the context of "the visual consumption of womanhood in the 1920s"; and Mary Hammond turns to British photoplay editions of stage plays to ponder their dynamic of "cultural recycling."[91] This is a curious scholarly oversight because photoplay editions, as we shall see, sit at the very interface of various newly emerged cultural forms and modes, including motion pictures, motion-picture print culture, mass and reprint publishing and too, in this instance at least, high-literary culture.

As far as I have been able to ascertain, while a number of European, British and American canonical texts have appeared in the format of a photoplay edition, Cather's *A Lost Lady* is one of the few modernist texts to have done so.[92] While it certainly affords yet another opportunity to ponder the interactions of commercial and modernist cultures, and the vexed relationship of authors and readers to what Jaillant has termed "cheap modernism," this edition of Cather's novel also, and arguably more significantly, registers to reveal the ways and the very fact that motion pictures, and a broader motion-picture culture, came to intrude upon a higher literary culture through the early decades of the twentieth century.

Most photoplay editions, "published by the tens of thousands per title," were cheaply produced hardback books that could either novelize original motion-picture stories or, and these were more common, return to print— reprint—novels, short-story collections and stage plays that had already been successfully adapted to the screen.[93] Publishers would lease out their original plates to reprint publishers seeking ways to capitalize on the popularity of narrative film and on print culture's increasing reciprocal relationship with the motion-picture industry. Grosset and Dunlap's 1914 edition of Frank Norris' 1903 novel *The Pit* is generally considered to be the earliest photoplay edition of an adapted novel, followed two years later by A. L. Burt's edition of Rex Beach's 1905 *The Spoilers*.[94] Grosset and Dunlap also produced an edition (but not a photoplay edition) of Cather's *The Professor's House* in 1925. A. L. Burt as well as Bobbs-Merrill were the principal publishers of reprint photoplay editions. As disposable as they were made to be, photoplay editions now lie among the dust heap of what Earle has termed "the literary trash of the twentieth century."[95] They were, as Cather reportedly said in 1925 of the contemporary novel more generally, a "commuter's convenience," something to be "bought and thrown away at the end of journey."[96]

What distinguishes photoplay editions from other cheap reprint editions, and as with most novelizations, is the simple fact of their inclusion of film paratexts, signaling their particular alignments with the motion-picture industry. These could comprise a dust jacket with a brightly colored illustration of a scene taken from the motion-picture adaptation, stills from the adaptation sprinkled throughout the edition, a list of the motion picture's cast, an acknowledgment of the motion-picture production company involved, and some prefatory account of the process of page-to-screen adaptation, as in the photoplay edition of Hughes' *The Patent Leather Kid and Several Others*. As part of a reciprocal relationship with the motion picture in which

they tied, according to promotional materials of a New York–based publisher of photoplay editions, "One helps the other infinitely. As you read the book you imagine how the characters must have acted at the critical turns in the drama, and when you see the picture your ideas are broadened and deepened." Indeed, "the Book and the Photoplay belong together."[97] We may well wonder why readers would not simply have returned to, say, the original 1903 edition of *The Pit* in order to extend the pleasure they no doubt took in its screen adaptation, *A Corner in Wheat* (dir. Griffith, 1909). Photoplay editions had several advantages over their higherbrow relative. First of all, they were considerably cheaper, at seventy-five cents each;[98] and second, their inclusion of images meant they appealed to an increasingly visually literate audience who might not otherwise purchase literary novels such as *The Pit*. It was only the arrival of paperback novels and their rapid dominance of the literary marketplace from the late 1930s that put many reprint publishers out of business, along with their photoplay editions.

Although hugely popular during the 1920s and 1930s, the photoplay edition remains a strangely overlooked object of book history. We have surely missed a rich opportunity to learn more about the complex and frequently odd formations of the book on literary culture's increasing engagements with motion pictures from the early twentieth century on, particularly as the publishing industry sought to hitch its fortunes to what must have seemed motion pictures' enviable mass circulation. This rare, and arguably sole, example of a photoplay edition of a modernist novel—Grosset and Dunlap's *A Lost Lady*—helps us understand the status, the wishes and the "mass-media queasiness" of a high-literary culture at once drawn to and repulsed by the mass form of motion pictures.[99]

Cather's novel tells of the youthful Niel Herbert's cycle of infatuation and disillusionment with the worldly Mrs. Forrester—the lost lady of the title—who, unhappily married to the much older Captain Forrester, engages in a series of flirtations and eventually an affair. At the time of its original publication in 1923, Cather, shortly to win the Pulitzer Prize for *One of Ours*, seemed amenable to the expanded readership that reprints and serializations of her fiction in mass magazines and in book form promised. *A Lost Lady* passed through quite a number of iterations and modes—magazine serial, book, photoplay edition, long short story—although this sequence would appear to accord with what motion-picture producer Benjamin B. Hampton described in 1921 as "The ordinary practice of marketing a novel . . . first, serialization in a monthly or a weekly periodical . . . second, publication

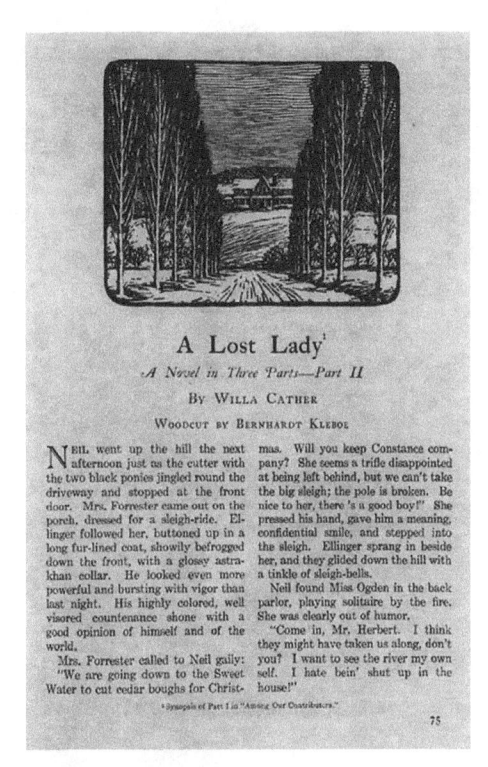

Figure 3.5 *The Century Magazine*'s second installment of Willa Cather's *A Lost Lady*, May 1923. Bernhardt Kleboe's woodcuts introduced parts two and three.

Woodress, James. "Historical Essay: Basis in Early Experience." In *A Lost Lady*. The Willa Cather Scholarly Edition by Willa Cather. Lincoln: University of Nebraska Press, 1994. Willa Cather Archive. https://cather.unl.edu/writings/books/0024.

in book form . . . third, newspaper serialization; fourth, publication in reprints."[100] Cather's narrative first appeared between April and June 1923 in serial form as a "Novel in Three Parts" in Charles Scribner's Sons illustrated monthly *The Century Magazine*, targeted at an educated urban readership. Alfred A. Knopf published it in book form several months later (Figures 3.5 and 3.6).

In December of the following year, Warner Bros. released its screen adaptation of *A Lost Lady* under the direction of Henry Beaumont with the studio's star, Irene Rich, cast in the title role. (Cather had little, and probably no, input into this production.) While the film is no longer extant, significant traces of it remain in the Cather holdings collated at the University of Nebraska–Lincoln: the "Final" scenario with its 319 scenes and 104

Figure 3.6 The 1923 Alfred A. Knopf cover of Willa Cather's *A Lost Lady* reproduced and tinted Bernhardt Kleboe's woodcut used in *The Century Magazine* installments.

intertitles, and the "Cutting Continuity," which includes a list of the film's scenes and titles, and indicates that it was seven reels—about 90 minutes—in length. Grosset and Dunlap reprinted *A Lost Lady* as a photoplay edition in 1925, and it appeared once more as a discrete narrative in the March 1926 issue of *Ainslee's* magazine, a "semi-urbane" *Smart Set* of sorts that specialized in fiction reprints—as did *Golden Book Magazine*, another mass-circulating "quality fiction pulp paper magazine," which re-serialized the narrative, this time in four parts, between September and December 1931 (Figures 3.7–3.9).[101] And finally, in 1934, Warner Bros. produced a second motion-picture adaptation of Cather's story, this time with sound, which starred Barbara Stanwyck.

A Lost Lady is then at least as complex in its various remediations as Chesnutt's *The House Behind the Cedars* or Elinor Glyn's *It*, and it would of

Figure 3.7 The luridly-colored dust jacket of Grosset and Dunlap's 1925 photoplay edition of Willa Cather's *A Lost Lady*.
Courtesy of Special Collections and Archives, University of Nebraska–Lincoln Libraries.

course be of some interest to trace the relatively minor changes between magazine and book publication. What alterations were made to Cather's narrative in the process of its two page-to-screen adaptations are predictable enough. As far as can be deduced from the final scenario and the cutting continuity, these amendments combined in the silent-film adaptation to amplify the novel's potential melodramatic plot points with its—the film's—more explicit and protracted depiction of the imprudence of its "lost lady," Mrs. Forrester (and thus the contracting of the sense of "lost" of the novel's

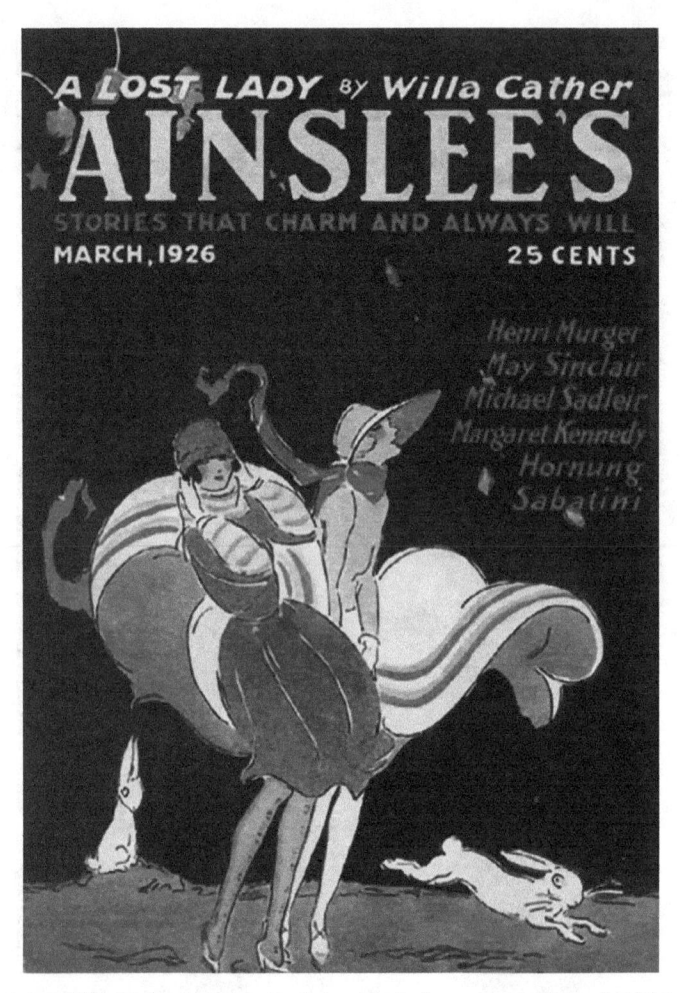

Figure 3.8 Willa Cather's *A Lost Lady* in *Ainslee's* magazine, March 1926.
Courtesy of The Fiction Mags Index.

title), and of her lover Frank Ellinger's villainy. As Andrea Faling writes of the silent-film adaptation,

> enough superficial similarities remained to make it recognizable as a step-child to the published work. Cather's characters appear in the film, and Marian Forrester's initial flirtation with Frank Ellinger and later decline after Captain Forrester's death is detailed by her youthful admirer Niel Herbert, although the sense of Marian being something more than a dissatisfied jazz age wife is lacking.[102]

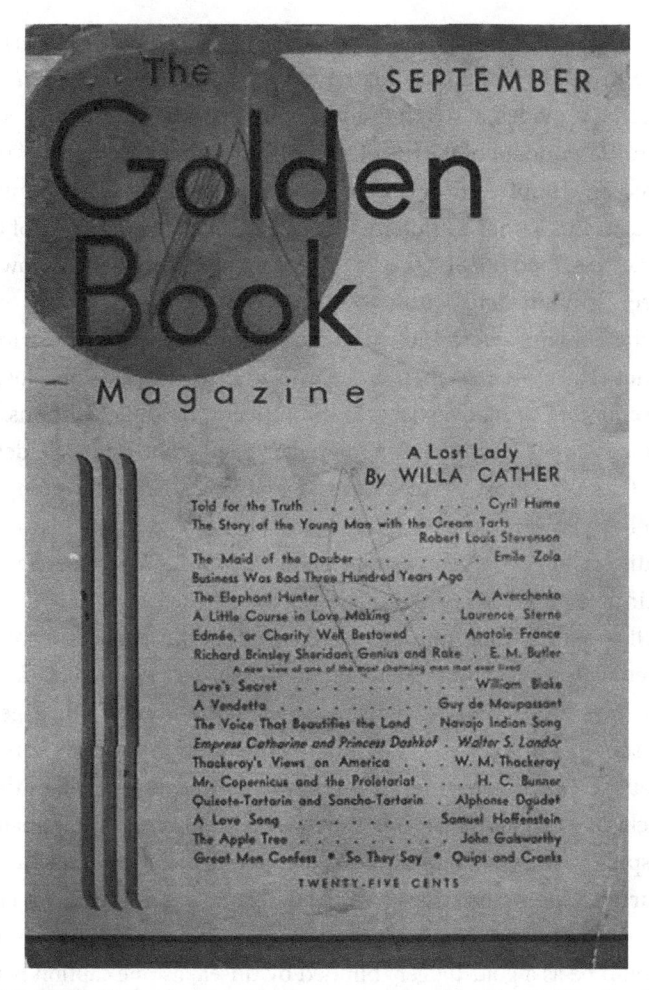

Figure 3.9 Willa Cather's *A Lost Lady* was serialized in *The Golden Book Magazine* between September and December 1931.
Courtesy The Fiction Mags Index

As for the sound adaptation, it plays fast and loose with the plot of Cather's novel to such an extent that it bears very little resemblance to it.[103]

It is the lost 1924 silent-film adaptation of Cather's novel in which the Grosset and Dunlap photoplay edition ties, and this edition, as I have said, contains several illustrations and images pertaining to that Warner Bros. motion picture. To begin with, its dust jacket is a chromolithograph of Niel and Mrs. Forrester derived from a scene from the motion picture (Figure 3.7). (We know this because a still taken from this same scene appears as the

edition's captioned frontispiece.) The jacket illustration's rather garish reds, purples, and yellows (not dissimilar to that of the *The Masquerade*'s cover, incidentally) provides a striking contrast to Bernhardt Kleboe's subdued monochrome woodcut of the bucolic scene that adorns the cover of the original Alfred A. Knopf edition (Figure 3.6). According to Kari Ronning, the dust jacket of this Knopf edition included "a detailed line drawing of Captain Forrester's tree-lined lane (signed K for Bernhard Kleboe) in yellow-brown on a green ground, and within black decorative rule." Knopf's pictorial jackets, she explains, were "not in the representational style" of Houghton Mifflin jackets, "which by then was associated with magazine illustrations and genre fiction" and advertising—and indeed photoplay editions.[104] And this is exactly how Grosset and Dunlap packaged what Henry Seidel Canby declared Cather's "most perfect" novel—smuggled behind a pulpy façade, passed off as genre fiction.[105] Surely some of the readers of this "machine-made" edition may have been caught unawares by the narrative they discovered behind its rather sensational cover.[106]

A small note in the bottom right-hand corner of the dust jacket announces, "Illustrated with scenes from the photoplay. A Warner Bros. screen classic *starring Irene Rich*"—this information is repeated on the edition's title page. The illustrated scenes comprise seven black-and-white motion-picture stills scattered throughout the edition, beginning with, as its frontispiece, a still of the glamorous Rich, one of Warner Bros.' stars, as Mrs. Forrester.[107] The remaining six stills are spread across five of the narrative's chapters, and together tell a very particular narrative, or present a very particular portrait, of the "lost" Mrs. Forrester. Were the reader to view these six stills alone, the impression they would have of her would be as a gold-digger "blinded by tinsel," as one caption reads, and in need of a paternal figure—like the elderly Captain or the "rich, cranky old Englishman" she marries on his death—to save her from herself.[108] For the stills show Mrs. Forrester presented with jewels by the old and ailing Captain; on the phone to her jilting lover, Ellinger; and finally, remarried to yet another older man, the caption to which states that "she is no longer lost." And were one not yet familiar with the narrative, the still included as the frontispiece—and which the jacket's chronolithograph adapts—would suggest some lurid after-hours encounter, depicting as it does an anguished-looking Mrs. Forrester dressed in a robe, with an elegantly attired gentleman at her elbow. (It is in fact her young friend and admirer, Niel [played by Matt Moore]—not a lover.)

In addition to the particular emphasis the selected stills effect is their frequently odd placement in this edition. For, as with "A Man's Duty" and "The

Patent Leather Kid," not all the stills align to illustrate the narration on the facing page. In one instance, a still depicts an event that occurred in a previous chapter, and in other instances, stills depict events that have not yet occurred; and in that sense, and as we have seen in other examples of novelizations, they spoil the plot—indeed, novelizations were marketed to do exactly this: "*See the picture, then read the novel*," as reprint publisher Moffat, Yard encouraged. To take one example, the final still of the photoplay edition of *A Lost Lady* appears in part 2, chapter 8, a chapter in which Niel, after some absence, returns to find Mrs. Forrester much changed following the death of her husband and discovers her affair with the boorish Ivy Peters. But the still shows Mrs. Forrester in what looks to be a bar with an older man whom the reader will recognize as someone other than Captain Forrester—the Captain has appeared in two previous stills—and who is clearly not the significantly younger Ivy. The still is of Mrs. Forrester and her second husband in a hotel bar in Buenos Aires—but we do not learn that until the next chapter (Figure 3.10).

A Warner Bros'. Screen Classic. A Lost Lady.
RESTORED ONCE MORE—NO LONGER "LOST"—BY A CAPRICIOUS SPIN OF FATE'S UNERRING WHEEL.

Figure 3.10 A still depicting Mrs. Forrester (Irene Rich) and her second husband, from the 1924 Warner Bros. adaptation, reproduced in Grosset and Dunlap's 1925 photoplay edition of Willa Cather's *A Lost Lady*, part 2, chap. 8, opp. p. 166.
Courtesy of Library of Congress.

It is also worth noting that the captions accompanying the stills do not derive from the narrative they would ideally illustrate or, for that matter, from the scenario—including its intertitles—of the motion picture in which it should tie. Indeed, we could say that the captions form yet another narrative or add yet another layer of narrative complexity to the one that the stills tell, Cather tells, and the motion-picture adaptation tells. Because of their odd placement and odd captions, the stills in the Grosset and Dunlap photoplay edition of *A Lost Lady* do nothing to advance or support our understanding of the story—they fail even to *illustrate* it. They are, rather, disorientating, as indeed popular illustration frequently could be at this time. Adam Sonstegard, in a recent account of the relationship of narrative to image in books and magazines of the so-called golden age of illustration—the late nineteenth century—finds that images "could 'spoil' a chapter's narrative surprises. They could interrupt sequential action" to effect "dissonance rather than harmony."[109] While he does not mention photoplay editions specifically, Grosset and Dunlap's *A Lost Lady*, as with other novelizations examined thus far, is typical of such illustrated editions' failure to mediate between the two narrative forms, to supplement what each might lack.

We do not know what Cather thought of the Grosset and Dunlap stills-illustrated reprint of her beautiful novel. We do know, and this is well documented, that she was not opposed to illustrations per se, as her collaboration with illustrator W. T. Benda, who contributed the eight elegant black-and-white woodcuts to *My Ántonia* (1918), attests. As Janis Stout has noted, "Benda . . . captured in these spare drawings much of the essence of Cather's spare style. They have the visual equivalence of her selective focus on a few details set against a far prospect with an emptied middle ground."[110] A style of woodcut illustration—similar to Benda's—introduces, as I have said, parts two and three of *The Century's Magazine* original three-part serialization of *A Lost Lady* as it also graces the cover of the novel's Knopf edition. But surely the garish cover of the photoplay edition, the particular way the stills direct us to read Mrs. Forrester, as well as its mismatch of word and image were elements at odds with Cather's aesthetic sensibility. As we shall see, Cather would very soon come to experience and declare a great deal of ambivalence and anxiety concerning the marketing of literature—including and particularly her own—in this postliterary age.

To read *A Lost Lady* in its photoplay edition requires negotiating its motion-picture paratexts before arriving at the story itself, and this is a manner of reading Cather's *A Lost Lady* that has the effect of drawing out,

in this late nineteenth-century-set narrative, what I suggest are its otherwise muted engagements with motion pictures and their broader culture. *A Lost Lady* exhibits a profound understanding of, and indeed a real fascination with, the operations of two particular aspects of the motion-picture industry: the picture personality and an accompanying fan culture, both aspects in which photoplay editions themselves participated.

The manner in which Mrs. Forrester is narrated and presented, and how we know what we *do* know about her, are suggestive of the novel's awareness of, and indeed fascination with, personality and its effects. To Niel, Mrs. Forrester, who seems to "belong to a different world," is "bewitching," "teasing." Seeming "to promise a wild delight," she is frequently seen wearing a veil—although this does "not in the least obscure those beautiful eyes, dark and full of light." The distance at which the narrative holds Mrs. Forrester—even as "If she merely bowed to you, merely looked at you, it constituted a personal relation"—in such descriptions of her appearance is also an effect of the novel's particular narrative situation.[111] Narrated in the third person, its perspective is largely aligned with Niel's, a manner of narration that Cather described in a 1925 interview as "the indirect method." While such a method ensures Mrs. Forrester remains at some remove from the reader, it simultaneously registers Niel's fascination with her, placing him in the position of spectator. Cather explained in that same interview that Niel "isn't a character at all; he is just a peephole into that world. I am amused when people tell me he is a lovely character, when in reality he is only a point of view."[112] Cather's use of "peephole" to describe what is arguably the most striking feature of this narrative of fascination and personality, and one that appears between the covers of a *photoplay* edition, might bring to mind a device associated with early-film spectatorship, and I am thinking here of Thomas Edison's Kinetoscope. To view a moving picture using a Kinetoscope, the spectator looked through a peephole—a slot cut into the top of the Kinetoscope box—and that way experienced the film as a series of flickering images, a series of flashes (Figure 3.11).[113] And it is just such diction *A Lost Lady* deploys to characterize Mrs. Forrester. "Flash" is used no less than five times throughout this short novel in efforts to capture her allure: "Something about her took hold of one in a flash" and "her image flashed into [Niel's] mind."[114] But she remains elusive; aside from what might be gleaned from the malicious gossip of the townswomen, what we know of Mrs. Forrester is largely limited to such flickerings.[115] Indeed, she is nothing much more than a "flash of personality."[116]

Figure 3.11 Publicity photograph of man using Edison Kinetophone, ca. 1895.
Courtesy of Wikimedia Commons.

Several years after the novel's original publication, Cather would account for her presentation of Mrs. Forrester in terms of a miniature: "I didn't try to make a character study, but just a portrait like a thin miniature painted on ivory," an observation that resonates rather intriguingly with a review of the silent adaptation of the novel in which Irene Rich's turn as Mrs. Forrester is described as "clean-cut as a cameo."[117] Cameos and miniatures are both collectible objects; they create, reproduce, and distribute personality, and in that sense, anticipate the motion-picture author cameos discussed in Chapter 1, which, as Mark Goble notes of cameo appearances more generally, function

to "reproduce stardom"—personality—"in miniature," making it "available for the rest of us to see." The cameo is, *in nuce*, "stardom writ small."[118]

One of the most effective means the studios had at their disposal to promote and circulate their picture personalities was the glamor shot or publicity still, which was, just like the miniature and cameo, yet another collectible visual object, and may recall the author logos of Gertrude Atherton and Jack London discussed in Chapter 1. Portrait photography became institutionalized in motion-picture studios from the early 1920s—that is, around the time that Cather was composing *A Lost Lady*—with Paramount Pictures establishing in 1921 the first on-site studio with the express purpose of photographing its actors and actresses. These glamor shots, like motion-picture stills, could be transformed into lobby cards, postcards and associated promotional materials, and reproduced in motion-picture fan magazines—and indeed in photoplay editions.[119]

It is true that Cather's narrative makes no mention of photography in any form.[120] But Dorothy Farnum's 1924 silent-film scenario of *A Lost Lady* does, and it is particularly attuned to the role of the collectible image in the dynamics of personality, and in ways that bring to the fore the novel's more subdued engagements with motion-picture culture. Several times throughout this scenario, Niel is shown gazing "admiringly" upon a photograph Mrs. Forrester gave him as a young boy. We discover from an envisaged close-up that it constitutes "A MADONNA-like study of Marian Forrester," an analogy that evokes a figure not only of great beauty but also, course, of adoration.[121] On the back of this portrait photograph, Niel writes, "Too High To Serve. Too Far To Love," a caption that suggests the dynamic of simultaneous distance and allure embodied in the picture personality.

The motion-picture stills collected in the photoplay edition of *A Lost Lady* likewise function to reproduce and circulate—in miniature, as Goble has it—picture personalities, in this instance, Irene Rich. In the still used in the edition's frontispiece, Rich as Mrs. Forrester appears draped in an elegant fur-trimmed satin gown, holding a candle in such a way thatits illumination spotlights her face in profile (Figure 3.12). We can recognize in this still the features of the glamor photograph—and too the cameo—with its high definition and sharp contrast in light and shade. Devised to promote motion pictures, this glamor shot is placed at the opening of a novel. The photoplay edition of *A Lost Lady* is simply another cog in the machinery of motion-picture advertising. Such glamor shots, as Liz Willis-Tropea notes, were often "collected and traded within star-centered fan clubs," and could

A Warner Bros'. Screen Classic. *A Lost Lady.*
IRENE RICH AS MARIAN FORRESTER.

Figure 3.12 The frontispiece of Grosset and Dunlap's 1925 photoplay edition of Willa Cather's *A Lost Lady* comprises a still of Irene Rich as Mrs. Forrester from the 1924 Warner Bros. adaptation.
Courtesy of the Library of Congress.

be used by fans in a variety of ways, for example, as David Shields has found, "framed for the wall or bedside table" or "pasted into scrapbooks."[122] In a similar way, attractively illustrated periodicals like *Ainslee's*, in which *A Lost Lady* appeared in 1926, were "often cut up for use in scrapbooks, as pictures for framing, as wallpaper, or as packing material."[123] While I stop short at equating Mrs. Forrester with a star, she, like *A Lost Lady* in its various print iterations, and the stills that punctuate its photoplay edition, participates in

modes of circulation and consumption across a series of miniaturizations, flickers and cut-ups associated with a broader motion-picture culture. In short, the photoplay edition of *A Lost Lady* is a manifestation of, a product of, as it also *narrates*, a fascination not just with personality—the picture personality—but too with its very dissemination.

Cather would surely have found abhorrent the cheaply manufactured photoplay editions, with their gaudy chromolithograph dust jackets, that Grosset and Dunlap, A. L. Burt, and Bobbs-Merrill published. She took great pains to ensure where she could that her own books were printed using quality paper and a particular typography.[124] She was not interested, as she declared in "The Novel Demeublé," in producing "the novel manufactured to entertain great multitudes of people."[125] Such denouncements of the mass novel—of which photoplay editions are, of course, a form—are characteristic of the public profile Cather sought to fashion and project. When asked in 1925 whether an increasingly accessible literary marketplace, which facilitated what she termed "the machine-made novel," "was a help to culture, or detrimental," she replied, "fewer and better books would be a great improvement. I think it a great misfortune for every one [*sic*] to have the chance to write—to have a chance to read, for that matter."[126] While she here raises the important matter of increased access to authorship, I am more interested, in terms of my focus here—the photoplay edition—in her expression of anxiety over a mass readership. And yet, as Melissa Homestead and others have argued, her relationship to the marketplace was always marked by a degree of ambivalence.[127] That is to say, despite her "public posturing" about the ills of the mass novel and mass literary marketplace, Cather also quietly courted certain forms of mass culture—including motion pictures—in order to expand her readership for the purposes of short-term financial gain.[128]

One reader of *A Lost Lady*, believing Cather shared his hostility to modern life, wrote to her in 1923, "I know that there is a passport between us who know that America has been dulled and cheapened by standardization and machinery" and long for the passing of "the maddening neurotic nightmare of giant cubistic cities, mechanical circuses and diversions, steam radiator caves, cafeterias, 'movies,' jazz, chambers of commerce, etc. etc. etc."[129] It is true Cather at times singled out motion pictures for their fraying effects upon more modest ways of life associated with the region. In an essay she composed around the time of *A Lost Lady*'s publication, she depicts her home state of Nebraska as menaced by the irruption of modernity. After marking

Nebraska's "cheerful dwellings" and "clean and well kept" towns, the essay takes a far less celebratory turn:

> there is the other side of the medal, stamped with the ugly crest of materialism Too much prosperity, too many moving-picture shows, too much gaudy fiction have colored the tastes and manners of so many of these Nebraskans of the future. There, as elsewhere, one finds the frenzy to be showy; farmer boys who wish to be spenders before they are earners, girls who try to look like the heroines of the cinema screen.[130]

Key here is that motion pictures' vast reach means they have the capacity to affect "so many" and "into the future." And yet this very capacity is surely what must also have appealed to Cather when she agreed to the 1924 film adaptation of *A Lost Lady*, the first of her works to be adapted to the screen—and, as it turned out, the last, at least during her lifetime. Indeed, at this point, the 1920s, Cather expressed only an ambivalent, and at times mild, pleasure in filmgoing. In a letter to the *Omaha World-Herald* in 1929, she opined, "A movie, well done, may be very good indeed, may even appeal to what is called the artistic sense; but to the emotions, the deep feelings, never! Never, that is, excepting Charlie Chaplin at his best."[131] While she may not have been fascinated by motion pictures then, she was somewhat attracted to them, at least to begin with, and likely because of their potential to promote literature—including her own—in the same way reprints promised to do. For, as we know, she not once but *twice* sold the rights to *A Lost Lady* to Warner Bros.—first as a silent and then as a sound, film. One of her biographers has speculated that she may well have seen the silent-film adaptation at its Red Cloud premier on January 6, 1925, since she was in town at this time.[132] Either way, she was clearly not displeased with this adaptation, if we take as a sign of such her sale to Warner Bros. of all motion-picture rights concerning the novel several years later.[133] While she insisted her name not be

> attached to dialogue written by some person whose name and ability I do not know . . . I would however want a signed statement from them that they would, in all the advertising, use that phrase—"Adapted from the novel by that name by Willa Cather" or "Adapted from Willa Cather's novel."[134]

But then, following the release in 1934 of the sound film of *A Lost Lady*, Cather "became absolute and unvarying in her refusal to allow any of her books or stories to be filmed."[135] What came so to irk Cather was the significant role

motion pictures played in what she considered to be the era's cheapening of literary culture. While, as we have seen throughout *Silent Film and the Formations of US Literary Culture*, especially in Chapter 1, there may have been "incalculable" beneficial effects, as Hampton put it, in motion pictures for authors—"The author's field of influence is widened; he reaches not only a magazine, newspaper, and book audience—he goes further than that and appeals to millions who read only occasionally"—this was in fact for Cather the very crux of the problem.[136] That is to say, motion pictures, along with their attendant print materials like photoplay editions, circulated literature *too* widely ("to millions") and to the *dilettante* (who "read[s] only occasionally"). While, in a 1932 letter to Ferris Greenslet at Houghton Mifflin, Cather may have acknowledged the ability of motion-picture adaptations to provide sales of her books with "a temporary punch," she was more concerned, and indeed horrified, by the "hundreds of letters from illiterate and sloppy people" that the film of *A Lost Lady* prompted, and which "which gave me a low opinion of 'movie' audiences"—no doubt unable, to use her terms from "The Novel Demeublé," to distinguish Tanagra figurines from Kewpie brides.[137]

Cather's anxiety around a mass readership emerges again in her response to a Hollywood agent's request, some years later, in 1941, for material to adapt to the screen: "I prefer to have my books read by a few thousand who have an ear trained in English prose rather than be presented in any form to millions of people who do not particularly care."[138] Her choice of "training" here is indicative of her wish to separate out the specialist reader from those readers—filmgoers-cum-readers—who prefer "stories that surprised and delighted by their sharp photographic detail and that were really nothing more than lively pieces of reporting," as she wrote in her 1920 essay "On the Art of Fiction." The vast moviegoing audience she had once if briefly courted could not, it turned out, be trusted to read *in the right way*.[139]

A review of the 1924 silent adaptation of *A Lost Lady* hailed it "an art triumph" and characterized Cather as an author who had achieved "fame, not only as a bestseller but one of America's most distinguished literary lights."[140] This anonymous reviewer rather insightfully and efficiently here captures Cather's precarious position at the interface of high and mass cultures, a position signaled by her shifting and at times inconsistent attitudes toward and engagements with motion-picture culture, in particular its vexing ability both to promote and to contaminate high-literary culture. It is this precariousness, which literature now risked in confronting, exploiting and/or negotiating with a rampant motion-picture industry, that novelizations and their routes of circulation so effectively manifest and disclose.

4

Readerly Pleasures: Screen Reading and
The Motion Picture Story Magazine

When a columnist in 1915 figured motion pictures as "the newest and most rapid of circulating libraries," they were merely adopting an analogy—of motion pictures with the book and book culture—that had become widespread throughout the early twentieth century.[1] Various columns in *The Motion Picture Story Magazine* describe motion pictures as "the books of the masses" or "the book of the people" and as an "advanced version" of "Gutenberg's crude press" since both "disseminat[e] knowledge and familiarize[e] the people with other peoples and other countries."[2] It was not just in terms of circulation that motion pictures were like books however. For, as Michel Chion notes, "With silent films the audience was invited not only to see moving images and hear live sound . . . but also to do a lot of reading, both diegetic text and not."[3]

Thus far, *Silent Film and the Formations of US Literary Culture* has considered motion pictures' effects on literary culture as these played out in the various sites and means of production and circulation. This chapter, picking up on Willa Cather's wry observation that it would be a "great misfortune for every one [*sic*] . . . to have a chance to read," explores the way motion pictures now contributed to, encouraged or altered "everyone's" participation in literary culture and, in particular, the effects of these and moviegoing on reading.[4] Thanks to motion pictures, readers, moviegoers could now encounter literature in novel ways and environments beyond its more conventional institutions and its more canonical formations. More than this, motion pictures and their adjacent print culture began to address filmgoers as readers, a phenomenon that invites a consideration of the types of readers the motion-picture industry attempted to cultivate across its different sites, and the reading practices it produced. In sum, when literature relocated to the realms of motion pictures, what sort of readers and reading did it generate, encourage, or require?

This is a question that serves the recent surge in interest in histories of reading, and is particularly pertinent in view of motion pictures' recourse to and near reliance on literary culture at the very moment of the "split between

popular and elite readerships."[5] And yet is close to impossible to answer in any precise or comprehensive way the question just posed. Reading, as private an activity as it largely always has been, leaves few traces. However, the modes of reading I am interested in here are public and shared, and were often recorded in a variety of motion-picture print materials. But it is in attending carefully to the ways motion pictures addressed their audience via their invitations to read, both on the screen and in the pages of the motion-picture fan magazines, that provides particularly fruitful insights into movie-going readers and reading. And as it turns out, the motion-picture industry's efforts to engage its viewers as readers not only ensured the expansion of reading practices but too of the materials to be read.

I begin this investigation into motion-picture readers and reading by considering some of the different environments and forms in which literature could now be encountered. As we shall see in turning to Hobart Bosworth's 1914 adaptation of Jack London's *Martin Eden* and to Paramount Pictures' 1927 adaptation of Elinor Glyn's *It*, motion pictures came to incorporate literary quotations (or, as was sometimes the case, ostensible literary quotations) and literary objects—books, magazines, libraries—as a means to issue their viewers with invitations to read, and to position and address filmgoers as readers. As literary objects and literary text proliferated on screen, so did they in the pages of the motion-picture fan magazines. While it is true these magazines had a range of functions, such as the legitimization of film as a respectable art form, and the fostering of fan culture, "[i]n their early years," as Richard Abel and Amy Rogers have rightly observed, "these publications demonstrated how deeply entwined motion pictures and popular print culture were."[6] It is for this reason they provide, not least of all in their reader interactivity, a particularly productive means not only to examine additional ways motion pictures invited reading but also how film readers responded to these. My case study here is *The Motion Picture Story Magazine*—retitled *Motion Picture Magazine* in March 1914, with offshoots *Motion Picture Supplement* (in 1915) and *Motion Picture Classic* (from 1916)—one of the earliest motion-picture fan magazines whose sole purpose, at least at its outset, was to circulate short-story versions of current popular films. In what follows, I focus on the magazine's full run during the 1910s, the period when narrative came to dominate motion-picture production in the form of the feature film and when motion-picture production, as we have seen, attached onto and leached into literary culture. It is for this reason that a magazine such as *The Motion Picture Story Magazine* provides an invaluable opportunity to gauge reading

practices as literature moved into motion-picture environments. And as motion pictures generated new materials for reading, they also generated diverse readerly pleasures. Such pleasures could arise from film readers' experiences of recognition—an equally gratifying *mis*recognition at times—of remediated literary texts, as well as from the *prospective* reading that motion pictures and a broader motion-pictures print culture encouraged. In short, this chapter seeks to understand what it was to to read after film.

From Universal Language to Screen Reading

As we know, the motion-picture industry had from its earliest days plundered the works of both long-dead and contemporary authors in the hope, among others, that adaptations could address a basic challenge of early narrative film: comprehensibility. As a "stage-man of one of the first-class picture houses in a big Eastern city" observed in 1914, motion-picture audiences were a diverse bunch, composed of the "milk wagon" or morning crowd ("bums" wanting a nap, tourists awaiting their train), the business snatch ("the business men and women" filling up their lunch hour), the matinee crowd ("ladies and kids"), the five o'clock tea crowd ("the hungry, the homeless, and those tired out") and the cream (the "well fed" who "come with the express purpose of seeing and enjoying a show").[7] But motion pictures could communicate to such a miscellany thanks to, as a 1908 column in the *New York Dramatic Mirror* put it, its "language that is universal," one that promised to transcend barriers of class, education, culture and, most importantly, language. "No matter what may be the tongue spoken by the spectator," this columnist continued, "he can understand the pictures and enjoy them."[8] This was the dream of motion pictures. As a 1919 *Photoplay Magazine* editorial waxed lyrically of motion pictures,

> I am the Universal language.
> I call every man in the world Brother, and he calls me Friend.
> I have unlocked the riddle of Babel after fifty centuries of misunderstanding.
> I am the Voice of Home to Democracy's lonely sentinels on Liberty's frontier.
> I am a chorus of Eagle and Lion and Cock, crying "Shame!" to the Bolshevik Bear.
> I am the rising murmur of repentance on lips in the Kingdom of Sin.

I am California, springing a funny story on Constantinople.

I am a Chinese poet of a thousand years ago, singing gently in Chicago.

I am a salesman purveying harvesters, tractors, overalls, oil stoves and hog products to the Siberians.

I am a vertical and eternal Peace Table, and my Conference has five hundred million delegates.

I am a tenement doctor, telling mothers of twenty races how to wash their babies' milk-bottles.

I am the rusty tongue of Rameses, thrilling Broadway with the sunbright story of my lotus-columned temple on the Nile.

I am the voice of Christ in the country of Confucius.

I am the remembrance of Old Age.

I am the chatter of children with blue eyes or almond eyes.

I am the shy confession of Miss and Ma'amselle and Senorita.

I am a Caspian fisherman, visiting a coffee planter in Santos.

I am the Apostle of Kindness, the Orator of Tolerance, the Minstrel of Love.

I am the greatest Story-Teller of the Ages.

I am the Universal Language.

I am the Motion Picture.[9]

Filmmakers, authors and cultural commentators shared this editorial's faith in cinema's ability to unlock "the riddle of Babel after fifty centuries of misunderstanding." Because their language was primarily visual, motion pictures were presumed readily transparent or at least decipherable, including to the hard of hearing, children, the illiterate or semiliterate and foreign-language speakers.[10] Vitagraph's J. Stuart Blackton was convinced that, thanks to motion pictures, "millions of people will see and understand who would never read the message at all, and whose minds would not be attuned to its message."[11] And for Jack London, "The greatest minds have delivered their messages through the book or play. The motion picture spreads it on the screen where all can read and understand—and enjoy" by virtue of its universally legible strategies of "[p]antomime and pictures."[12] While a columnist in *The Motion Picture Story Magazine* agreed that film's promise inhered in its "pantomime"—"Actions speak louder than words. The eyes can speak as well as the lips. The countenance is more eloquent than words"[13]—Vachel Lindsay understood what he called "moving picture Esperanto" in terms of the unit of the hieroglyph, which would, as Tom Gunning explains, prove "immediately understandable, even by children or illiterate immigrants."[14] It is no

wonder then, as Miriam Hansen writes, "the universal-language metaphor was . . . adapted by industrial publicists and advertisers (most graphically in Laemmle's retroactive motivation of his choice of name for Universal)."[15]

But what these commentators failed to appreciate or chose to overlook was the frequent *un*intelligibility of early motion pictures' alleged universal language. Film was not, it turned out, an Esperanto. And this was not simply because many filmgoers had little or no familiarity with English or, indeed, were illiterate or close to illiterate, and thus unable to comprehend English-language intertitles. Rather, as film "struggled to transform itself into a story-telling medium," and as studios produced "more complex, unfamiliar narratives . . . audiences often found it difficult to follow what they saw on the screen."[16] Even *The Motion Picture Story Magazine*'s highly film-literate Photoplay Philosopher had to "reluctantly admit" in 1912 "that during the past thirty days I have seen at least a dozen Photoplays [films] that I did not understand. Assuming that I am of average intelligence, the conclusion is that at least a dozen scenario editors have been careless. I have also heard several others exclaim that certain plays [films] were 'pretty, and well done, but hard to understand.'"[17]

Motion-picture periodicals of the 1910s—fan and industry magazines, newspapers—are replete with columns and readers' letters lamenting the incomprehensibility of films of the day, at times the upshot, they complained, of the breakneck speed at which motion pictures were screened. As one columnist explained to readers in a 1911 issue of *The Motion Picture Story Magazine*, "The trouble lies with the manager or operator of the Photoplay theater. . . . Film is supposed to be passed thru the projection machine at the rate of one foot each second. . . . Many managers, when the house is full, rush the films thru at a speed which makes the players appear to jump thru their scenes."[18] And an exhibitor griped, "I think that half of the time the theater manager himself does not understand the picture as it is projected on the canvas."[19]

But it was the poor use of intertitles, which in the context of the U.S. presumed a literate, English-speaking audience, that most attracted the ire of viewers. The pace at which intertitles—designed exactly to combat incomprehensibility—were screened proved a challenge. Viewers were often granted "but a moment to read and understand," the Photoplay Philosopher complained.[20] And to make matters worse, intertitles were often shown "at the beginning of a scene rather than at the place they belong," that is, "at a place just preceding the incident. I have seen many films

made unintelligible by this fault."[21] The language used in intertitles also came in for criticism. The Photoplay Philosopher bemoaned their frequent baroque diction—rather than "the simplest, briefest, correctest kind of words"—which failed to cater to motion pictures' diverse audiences: "some children, some foreigners, some illiterates" and some with bad eyesight.[22] The complexity of early-film plots then, along with the challenges of projection and intertitling almost guaranteed the betrayal or failure of the dream of a cinematic Esperanto.

To offset the limitations of the universality of film language, producers developed extraneous devices and other strategies to ensure narrative comprehensibility. These included producing films based on popular fiction and topical stories to leverage audience foreknowledge of plot; "mediation by a lecturer and sound effects"; positioning actors behind the screen to read aloud the film's dialogue; and instituting what Gunning has termed the "narrator function," according to which the narrator was integrated into the film itself to address, *read* it, "to the spectator like a printed book."[23]

The depiction on screen of literary objects and scenes was yet another strategy producers began to deploy in order to render motion pictures more legible, just as this granted literature, like the author cameos Chapter 1 examined, an increased visibility. Such objects included books, book and magazine covers and pages, manuscript and typescript fragments, and literary quotations in addition to representations of readers and scenes of reading. The incorporation of these objects and scenes was not only intended to attract to motion pictures a higher-brow audience—readers—but also to assist a broader moviegoing public in acquiring the necessary skills to comprehend a film by inviting them to see it as like a book. That is to say, while motion pictures developed a set of invitations to read for the sake of both artistic credibility and intelligibility, these invitations also supported or supplemented the film-viewing experience, to guide and instruct the film-viewer.

As Gunning and Hansen have separately argued, while the classical form of film narration was largely in place by 1917, the appropriate relations between the viewer and the screen upon which it depended had to be *learned*.[24] On-screen literary objects and scenes of reading coaxed the viewer into the unfolding story, cueing how it should be consumed via analogy with the older, and likely more familiar, form of the book. Author cameos could help familiarize a moviegoing audience with a new narrative medium; a familiar visible figure—putting a face to a favorite author's name—invited and

welcomed the reader-cum-spectator into the world of the filmed narrative, providing film-viewers with "suggestions for modes of spectatorship."[25] Such on-screen representations of books and a broader book culture, then, addressed and constructed viewers in particular ways as they underscored the association of viewing a film with reading a book.

George Méliès' charming 1900 short, *Le livre magique*, is one of the earliest films to feature a book--in this instance, an outsized magical book whose illustrated commedia dell'arte characters come to life to walk out of its pages. But it is a book without words. Griffith's *Intolerance* (1916) uses a similar ploy; it opens with a still of the first few pages of a fictitious novel, *Intolerance*. Additional pages from this novel appear throughout the film as a means to mark the shifts between the four different stories and epochs it narrates. And although this book contains text (as it is authorless), this is not legible to film-viewers. It is enough that this object *signifies* as a book and gestures to the literary as it employs these gestures to signal to the viewer not only shifts in narrative structure but, too, that film is "the new form of the book . . . the modern form of writing."[26]

It was not simply that motion pictures began to reference, draw on, and depict objects from literary culture as Méliès' and Griffith's did. They also began to present literature—literary text—for reading so that the movie theater itself became a site of reading. The 1915 motion picture *The Italian*, which was produced from an original scenario by Thomas Ince and C. Gardner Sullivan, is prefaced and concludes with an on-screen book that, unlike Méliès' book, includes text, and text, unlike Griffith's book, that is legible. At the opening of *The Italian*, a pair of theatrical curtains are drawn aside to reveal the elegantly attired, renowned Broadway actor George Beban, seated in a cozy parlor. He chooses from a small library a (once more fictitious) novel that, as with the novel in Griffith's *Intolerance*, shares its title with the film— *The Italian*—and whose cover reveals Ince and Gardner to be its coauthors (Figures 4.1 and 4.2). As Olsson has written of this film's opening, "The cover . . . transports us into the fiction as if it were a literary one."[27] We next see, via a close-up, this novel's opening page (Figure 4.3). The camera lingers long enough on this insertion's generously sized font to enable the audience to read along with Beban—should they read English; indeed, should they read at all—and in that way, the scene positions the audience as readers of a quality book, one attractively packaged with an engraved cover. A fade then transports us to rural Italy where Beban reappears, this time in character as

Figure 4.1 Still depicting George Beban, from Paramount Pictures' *The Italian* (1915).
Courtesy of Library of Congress

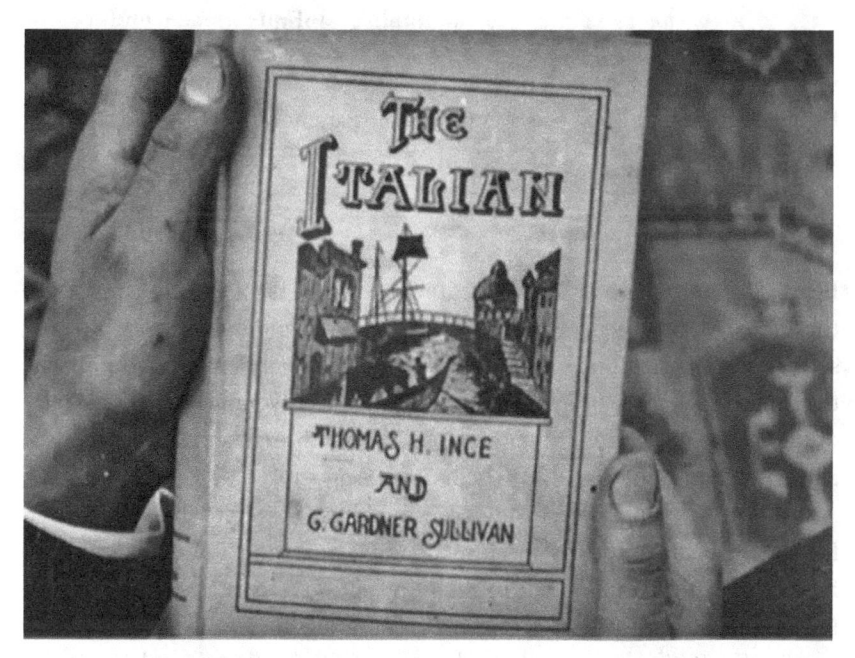

Figure 4.2 Still of the fictitious novel in Paramount Pictures' *The Italian* (1915).
Courtesy of Library of Congress

The ITALIAN

IN OLD ITALY
Chapter I

FROM the gray, old monastery, flung like a rampart of the faith against the Italian sky, the bells were ringing the Angelus. A deep, sweet silence had shrouded the vineyards, where the peasants stood with bowed heads. Even the shaggy burros seemed to understand as they gazed with calm, patient eyes over the scene they had grown to love; the sunshine, the mountains. Infinite peace and

9

Figure 4.3 Still of the first page of the novel in Paramount Pictures' *The Italian* (1915).
Courtesy of Library of Congress

Beppo Donnetti—the Italian of the film's title—a peasant soon to emigrate to the United States. The last minute or so of *The Italian* returns to the opening setting, with Beban once more the distinguished gentleman who prefaced the story. This time he is depicted reading the (poorly punctuated) final page of the novel Ince and Gardner supposedly coauthored, so transporting the audience back to the here and no (Figures 4.4 and 4.5).

As these opening and closing scenes address a literate, indeed literary, filmgoer, Beban models a mode of reading analogous with filmgoing in its absorption (losing oneself in the film) and in its sustained (hour-long) fantasy (being transported). The inclusion of legible text from the (mock) novel—*The Italian*—is also an inadvertent reminder that the celebration of film's universal language very quickly became a much narrower appeal to English-language readers as film of all sorts came to depend upon on-screen text to make meaning and, in the process, converted viewers of films, lured into the motion-picture narrative by its literary pretentions, into readers of (on-screen) books.

Figure 4.4 Still of George Beban in the closing scene of Paramount Pictures'
The Italian (1915).
Courtesy of Library of Congress

The Italian

with the precious flowers in his worn, grimy hands,
Beppo, again knelt by the grave of his baby son.
"Pretty flowers for you, my bambino, my ". His
voice broke abruptly into a sob; a deep racking sob of
a man crushed beyond his strength to endure as he
threw himself across his baby's grave.

The End

Figure 4.5 Still of the final shot in Paramount Pictures' *The Italian* (1915).
Courtesy of Library of Congress

Literature's Proliferation and the Pleasures of Recognition

In incorporating literary objects into their narratives, motion pictures, at the same time that they produced the desire or at least need to read, frequently rewarded their readers with the pleasures experienced in readerly recognition and with the generation of new materials for reading. Sometimes literary text was excerpted from the novel of which the motion picture was an adaptation (that is, not from a fictitious novel, as is the case with *The Italian* and *Intolerance*), which was then transposed into intertitles and insertions. Bosworth's 1914 adaptation of London's *Martin Eden* (1909) is exemplary here—to some extent at least. As mentioned in Chapter 1, Bosworth's film elides London with his fictional—semiautobiographical—Eden. Following the image of London dressed in white shirt and tie that prefaces the motion picture (Figure 4.6), about five minutes in, we see Eden, played by Lawrence

Figure 4.6 The autograph and "medallion" of Jack London from *Martin Eden* (dir. Bosworth, 1914).

Courtesy Library of Congress Moving Image Section.

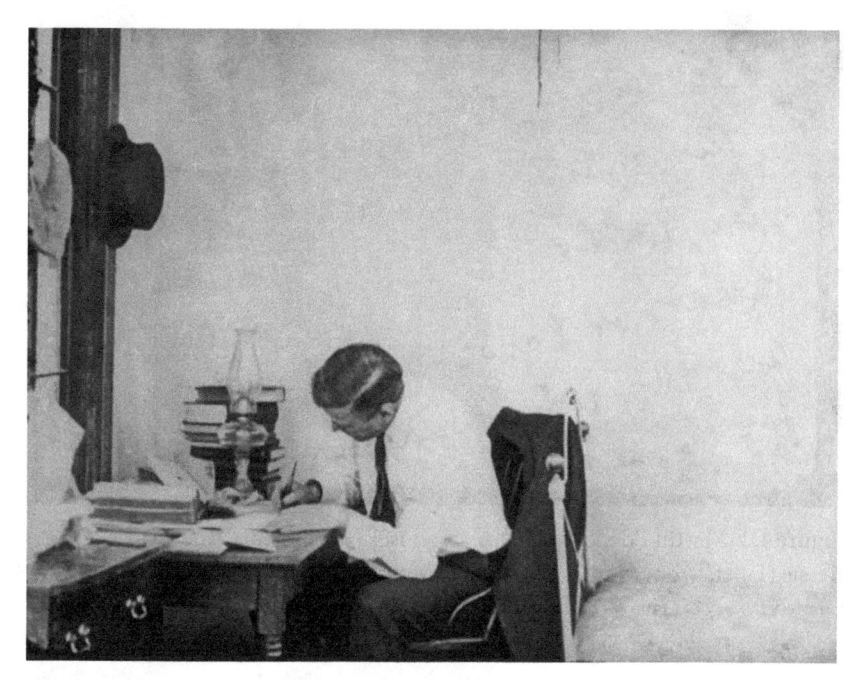

Figure 4.7 Martin Eden (Lawrence Peyton) at his desk, from *Martin Eden* (dir. Bosworth, 1914).

Courtesy Library of Congress Moving Image Section.

Peyton, more or less identically dressed and sporting a similar hairstyle (Figure 4.7). Eden is here depicted working on the manuscript from which he will shortly read aloud to his fiancée Ruth. A close-up enables us to read (again, if we *can* read, and if we can read *English*) the opening lines of what appears to be a handwritten short story entitled "The Cruise of the Bessie Hallet" (Figure 4.8): "The Bessie Hallet was a two masted whaler. I signed on as ships boy. The crew was not large—most of them were men who had been"—that is all that appears within the frame. This short passage does not appear in any London-authored narrative, and London, as far as I have been able to ascertain, did not write anywhere of a Bessie Hallet, as a whaling ship or otherwise. We can only assume that Bosworth, either with London's input or at least approval, composed these lines as representative of an, or *this*, author's—Martin Eden's? Jack London's?—early work. Moviegoers in the early teens familiar with London's oeuvre—and a good many of them would have been—might very well have recognized, or *mis*recognized, this Londonesque passage as from a London narrative.

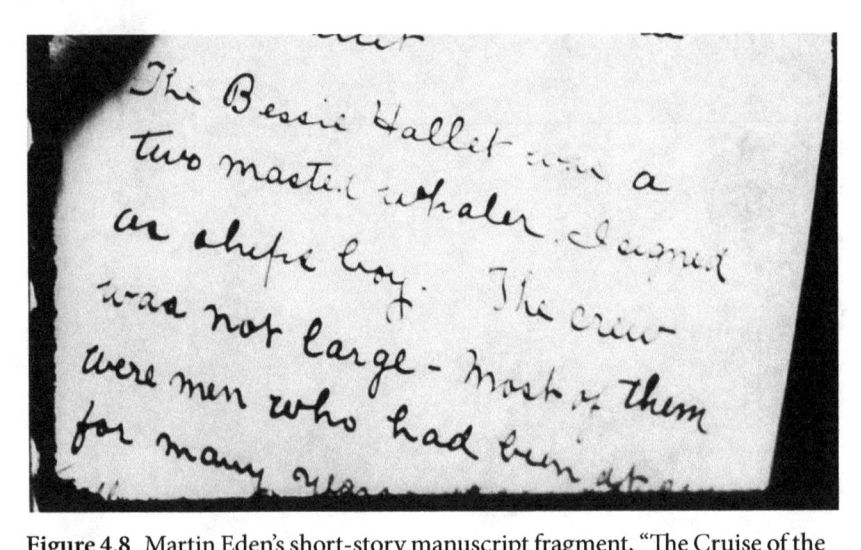

Figure 4.8 Martin Eden's short-story manuscript fragment, "The Cruise of the Bessie Hallet," from *Martin Eden* (dir. Bosworth, 1914).
Courtesy Library of Congress Moving Image Section.

Much later in the film, in the fifth reel, we see in close-up the final page, this time in typescript, of another story, perhaps from a novel Eden is in the process of writing:[28]

> I looked toward the cutter. It was very close. A boat was being lowered.
> "One kiss, dear love," I whispered. "One kiss more before they come."
> "And rescue us from ourselves," she completed, with a most adorable smile, whimsical as I had never seen it, for it was whimsical with love.

These *are* London's words—but they do not appear in *Martin Eden*, of which this film is an adaptation. Rather, they comprise the final lines of London's earlier—1904—novel, *The Sea-Wolf*. Some of the film's viewers may have recognized this passage from this hugely popular novel. Or some may simply have recognized it as, again, Londonesque. Either way, Bosworth's *Martin Eden* plays fast and loose as the fictional Eden completes London's bestselling novel *The Sea-Wolf*—published five years before London had perhaps even imagined *Martin Eden*'s (semi-)fictional author.

A little later in this same reel, Eden is seated on the side of his bed reciting a poem.. An excerpt from that poem appears on an intertitle so that we can read along with him:

I have done—
Put by the lute,
I am like a weary linnet,
For my throat has no song in it;
I have had my singing minute,
I have done—
Put by the lute

Now this *is* an extract from London's *Martin Eden*, from chapter 40. It forms the second half of, we learn from the novel, "an anonymous poem Brissenden [Martin's friend] had been fond of quoting to him," which is reproduced in full in the novel.[29] These lines reappear in the motion picture's rather affecting closing scene, superimposed over the wake of the ship from which Martin falls overboard, effectively taking his own life. This prolix—literary—film, from the manuscript page of "The Cruise of the Bessie Hallet" through to this final scene, directs a knowing wink at its audience who may have recognized the London excerpts and perhaps even have been bookish enough to distinguish between authentic and inauthentic London. Bosworth's adaptation surely provided the sophisticated filmgoer with some readerly pleasure—a pleasure in (literary) recognition, or at least in partial recognition.

A similar complexity arising out of the incorporation of authentic—as well as authentic-seeming—literary objects and text occurs in the 1927 Paramount Pictures' adaptation of Glyn's much-feted novella *It*, where, as we saw in Chapter 1, Glyn appears as herself. *It* was first serialized, as I have said, in *Cosmopolitan* in February and March 1927 and then published as a continuous narrative the following month (April 1927) in the British magazine *Pall Mall*, before being collected this same year in *"It" and Other Stories* (Tauchnitz), in which the story was now organized into chapters.[30] What differences there are between the two magazine stories and the book version are largely a matter of the changing definition of "It" rather than of plot, character, or setting.[31] All three print versions of the story begin by introducing John Gaunt who, although (or because) risen from nothing, "had that nameless charm with a strong magnetism which can only be called 'It'" and who soon falls for the genteelly impoverished Ava Cleveland. The motion picture opens quite differently. As Glyn recollected in her memoir,

I had published a story called *It* in the *Cosmopolitan Magazine*, in which the hero [John Gaunt] possessed this elusive quality, but the Paramount

organization wanted a scenario in which the girl [Betty Lou] was the attractive character, not the man. I tried to change the rôles, but could not think how to do it until I met Clara Bow; as soon as I saw her, however, I felt quite inspired, and the result was a decided "Box Office" success and grossed over a million dollars.[32]

In the process of transposition from page to screen, then, the protagonist underwent a gender reallocation, just as did the protagonist of the film *The Patent Leather Kid*, as discussed in Chapter 3. In fact, the plot of the film of *It* is so radically altered that there is very little to indicate its close kinship with Glyn's story; the two texts narrate two quite different stories, albeit stories of "It" people who fall in love across class lines.

The film, whose release in the United States tied in with the publication of the first of the story's two *Cosmopolitan* installments (that is, February 1927) opens, like the magazine versions, with Glyn's definition of "It," although now in slightly revised form.[33] An intertitle announces "'IT' is that quality possessed by some which draws all others with its magnetic force. With 'IT' you win all men if you are a woman—and all women if you are a man. 'IT' can be a quality of the mind as well as a physical attraction. Elinor Glyn [signature]." This adaptation may well have provided Glyn with an opportunity to rethink and revise her original definition of "It," at the same time that it offered viewers—readers—the pleasure of recognition in rereading, or reading a revised version of, the opening of her hugely popular story.

The lovers at the center of Paramount's film are no longer John Gaunt and Ava Cleveland but the brash flapper Betty Lou (now the bearer of "It" and played by Bow) and Cyrus Waltham, a businessman like Gaunt but who, unlike the self-made Gaunt, has inherited his wealth. While the magazine versions of Glyn's story open with a definition of Gaunt's "It" quality, before (like the Tauchnitz version) introducing the trials of "more or less well born adventurers" Ava and her brother, the film illustrates its prefatory definition of "It" differently, with Waltham's friend Monty's visit to his—Waltham's—department store.[34] Monty picks up a magazine lying about Monty's office and opens it to a page on which the camera zooms in. The illustration accompanying the story's opening page is of an elderly woman, likely the "Grannie" viewers would read of in the film's next close-up of the magazine's pages (Figure 4.9). However, this illustration is not taken from the *Cosmopolitan* issue in which Glyn's story was first published, and the illustrator named in this close-up, while their name is not fully legible, is clearly

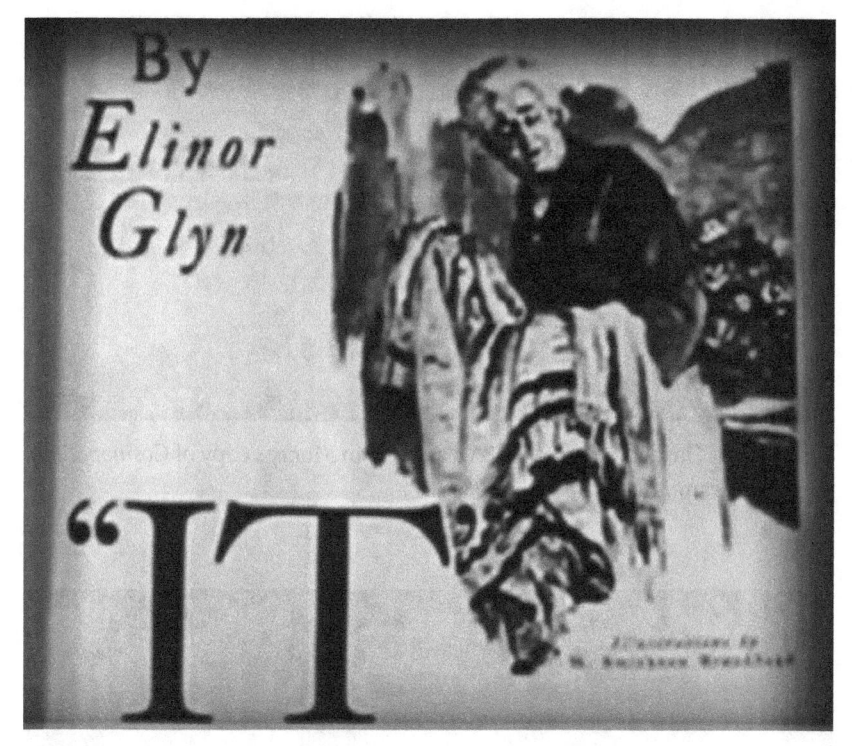

Figure 4.9 Monty's copy of Elinor Glyn's "It" in the mock *Cosmopolitan Magazine*, from the Paramount Studios film, *It* (1927).

not that of John La Gatta, who illustrated the actual *Cosmopolitan* version of the story. The camera then moves into a close-up of the text of this magazine story to yet another reworking of the definition of "It," as explained to Grannie, who does not appear in Glyn's original story (Figure 4.10).

Other passages from Monty's mock *Cosmopolitan* version of "It" soon follow, no doubt for comic effect as Monty, anxious about his own capacity to exude "It," gazes approvingly at his reflection in a mirror while unfavorably assessing Waltham for the same (Figure 4.11). These passages, masquerading, in close-up, as excerpts from Glyn's *Cosmopolitan* story, may very well have appeared in early drafts of Glyn's story. It is just as likely they were concocted by Glyn or the studio's scenarists in the absence of any completed magazine story at this point. Either way, the issue of *Cosmopolitan* Monty peruses in the motion picture's opening scene is neither the February nor the March 1927 issue—the cover of the magazine he reads is quite different from the covers of those issues. Although Monty folds over the cover in such a way

Figure 4.10 The definition of "It" as it appears in Monty's copy of *Cosmopolitan*, from the Paramount Studios film, *It* (1927).

Figure 4.11 Another excerpt from Monty's copy of the *Cosmopolitan* installment of Elinor Glyn's "It," from the Paramount Studios film, *It* (1927).

that its design is barely visible, we can see enough of it to make out a dark-haired woman accessorized with what seems to be a large white Peter Pan collar (Figure 4.12). Figures 4.13 and 4.14 show the covers of the two is-sues of *Cosmopolitan* in which "It" *did* appear. These covers bear no resem-blance to what we can glimpse of Monty's copy of *Cosmopolitan*. It is more than likely the issue of *Cosmopolitan* magazine in which the first installment of Glyn's story was to appear had not yet been published, and thus the mo-tion picture's mock-up with its unfamiliar cover image and unfamiliar illus-tration accompanying the magazine story's opening. The motion picture's

Figure 4.12 Monty reads Elinor Glyn's "It" in his copy of *Cosmopolitan*, from the Paramount Studios film, *It* (1927).

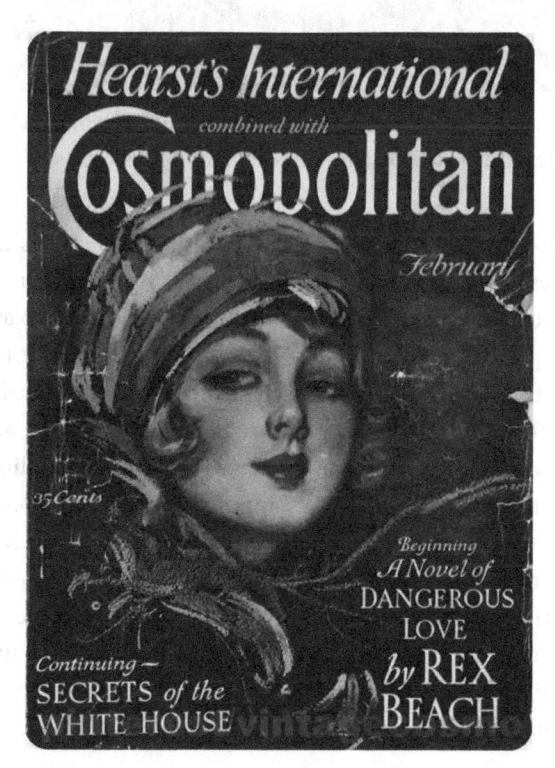

Figure 4.13 The cover of the February 1927 issue of *Cosmopolitan*, in which appeared the first of two installments of Elinor Glyn's "It."

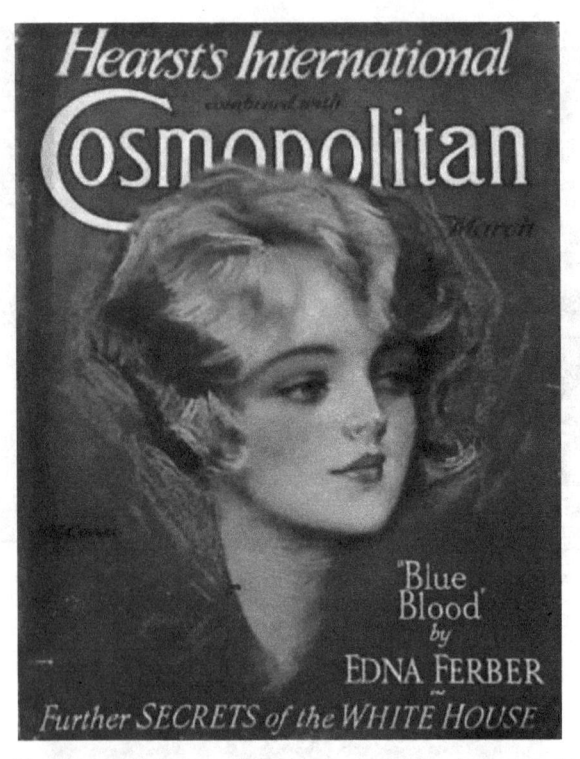

Figure 4.14 The cover of the March 1927 issue *Cosmopolitan*, in which appeared the second of two installments of Elinor Glyn's "It."

relationship to the magazine story is, then, rather odd one as far as tie-ins go. It promotes a mock issue of a magazine, and only a *version*—perhaps an earlier draft—of a story, even as it became "one of the earliest examples of literary product placement in the history of the cinema," as Vincent Barnett and Alex Weedon find.[35] While they here refer explicitly to *Cosmopolitan*'s placement, the motion picture, of course, also "places," markets the author of the adapted text, who is listed among its players in the opening credits—*Madame Elinor Glyn*—and who makes a cameo appearance in the motion picture's diegesis. There is some slippage, then, as we saw in Bosworth's *Martin Eden*, between the original narrative—its text, print objects, author—and its cinematic counterfeit, which generates a form of reading whose pleasure derives from (mis)recognition as well as from the anticipation of an unfolding familiar (in all likelihood) plot. But it is also the case that *It*, like *Martin Eden* and *The Italian*, produced new materials, and thus additional opportunities, to read.

Reading the *The Motion Picture Story Magazine*
Fan Magazines and Storyizations

Moviegoers whose appetites for texts were now whetted by such on-screen engagements with literature had additional venues for consuming film literature. The motion-picture fan magazines, which emerged in the early 1910s alongside industry publications, emulated and drew on literature and literary culture not only to promote and elevate motion pictures, and to address the challenges of early motion pictures' narrative intelligibility but also to appeal to and position filmgoers as readers. These magazines set out quite deliberately to resemble literary magazines in their repackaging of motion-picture narratives in literary form: short story mainly but also verse. In this kind of way, motion-picture story magazines extended the work of the motion-picture industry in creating, as the Photoplay Philosopher saw it at least, "a taste in the public for good literature."[36] For that reason, they mediated not only between their readers and a broader consumer culture, as Kathryn Fuller has argued, and not only between readers and star culture, as Marsha Orgeron has noted, but also between their readers and *literature*.[37] Because these magazines operated at the interface of motion-picture and literary cultures, they happen also to provide an invaluable resource for facilitating answers to the question this chapter posed at its opening: what sort of reading practices did motion pictures invite or imagine they were producing?

While it was not the first magazine to publish storyizations—before it, the trade magazine *The Moving Picture World* (1907–1922) printed motion-picture plots of the day—*The Motion Picture Story Magazine*, established in December 1910 by Vitagraph's J. Stuart Blackton with magazine editor Eugene V. Brewster, was the first magazine dedicated exclusively to the remediation of motion pictures in short-story and occasionally verse form. According to Fuller, filmgoers had already taken to reading "plot descriptions in the professional trade journals of movie theater managers" like *The Moving Picture World*, and so "a short-fiction magazine based on film story lines" such as *The Motion Picture Story Magazine* was not quite the "radical departure" it at first might seem. And because "[T]he American reading public variously consumed detailed newspaper articles, transcripts of long speeches, dime novels, and monthly fiction magazines devoted to stories about athletics, romance, and western and railroad adventures," there was in place "an already existing market eager to read such stories."[38]

With *The Motion Picture Story Magazine*, Blackton hoped not only to raise the value of the industry in which his own company, Vitagraph, led the way in its high-cultural aspirations but also to expand the motion-picture marketplace by converting readers into filmgoers. And one way to achieve that, as William McClain also finds, "was . . . to offer potential middle-class filmgoers an entrée into the form that matched with their pre-existing disposition for literary magazines . . . [and] not merely frame the cinema in a culturally comprehensible narrative system, but also in the respectable mode of the literary magazine and the short story."[39] Blackton was, on the evidence, largely successful in convincing readers of the value of storyizations. The magazine was certainly a commercial success, if its circulation of around 500,000 by 1912—that is, within its very first year of publication—is anything to go by.[40] Other magazines soon followed *The Motion Picture Story Magazine*'s lead: *Photoplay* (also from 1911) and *Movie Pictorial* (1913–1910) as well as major newspapers, such as the *Chicago Sun Tribune*, which, among other tie-ins, published the Selig Polyscope Company and *Chicago Tribune* serial collaboration, *The Adventures of Kathlyn* (1913).

The editorial that introduced *The Motion Picture Story Magazine*'s first issue in February 1911 announced that the magazine would publish at least a dozen motion-picture stories each month, to be illustrated with stills "of the photoplay upon which the story is based, and which will be produced within the current month at all of the leading photoplay-houses throughout the country."[41] Occasionally, as I have said, motion-picture stories were repackaged as poems, rather than short stories. The oddly titled (a result of a typographical error, no doubt) "Elaine in Picture" is a versification of Vitagraph's 1909 Knights of the Round Table short, *Launcelot and Elaine*. But, on the whole, motion pictures were remediated in short-story form, and these storyizations were generally composed by the magazine's "own staff writers who write all stories," with the odd guest appearance by a famous author such as Rex Beach.[42] In the early days of the magazine, storyization writers, along with the studios that produced the motion picture in question, were rarely credited. But as particular writers achieved something of a following among the magazine's readers—indicated, for instance, by a competition held in January 1912 inviting readers to nominate their favorite storyization writer[43]—they soon came to be credited, as did the studio that produced the motion picture the story narrated. The magazine's first editorial also clarified that the stories "will adhere closely to the original tale," an objective that became increasingly challenging as

filmmakers produced more complex and longer narratives adapted from complex and long novels such as Thackeray's *Vanity Fair*.[44] The storyization of that 1911 Vitagraph adaptation, published in the magazine's January 1912 issue, is all of fifteen pages—and this includes the large stills that appear on alternating pages—as opposed to the six hundred-plus pages of Thackeray's meandering narrative.

In addition to the dozen or so stories that appeared in each issue, at least over the first few years of its publication, *The Motion Picture Story Magazine* published a series of regular (or regular enough) departments such as Musings of a Photoplay Philosopher, Answer Department, with reader favorite the Answer Man (who was in fact the Answer *Woman*, Elizabeth M. Heinemann),[45] Gallery of Popular Players, which opened each issue, Chats, Brief Biographies, Greenroom Jottings and, less regularly, Letters to the Editor, as well as a variety of one-off columns sharing insights into the ins and outs of the industry, and the lives and labors of motion-picture players. From the mid- to late 1910s, these departments and inclusions came to dominate the pages of the magazine as it gradually shifted away from storyizations—decreasing the number of these to half a dozen and then, by 1917, to a mere two or three per issue—to become more of a motion-picture fan magazine in which the players, increasingly stars, were the main focus.[46] This shift in emphasis in response to audience interest is reflected in the magazine's name change in March 1914 to, simply, *Motion Picture Magazine*. And by July 1914, the titles of storyizations were no longer listed in a discrete section of the magazine's table of contents but were, rather, mixed in with those of the regular columns and special articles. (Storyizations did, however, continue to appear in their own section in the opening pages of the magazine.) The magazine's drift away from storyizations is reflected in readers' letters to the editor—at least in those the magazine chose to publish. Beginning around the mid-1910s, fewer readers' letters comment on the magazine's storyizations, instead commenting on the motion pictures themselves and their players.

Such a trajectory belies the challenge *The Motion Picture Story Magazine*, and film-story magazines like it, had set itself from the outset, and this was, in straddling both motion-picture and literary cultures, to cater and appeal to the film fan as well as the middle-class reader. To do so, the magazine developed certain forms of reader address, encouraged certain reader practices, and promised certain readerly pleasures. It mimicked and exploited several tendencies in the popular periodicals such as *Reader's Digest* in its "selection,

condensation and repackaging of material from a flood of textual informa-
tion too enormous for readers to grasp," and its relatively compact size and
layout were designed to resemble mainstream illustrated magazines such as
The Century.[47] Furthermore, as Anthony Slide notes, "Even in the earliest
years, the writing in the fan magazines was erudite. . . . The style was often
closer to Charles Dickens or [popular British novelist] Marie Corelli than
to the type of writing that audiences whose second language was English
[for example] would be drawn."[48] Indeed, one need only glance over the
advertisements and classifieds in the back pages of *The Motion Picture Story
Magazine* to find evidence of the magazine's appeal to this kind of broad
readership—film fan and middle-class reader—as it sought to merge popular
appeal with cultural aspiration.[49] These tout typewriters and (inexpensive)
volumes of Shakespeare and Edith Wharton alongside beauty products and
chocolate. The magazine's letters to the editor and readers' responses to the
competitions it conducted also provide a fair sense of the breadth of its read-
ership. A surprising number of letters the magazine chose to publish come
from both men and women, and as far afield as New Zealand and Australia
and from a range of professions and identities: military personnel, engineers,
prisoners, invalids. While such "unification of the mass audience required
the negotiation of different cultures, styles, prejudices, and traditions," it
also required new skills in its audience for the negotiation of different—and
indeed, across—media and registers.[50]

 The Motion Picture Story Magazine's storyizations addressed, in addition
to its broader cultural aspirations, the challenge of early motion pictures'
narrative incomprehensibility. As a solution to the allegedly poor plotting
of so many motion pictures, about which, as already mentioned, both in-
house writers and readers complained in the pages of *The Motion Picture
Story Magazine*, the Photoplay Philosopher suggested, "If everybody could
read the story of each photoplay in this magazine or elsewhere, before seeing
the [photo]play . . . defects in construction would be compensated by the
knowledge acquired in reading the story."[51] At least some, and likely more,
readers approached storyizations in just this way, that is, as an aid to com-
prehension. And yet storyizations frequently appeared indifferent to or ig-
norant of the work they undertook in this regard and, for that matter, what
kind of narrative form they in fact were. "The Life of Moliere," for example,
published in the first issue of *The Motion Picture Story Magazine*, is a scene-
by-scene, present-tense account—"We first see . . . ," "The next scene . . . ,"
"Next we view . . ."—of the eponymous 1910 motion-picture short rather

than a more conventional preterit narrativization. "Thomas a Becket," in this same first issue, likewise describes, again using the present tense, the historical biopic *Becket* (Vitagraph, 1910) rather than repackaging it in short-story form: "The opening picture shows . . . ," "A messenger is announced . . . ," and so on.

Other storyizations in *The Motion Picture Story Magazine*, particularly its early issues, bear such a tenuous or knotted relationship to the motion picture they were designed to serve that readers were surely left more bemused after having read these. "Elaine in Picture," which, as mentioned, claims to be a versification of Vitagraph's *Launcelot and Elaine*, reproduces several verses—largely abridged—from Tennyson's "Lancelot and Elaine" that narrate plots and scenes omitted from the motion picture. To complicate things a little more, *Launcelot and Elaine* was storyized for a second time, in *The Motion Picture Story Magazine*'s fifth issue, now as "The Story of Elaine" and ascribed to Montanye Perry (who would become the magazine's most popular writer) and with the acknowledgment, "from Tennyson's 'Lancelot and Elaine.' "[52] McClain, in pondering exactly these kinds of "fictionalizations of the same film," considers how the authors of storyizations came to write them. Perhaps they "saw different versions" of the films, and "[i]f they did not have access to the film at all, and perhaps only to stills and a scenario, then one might assume . . . a large variance between scenario and final film, or simple ambiguity in the relationship of the two."[53]

A further complication in the relationship of storyizations to the motion picture they ideally supported arose from the already intertextual nature of some of the literary texts the films remediated. Storyizations remediated these again in a kind of Russian doll sequence of relations that complicated the association of the films with their literary sources, and thus the effort to make them intelligible. One such example is the 1911 storyization of Griffith's *The Golden Supper* (1910), an adaptation of another Tennyson poem, "The Lover's Tale" (1879).[54] Tennyson's lengthy poem—it comes in at over one thousand lines—is already a remediation of sorts in its equivocal relationship to Boccaccio's *The Decameron*. The fourth section of "The Lover's Tale" is titled "The Golden Supper," and it narrates a version of Boccaccio's story of the resurrected bride, Camilla, the banquet held to celebrate her return from the dead, and her subsequent reunification with her husband, Lionel.[55] According to a column in *The Moving Picture World* about Griffith's adaptation, "it is quite probable that a good many in every audience will not know what it means. The sub-titles help, but it must be admitted that unless one

is familiar with the origin of the story it is more or less obscure."[56] It is, for instance, difficult to distinguish Julian from Lionel, the film's two rivals in love; neither the subtitles nor costuming help in this. As for the storyization, the stills that illustrate it are miscaptioned—the scene in which the grieving Lionel looks upon the dead (so it seems) Camilla reads, "Julian Looks His Last Upon His Love," only confirming the near impossibility of distinguishing Julian and Lionel in the film.[57] This is where the storyization ideally was to intervene, to share information—a backstory about Julian and Camilla's childhoods, for instance—available in Tennyson's poem but not in Griffith's adaptation.

In fact, in order for "The Golden Supper" (the storyization) to make sense of *The Golden Supper* (the film) to its filmgoing readers, and to fill in the quite significant gaps between Tennyson's and Griffith's retellings of Boccaccio's tale, this storyization needed to bypass the motion picture altogether at important points, and turn instead to the literary source the film elides. In the storyization, but not the motion picture, Camilla bears a child soon after her resurrection. In both motion picture and storyization, Julian seeks out Lionel—who, on learning of Camilla's death (as it seemed), takes on the life of a hermit—brings him home, and organizes a banquet in his honor. In the storyization's banquet scene, before presenting Lionel with a gift, as is the tradition of the country, Julian poses a riddle to his guests. The riddle is here rendered as a prose redaction of a section of Tennyson's poem:

> I knew a man who had been served for years by a faithful slave who, now
> grown old and weak, was thrust into the street to die. There came another
> man who pitied his estate, took him to his home and nursed him back to
> health. Now to which man—the one who cast him forth to die, or to the one
> who saved from death—did that old slave belong?[58]

This scene does not appear in the motion picture; Julian simply seeks Lionel out in his reclusion, brings him home to the celebratory banquet, and presents the truly living Camilla to him. The storyization's full title, " 'The Golden Supper' from the poem of Lord Tennyson," turns out to be more accurate than we might realize; the storyization is indeed "from the poem of Lord Tennyson" rather than from Griffith's motion-picture adaptation of it.

We might well wonder how the magazine's readers responded to and engaged with the complexities of storyizations' strange narrative modes. What must surely have been the often perplexing experience of reading these is

hinted at in readers' responses to a "Cash Prize Contest" *The Motion Picture Story Magazine* ran in August 1911, whereby readers were invited to nominate their favorite storyization and account for their choice. The magazine received "thousands" of entries from an assortment of readers around the globe—from "children and grandparents, from rich and poor, from college professor and workman, from philosopher and poet and from clerk and employer"—that suggest rather intriguingly that they did not quite know what exactly it was they were reading. That is to say, the magazines' readers appear unsure as to just what they are nominating in this favorite-storyization contest: motion picture or short story? Some readers responded to the storyizations as discete short stories, praising the writer's "vigorous English" or "good description of character." Others nominated a particular storyization because they liked the motion picture it remediated. One reader nominated "Perversity of Fate, from the Picture Play by Taylor White" (February 1911) because its "Characters . . . live, move and talk like human beings"; another nominated "The Big Scoop" (February 1911) because "The leading man 'looks the part,' and I should call this picture-story the equal of a good drama, leaving the audience in a comfortable, yet retrospective mood"; and yet another liked best "The Golden Supper" storyization because of "the sensitive beauty of Camilla, sad until she smiles and then like a ray of sunshine."[59]

The Motion Picture Story Magazine is replete with examples of this restless, ambiguous form, this convoluted remediation of film as literary fiction, making it difficult to accept, therefore, that storyizations "were well suited to be used by spectators as a tool to assure narrative comprehension."[60] For, motion-picture stories, as McClain reminds us, "represent not simple synopsis but fundamental re-creation of those films [in which they tie] with an entirely new aesthetic system," something—a "new aesthetic system"—also arising out of the incorporation of literary materials in motion pictures such as *The Italian*, *Martin Eden* and *It*.[61] The stories in the film fan magazines similarly expanded the contours of literature and literary form into motion-picture circuits. They too required a reader-viewer skilled in navigating both print and screen forms, and their manner of address was no less complex in the way they either assumed, or sought to inculcate, an aptitude for negotiating literary narrative increasingly dispersed across a range of motion-picture sites and textual forms. In carefully attending to other of the many inclusions in *The Motion Picture Story Magazine*—readers' letters, regular columns such as Musings of "The Photoplay Philosopher," among

others—we can discover a little more about the reading practices and readerly pleasures motion pictures' invitations to read came to promote.

Motion Pictures' Readers and Reading

Scattered throughout *The Motion Picture Story Magazine*, particularly during its early years, are various editorial and reader statements about the manner in which storyizations should be, and were, consumed. When should they be read? Before or after seeing the motion picture? Debates in the pages of the magazine reveal that no one—readers, contributors—really had an exact sense of this, or a sense of what the exact relationship of the motion picture to the storyization might be. Nor did the magazine have any particular editorial agenda or vision in this regard. At best, an editorial of May 1911 opined, "he who has seen may read, and he who has read may see, the best Picture Stories of the times. Who reads the wonderful stories and admires the beautiful pictures in this magazine, *will want to see the characters* MOVE; and who has been charmed with a photoplay, will want to have it retold in story and to preserve important scenes in permanent form."[62] And what evidence there is indicates that readers approached storyizations in unique ways.[63] One reader, for example, deployed storyizations as aide-memoires: they enable one to "imagine you see them [the motion pictures] again on the screen. With the help of your book"— *The Motion Picture Story Magazine*—"one can keep all the [photo]plays in mind, or easily recall them again."[64] Another reader approached the magazine's storyizations as self-contained literary units, quite independent of the film they storyized, something also reflected in the favorite-writer competition mentioned earlier.[65] Others used the stories as a substitute for moviegoing. As one reader explained,

> Altho I cant [*sic*] see the players on the screen, I love to read of them, for it give me an insight into their real selves, and not just "reel" selves. I don't think there is another girl anywhere who can say she has never seen a Motion Picture, but all my life I have been an invalid, but rather a cripple, and so I cannot go. But I am blessed with two good eyes, and I can read, and I read every line of the MOTION PICTURE MAGAZINE."[66]

And another found storyizations sufficed when unable to attend the theater, such as in bad weather.[67]

A common thread running through readers' letters describes the pleasure in reading storyizations after having learned something about a motion picture's players from the magazine's other regular departments and columns—evidence too of the evolution of the motion-picture fan and, by implication, stardom.[68] Readers found this experience of storyizations true of the magazine more broadly. That is to say, acquiring biographical information about the players could inform the viewing, not only the reading, experience, adding a dimension of theatrical performance and complexity to the representations seen on screen in terms of the similarities and differences between the lives and personalities of actors and those of the roles they played. As one reader wrote to the Letters to the Editor,

> For years I have been taking in Moving Pictures, and thought I was getting all there was in them. But the first copy of your very excellent magazine that came to my notice taught me that there were pleasures to be had from them, and which could only be brought about thru just such a medium as your magazine has proven to be. It has made me acquainted with real human characters, whereas before I was pleased with moving shadows. Formerly it was the plot, now it is the players that I go to see.[69]

Another reader agreed, describing the magazine as an "aid" in bringing the players and thus motion pictures to life; it could thus usefully function "as a text-book" for sharing knowledge of the players.[70] Others concurred. As one reader, an engineer, weighed in, the magazine "has added 50 per cent to the enjoyment we experience in looking at the filmed productions, and it makes the pictures more human from the knowledge we obtain of the actors from its pages."[71] Blackton was right: "the reader who reads the illustrated stories in this magazine would inevitably desire to see the characters *move*."[72]

However readers approached *The Motion Picture Story Magazine*, however they used its storyizations, the invertible imperative—"Read the book, and now see the film," "See the film, and now read the book"— used to promote motion-picture story magazines and other tie-ins, generated new reading habits, or at least altered or extended existing ones. The imperative urged something like repeat reading, or what we might more correctly understand as prospective reading. That is to say, it is safe to assume that the magazine's readers had at least some foreknowledge of the plots of the storyizations they so avidly consumed for the simple reason they had in all likelihood already viewed the motion picture these redacted, while viewers of the motion

picture may well have had the same kind of foreknowledge because they had read the storyization. To put this slightly differently, there was a good chance the plot was already spoiled, no matter the medium—motion picture or storyization—in which one first consumed it.[73]

What then, as Christina Lupton has wondered in a quite different context, are we to "make of the reader who knows how the journey will turn out"?[74] The pleasure that readers of storyizations anticipated, or rather the pleasure they evidently found in anticipation, is especially marked when we recall that the plots of popular films, and so with their storyizations, were often cliff-hangers, which, as Michaela Bronstein writes, "demand to be read breathlessly and aim many of their effects specifically at the first time reader."[75] But to know in advance, as *The Motion Picture Story Magazine*'s readers likely did, that the dire straits in which the protagonists find themselves or the obstacles to true love they encounter will all somehow work out in the end, makes it possible to enjoy the dangers and troubles rather than be come perturbed by them.

In some sense, the kind of prospective reading required or generated as literature dispersed itself across various motion-picture formations may very well characterize the experience of reading most popular fiction since, as Janice Radway argues of the romance genre, it "retell[s] a single tale whose outcome its readers already know"—unlike the serious novel, which "purports to tell a 'new' story of unfamiliar characters and as-yet uncompleted events."[76] Indeed, maybe all reading always involves a degree of anticipation since it is, Jonathan Gray reminds us, largely dependent on "networks of paratexts, and on previous relationships to a story, a character, actor, or genre."[77] In other words, the reader, and the viewer for that matter, always brings to what is read or viewed some knowledge outside of it, so that their reading (or viewing) is always to some extent prospective. But the point to be made here is that the very fact that publishers and motion-picture producers cross-promoted storyizations in earnest (as they did page-to-screen adaptation) suggests they were assured of the particular pleasure readers found in the anticipation of the known, in the unfurling of a plot already familiar to them. A reader could approach motion-picture stories secure in their anticipation of how the story will turn out, and in that sense, shared in the pleasures of recognition—or, as the case at times was, misrecognition—that moviegoers could experience in reading popular literature (Glyn's, London's) on screen.

The appeal to prospective reading in cross-promotional slogans such as "Read the book, and now see the film" and "See the film, and now read the

book" inhered not only in the anticipation of the unraveling of a familiar plot on page or screen but also in the anticipation of experiencing the same narrative in a different medium, that is to say, in the experience of remediation itself as a play of identity and difference between the rendering of the same story in two different media forms. McClain and Shelley Stamp are among the very few scholars who have considered the manner in which readers consumed tie-ins, such as motion-picture stories, in their dense cross-medial textual environments. McClain sees at work in readers' consumption of storyizations something akin to what Radway discovered in women's romance-reading whereby "the romance novel [is regarded] less as a text than as a transparent means of access to a pre-existing story world." Drawing on Radway's insight, McClain argues that readers of motion-picture fictionalizations, as he terms motion-picture stories or storyizations, "would be willing to suspend their attachment to the specifically filmic text and address the underlying 'story' in a qualitatively different form," that is, the storyization, the short story. In other words, "readers were likely anything but attached to a specific 'text' as the sole location of the story," a readerly experience generating what David Brewer has termed, in a radically different context, "imaginative expansion" whereby readers simply "wanted more," wanted to read, view, and experience the same plots, to encounter the same characters over and over, and in that way expand and thus prolong their enjoyment of the story world.[78] A more unusual example of such imaginative expansion is found in readers' repurposing of issues of *The Motion Picture Story Magazine* to create scrapbooks, a pastime that was, a 1912 column announced, "quite the fashion. Many of our readers are making them."[79]

It is not too much to suggest then that readers came to relish pursuing a single narrative or cluster of characters across different formats, between book, motion picture and magazine, and in any sequence. The evidence suggests, in other words, that moving between the conventions of reading and consuming images in different formats became a pleasure in itself where there is any kind of continuity to be had. One evidently avid reader of and frequent correspondent to *The Motion Picture Story Magazine* shared a similar insight: "The stories are very good in themselves, and when one realizes that sooner or later he will see the scenes upon the screen at the odeon, the interest becomes doubly keen."[80] Another reader summed up the pleasures in anticipatory reading: she "keeps all of *The Motion Picture Story Magazines* on her reading table, and when she returns from the Photoshow where she has seen a film, the story of which has appeared in a magazine, she sits down and

reads that story. 'I like to read the stories first,' she continues, 'but a second reading after I have seen the Photoplay has proven a fascinating luxury.'[81]

While *The Motion Picture Story Magazine* produced or required particular—prospective, expansive—modes of reading, it also usefully documents a broader range of reading practices and experiences generated by the arrival of motion pictures, including what one columnist called "mouth-reading," that is, lip-reading. A classified advertisement in the back pages of the June 1914 issue of *Motion Picture Magazine* (the magazine had by this time dropped "*Story*" from its title) promotes a book with the odd title *Movie Mouth Reading*, published by an equally oddly named company, Detroit's Movie Mouth Reading Co. According to the advertisement, this book promised to address such concerns as "How to Tell what the actors say in moving pictures" as it guaranteed "Enjoyment greatly increased. Easy method, complete, copyrighted, 25c, postpaid. 'Movie' Mouth Reading Co., Detroit, Mich."[82] The advertisement clearly caught the magazine's attention because several months later, R. J. Cassell—the book's author, as it turned out—published an article, "The Soundless Message," in its December 1914 issue. Here, Cassell describes "a great discovery, the reading of the movements of the mouth, the words as pronounced on the actor's lips," which "should supply the one element lacking in the photodrama—that of telling what the actors are saying." Noting it is already "being used by deaf people all over the country," he claimed, "If this wonderful art is developed by the patrons of the photoplay . . . [it] will enable the vast masses to enjoy and reap the benefit."[83]

Other guides to "reading" motion pictures began to appear in the pages of the magazine, for example, its editor Brewster's four-part manual "Expression of the Emotions," beginning in the July 1914 issue, which aimed to train the magazine's readers to read players' emotional expressions. Each of the relatively lengthy installments, among which were guides to reading teeth (September 1915) and gaits (March 1916), incorporated a list of "some of the principal emotions and sensations . . . Abhorrence, Admiration, Adoration, Affection, Alarm" and so forth, right through to "Zeal."[84] Illustrations accompanied Brewster's manual to assist his readers in reading on-screen facial expressions (Figure 4.15). The final installment includes a series of images of Norma Talmadge "showing her remarkably expressive face under different emotions" (Figure 4.16).

Most obviously, motion pictures also generated on-screen reading in the ubiquitous non-diegetic (credits, intertitles) text as well as diegetic text such

Figure 4.15 From Eugene V. Brewster's "Expression of the Emotions," *Motion Picture Magazine*, July 1914, 112.
Courtesy of the Media History Digital Library.

as newspaper, letters and street signs. But as we have seen, motion pictures also presented for reading, or partial reading, pages and quotations from (even if at times mock) novels and short stories and poems as well as legible literary objects such as the cover and pages of books and magazines in which these appeared. Screen reading would come both to trouble and entrance authors. In a speech entitled "Enemies of the Book," delivered at the annual dinner of the American Booksellers' Association in New York in 1936, Sinclair Lewis declared the vexing decline in book sales as referable to what would become the usual suspects charged with diverting the pool of potential serious readers: radio, the automobile, "the welter of cheap pulps" and, of course, motion pictures. Pondering these threats to the survival of "books as we know them," Lewis conjured for his audience a dystopian "ingenious microscopic gadget whereby you can carry the entire works of Balzac in your cigarette case."[85] His gadget—effectively a miniature

Figure 4.16 Norma Talmadge in Eugene V. Brewster's "Expression of the Emotions," *Motion Picture Magazine*, August 1914, 109.
Courtesy of the Media History Digital Library.

e-reader—not only anticipates the digital screen technologies of our own era but, too, resonates with a vision contemporary with his own. Several years before Lewis delivered this speech, Robert Carlton Brown (Bob Brown), who happened to be a major contributor of storyizations to *The Motion Picture Story Magazine*, among other talents, wished, as Karin Littau writes, "to bring reading practices in line with modern film-viewing."[86] Brown dreamed of something called "readies":

> A simple reading machine which I can carry or move around and attach to any old electric light plug and read hundred thousand word novels in ten minutes if I want to, and I want to. . . . This reading film unrolls beneath a narrow magnifying glass four or five inches long set in a reading slit, the glass brings up the otherwise unreadable type to comfortable reading size, and the reader is rid at last of the cumbersome book.[87]

In a very real sense, motion pictures already had the capacity to "rid" readers "of the cumbersome book," even if at significantly larger scale than Brown envisaged and even if largely fixed (and thus cumbersome?) as they projected onto the screen—even if in a single shot or a series of shots rather than in scrolling as with a microfilm reader—excerpts from novels, poems and short stories for the moviegoer to read. In other words, audiences were already reading literature (not just any print materials), even if in abridged and excerpted form, on screen, in ways that foreshadowed Brown's and Lewis' reading-machine visions.

Reading literary narrative and encountering literary objects on screen, it is worth noting, occurred in public—in the shared space of the picture palace—and thus well outside of more traditional sites of reading found within the home, library, or school. Just as motion pictures had extracted the author from the study and moved them into shared and more public sites of authorship, so did they draw readers into corresponding locations like the theater. One effect of the public reading motion pictures facilitated, as Nancy Bentley writes of the late nineteenth-century amusement park, was that "mass consumers [were able] to see themselves gathered as a visible social body."[88] This dynamic was not limited to moviegoers, however. The mass-circulating pages of the motion-picture story magazines also functioned as a shared space generating if not actual embodied communities as did the motion-picture palace, then certainly virtual communities of readers and fans. The cross-industrial collaborations between exhibitors and magazines, whereby the release of the magazine and the motion-picture tie-in coincided, contributed to these formations. Commensurate with the typical publication and exhibition schedule of tie-ins, a reader could read a particular storyization more or less simultaneously with other readers (during the same month at least) and view its motion picture tie-in if not at the very same time as those others gathered at the same screening, then at least during the same week.[89]

The motion-picture story magazines more actively forged virtual communities of moviegoing readers with inclusions requiring interactivity such as competitions, quizzes and letters to-the-editor columns as well as departments such as *The Motion Picture Story Magazine*'s hugely popular Answer Department, which encouraged readers to write in with their queries about current motion pictures, players and so forth. Such columns and related inclusions encouraged interaction not only between readers and the magazine but also between readers. A sketch entitled "Faces in the

Figure 4.17 "Faces in the Audience," *Motion Picture Magazine*, February 1915, 140.
Courtesy of the Media History Digital Library.

Audience," which appeared in the February 1915 issue of *Motion Picture Magazine*, depicted a range of audience reactions to a series of standard motion-picture scenes (and moviegoing experiences such as "When the Machine is out of Order"): "When Broncho Billy dashes to the Rescuer," "When Grace Cunard steals the Jewels," "When Mabel Normand gets in a Fight," "When Blanch [*sic*] Sweet is imposed upon," and so on (Figure 4.17). As Abel and Rogers find of this same illustration, "Besides invoking a sense of belonging, such images made spectators a material presence, testifying to their importance to the success of both print and film."[90] Film reviewer Hazel Simpson Naylor's column As Others See You, Gleanings from the Audience, which ran in *Motion Picture Magazine* from August 1915 through May 1916, in which she also reported on, if with a greater degree of earnestness, audience reactions to films she had attended, must have similarly forged audience self-awareness at the same time as her reports connected readers to

each other as well as to the space of moviegoing. Indeed, as Shawn Shimpach has argued, "mass-market magazines were learning to think of the motion picture audience as a virtual social object," and articles that published moviegoing statistics in the popular press must have further contributed to "the motion picture audience as a distinct and preexisting entity, out there to be known, measured, reformed and eventually entered into."[91]

It was in this shared space of the magazine's pages that readers not only consumed storyizations but too shared their thoughts about them.[92] To take just a couple of examples from *Motion Picture Magazine*, reader George Miller, incarcerated on Blackwell's Island (renamed Welfare Island in 1921, and where Wallace Thurman would die and *The Interne* is set), wrote a letter to the editor, published in the September 1914 issue: "the stories are fine—the best ever. I've read a good many books, but yours [your stories] are the best. . . . You know when I am thru reading these magazines I pass them along to my fellow prisoners, so they can enjoy reading them also."[93] As motion-picture magazines delivered literary form (short stories, verse) and plots (were these storyizations of page-to-screen adaptations) into prisons under cover of motion pictures and their fan cultures, so did they deliver these to military personnel stationed overseas. In his letter to the *Motion Picture Magazine* editor, an army sergeant based in the Philippines described the reading group he had formed:

All the boys are sitting in groups, reading and discussing THE MOTION PICTURE STORY [*sic*] MAGAZINE. Work that needed a week to be done is now carried out in twenty-four hours; everybody hustles to get back to the magazine. . . . A native from the mountains saw one of the copies; tho he could not read, he wanted it so badly, to show the pictures when he gets back to his tribe.

Even a local monkey enjoyed "looking at the magazine."[94] Another reader, a Miss Bessie Havens, while traveling on a bus in Pittsburgh, observed that fourteen of its twenty-seven passengers "were buried alive behind the covers of MOTION PICTURE MAGAZINE."[95] These letters comport with the objective of Appreciation and Criticisms of Popular Plays and Players By Our Readers, a column appearing from 1913 that encouraged the magazine's readers to emulate "a family gathering of photoplay friends . . . a get-together effort."[96] In a more focused effort to generate motion-picture-story-reading communities, the Photoplay Philosopher suggested readers form a "moving

picture club," which, among a number of activities such as filmgoing most obviously, should include "reading of a story from THE MOTION PICTURE STORY MAGAZINE."[97]

While it is true that the proliferation of literature across motion-picture environments generated as it also expanded a variety of reading practices, and introduced filmgoers and film fans to literature—literary form and plots—it is also true that the reading practices that this development produced comprise what might be understood as *bad* reading: reading for plot, partial and abridged reading, apparatus-dependent reading, nonlinguistic ("mouth") reading, reading aloud, fan and interactive reading, public reading, passive reading (on screen, it is "a book whose pages are turned for us—and isn't this the way that we all started with books?"), all of which are practices and experiences of reading, whether on screen or in the pages of the fan magazines, that go against the grain of good reading.[98] Good reading, which good literature—such as the novel—requires and warrants, demands and produces habits of sustained close reading, reflection, inter-pretation, profundity and critical distance. Just as importantly, good reading is practiced in solitude and in silence. Motion-picture reading, conversely, occurs in reading communities—frequently film-fan communities—and in the shared and frequently noisy and disruptive spaces of the cinema. As a *Motion Picture Magazine* reader complained, moviegoers "evidently [lack] in knowledge pertaining to appropriate decorum at the Motion Picture the-ater. . . . When a letter or note is flashed upon the screen, some of the people are so ignorant that they actually read it aloud."[99]

While the spaces of motion-picture reading were evidently hostile to the absorption and attentiveness required in reading serious literature, the manner of encountering literary text and objects in motion-picture contexts was likewise antagonistic to older, privileged modes of reading. As we have seen with storyizations, magazine readers devoured the same story across media and even across magazine titles and issues, as in the ex-ample of the verse storyization "Elaine in Picture," which reappeared four months later as the short story "The Story of Elaine." Especially in the early days of storyizations, when magazines such as *The Motion Picture Story Magazine* omitted the names of their authors, narrative became unmoored from authority, that is, from the author of the storyization and, in the case of screen adaptations, from the author of the original or source narrative. It was the story, the plot, alone that mattered, and not necessarily its unfolding per se, but its unfolding across different media, genres, and retellings,

multiplying seemingly exhaustively and ensuring literary form and narrative became participants in a "mass-culture excess" so antithetical to "literary profundity."[100]

This readerly desire for more, to follow, as I have said, a favorite character or favorite plots across various retellings, encouraged a skittish, piecemeal habit of reading, something along the lines of what Chion calls, in the context of reading intertitles, "half-reading": "text inserted into a dramatic action had to be read in a limited time, since the film had to move on. So it was necessary not to have too many words and for the spectator to have the time to read."[101] In terms of the more specific practice of reading literature, even quasi-literature, on screen, we need only recall the interrupted text of "The Cruise of the Bessie Hallet" in Bosworth's adaptation of London's *Martin Eden*, as well as those intertitles incorporating unfinished bits of text supposedly excerpted from *Cosmopolitan*'s version of Glyn's "It," which we see projected in the 1927 film. Half-reading is a practice arguably only exacerbated when the literary narratives are fictitious, as is the case with these two examples. Reading literature on screen, as well as in the pages of the motion-picture magazines, involved half-reading in another sense, in that these narratives were abridged, compressed, squeezed into intertitles and into the space of several pages of the story magazines, a suitable format for those readers reading distractedly—flipping through the pages of a fan magazine, irked by the rapid pace at which intertitles were often projected. The reader of literature in motion—the half-reader—who indiscriminately reads scraps on screen and in the motion-picture magazine resembles what Molly Travis calls the foraging reader, a term she takes from a 1925 essay published in *The New Republic* that lamented the transformation of "the dear reader" from "a feeder" to "a nibbler, and the reason is because there is so much more fodder and so many more extraordinary varieties of it for him to nibble at. . . . And what does he read? or rather what doesn't he read? . . . [H]e nibbles everywhere."[102]

The excesses of motion-picture reading—dipping in and out of literary form and plots across the various fora and sites of motion-picture culture are more decisively grasped if we follow Richard Ohmann in tracing the etymology of "magazine" back to *magasin*, the French for, first, storehouse, then store, and now the modern department store. We recognize in a magazine like *The Motion Picture Story Magazine*'s multiple and various inclusions, both visual and textual—star portraits and biography, classifieds, storyizations (at times authorless), advertisements for chocolates and cheap volumes of

Shakespeare and Wharton, and all the other inclusions mentioned in this chapter—Ohmann's analogy of the mass magazines and a "profusely with miscellaneously stocked" warehouse.[103] The reader of *The Motion Picture Story Magazine*—like the department-store shopper—can readily return to their preferred departments, having familiarized themselves with the exact location of each item. Just like this shopper, the reader of literature in motion reads amid the "competing stimuli" of the various departments found in the pages of the fan magazine and in the theaters of early-film exhibition, particularly in its variety-show contexts.[104] As Ohmann writes of the magazine/*magasin*, attractive colored covers enticed "browsers" and transformed the magazine into a commodity itself, in the same way that its editorial plugs and promotions and its advertisements did.[105] We have already seen the way the motion-picture industry marketed authors and the way it began to deploy in films such as *It* literary objects (magazine covers and pages, authors) for the purposes of product placement and brand promotion. Literary forms and digested literary narratives circulated in motion-picture fan magazines in a similar way. As literary culture—its objects and authors—became a means to promote and market motion pictures and something to be consumed by their audiences, film-fan practices converted it into a series of fashionable objects for consumption. Indeed, literature encountered within the sphere of motion pictures could be consumed quickly, as the screen grab or sound bite, and in digest form, encouraging the reader to move on to the next pleasurable course. In the end perhaps, something Stamp also ponders, "the pleasure of consuming the narrative overrides enjoyment derived from the story itself."[106]

When literature relocated into motion pictures' sites, it netted itself new readers—film fans—a vexatious turn for some, as we saw in the example of Cather's motion-picture experiences. But in a 1913 *The Motion Picture Story Magazine* column, Literature and Filmland, scenarist William Lord Wright singled out the *uplifting* effects of page-to-screen adaptations—on "young ladies" at least. Adaptations of canonical literature, Wright argues, guide women past "the temptations of the 'six best sellers' for classic authors," something evidenced, he claims, in the increased demand for Dickens, Thackeray, Scott, Stevenson and Dante: the "Dickens vogue in Moving Pictures has popularized Dickens among many thousands of new readers. . . . Who shall assert that hundreds of thousands who never have had the opportunity to read the poems of Dante, or the works of Shakespeare, are not benefited by the depiction on the screen of the works of these and other authors?"[107]

The Photoplay Philosopher made a similar observation: "Motion Pictures increase the desire to read, as is evidenced by the testimony of numerous booksellers and librarians, who state that whenever a great classic or novel has been shown in the Motion Pictures the demand for books on that subject is multiplied."[108] For one of the magazine's amateur poet-readers, motion pictures facilitated literary access for "idlers" in the same way picture books do:

> Time was when education came
> To only those who sought her out:
> The books that brought their authors fame
> We idlers never knew about.
>
> But things've changed, now children know
> The wondrous tales that Dickens wrote;
> The story folks of long ago
> Before their happy visions float:
>
> The gorgeous history of old Rome;
> The sacred one of Palestine;
> The village where Christ had His home
> Before the world knew Him divine,
>
> And all the many stories laid
> Away on dark and dusty shelves,
> The movie actors now have made
> In pictures that explain themselves.
>
> The movies give us all that's best
> In literature, if we but look,
> For, in their great scenario quest,
> They've made the world a picture book.[109]

Thanks to motion pictures' mobilization of literary narrative, readers, now also filmgoers and film fans, were able at least to acquaint themselves with "the best books" and at some speed, something that had the effect of facilitating what Bennett Cerf would call "short cuts to culture."[110] But it was exactly literature's transformation into a picture book—and its emergence *in* picture

books, if we can think for a moment of motion-picture story magazines in that way—that so appalled authors like Cather, whose publicly articulated anxiety around a mass readership I have noted. Motion pictures engendered both bad reading and bad readers unable to be trained in good reading, and who were seemingly impervious or indifferent to the reading how-to guides so popular at the time.[111] So while this magazine reader's poem, along with Wright and the Photoplay Philosopher's ponderings on the subject, may project a rosy outlook in terms of motion pictures' effects on reading and the reading public, thanks to their capacity to expand the reading public by "mak[ing] the world a picture book" and thereby "creat[ing] a taste in the public for good literature," others—authors and publishers—besides Cather were not always or nearly as sanguine. Indeed, Gertrude Atherton, following her short-lived and not so successful stint as one of Goldwyn's Eminent Authors, as we saw in Chapter 1, wondered whether moviegoers and book readers were in fact quite distinct publics, in which case moviegoers could never be relied upon to become readers—good or otherwise—and vice versa.[112] More disquieting is the story the Photoplay Philosopher relayed, in 1913, of "a well-known writer" of novels and stories for "small boys" who "recently applied to this magazine for a position as one of our staff of writers" because "Do you know you Moving Picture people have well-nigh put us fellows out of business? All the publishers have been complaining for the last few years that the small boys who used to read our lurid stories now spend their spare time at the picture shows."[113]

This theme was taken up in the more earnest venue of *The Authors' League Bulletin*, in which a columnist declared the "remarkable falling off in the reading of books" to be a result of "the enormous attendance at the motion-picture theatres. . . . [D]uring every week thousands of citizens whose recreation was light reading now prefer to patronize the new counter-attraction."[114] As far as authors were concerned then, rather than generating readers and thus demand for books, motion pictures instead threatened to transform readers into moviegoers, so contracting the literary marketplace. Lewis, once more writing from the vantage point of the mid-1930s, while generally sharing this gloomy view of the rivalry between motion pictures and literature, also found something salutary in it: "Who would read Sir Thomas Browne, or William Faulkner, if you prefer it that way, when he could be listening to Eddie Cantor or Ray Knight's Cockoos [*sic*]?"[115] The "sentimentalists whose purchases once determined the best-selling list simply are not buying books at all—they have gone off to the movies instead . . . and their proxies have

been taken over by more literate readers" with "a hugely greater selectivity on the part of the majority of readers"—which means, Lewis concluded, the reading public today is "one hundred percent more canny than that of twenty years ago."[116] And so perhaps it is after all the reader produced by motion pictures—the nibbler rather than the bookworm, as Katherine Fusco has it— who is best equipped "for the fast pace and multiple stimuli of modern life— which the early cinema both represented and constituted."[117]

Afterword

Roaming with Vachel Lindsay and Oscar Micheaux

Silent Film and the Formations of US Literary Culture has tracked the ways motion pictures came to mobilize literature so that it moved into new sites of exhibition and consumption, and into new forms. To give this study of these shared mobilities one final push, I here turn my attention once more to the subtitle of my book, *Literature in Motion*, and I do so via a brief consideration of the almost coeval perambulations during the 1910s of film-theory pioneer and prolific poet Vachel Lindsay, and race-film pioneer and prolific novelist Oscar Micheaux. Both men traveled—tramped, rode the rails—significant distances through the Midwest and South, peddling, at times in some kind of roadshow extravaganza, their poetry, novels and/or motion pictures, and in so doing, carved out circuits along which their works found new form and new audiences. Showmen in their own right, Lindsay and Micheaux traversed the highways and byways and railroads of urban and regional America in ways that mimicked or emulated motion pictures' itinerant exhibitors. Both have haunted the pages of this book to varying degrees. Indeed, it was discovering their extensive trampings several years ago that suggested an instructive analogy for rethinking the relationship of motion pictures and literature. I sensed in Lindsay's and Micheaux's respective roamings experiences that shaped their aesthetic interests and professional trajectories. In turn, their trampings—and what and how they produced and distributed during these—generate a series of associations that offer a means to understand more fully just what was going on in literary culture on the invention and development of motion pictures.

Walking, as we know, contributed to the dream of motion pictures, to the precinematic imagining that enabled their very invention. The chronophotographic studies of Eadweard Muybridge (originally a

Silent Film and the Formations of US Literary Culture. Sarah Gleeson-White, Oxford University Press.
© Oxford University Press 2024. DOI: 10.1093/oso/9780197558058.003.0006

Figure AF.1 A man walking. Collotype after Eadweard Muybridge, 1887.
Courtesy Wellcome Collection

bookseller) captured both animal (his famous galloping horses) and human
locomotion (Figure AF.1). French physiologist Étienne-Jules Marey, who
coined the term "chronophotography," also produced studies of humans
walking. Unlike Muybridge's motion series, in which each image remains
discrete, contained within a square of the larger grid, the walking body in
Marey's series "effectively disappeared and we are left with an abstract repre-
sentation of movement" (Figure AF.2).[1]

Muybridge's and Marey's, among others', chronophotographic studies,
Deac Rossell has written, posed to "the photographic community, the en-
tertainment community, the entrepreneurial community of inventors and
tinkerers, and the technical community looking to extend the remarkable
visual progress of the nineteenth century" the dream of moving pictures.[2]
For Tim Cresswell, these motion series contributed to a "wider constella-
tion of mobility," that is, those "historically specific alignments of forms and
patterns of physical movement, meanings and narratives of movement, and
distinctive practices of moving" we find in, during this period at least, the
train, hobo, horse, camera and photography, and car. Cresswell does not
explicitly mention motion pictures here but they surely belong amid the
era's constellations.[3] While motion pictures captured and projected mo-
tion, Cresswell's point that the "history of photography has been (among
other things) the gradually increasing capacity to move as part of an

Figure AF.2 Chronophotography by Etienne-Jules Marey.
Courtesy of Alamy Stock Photo.

image-making person/camera assemblage" makes sense of the motion-picture camera too.

Early exhibition practices ensured motion pictures were themselves mobile, thanks not least of all to the portability of the projector, which meant, as Haidee Wasson has written, as with the products of "the printing press . . . pictures of the world were made in one place and then traveled to various sites to be brought to life again." Indeed, "Cinema was born portable, moving from showplace to stage to fair" with "Itinerant showmen, traveling lecturers and touring entertainment troupes."[4] Before motion pictures settled into nickelodeons from around 1905, and then into dedicated movie palaces, they traveled about the countryside to nontheatrical sites such as circuses, amusements parks and fairgrounds, churches and townhalls, as well as urban vaudeville houses.[5] According to Laura Rabinowitz, the first motion pictures many Americans encountered would have "appeared as parts of shows run by itinerant lecturers and camera operators who traveled from town to town," so placing "the world within one's reach."[6]

Motion pictures, traveling with movie roadshow men around the Midwest and East mainly, were incorporated into a variety of acts that were "relatively

undifferentiated," as was characteristic of much turn-of-the-twentieth-century mass entertainment. That is to say, motion pictures were screened as simply one among a series of entertainments, and often as the program's concluding—chaser—act to accompany the audience's departure. Traveling showmen screened motion pictures, including "many of those that have come down to us as the classics of the period such as *The Rice-Irwin Kiss*, *Black Diamond Express*, *The Life of a Fireman*, prizefight reproductions," that were readily available through "the Sears, Roebuck catalogs."[7] They also produced their own motion pictures, something that was particularly common with traveling lecturers who wished to illustrate their talks. This is what explorer Edward A. Salisbury did, and it was none other than Rex Beach, one of the first authors, as we have seen, to grasp the opportunities motion pictures offered, along with Mary Roberts Rinehart, soon to join Beach at Goldwyn's Eminent Authors Inc., who accompanied Salisbury on one of his expeditions around Central America and the Caribbean and who appeared in all three of the motion pictures he made of these in 1915: *On the Spanish Main*, *Pirate Haunts* and *The Footsteps of Capt. Kidd*.[8] Beach also participated in the production of these travel films, composing their titles. What Beach and Rinehart may have recognized in itinerant motion-picture exhibition that suggested to them its capacity to disperse literature in comparably mobile form we can only speculate.

It is the more sustained, diverse—and slightly better-documented—traveling extravaganzas of Lindsay and Micheaux that provide a final opportunity to consider literature in motion. Lindsay tramped about the country between 1906 and 1912, covering vast distances while reciting his poetry in exchange for food and sometimes board. Between trampings, he composed what is considered to be the first sustained tract of film theory, *The Art of the Moving Picture* (1915)—according to *Motion Picture Magazine*, "Mr. Lindsay is the first writer to take up this great subject"—as well as a series of poems about motion-picture stars and technologies.[9] By 1924, Lindsay "had recited his poetry to over one million Americans over the course of twelve years; by the time of his death in 1931 that figure roughly would be tripled."[10]

Before setting out on his first long trek, Lindsay wandered the streets of New York City in 1905, selling, as Edgar Lee Masters recalled, "copies of his poems door-to-door for a few cents each. . . . Trading on his live presence, he advertised as follows: 'You can see me the author,'" a pitch in some ways anticipating the particular kind of literary celebrity motion pictures

would generate in subsequent decades, as we saw in Chapter 1.[11] The following year, he set out on the first of three major treks: this first in 1906, through Florida, Georgia, North Carolina and Tennessee; the second in 1908, through New Jersey and Pennsylvania; and the last in 1912, through Missouri, Kansas, Colorado and New Mexico. Fortunately for us, Lindsay documented these trampings in two volumes, which he both wrote and published out of chronological sequence. The first of these volumes is *Adventures While Preaching the Gospel of Beauty*, published in 1914, which documents his 1912 trampings "from my home town, Springfield, Illinois, across Illinois, Missouri, and Kansas, up and down Colorado and into New Mexico," and during which he carried "my *Gospel of Beauty* (a little one-page formula for making America lovelier), and my little booklet, *Rhymes to Be Traded for Bread*" as well as some of his artworks such as "*The Village Improvement Parade*, a series of picture-cartoons with many morals."[12] The volume is structured as a series of diary entries—Dan Guillory describes these as Lindsay's "spiritual home movies"[13]—interspersed with several of the poems he recited during his roamings, including some of his most famous such as "The Kallyope Yell."

A Handy Guide for Beggars, Especially Those of the Poetic Fraternity: Being Sundry Explorations, Made while Afoot and Penniless in Florida, Georgia, North Carolina, Tennessee, Kentucky, New Jersey, and Pennsylvania, published in November 1916, documents Lindsay's earlier—1906 and 1908—trampings. By this point, he had published *The Art of the Moving Picture* as well as *The Congo and Other Poems*, which included two poems about motion-picture stars, Blanche Sweet and Mary Pickford.[14] He had by this point also published *The Chinese Nightingale and Other Poems*, in which appear two additional motion-picture poems, about Mae Marsh and John Bunny, as well as, a couple of years earlier, in 1914, "The Goodly, Strange Lanterns (In praise of Edison's great invention, and in sorrow of the news that must be shown").[15] Lindsay tells us in *A Handy Guide for Beggars* that he carried with him on these earlier trampings "a little package of tracts in rhyme I was distributing to the best people: *The Wings of the Morning*, or *The Tree of Laughing Bells*."[16]

Both volumes—*Adventures While Preaching the Gospel* and *A Handy Guide for Beggars*—provide rather enchanting, and surely romanticized, stories of the labors and performances Lindsay offered in exchange for food. *A Handy Guide for Beggars* includes a particularly fascinating passage in which Lindsay reflects on the meaning of his own itinerancy, as well as on

what he deems the "the modern tramp," many of which type he encountered and observed during his travels:

> The modern tramp is not a tramp, he is a speed-maniac. Being unable to afford luxuries, he must still be near something mechanical and hasty, so he uses a dirty box-car to whirl from one railroad-yard to another. . . . The landscape hurrying by in one indistinguishable mass and the roaring of the car-wheels in his ears are the ends of life to him. He is no back-to-nature crank. He is a most highly specialized modern man.[17]

Now with motion pictures on his mind, Lindsay here composes a striking description of the boxcars that "whirl from one railroad-yard to another . . . [and] the landscape hurrying by in one indistinguishable mass." Lynn Kirby has recently argued that "no form of transport has haunted the history of cinema as much as the train"; "the cinema finds an apt metaphor in the train, in its framed, moving image, its construction of a journey as an optical experience, the radical juxtaposition of different places, the 'annihilation of time and space.'"[18] Similarly for Ian Christie: "From the carriage window to the screen was an easy transition"; "sixty years of railways had prepared people to be film spectators."[19] Bearing in mind these associations of train travel with motion pictures, it is perhaps not surprising that a particularly popular form of entertainment from around 1905 was "Hale's Tours and Scenes of the World," exhibited in "small theaters, located in real or simulated railway cars, with a screen at one end . . . and [t]ypically shot from the front of a moving locomotive, so as to give the impression that the car is proceeding down the tracks. . . . During projection, invisible personnel produced the synchronized sounds of a real railway ride"[20]—which may well have included the "roaring of the car-wheels" Lindsay heard on his wanderings.

In this same volume—*A Handy Guide for Beggars*—Lindsay also remarks on the significance for American life of the unofficial, unobserved, lesser-known connections and networks that the tramp (the "back-to-nature crank"?) marked out, and that were so integral to the workings, indeed the binding, of the nation: "wherever in our land there is a railway, there is a little path clinging to the embankment holding the United States in a network as real as that of the rolled steel."[21] Lindsay, who largely eschewed train travel (a vow he records in his 1912 pamphlet *Rhymes to Be Traded for Bread*) at least during his earlier trampings, participated in this alternative network, along which, as we will see, he performed in a mode he terms "Higher Vaudeville."

As Lindsay wound up his ambitious cross-country roamings in 1912 (he continued to roam to recite his poetry through most of the rest of his life but in less ambitious, lengthy and provisional ways), ex-Pullman porter Micheaux set out on his own travels throughout the Midwest, East, and South, selling advance copies of his novels and later, shares in his book and motion-picture company; exhibiting his motion-picture adaptations of his novels; and setting up book and film distribution networks. Beginning in the spring of 1913, he traipsed about his own small pocket of South Dakota, between Gregory, Dallas and Winner, "handing out dummy copies of Chapter One" of his as-yet unpublished first novel *The Conquest*, "and taking advance orders from friends and neighbours for $1.50 per book." According to his most recent biographer, Patrick McGilligan, Micheaux "collected 142 orders in Gregory and Dallas on his first day of pitching the book. . . . Within two weeks, Micheaux could boast fifteen hundred orders. . . . A month later he was back in Gregory flourishing 'a few advance copies'" of the novel. And so began, between late 1913 and the summer of 1915, "a long period of itinerancy" to the East and then down South, shuttling "between major towns and cities, selling *The Conquest*."[22] According to J. Ronald Green, the trip, presumably by railway, included "significant stops in Dayton, Columbus, Cincinnati, Atlanta, Memphis and New Orleans," during which the ever-canny Micheaux set up business networks that would become "important to his later success in marketing his films."[23]

Like Lindsay, Micheaux recorded—or at least dramatized—some of these travels, particularly those he undertook through the South. In his second novel, *The Forged Note: A Romance of the Darker Races* (1915), Sidney Wyeth, its author-protagonist, travels with a suitcase full of books from Dayton to Cincinnati, through Columbus and down to Atlanta (here named Attalia), hawking copies of his novel, *The Tempest: The Story of a Negro Pioneer* (standing in for Micheaux's *The Conquest: The Story of a Negro Pioneer*), and more specifically, we read on the novel's opening page, to "[attend] to matter [sic] in connection with the circulation of his work, for he is his own publisher."[24] In fact, *The Forged Note*'s unusually detailed (and admittedly rather tedious) descriptions of door-to-door sales, the hiring of agents, and establishing of distribution networks in many ways make this novel something of a how-to manual for aspiring Black booksellers. Indeed, *The Forged Note* stands out among Micheaux's other Black-author narratives discussed in Chapter 2, in that it depicts very few scenes of writing—in fact, none at all. Authorship instead encompasses a series of business practices shaped by modes of

production, sales and distribution so that, to rephrase slightly William Dean Howells, "the man of letters" in Micheaux's novel is not much more than "a man of business."[25]

On the conclusion of this eighteen-month journey, Micheaux established his Western Book Supply Company in Sioux City, Iowa, which also functioned as a base for his ongoing door-to-door sales trips.[26] And as has been well documented, and as we also saw in Chapter 2, it was not long after his lengthy travels down South that George Johnson approached Micheaux, in 1918, about adapting to the screen his—Micheaux's—most recent novel, *The Homesteader*. According to McGilligan, while considering Johnson's invitation, Micheaux insisted any adaptation of his fiction would have to circulate as a traveling extravaganza, incorporating live attractions such as musical performances.[27] Now expanding the business in 1918 to take in motion-picture production—his Western Book Supply Company became the Micheaux Book and Film Company—Micheaux took to the road again, the following year, once more traveling through the Midwest and South, and likely returning to the routes already forged while establishing his book distribution networks. This time he sojourned for only six weeks, selling stock in his new company, and doing what Johnson would not or could not do for him: he exhibited the adaptation of *The Homesteader*, which he ended up producing himself, as a "road-show concept." To promote *The Homesteader*'s screenings, Micheaux sometimes hired a car "to cruise black neighbourhoods trumpeting the film through a loudspeaker." He would at times also take to "the stage to host some of the major theaters, and [tenor] singer George Garner Jr., traveled with the print as well, performing operatic passages to add to the evening's entertainment. Where possible, small local orchestras or a piano man played [jazz musician] Dave Peyton's music."[28] Micheaux evidently wished to exhibit his films thus right through to the early 1930s at least; he announced in January 1931 that to exhibit *The Exile*, Micheaux Film Corporation "will seek a special road show engagement in a large number of key cities before the picture is released for general exhibition."[29] In other words, to encourage among the race what he called an "appreciation of these finer arts"—here, both literature (as adaptation) *and* the motion-picture drama—he deployed exhibition practices taken from the roadshow, where motion pictures were just one of a series of attractions.[30]

This is how Lindsay, several years earlier, had packaged his own performances of "the finer arts." He told Hamlin Garland in a 1912 letter that he "cut something of a harlequin figure" from the commedia dell'arte

while on his performance circuit.[31] Indeed, Lindsay had by this point developed his theory of the relationship—indeed the merging—of vaudeville and the "finer arts," which he termed the "Higher Vaudeville." Interested in the ways vaudeville could be deployed in support of poetry, he devised a practice of energetic recitation to implement his theory, a practice that emulated mass-marketed theatrical entertainments of the day. As his earliest biographer noted, he "had observed how vaudeville actors, with a seemingly informal presentation—they sang, spoke, acted, danced, as mood or role or expediency dictated—established a certain intimacy with their audience, and this appealed to him as democratic if not as art. Something like it, then, would perhaps afford the best possible medium for his democratic gospel of beauty."[32] And so, as Ana Massa writes, having remarked the enthusiastic and sizeable audiences of vaudeville, Lindsay built "up a recitation ritual which would mix the brash, the exquisite, the everyday, the exotic, the funny, the sentimental and the admonitory. . . . This was why Lindsay became a one-man vaudeville show, willing to don fancy dress, to sing and dance, to use refrains and to repeat lines until they became as familiar as vaudeville fall-lines and catch-phrases."[33] It was in vaudeville practices, in short, that he found an opportunity to mass-circulate his poetry. As he explained in a 1914 letter to fellow poet Jessie B. Rittenhouse, "The American people hate and abhor poetry. I am inventing a sort of ragtime manner that deceives them into thinking they are at a vaudeville show and yet I try to keep it to a real art."[34] This "ragtime manner," highly stylized, "often employ[ed] whoops, whispers, and yells as well as musical instruments and sound effects."[35] Lindsay also incorporated his (visual) artworks into his tours, as well as lectures on topical matters such as, as one program he delivered was titled, "A Talk on the Art of the Moving Picture." In other words, his poetry circulated in a way Micheaux's filmed novels would do and in emulation of the itinerant showmen who were among motion pictures' first exhibitors. In his introduction to *The Congo and Other Poems* (1915), Lindsay expressed his wish to "restore poetry to its proper place—the audience-chamber, and take it out of the library, the closet."

One of the most popular poems he performed on his Higher Vaudeville circuit—and one of his best known today—is "The Kallyope Yell," which was first published in 1913. After the poem's opening instruction for recitation— "Loudly and rapidly with a leader, College yell fashion"—the poet takes on

the voice of the calliope, that strange steam-whistling instrument we would still instantly recognize and associate with the circus and the fairground:

> I am the Kallyope, Kallyope, Kallyope,
> Tooting hope, tooting hope, tooting hope, tooting hope;
> Shaking window-pane and door
> With a crashing cosmic tune,
> With the war-cry of the spheres,
> Rhythm of the roar of noon,
> Rhythm of Niagara's roar,
> Voicing planet, star and moon,
> SHRIEKING of the better years.

In the calliope, Lindsay heard and saw all of modernity, as he wrote in one of his pamphlets: "street-car advertisements, bill boards, automobile horns, electric signs, megaphones, phonographs, motion pictures, uplift magazines, girl-and-music shows, brass bands, yellow journals, and the like"—as well as, no doubt, "the roaring of the car-wheels" of the box-car. But while the calliope may be, as he writes in "The Kallyope Yell," the "Music of the mob," importantly it also "stands for many deeper, finer things as well"; it is "the thread of silver music under the toot," he wrote in 1916—and thus the Higher Vaudeville.

In preparation for his live poetry performances, from 1916 onward at least, Lindsay sent ahead a self-published pamphlet, *A Letter About Four Programmes*, as well as copies of the poems to be performed, which he hoped would be distributed among public libraries, interested societies and "the English teachers of the local High School or College" who seem to be "my natural allies." As the title of the pamphlet indicates, he offered a choice of four different programs on this particular circuit: "The Gospel of Beauty," which he advised was best for art schools and art departments; "A Talk on the Art of the Moving Picture" (named for his book of film theory published the previous year, and which included a discussion of a "recent book on the motion picture");[36] "An Evening of Higher Vaudeville, and Orthodox Verse"; and "The Chinese Nightingale and Dramas for Impromptu Actors." A separate section of the pamphlet, "The Hieroglyphic Section," includes his own delicate ink drawings to accompany several more poems.

As part of program 1—and possibly program 2—Lindsay performed two poems about picture personalities: "To Mary Pickford Moving-Picture Actress (On hearing she was leaving the moving-pictures for the stage)" and "John Bunny, Motion Picture Comedian." In *The Art of the Moving Picture*, Lindsay claimed Pickford, along with two of the other stars about whom he also wrote poems—Marsh and Sweet—as among his muses, and declared he was "the one poet who wrote them songs when they were Biograph heroines, before their names were put on the screen."[37] In "To Mary Pickford," Lindsay laments Pickford's decision to join "that prison called Broadway," thus relinquishing the motile possibilities that motion pictures invited, enabling the screen star to shape-shift from "a free-limbed page in hose" to "Kitchen-wench another day" to "a fairy from the sun" and to "Fish-wife siren, full of lure."[38]

Reflecting on his wanderings, Lindsay found they were "full of suggestions for poems."[39] While it may be too much even to begin to claim that Lindsay's itinerant performances, and encounters with and experiences of the speed-maniac modern tramp, in any way generated his thinking about motion pictures—in these poems or in, for that matter, *The Art of the Moving Picture*—it is perhaps not too much at least to find instructive analogies for thinking about the new circuits mass-marketed popular entertainments, including motion pictures, opened up for literature. By the early 1920s, "caught in a circuit of production and consumption that he wanted, but could not afford, to escape," as Tyler Hoffman puts it, Lindsay grew increasingly impatient with his life as an itinerant showman, now not only riding the rails but the Pullman coach too: "I have been looking out standardized windows of 'The Flat-Wheeled Pullman Car.' I have been living in standardized hotels, have been eating jazzed meals as impersonal as patent breakfast-food." Notwithstanding Lindsay's frustration with what he regretted was his "Barnumised" fate, I find in the roamings of these two author-showmen, Lindsay and Micheaux, as different in kind and in objective as they may be, a commitment to sharing widely and to promoting the "finer arts" packaged in the mode, within a broader program, of vaudeville amusements—musical performance, highly charged recitation, illustrations, motion pictures, lectures.[40] This commitment suggests something about literature after motion pictures, literature in the postliterary landscape, as it moved along circuits opened up by and shared with vaudeville performance, including itinerant motion-picture exhibition.

In fine, Lindsay's and Micheaux's roamings offer up a model of sorts for thinking through a little further literature in motion, literature newly inserted into the spectacular and mobile world of motion pictures. Henry Seidel Canby described in his memoir a performance Lindsay delivered at Yale around 1920, during which he recited two of his most famous Higher Vaudeville poems, "The Congo" and "General William Booth Enters Into Heaven," swinging to "persuasive rhythms." To this audience, Canby recalled, it was "only a show . . . not literature as they had been taught to regard literature."[41] This might, in the end, be the very story of literature in thrall, hitched, to motion pictures that this book has told.

Notes

Introduction

1. James, "The Future of the Novel," xi.
2. For comprehensive accounts of these transformations, see Lichtenstein, "Authorial Professionalism and the Literary Marketplace"; Ohmann, *Selling Culture*; Wilson, *Labor of Words*; and West, *American Authors and the Literary Marketplace*.
3. On literary access, see Brodhead, *Cultures of Letters*.
4. Wilson, *Labor of Words*.
5. Olsson, *Los Angeles before Hollywood*, 322.
6. Watson, *William Faulkner and the Faces of Modernity*, 100; Goble "Faulkner at the Speed of History," 160.
7. Kaestle and Radway, "Framework for the History of Publishing and Reading," 20–21.
8. Fusco, *Silent Film and U.S. Naturalist Literature*; Wutz, *Enduring Words*.
9. Norris, *McTeague*, 337. For an account of Norris' arguably anachronistic use of the kinetoscope here, see Litton, "The Kinetoscope in *McTeague*," esp. 107–11.
10. Garland, *Hesper*, 223.
11. Seed provides a particularly useful overview of literary depictions of Black and white moviegoing in *Cinematic Fictions*.
12. Blackton, "Literature and the Motion Picture," xxv.
13. Garland is quoted in Kilmer, "Says New York Makes Writers Tradesmen," 13.
14. Jones, "Motion Pictures and Inside Facts," 19.
15. McGill, "Literary History, Book History, and Media Studies," n2, 176.
16. Wilson, *Labor of Words*; Auerbach, *Male Call*; and Glass, *Authors Inc.*
17. Auerbach, *Male Call*, 2.
18. London, "To Joseph Noel, October 9 1913."
19. Birchard, "Jack London and the Movies"; Clayton, *Literature and Photography in Transition*, 130–163; Fusco, *Silent Film and U.S. Naturalist Literature*; and Williams, "War of the Wolves." Orgeron's chapter about London in *Hollywood Ambitions* comes closest to my own project here. In her analysis of London's engagement with motion pictures, Orgeron finds "something in the culture of authorship was changing, and the shift was at least partly a reaction to the motion picture industry" (p. 73).
20. On the Hollywood novel, see Eaton, "What Price Hollywood?" The scholarship about page-to-screen adaptation is too vast to list here, but see Murray's excellent, *The Adaptation Industry*. For scholarship about authors in Hollywood, see Fine's *West of Eden*, and scholarship about the Hollywood experiences of individual authors such as William Faulkner and F. Scott Fitzgerald. Slide's *They Also Wrote for the Fan*

Magazines is an excellent collection of motion-picture-magazine articles by (soon-to-be) established literary authors such as e.e. cummings. On screenwriting and the screenplay, see Price, *History of the Screenplay*.

21. For a useful overview of the many scholarly approaches to the relationship of literature and film, see Forster, *Modernism and Its Media*, 27–70.

22. There are important exceptions to these broad generalizations. See, for example, Dabashi's chapter on Nella Larsen in *Losing the Plot*.

23. Murphet, "New Media Modernism," 210.

24. Gunning, "Cinema of Attractions." On film's transitional era, see Hansen, *Babel and Babylon*, esp. 60–89, as well as Keil and Stamp, ed. *American Cinema's Transitional Era*.

25. Beach, *Personal Exposures*, 113–14.

26. Bentley, *Frantic Panoramas*, 10. Foltz makes a similar point: "although most critical accounts of the relationship between film and literature stress their antagonistic relationship as competing media, the model of competition is hardly adequate to describe this reality"; Foltz, *Novel after Film*, 13.

27. Bentley, *Frantic Panoramas*, 6.

28. Bentley uses "postliterary" to describe that "era when literary culture could no longer presume to be the implicit model of the public sphere"; *Frantic Panoramas*, 5.

29. Stempel, *Framework*, 3.

30. Hammill, *Women, Celebrity, and Literary Culture*, 7. See also Ardis, "Making Middlebrow Culture," 20; Felski, *Gender of Modernity*, 25; Goldstone, "Modernist Studies without Modernism"; Hayot, "Against Periodization"; and Bluemel's introduction to *Intermodernism*.

31. See also Collier, *Modern Print Artefacts*, 236–42.

32. To my knowledge, Brower is the only other scholar who has written on Barton's film. See his introduction to *Classical Hollywood, American Modernism*.

33. Movie stars were first known as "picture personalities" on the emergence of the star system. See deCordova, *Picture Personalities*.

34. Quoted in Giles, "Ralph Barton," 131.

35. Blackton, "Literature and the Motion Picture," xxvii–xviii.

36. Bosworth, "To Jack London, September 15 1913."

37. Garbutt, "To Jack London, September 10, 1914."

38. Baetens, *Novelization*, 8.

39. See also Hoyt, *Ink-Stained Hollywood*; Abel, *Menus for Movieland*.

40. For example, Glass, *Authors Inc.*; Jaffe, *Modernism and the Culture of Celebrity*; Moran, *Star Authors*; Harris, *On Company Time*; Volpicelli, *Transatlantic Modernism and the US Lecture Tour*.

41. Olsson is the only scholar, to my knowledge, even to broach the topic of on-screen author cameos, in *Los Angeles before Hollywood*, 331–33.

42. Bentley, *Frantic Panoramas*, 206.

43. I take this phrase from Nowlin's *Literary Ambition*. Black literary ambition, he writes, "originates in the experience of literature, and 'literature' as these [Jim-Crow era] writers generally experienced it was predominantly white and European," 2.

44. Jones, "Moving Pictures Offer the Greatest Opportunity," 6.

45. Johnson, "Dilemma of the Negro Author."
46. Butters, *Black Manhood on the Silent Screen* 198.
47. Gaines, *Fire and Desire*, n26, 278.
48. Foltz, "Writing of Circumstance"; Baetens, *Novelization*.
49. According to *The Competitor*'s 1921 "salutatory," quoted in Dahlinger, "Rising Tide of Color," 72.
50. Bentley, "Mass Media and Literary Culture," 192.

Chapter 1

1. Blackton, "Yesterdays of Vitagraph," 28; Hansen, *Babel and Babylon*, 70.
2. "Well-Known Authors"; "Authors in the Movies."
3. This was the title of a film Vitagraph and the league had initially intended to produce. See "Well-Known Authors."
4. London, "To Joseph Noel, September 4, 1913."
5. See, for example, Cartmell ed., *Companion to Literature, Film, and Adaptation.*
6. Beach, *Personal Exposures*, 183.
7. "Well-Known Authors."
8. Howells, "Editor's Study."
9. Bentley, *Frantic Panoramas*, 42. For a more extended discussion of the study, see Bentley, "Museum Realism," 83–89.
10. Bentley, *Frantic Panoramas*, 44.
11. Orgeron, *Hollywood Ambitions*, 72.
12. Wutz, *Enduring Words*, 12
13. Seed, *Cinematic Fictions*, 24, n59.
14. Beach, *Personal Exposures*, 115. See also Evans, "He Rolled Up His Sleeves." At around this same time, Zane Grey founded a company to produce adaptations of his own works, such as a 1926 adaptation of his 1913 novel *Desert Gold: A Romance of the Border*. The Grosset and Dunlap photoplay edition of this novel, held in the Library of Congress, includes on its title page "Illustrated with Scenes from the Photo Play produced by Zane Grey's own company." And in 1934, Edgar Rice Burroughs likewise formed his own motion-picture production company to produce his Tarzan narratives. See Seed, *Cinematic Fictions*, 18.
15. Hughes, "At Home in Hollywood," 30, 62.
16. Yezierska, "This Is What $10,000 Did to Me," 41.
17. Beach, "To Hamlin Garland, September 2, 1913."
18. Garland, *My Friendly Contemporaries*, 14.
19. Uricchio and Pearson, *Reframing Culture*, 3.
20. Beranger, "Story," 142. See also Ennis, "Them Were the Happy Days."
21. According to Yumibe, applied color techniques, derived from magic-lantern slides and photography, "were common in the cinema through the mid-1920s," *Moving Color*, 3.
22. Garland, "Suggestions for Tinting."

23. Brady, "To Hamlin Garland, April 20, 1916."

24. Garland, *My Friendly Contemporaries*, 123–24.

25. Blackton, "To Hamlin Garland, April 18, 1917."

26. Garland, Vitagraph Contract.

27. Staiger, "'Tame' Authors and the Corporate Laboratory," 34.

28. According to Staiger, the screenplay, "which seemed so vital to the sound period of the 1930s and 1940s actually was a well-established procedure by at least 1915—in conjunction with the diffusion of the multiple-reel film"; Staiger, "Blueprints for Feature Films," 192.

29. For accounts of these on-site writing departments, see Stempel, *Framework*; Eaton, "What Price Hollywood?"; Price, *Screenplay*; and Bordwell, Staiger, and Thompson, *Classical Hollywood Cinema*, 165f.

30. Coffee, *Storyline*, 26.

31. Atherton, *Adventures of a Novelist*, 544.

32. Eaton, "Butchering Brains," 28–29.

33. "General Purpose of the Authors' League."

34. Beach, "Editor's Note," 5.

35. Beach, "Photo Plays," 6.

36. Beach, *Personal Exposures*, 112.

37. The case hinged on "the decision of a Los Angeles court upholding the contention of a moving picture company that once a story is printed, either serially or as a book, the copyright becomes void and the story is public property, to be dramatized, produced as a moving picture, or reprinted"; "Authors League to Test Copyright Law."

38. Blackton, "Literature and the Motion Picture," xxv, xxvi–xxvii.

39. Sargent, "Photoplaywright," 837.

40. Decherney, *Hollywood's Copyright Wars*, 54–55.

41. Hansen, "Early Silent Cinema," 151.

42. "Authors for Mutual Film." Edison Inc.'s scenario guidelines are held in the "Edison Manufacturing Co., scripts," Film Study Center, Museum of Modern Art, New York City.

43. "What Is the Matter with Your Motion Picture Scenario?" 14.

44. Pollock, "Author in Blunderland."

45. Griffith is quoted in Smith, "Belasco of the Motion Picture Art," 261.

46. London, "Message of Motion Pictures," 106. London's article first appeared in *Paramount Magazine* in February 1915.

47. Garland, *Crumbling Idols*, 8, 189–90.

48. Dixon, "Hope of the World," 8, 14.

49. Beach, *Personal Exposures*, 184.

50. Authors' League of America Year Books.

51. Osbourne, "To Theodore Dreiser."

52. London, *Hearts of Three*, v–vi. See Orgeron, *Hollywood Ambitions*, 88–97, for a more detailed account of the composition and plot of *Hearts of Three*, which first appeared in book form in 1918, after London's death in 1916, and was then serialized in the *New York Evening Journal* and *Oakland Tribune* in 1919. The Huntington's Jack

London Papers indicate that he began work on this project in late October 1915; see London, "To James Sisson, Oct 28, 1915." However, he may have begun planning it a year earlier; see London, "To James Sisson, Nov 1, 1914": "Will I retain book rights second serial rights on my novelization of moving picture play"—surely a reference to *Hearts of Three*.

53. "Report of Motion-Picture Committee," 16, 22–23.
54. Hampton, "Author and the Motion Picture," 221.
55. York, "Plays and Players," August 1919, 130.
56. "Famous Authors with Universal." As Brower has noted, several studios followed suit: "Metro Pictures advertised its stable of writers as early as 1920, and Famous Players-Lasky followed in 1921 by hiring sixteen authors of repute, among them Elinor Glyn, W. Somerset Maugham, Samuel Merwin, and Gilbert Parker, to write original scenarios (see *Exhibitors' Herald* 1921)." Brower, "'Written with the Movies in Mind,'" 250.
57. An advertisement in the June 1921 issue of *Photoplay* announced "The Greatest Living Authors Are Now Working with Paramount" and reminded readers that in motion pictures, "'The Play's the Thing'. . . . It is by the genius of great authors that plays are created"; "The Greatest Living Authors Are Now Working With Paramount."
58. Beach, *Personal Exposures*, 6.
59. Hughes, "At Home in Hollywood."
60. "Eminent Authors Pictures Formed."
61. "Announcing Eminent Authors Pictures."
62. Atherton, *Adventures of a Novelist*, 543–44.
63. Prescott, "Books of the Times"; Rothman, "An Artist Unfrozen." For an account of Yezierska's experiences in Hollywood, see Botshon, "Anzia Yezierska and the Marketing of the Jewish Immigrant."
64. See Lewis and Lewis, "Include Me Out," 133.
65. "Good Production and Some Thrills." The "Exhibitors' Reports on New Releases" in the November 6, 1920, issue of *Motion Pictures News* described it as "an average picture."
66. Atherton, *Adventures of a Novelist*, 525.
67. Leider, *California's Daughter*, 287.
68. "Rex Beach to Samuel Goldwyn, September 25, 1921."
69. "Announcing Eminent Authors' Pictures."
70. Hampton, "Author and the Motion Picture," 221.
71. Goldwyn, *Behind the Screen*, 251.
72. Berg, *Goldwyn*, 96.
73. Goldwyn, *Behind the Screen*, 243.
74. Maugham, "On Writing for the Films," 675.
75. Mayer, *Merely Colossal*, 11.
76. This clause was included in all the contracts between Goldwyn and the (original) Eminent Authors. The contract I cite here is Rupert Hughes'. Hughes, "Contracts."
77. *Los Angeles Tribune* April 26, 1913, n.p.

78. London, "To Hobart Bosworth July 30, 1913." The Huntington Library holds over fifty-four photographs of London taken between 1896 and 1916. As Reesman et al. remind us, London was himself an accomplished photographer, producing nearly twelve thousand photographs during his lifetime, some of which were used in newspaper and magazine stories and in his books *The People of the Abyss* and *The Cruise of the Snark*. See Reesman, Hodson, and Adam, *Jack London*, esp. the introduction, 1–24.

79. See, for example, Advertisement for *The Sea Wolf*.

80. London, "To Frank Garbutt, Jan 26, 1915." London mentions writing on board the *Roamer* near Angel Island; see London, "To Frank Garbutt, October 7, 1914." See also London, "To Frank Garbutt, September 30 1914."

81. Wilson, *Labor of Words*, 94.

82. Bosworth Inc. Presents John Barleycorn: " 'John Barleycorn' is distinguished by a close view of Mr London on his yacht, 'The Roamer,' " 4.

83. Bosworth Inc. Presents John Barleycorn, 4.

84. Bosworth, "To Charmian and Jack London, 1914 Jan 1."

85. "Jack London himself appears in the picture [Bosworth's 1914 film adaptation of *The Valley of the Moon*] overlooking his ranch at Sonoma from the same cairn on which Saxon and Billy, the main figures who stalk through the picture, stand when they get their first glimpse of 'The Valley of the Moon' "; review of *The Valley of the Moon* (dir. Bosworth, 1914), *Fresno Californian Republican*, July 20, 1914, quoted in Williams, *Jack London*, 34; Los Angeles Tribune, April 26, 1913.

86. Bentley, *Frantic Panoramas*, 44.

87. Goble, *Beautiful Circuits*, 90.

88. Andersen, *Stars and Silhouettes*, 38.

89. See for example, Andersen, *Stars and Silhouettes*, 49, and Withalm, "The Self-Reflexive Screen," 132.

90. See Olsson, *Los Angeles before Hollywood*, 326, 332, 340. See also Salt, *Film Style and Technology*, 90–91.

91. *Los Angeles Tribune*, April 26, 1913; Glass, *Authors Inc.*, 24.

92. Bosworth Inc. [Publicity Release]. According to a May 1913 clipping from the *Louisville Times*, in London's scrapbook, his Balboa Amusement Producing Company "contract also calls for this appearance in at least 300 feet [in] each picture"; see London, Scrapbooks, Vols. 12, 13, 14. Bosworth Inc. [Publicity Release]; *Los Angeles Tribune*, April 26, 1913.

93. Decherney, *Hollywood's Copyright Wars*, 36.

94. Ayres, "To Jack London, June 2, 1913."

95. "From Authors League of America, November 19, 1913"; the name of the recipient is not included. There is a lot of scholarship about the London and Balboa case. See, for example, Orgeron, *Hollywood Ambitions*, and Williams, "War of the Wolves." Orgeron usefully summarizes the case: "London broke his initial April 29, 1913, contract for exclusive motion picture rights with the Balboa

Amusement Company when they failed to produce the number of films they had initially promised, initiating years of legal battles between the two"; *Hollywood Ambitions*, 74.

96. Bosworth, Telegram, Oct 13, 1913. H. M. Horkheimer founded Balboa Amusement Producing Company.

97. Bosworth Inc. Presents John Barleycorn.

98. Brégent-Heald, *Borderland Films*, 69.

99. Codori, liner notes to *Little Orphant Annie*.

100. van Allen, *James Whitcomb Riley*, 258. According to Moran, there were similarly "many products manufactured in [Mark Twain's] name, including postcards, cigars, tobacco, whisky, a patented self-pasting scrapbook and a board game"; *Star Authors*, 23.

101. Other author cameo appearances of the period include those by Arthur Conan Doyle and Irvin S. Cobb in the 1914 Reliance serial *Our Mutual Girl*; while the fifty-two-part serial is no longer extant, surviving stills include one of Cobb. Charles E. Van Loan appeared in at least one of the 1915 adaptations of his *Buck Parvin and the Movies: Stories of the Moving Picture Game*. According to T. S. Mead's 1915 review of "Man Afraid of His Wardrobe" (American-Mustang), an adaptation of one of these stories, "American Film Manufacturing Company will start to release every third week a three-reel picture based upon the series of Charles E. Van Loan's 'Buck Parvins'. . . . From the time that Charles E. Van Loan, the author of these stories, is seen in the act of conceiving the idea of their being put on the screen, the action does not lag for one moment during the three reels"; Review of "Man Afraid of His Wardrobe."

102. Méliès' 1907 short "La mort de Jules César (Shakespeare)" ("Shakespeare Writing 'Julius Caesar'") is generally considered the first motion picture to represent literary authorship; it depicts Shakespeare (played by Méliès himself) at his desk struggling to write *Julius Caesar*'s assassination scene. Bosworth's 1913 adaptation of London's *The Sea-Wolf* may well have included scenes of authorship since the novel's protagonists, Humphrey Van Weyden and Maude Brewster, are both authors. The film is no longer extant.

103. It probably worked both ways. Jack London's scrapbooks include clippings about Beach, indicating London watched Beach's career quite closely. See London, Scrapbooks.

104. Glyn, *Romantic Adventure*, 193.

105. Beach, "Spoilers."

106. Campbell, *Spoilers*, American Film Institute Catalogue notes. See also Slide, "Commentary."

107. See Cummings and Kuhn, "Elinor Glyn."

108. Glyn's "It" was first published in the 1927 February and March issues of *Cosmopolitan* magazine. It was then published as a novella as *It: The Romance of a Little Sister of the Rich* with illustrations, and then as *It and Other Stories* in the United Kingdom and

as simply *It* in the United States. For an account of the different versions of Glyn's story, see Barnett and Weedon, *Elinor Glyn*, 133–35.

109. Stead, *Off to the Pictures*, 170. Her source is E. Glyn (1926b), "Sequence Synopsis of IT by Elinor Glyn," Elinor Glyn Collection, University of Reading, Special Collections, University of Reading MS 4059.

110. There remains some confusion about the dates on which the novella appeared in *Cosmopolitan*. See Barnett and Weedon, *Elinor Glyn*, 134–35. The Elinor Glyn holdings in the University of Reading's Special Collections clarify that the first installment was published in the February 1927 issue and the second, in the March 1927 issue.

111. This is in turn a reworking of the definition Glyn provides in "It" as it appeared in *Cosmopolitan* in the February 1927 issue.

112. Bosworth, "To Charmian and Jack London, 1914 Jan 1."

113. Andersen, *Stars and Silhouettes*, 49.

114. Mayer, *Merely Colossal*, 11.

115. Letters to the Editor, *Motion Picture Story Magazine*, December 1913, 170.

116. Staiger, "'Tame' Authors and the Corporate Laboratory," 41.

117. "Eminent Authors Pictures Formed," 1469.

118. See, for example, "*Pardners* by Rex Beach."

119. Hampton, "Author and Motion Pictures," 221.

120. "'The Barrier' a Success without a Big Star."

121. "'The Barrier,'" *Film Daily*.

122. Beach, *Personal Exposures*, 116

123. Beach, *Personal Exposures*, 199.

124. "Rex Beach and Samuel Goldwyn Announce First Seven."

125. "Feature the Author."

126. "Goldwyn Makes Its Start on Advertising Campaign."

127. Hughes, "Early Days in the Movies," 120.

128. Orgeron, *Hollywood Ambitions*, 25, 24.

129. "Well Known Artists of Stage and Screen."

130. Andersen, *Stars and Silhouettes*, 16.

131. Goldwyn, *Behind the Screen*, 235. Film historians generally agree the star system emerged around 1909 with Florence Lawrence at Carl Laemmle's Independent Moving Pictures Company; see, for example, Shail, *Origins of the Film Star System*, 158 and 164, as well as chapter 2 for an excellent account of the emergence of the star, and chapter 3 for its development.

132. Glass, on Jack London, in *Authors Inc.*, 25.

133. Adriaensens, "Winnifred Eaton."

134. "Authors Urged to Write Photoplays."

135. Adriaensens, "Winnifred Eaton."

136. Petrie, *Templates for Authorship*, 99.

137. Petrie, *Templates for Authorship*, 85.

138. "The 'Author's Author' Voting Contest Final Results."

139. "Mutual News," unnumbered page following 1135; "On Mutual Schedule."

140. Atherton, "Contracts and Copyright," 4.
141. Atherton quoted in Pollock, "Authors Strike," 104.
142. Atherton, "Agreement."
143. "More Eminent Author Films."
144. Atherton's thirteen-page typed synopsis, "Noblesse Oblige," is extant. The film of it, *Don't Neglect Your Wife*, is not. Atherton, *Adventures of a Novelist*, 543.
145. "'Don't Neglect Your Wife' (Goldwyn)."
146. "Goldwyn Induced America's Authors to Cooperate."
147. "'Don't Neglect Your Wife' (Goldwyn)."
148. "Screen: A Novel in the Mill."
149. Quoted in Leider, *California's Daughter*, 287.
150. Although the contract explains that its use of "Producer" throughout refers to Goldwyn as well as Beach, who headed up the Eminent Authors Inc., it may well have been Goldwyn who approved the alterations to Atherton's synopsis; like Atherton, Beach was an author of historical fiction and would have had a good sense of the expectations of Atherton's moviegoing readers.
151. Atherton, *Adventures of a Novelist*, 525–26.
152. According to Advertisement for *The Woman Accused*.
153. Leider, "'Your Picture Hangs in My Salon,'" 336, 333.
154. Leider, *California's Daughter*, 5
155. Petrie, *Templates for Authorship*, 103.
156. "Ten Writers Filmed for Use in Para. Picture."
157. Andersen, *Stars and Silhouettes*, 31.
158. Andersen makes a comparable observation about the instantly recognizable "abstract silhouette" of Alfred Hitchcock that introduced the television program *Alfred Hitchcock Presents* in the 1950s and 1960s. Andersen, *Stars and Silhouettes*, 16.
159. Stein, *Autobiography of Alice B. Toklas*, 129.
160. Stein, "To Carl Van Vechten, April 2, 1935," 423.
161. Stein, *Play Called Not and Now*, 442.

Chapter 2

1. Allen, "Relocating American Film History," 71.
2. Howells, "Mr. Charles W. Chesnutt's Stories," 700; Howells, "Introduction," xvi. Howells, "To Mr. David Douglas, February 4, 1897," quoted in Jarrett, *Paul Laurence Dunbar*, 234. On "widespread calls for the production of a literature by black Americans," see Warren, *What Was African American Literature?* 16.
3. Matthews, "Value of Race Literature," 291.
4. Du Bois, "Negro in Literature and Art," 236–37. See Warren on this essay in *What Was African American Literature?* 16. See also Warren, 10–11, for his useful distinction between the indexical and instrumental objectives of Black writing of the period.
5. Gaines, *Fire and Desire*, 114, 128, 129.

6. Taylor, "Oscar Micheaux and the Harlem Renaissance," 133.

7. McHenry, *To Make Negro Literature*, 9; italics in original.

8. Nowlin, *Literary Ambition*, 9.

9. Thurman, "Notes on a Stepchild," 237.

10. Hoberman, "Building an Empire," n.p.

11. This is the subtitle to Micheaux's 1915 novel *The Forged Note: A Romance of the Darker Races*.

12. Nowlin, *Literary Ambition*, 4.

13. Du Bois, "Negro in Literature and Art," 236–37.

14. Micheaux, *Homesteader*, 401.

15. *The Wind from Nowhere*'s references to London are excised in the scenario of Micheaux's 1948 film adaptation, *The Betrayal*. While the film itself is no longer extant, the scenario is held in the State Archives of New York at Albany.

16. London, *John Barleycorn*, 242. London's memoir was published in the same year as Micheaux's first novel.

17. Intertitle from Bosworth, *Martin Eden* (1914). London, "To Houghton, Mifflin & Co. January 31 1900," quoted in Labor, Leitz, and Shepard, *Letters of Jack London*, 149.

18. London, *Martin Eden*, 454, 305, 301.

19. Micheaux, *Wind from Nowhere*, 328.

20. James Weldon Johnson, "When Is a Race Great?" *The New York Age Editorials (1914–23). Vol. 1: The Selected Writings of James Weldon Johnson*. Ed. Wilson, Sondra Kathryn. New York: Oxford University Press, 1995. 269. Quoted in Nowlin, *Literary Ambition*, 10.

21. Micheaux, *Forged Note*, 67, 260, 40–41.

22. Micheaux, *Homesteader*, 429.

23. Micheaux, *Case of Mrs. Wingate*, 91, 69.

24. Jones, "Moving Pictures Offer the Greatest Opportunity," 6.

25. Micheaux, "The Negro and the Photoplay," 11. It is unclear whether he has in mind film stories or short stories which might then be adapted to the screen.

26. Jones, "Motion Pictures and Inside Facts," 16, 19.

27. Dunbar Nelson in Hull, *Give Us Each Day*, 74–75. For a full account of Dunbar Nelson's film writings and attempts to break into the race-film industry, see Gleeson-White, "Alice Dunbar Nelson at the Movies."

28. Klotman, "The Black Writer in Hollywood," 91. Micheaux apparently adapted a novel and play of Black playwright Henry Francis Downing; see Musser et al., "Oscar Micheaux Filmography," 265, 266. Micheaux also apparently planned to film a Zora Neale Hurston story, "Vanity." However, I have not been able to find any trace of this Hurston story; see "Oscar Micheaux Filmography," 277. Micheaux was more inclined to adapt the work of white authors such as T. S. Stribling. Gaines wonders "about the contribution that Du Bois might have made to the history of African American cinema," *Fire and Desire*, 97.

29. Jones, "Moving Pictures Offer the Greatest Opportunity," 6; Jones, "Motion Pictures and Inside Facts," 16.

30. Micheaux, *Case of Mrs. Wingate*, 71.

31. Field, *Uplift Cinema*.

32. For accounts of the vexed efforts to produce *The Birth of a Race*, see Gaines, *Fire and Desire*, 97–98; Stokes, *D. W. Griffith's The Birth of a Nation*, 163–68; Cripps, "Making of *The Birth of a Race*"; and Lupack, *Literary Adaptations in Black American Cinema*, 72–75.

33. Gaines, *Fire and Desire*, 263.

34. Micheaux, *Forged Note*, 356; italics in original.

35. Fauset, *Plum Bun*, 74–75. Dunbar Nelson describes a dishearteningly similar (real-life) experience when attending a matinee with two darker-complexioned companions at the Globe Theater in Atlantic City in 1921; see Dunbar Nelson in Hull, *Give Us Each Day*, 69. Although segregation was not legislated in the North, as it most certainly was in the South, it is still the case, as Fauset's novel and Dunbar Nelson's recollection press home, that de facto segregation organized race relations there.

36. West, "Odyssey of an Egg," 109, 113. It is unclear exactly when West wrote this story; it wasn't published until 1995, in *The Richer, The Poorer: Stories, Sketches, and Reminiscences* (New York: Doubleday, 1995), a collection of West's shorter pieces composed between 1926 and 1987.

37. For important considerations of the vexed place of motion-picture theaters and film-going in Black cultural life, see Baldwin's *Chicago's New Negroes*, Caddoo's *Envisioning Freedom*, and Stewart's *Migrating to the Movies*.

38. Matthews, "Value of Race Literature," 293; Howells, "Introduction," xiv, xvi.

39. Babb, *History of the African American Novel*, 51.

40. According to Robinson and Robinson, "many performers, white and Black, enacted public recitations or sang musical settings of [Dunbar's] dialect poetry," and a number of hospitals, schools, and housing blocks were named for Dunbar; "Paul Laurence Dunbar" 225.

41. White, "Review of *The Colored American Winning His Suit*," 6. Traverse Spraggins and Reverend William S. Smith were among the company's founders. Smith, who wrote screenplays, is named in the correspondence and contracts relating to Dunbar's "The Scapegoat," held in the Dodd, Mead and Company Archive MSS0250, Special Collections, University of Delaware Library.

42. Butters, *Black Manhood on the Silent Screen*, 104. These Douglass Film Company objectives are quoted in Sampson, *Blacks in Black and White*, 118. Sampson's source is the *Frederick Douglass Film Company Press Book*, Frederick Douglass Film Company file, George P. Johnson Collection, University of California–Los Angeles.

43. Dunbar, "The Scapegoat," 7.

44. Walton, "Review of *The Scapegoat*," 6.

45. Walton, "Review of *The Scapegoat*," 6.

46. Quoted in Sampson, *Blacks in Black and White*, 181.

47. For a good discussion of Dunbar's use of dialect—and his later regrets concerning which—see Jarett, *Paul Laurence Dunbar*, for example, 381–82.

48. Walton, "Review of *The Scapegoat*," 6.

49. Adler, "Robert E. Levy and the Film Industry," 738.

50. Petersen, "'Reol' Story," 309.

51. Chesnutt, "To Oscar Micheaux, January 27, 1921."

52. Dunbar Nelson's misspelling throughout her diaries confuses Reol and Realart Pictures Incorporated. The latter was founded by Adolph Zukor in 1919 as a

subsidiary of Paramount and became "one of the leading production companies in Hollywood"; Eptin, *Bebe Daniels*, 53.

53. Hull, *Color, Sex and Poetry*, 74.

54. Dunbar Nelson produced another synopsis, "Love's Disguise," in which she also failed to interest a motion-picture producer. It tells of a young woman (of unstated race) whose face is beautiful on one side and badly disfigured on the other, as a result of which she lives a life of seclusion until she meets a doctor who promises to repair her face. He succeeds, they fall in love, and marry.

55. Dunbar Nelson in Hull, *Give Us Each Day*, 118.

56. Chesnutt, "To Houghton Mifflin, February 18, 1921," 1. Levy had written a few days earlier to Chesnutt, "I was told it was a good story which would possibly lend itself for the making of a motion picture"; Levy, "To Chesnutt, February 15, 1921." Chesnutt also hoped Reol would produce "other stories published and unpublished which would make excellent films; indeed the Micheaux people speak of wanting me to write several others for them. I imagine there is no difficulty about my writing for any one who wants my services"; Chesnutt, "To Robert Levy, February 7, 1921."

57. Chesnutt, "To Robert Levy, February 18, 1921"; Chesnutt, "To W. B. Pratt at Houghton Mifflin, February 18, 1921 [same day]"; Chesnutt, "To Houghton Mifflin, February 18, 1921"; Chesnutt, "To Reol, March 12, 1921."

58. "More Fiction," *The Nation*, June 5, 1902, 449; quoted in Daigle, "Paul Laurence Dunbar and the Marshall Circle," 644.

59. Dunbar, *Sport of the Gods*, 2.

60. Johnson, *Along This Way*, 151.

61. Dunbar, *Sport of the Gods*, 168.

62. Dunbar, *Sport of the Gods*, 88.

63. Dunbar, "Negroes of the Tenderloin."

64. Smethurst, *African American Roots of Modernism*, 115.

65. Johnson, *Along This Way*, 152.

66. The narrator describes the family as leading the life of a "typical, good-living negro"; Dunbar, *Sport of the Gods*, 2.

67. Dunbar, *Sport of the Gods*, 117.

68. Dunbar, *Sport of the Gods*, 101, 99, 102, 106.

69. Petersen, "'Reol' Story," 310.

70. Adler, "Robert E. Levy and the Film Industry," 737. According to Slide in *The New Historical Dictionary of the American Film Industry*, 63, the Ideal Company of Hollywood was the Hollywood branch of the Éclair Company of Fort Lee, NJ.

71. Petersen, "'Reol' Story," 308.

72. *Chicago Defender*, "'Sport of the Gods': Dunbar Feature," 7; *Chicago Defender*, "'Sport of the Gods': Great Production," 6.

73. *Chicago Defender* (Big Weekend Edition), "Reol Co.," 4.

74. Beach, *Personal Exposures*, 116.

75. Robinson and Robinson, "Paul Laurence Dunbar," 215–16.

76. Thurman, "Negro Poets and Their Poetry," 209; Thurman, "This Negro Literary Renaissance," 247.

77. Thurman, "To Bill [William Jourdan Rapp], 1929," 141.

78. The Lafayette Players were based in Los Angeles between 1928 and 1932, performing at the Lincoln Theater to take advantage of the "great demand for colored shows here"; Thurman, "To Bill [William Jourdan Rapp], 1929," 141. See also Adler, "Robert E. Levy and the Film Industry," 738. Thurman was equally dismissive of the Lafayette Players, describing them in this same letter to Rapp as "soaked in the ordinary stock melodrama . . . and how these Negro actors do act in" "the tenth rate melodramas written for whites," in which he had seen them perform.

79. Thurman, "To Bill [William Jourdan Rapp], 1929," 141.

80. See Dyja, *Walter White*, 98l; Janken, *White*, 111; and Cripps, *Slow Fade to Black*, 267. According to Cripps, James Weldon Johnson sold the motion-picture rights to his song "Lift Every Voice and Sing," 267. See McKay, *Long Way from Home*, 273.

81. Thurman "To Langston Hughes," 109 (c. mid-1926).

82. Thurman, "To Rapp [William Jourdan Rapp], July 1929," 145; Thurman, "To Langston Hughes, c. May–June 1929," 119.

83. Thurman "To Bill [William Jourdan Rapp], Saturday," 135; Thurman "To Bill [William Jourdan Rapp], Tuesday, August 13, 1929," 157. Thurman's correspondence with Rapp and Hughes in mid-1929 (in Thurman, *The Collected Writings of Wallace Thurman*) provides invaluable insights into Hollywood at this time, particularly the place of Black authors and Black-cast films.

84. Thurman, "Cordelia the Crude," 302. By the mid-1920s, the Roosevelt Theater had "abolished race restrictions that consigned Black audience members to a specific part of the theater"; see Frymus, "Black Moviegoing in Harlem," 87–88, 96.

85. Nowlin, *Literary Ambition*, 98.

86. Thurman's dream may have been prompted by *L'Inferno* (1911), an Italian "international blockbuster," according to Alicia Fletcher in her essay about the film for the 2019 San Francisco Silent Film Festival. She also notes it included a "preponderance of naked flesh."

87. Thurman, "Notes on a Stepchild," 235.

88. Johnson, *Along This Way*, 152; Nowlin, *Literary Ambition*, 98.

89. Hughes, *Big Sea*, 235.

90. Geltzer, *Dirty Words and Filthy Pictures*, 104.

91. *Hollywood Reporter*, "Foy Writer Arrives," 7.

92. Thurman, "To Harold Jackman, postmarked 13 March 1934," JWJ MSS 12 James Weldon Johnson-Wallace Thurman Papers, Beinecke, Yale; quoted in van Notten, *Wallace Thurman's Harlem Renaissance*, 297.

93. West, "Elephant's Dance," 174.

94. Thurman, "To Langston Hughes, February 1934," 129. This is the sort of diction— of slavery—that Faulkner used around this time to describe his own experiences in Hollywood; see Gleeson-White, *William Faulkner at Twentieth Century-Fox*, 40. Thurman, "To Harold Jackman, March 13, 1934"; quoted in van Notten, *Wallace Thurman's Harlem Renaissance*, 297.

95. Fine, *West of Eden*, 92.

96. Gleeson-White, *William Faulkner at Twentieth Century-Fox*, 8.

97. On Black-authored white-life narratives, see Li, *Playing in the White*. She mentions *The Interne* very much in passing, 202.

98. Lederer, "Repellent Subjects," 91.

99. *Hollywood Reporter*, "Foy's 'High School Girl' Just a Moral Preachment."

100. Wilbur, *High School Girl*.

101. Esmond, untitled document, June 19, 1932. Esmond was the director of the Motion Picture Division of the New York State Education Department.

102. Esmond, "To Hal Hode, Columbia Pict. Corp., NYC, November 16, 1934"; emphasis in original.

103. *Variety*, "B'ham Ban on 'High School Girl' First in a Long Time," 13.

104. *Hollywood Reporter*, "Foy Sterilization Picture Is Dull," 3

105. *Hollywood Reporter*, "Foy's 'High School Girl' Just a Moral Preachment," 2.

106. West, "Elephant's Dance," 174.

107. New York State Department of Education, "In the Matter of the Appeal of Foy Productions, Ltd."

108. Luczak, *Mocking Eugenics*, 125.

109. These are described in Geltzer, *Dirty Words and Filthy Pictures*, 104–06. Thurman is not named in any of the documents pertaining to the censorship issues raised by the state of New York.

110. "In the matter of the application of Foy Productions," 4.

111. Wilbur, *Tomorrow's Children*, 1934.

112. " 'Tomorrow's Children', Dialogue Sheet," reel 5, p. 4.

113. Feaster, "The Woman on the Table," 353.

114. Quoted in Feaster, "Woman on the Table," 353.

115. "In the matter of the application of Foy Productions," 6.

116. See, for example, Klotman, "Wallace Henry Thurman," 269.

117. I use "pulp" as "an aesthetic classification," like Fitzpatrick, "to describe the sensational content and perceived low quality of mass-produced media in relation to hierarchical conceptualizations of taste, culture, and social order"; Fitzpatrick, *True Story*, 13.

118. *Hollywood Reporter*, "Foy Sterilisation Picture Is Dull," 3.

119. Waggoner, " 'My Most Humiliating Jim Crow Experience,' " 516. While Waggoner also mentions *The Interne*, *High School Girl*, and *Tomorrow's Children*, their objective is to discover how "Thurman redefines biomedical narratives that were mostly available to white authors," 515. In a similar manner, Luczak, in "Men in Eugenic Times," reads *Infants of the Spring* within the eugenics discourse of the 1920s. And in *Mocking Eugenics*, she examines "Thurman's growth as a black intellectual navigating a discourse of eugenically inspired racial uplift and struggling, through the use of irony and satire, against the prevalent and eugenically motivated discourses of racism and racialism," 125. She is absolutely right that "After the perusal of Thurman's early writings, his script for *Tomorrow's Children* does not read as an artistic aberration but rather as a consequence of his life-long studies of social problems framed by the science of heredity," 134.

120. Thurman, *Infants of the Spring*, 129, 168.

121. Thurman, "Grist in the Mill," 301.

122. Fitzpatrick, *True Story*, 2, 86.

123. Earle and Smith, "'True Stories from Real Life,'" 36.

124. Fabian, "Making a Commodity of Truth," 60, 56.

125. Griffen-Foley, "From Tit-Bits to Big Brother," 538; Thurman, "To Langston Hughes, c. January 1932," 128.

126. Hughes, *Big Sea*, 234.

127. Earle, "Black Writers for the Pulps."

128. Thurman, "Notes on a Stepchild," 235.

129. Thurman, "To Langston Hughes, c. January 1932," 128; Kilinski, "Macaulay," 758.

130. *Crisis*, "Editor Thurman," 292.

131. Thurman, "To Langston, c. January 1932," 128.

132. Fitzpatrick, *True Story*, 94.

133. Email exchange with Earle, February 2022.

134. Macfadden, "Reared Amidst Falsehoods," *True Story* July 1925, 1; quoted in Tell, *Confessional Crises and Cultural Politics*, 38.

135. West, "Elephant's Dance," 174.

136. Thurman, "Untitled, four pages of handwritten manuscript about tubercular patients," 1, 2.

137. Thurman—feted on the title page as "Author of INFANTS OF THE SPRING[,] THE BLACKER THE BERRY, etc."—is granted first authorship.

138. West, "Elephant's Dance," 173–74.

139. Thurman, "To Granville Hicks, January 30, 1932," 167. Thurman also mentions this "hospital novel" and "hospital play" in "To Langston Hughes, c. January 1932," 128. He adds there, "Have another book scheduled for March. An experiment. Novelization of a play I recently finished, entitled *The Interne*. Wherein Mr Thurman gives city operated hospitals particular hell. If you ever hear of me being ill, don't let them send me to any city hospital. I am sure to be given the black bottle," that is, poison for unwanted patients (p. 127). See also Thurman, "To Langston Hughes, September 1934," in which he tells Hughes he is in "the very hospital I damned and god-damned when I wrote *The Interne*. Ironic, I calls it. Or is nature finally avenging art?" (p. 131).

140. Thurman, "To Granville Hicks, January 30, 1932," 167.

141. *Hollywood Reporter*, "Thurman Novel Sold," 12.

142. Indeed, a column—"Books" by Edwin T. Grandy—in the *Hollywood Filmograph*, nominating books that would make good films, opined *The Interne* "Ought to be a big box office bet as a shimmering, shimmying shinema"; see Grandy, "Books."

143. Thurman and Furman, *Interne*, 33; and Thurman, "Untitled, four pages of handwritten manuscript about tubercular patients," 1, 2.

144. Thurman, "Untitled, four pages of handwritten manuscript about tubercular patients," 1.

145. See, for example, Halpern, "Health Care Fictions," 641–45.

146. Thurman and Furman, *Interne*, 48–49.

147. Thurman and Furman, *Interne*, 71, 115, 156–57.

148. Earle, "Black Writers for the Pulps." Another such girlie-pulp was *10 Story Book*, which just so happened to publish, in its September 1930 issue, a story by an A. Gerald Macauley [*sic*] called "Interne." I have been unable to locate a copy of this issue, and thus of this story.
149. See, for example, Thurman and Furman, *Interne*, 16, 70, 92, 188, 138, 115, 251.
150. Thurman and Furman, *Interne*, 96.
151. West, "Elephant's Dance," 173–74.
152. Waggoner's " 'My Most Humiliating Jim Crow Experience' " is a notable exception.
153. Bentley, *Frantic Panoramas*, 206.
154. Hughes, *Big Sea*, 235; italics in original.
155. Nowlin, *Literary Ambition*, 95.
156. Nowlin, *Literary Ambition*, 97; Thurman, "To Granville Hicks, January 30, 1932," 167.
157. Thurman and Furman, *Interne*, 108, 242.
158. Earle, *Re-Covering Modernism*, 123.

Chapter 3

1. For a good overview of the history of novelizations, see Van Parys, "Commercial Novelization," in which he explains that novelizations have their roots in film catalogue descriptions and synopses. See also Baetens, *Novelization*; Foltz, "Writing of Circumstance"; McLean, " 'New Films in Story Form' "; and Singer, "Fiction Tie-Ins and Narrative Intelligibility."
2. To compose *Hearts of Three*, Goddard provided London with the scenario installments, which London would then rewrite as chapters. See Orgeron, *Hollywood Ambitions* for an account of this project.
3. Baetens, *Novelization*, 1, 2.
4. Singer, "Fiction Tie-Ins and Narrative Intelligibility," 489.
5. Foltz, "Writing of Circumstance," 796. For another example of an account of novelizations that does not come out of film studies, see Baetens' media-studies approach in *Novelization*.
6. For the role of the little and big magazines, see, for example, Churchill and McKible, eds. *Little Magazines and Modernism*, and Harris, *On Company Time*.
7. Bolter and Grusin, *Remediation*, 19.
8. Hammond, "Multimedia Afterlives of Victorian Novels," 30. On the limits of remediation for understanding novelizations, see Baetens, "Novelization, a Contaminated Genre?"
9. "The Spotlight," 5.
10. Field, *Uplift Cinema*, 2.
11. [Article 2—No Title], 7.
12. Unfortunately, none of these films is extant. *A Man's Duty* survives in various print forms for example, the storyization I discuss here, as well as the synopsis—"A Man's

Full [sic] Duty"—held in UCLA's George P. Johnston Negro Film Collection. Print materials pertaining to *By Right of Birth* are held in the New York State Archives in Albany, NY. Fragments of this film, as well as print materials to do with the other films, are held in the George P. Johnston Negro Film Collection 1916–1977 at UCLA. For an account of *The Realization of a Negro's Ambition, Trooper of Troop K* and *The Law of Nature*, see Stewart, *Migrating to the Movies*, 203–208. See also Cripps, *Slow Fade to Black*, 75–83; and Butters, *Black Manhood on the Silent Screen*, 109–20.

13. "Opening of the New Angelus a Notable Success"; quoted in Everett, *Returning the Gaze*, 117.

14. Stewart, *Migrating to the Movies*, 218. For a full account of the Lincoln Motion Picture Company, see Stewart, 202–10.

15. "A Man's Full [sic] Duty."

16. Quoted in Butters, *Black Manhood on the Silent Screen*, 119. Butters' source is George Paul to Lincoln Motion Picture Company, 5 Oct 1919, LMPC file, GPJC [George P Johnson Negro Film Collection, Dept of Special Collections, UCLA]. According to Stewart, the States, which opened around 1914, was "one of the most prominent and highly publicized of the establishments catering to Chicago's Black audiences." It seated "almost seven hundred" and showed "multireel dramas screened in The Loop months before," including Griffith's *Intolerance* (1916) in November 1917. It sometimes screened race films such as *A Man's Duty*. See Stewart, *Migrating to the Movies*, 174–76.

17. Sampson, *Blacks in Black and White*, 38.

18. "A Man's Duty," September 27, 1919.

19. "Why This Magazine." Everett writes briefly of Atwood's "A Man's Duty" in *Returning the Gaze*, 148.

20. Langston, "Moral and Movies," 74.

21. Everett, *Returning the Gaze*, 148–49.

22. "An Offer."

23. The caption names her Dorothy; in the narrative she is Dorothea, yet another slippage.

24. Foltz, "Writing of Circumstance," 810.

25. Foltz is here writing specifically of the complexity of novelizations of motion-picture serials such as *What Happened to Mary* (1912). In a similar manner, Stamp finds in serial motion-picture tie-ins "intertextual viewing practices that were distinctly at odds with models of spectatorship becoming standardized in classical narrative"; *Movie-Struck Girls*, 102–03.

26. Hughes, "Patent Leather Kid." The 1927 film is extant; its six reels are held in the Library of Congress' Motion Picture, Broadcasting and Recorded Sound Division.

27. The *New York Times'* film critic Mordaunt Hall hailed it as an "emphatically human chronicle" and "well nigh perfect"; Hall, "Mr. Barthelmess at His Best." The film *The Patent Leather Kid* was one of the "best-selling" motion pictures at least up until 1938, and the film that "reached highest box office totals"; Ramsaye, *1937–38 International Motion Picture Almanac*, 942.

28. Hughes, *Patent Leather Kid and Several Others*, v.

29. "A Man's Duty," October 4, 1919.

30. "Brooks Returns."

31. Micheaux, "Negro and the PhotoPlay," 11.

32. McHenry, *To Make Negro Literature*, 6.

33. Micheaux, "Acknowledgment," in *Masquerade*, n.p.

34. *The House Behind the Cedars* "was a very faithful adaptation of [Chesnutt's] novel modernized in such a manner as not to destroy the story and at the same time making it a little more appealing," " 'The House Behind the Cedars' Shown at Royal Sunday." *Veiled Aristocrats* is likewise "modernized," no doubt a decision driven by budgetary considerations.

35. Creekmur, "Telling White Lies," 149. Italics in original. Creekmur is here characterizing Micheaux's entire career in film and literary production.

36. McGilligan, *Oscar Micheaux, the Great and Only*, 326.

37. Brawley, *Negro in Literature and Art*, 45. For an excellent overview of Chesnutt's career, see Nowlin, *Literary Ambition*, 25–48.

38. Chesnutt, "To Harry C. Bloch."

39. Micheaux, "Where the Negro Fails," and Micheaux, "Colored Americans Too Slow to Take Advantage."

40. For a detailed account of this collaboration, see Regester, "Oscar Micheaux the Entrepreneur."

41. Micheaux, "To Charles W. Chesnutt, June 17, 1921."

42. Chesnutt, "To W. B. Pratt at Houghton Mifflin, January 20, 1921."

43. Chesnutt, "To Oscar Micheaux, September 23, 1921."

44. Chesnutt, "To Oscar Micheaux, January 29, 1924."

45. Chesnutt, "Negro in Art," 29.

46. Micheaux, "To Charles W. Chesnutt, January 18, 1921."

47. Chesnutt, *House Behind the Cedars*, 292.

48. Micheaux, "To Charles W. Chesnutt, January 18, 1921."

49. Du Bois, "Opinion," 263, 266. Italics in original. For a discussion of Du Bois' role in the selection of cover designs for the *Crisis*, see Harris, *On Company* Time, 82–85.

50. Micheaux "To Charles W. Chesnutt, January 18, 1921."

51. Salvant, *Blood Work*.

52. Chesnutt, *House Behind the Cedars*, 397.

53. Chesnutt, *House Behind the Cedars*, 447–48.

54. Rauterkus, "Racial Fictions," 138, 139.

55. Chesnutt, *House Behind the Cedars*, 449.

56. Chesnutt, *House Behind the Cedars*, 455.

57. Chesnutt, *House Behind the Cedars*, 456; Micheaux, *Masquerade*, 389.

58. Micheaux, *Masquerade*, 390.

59. Micheaux, *Masquerade*, 400.

60. Gaines, "Within Our Gates," 67–88, 77, 78. Gaines' comments on Micheaux's lost 1927 film *The House Behind the Cedars* are likely in response its relevant press materials, listed in Musser et al., "Oscar Micheaux Filmography," 253–54.

61. Gaines, "Within Our Gates," 67–68, 72.
62. Chesnutt, *House Behind the Cedars*, 110.
63. Micheaux, "To Charles W. Chesnutt, January 18, 1921."
64. Smith, "Our Need for More Films."
65. Micheaux, *Masquerade*, 389.
66. On plagiarism as strategic, see Pavletich, "'. . . We Are Going to Take That Right.'" See also Gleeson-White, "Reading Plagiarism." Compare Williams: "no rhetoric of formalist innovation can mitigate the error of an author's verbatim copying from another author"; Williams, "Lie of Omission," 205.
67. Yarborough, "Introduction," e5.
68. Cripps, *Slow Fade to Black*, 345. That is to say, it was screened over three to four days only.
69. Howells wrote admiringly of Chesnutt in *The Atlantic Monthly* on the publication of *The Wife of His Youth and Other Stories of the Color Line*: "Mr Chesnutt seems to know quite as well what he wants to do in a given case as Maupassant, or Tourguenief, or Mr James or Miss Jewett, or Miss Wilkins . . . and has done it with an art of kindred quiet and force. . . . He touches all the stops, and with equal delicacy in stories of real tragedy and comedy and pathos"; "Mr Charles Chesnutt's Stories," 700.
70. Sidney Wyeth is also the name of the author-homesteader protagonist of Micheaux's autobiographical novel *The Forged Note: A Romance of the Darker Races* (1915), as discussed in Chapter 2.
71. Micheaux, *Story of Dorothy Stanfield*, 74, 81, n.p.
72. Micheaux, *Masquerade* 143.
73. Micheaux, "Acknowledgement," in *Masquerade*, n.p.
74. Holloway, *BookMarks*, 39; J. Ronald Green, in email correspondence with McGilligan, quoted in McGilligan, *Oscar Micheaux, the Great and Only*, 327.
75. Cremins, "Oscar Micheaux, Charles Chesnutt," 159.
76. Fusco, *Silent Film and US Naturalist Literature*, 87.
77. President Wilson reportedly commented, on seeing *The Birth of a Nation*, that Griffith's film was "like writing history with lightning." See Benbow, "Birth of a Quotation."
78. Corbould, "Making the Slave Anew," 39.
79. Micheaux, *Conquest*, 10, 142. While Devereaux does not name the magazines he reads, he does tell us he has read Thomas W. Lawson's *Frenzied Finance*, Ida Tarbell's *The History of the Standard Oil Company*, and Ray Stannard Baker's *Following the Color Line* in magazine form, all of which appeared in the three magazines I name here.
80. Helton et al., "Question of Recovery," 3.
81. Micheaux, *Masquerade*, 9.
82. Helton et al., "Question of Recovery," 4.
83. Chesnutt, "To Carl Van Vechten, December 1926," 224.
84. Chesnutt, "Post-Bellum—Pre-Harlem," 546.
85. Micheaux, *Story of Dorothy Stanfield*, 198.

86. McGilligan, *Oscar Micheaux, the Great and Only*, 318. He is quoting Elton Fax here, from Pearl Bowser's interview with Fax as part of the Museum of the Moving Image oral history collection; Elton Fax to Pearl Bowser, 1991, New York City.

87. For a useful overview of these debates, see Johanningsmeier, "Cather's Readers," 38.

88. The work of Ardis, Collier, Earle, Harris, Jaillant and Rabinowitz, among others likewise interested in modernism's engagements with commercial circuits, has been crucial in expanding accounts of literary modernism circumscribed by smaller-scale investments in coterie presses, bookstores, patrons and readers.

89. Ardis, "Modernist Print Culture," 814.

90. See the following bibliographies compiled by collectors: Petaja, *Photoplay Edition*; Davis, *Photoplay Editions and Other Movie Tie-In Books*; Miller, *Photoplay Editions*; and Mann, *Horror and Mystery*. Van Parys (in "Commercial Novelization") and Foltz (in "Writing of Circumstance") mention photoplay editions in their discussions of novelizations.

91. Dalbello, "Metaphysics of Replacement," 79; Hammond, "Multimedia Afterlives of Victorian Novels," 30.

92. Cather's novel was not strictly speaking the sole modernist novel to appear as a photoplay edition. But it was to my knowledge the only one to appear alongside or immediately subsequent to its original publication rather than as a novelistic afterlife, which is the case with the only other photoplay editions of modernist novels I have been able to locate: F. Scott Fitzgerald's *The Great Gatsby* (1925) and Ernest Hemingway's *A Farewell to Arms* (1929). Both novels were adapted by Paramount, in 1949 and 1936, respectively; and Grosset and Dunlap produced photoplay editions of each to tie in with these adaptations—in the case of Fitzgerald, posthumously; *The Great Gatsby* (Grosset and Dunlap, 1949; Paramount released the film in 1949), and Ernest Hemingway's *A Farewell to Arms* (Paramount released the film in 1936, with the Grosset and Dunlap photoplay edition shortly following; see Leff, *Hemingway and His Conspirators*, 181). Paramount also produced Edith Wharton's popular 1928 novel *The Children* as *The Marriage Playground* in late 1929, with Grosset and Dunlap reprinting the novel, under Paramount's new title, around that time. It is difficult to date photoplay editions with any precision since the date included on copyright pages is that of the novel's—or play's or short-story collection's—original date of publication.

93. Petaja, *Photoplay Edition*, 20.

94. Petaja, *Photoplay Edition*, 151. Photoplay editions of motion-picture serials emerged slightly earlier, in 1913, with *What Happened to Mary* by Bob Brown (Grosset and Dunlap).

95. Earle, *Re-Covering Modernism*, 6.

96. "Menace to Culture in Cinema and Radio Seen By Miss Cather." This was a report of her address to Bowdoin College on May 13, 1925. It was also reported in "Three Menaces to Human Culture: Willa Cather Names Them in Bowdoin Lecture," *Boston Evening Globe*, May 14, 1925.

97. This slogan is from an advertisement Moffat, Yard and Company placed among the back matter of their photoplay editions. Dalbello cites this notice in "Metaphysics of Replacement," 81.

98. Petaja, *Photoplay Edition*, 20.

99. This is Bentley's phrase in a discussion of Howells, James and Wharton, in Bentley, "Mass Media and Literary Culture," 194.

100. Hampton, "Author and the Motion Picture," 222. Hampton's observation echoes Frank Norris' description of the processes of a "saleable, readable, brisk bit of narrative": "First it is serialized either in the Sunday press or, less probably, in a weekly or monthly. Then it is made up into book form and sent over the course a second time. The original publisher sells sheets to a Toronto or Montreal house and a Canadian edition reaps like a harvest. It is not at all unlikely that a special cheap cloth edition may be bought and launched by some large retailer either of New York or Chicago. Then comes the paper edition. . . . Next the novel crosses the Atlantic, and a small sale in England helps to swell the net returns, which again are added to—possibly—by the 'colonial edition' Last of all comes the Tauchnitz edition" and "maybe a ninth reincarnation" by the dramatist. See Norris, "Fiction Writing as a Business," 1174.

101. Underwood, *Literary Journalism in British and American Prose*, 72. According to Mott, *Golden Book* "was well printed, without illustration but with attractive typography" and used good quality paper; *History of American Magazines*, 118. A 1926 column in *Variety* reports that so "popular are the reprint magazines . . . that 'Ainslee's,' that old standby of fiction, has also gone over to that class. The reprint idea was started by the 'Golden Book' magazine, which announced a policy of reprinting the best known stories of past and living authors. The publication was a hit from the start, with 'Famous Story' magazine and others springing up" ' "Reprints of Shorts." For a good account of *Golden Book* magazine, see Earle, *Re-Covering Modernism*, 66–68.

102. Faling, "*Lost Lady* in Hollywood," 69–70. She is drawing on "the documents constituting the *A Lost Lady* collection in the Warner Brothers Archives, University of Southern California," 73.

103. For an account of the 1934 sound adaptation of *A Lost Lady*, see Michael Schueth, "Taking Liberties," and Faling, "*Lost Lady* in Hollywood."

104. Ronning, "Speaking Volumes," 529. Ronning notes that "the first printing cover was made to stand out, and then not used again. It was pale green with the title in Cather's handwriting diagonally across the front," 525.

105. Canby, "Cytherea," 59. Reprinted in *Willa Cather: The Contemporary Reviews*, ed. O'Connor, 185.

106. Cather, "1925: Chicago," lecture delivered at the University of Chicago on November 17, 1925, and reported in " 'Machine-Made' Novel Deplored," *Chicago Daily Maroon*, November 18, 1925, and "Art Now Only Rule for Writing Novels, Willa Cather Says." *Chicago Daily Tribune*, November 21, 1925. Both articles are reprinted in Bohlke, ed. *Willa Cather in Person* and at https://cather.unl.edu/writings/bohlke/speeches/bohlke.s.05.

107. I suggest this is a still from the motion picture rather than a posed publicity shot since stills were significantly less costly to produce than were publicity shots. The whole point of photoplay editions was their relative affordability.

108. Cather, *A Lost Lady*, Vintage, 1990, 148; Cather, *A Lost Lady*, Grosset and Dunlap, 1925, 173.

109. Sonstegard, "Visual Art, Intertextuality, and Authorship."

110. Stout, "Observant Eye."

111. Cather, *A Lost Lady*, Vintage, 1990, 33, 26, 65, 71, 147, 11, 26, 135, 29. It is perhaps no coincidence that Mrs. Forrester hails from and returns finally to California, "to people of [her] own kind" (p. 132).

112. Merrill, "A Short Story Course Can Only Delay," 77, and https://cather.unl.edu/boh lke.i.21.html.

113. See Bordwell, Thompson and Smith for an account of early motion pictures' flickering effect more generally, a result of "critical flicker fusion"; *Film Art*, 10. See also Nichols and Lederman, "Flicker and Motion in Film."

114. Cather, *A Lost Lady*, Vintage, 1990, 27, 59.

115. "Mrs. Beasley was the Sweet Water central, and an indefatigable reporter of everything that went over the wires," we read; Cather, *A Lost Lady*, Vintage, 1990, 110.

116. Cather, *A Lost Lady,* Vintage, 1990, 94; my emphasis.

117. Cather, in Merrill, "A Short Story Course Can Only Delay," 77.
 "'A Lost Lady' Is Real Dramatic Gem." Cather again describes Mrs. Forrester as a miniature—as having "a delicate face laughing at you out of a miniature," in Merrill, "A Short Story Course Can Only Delay," 78.

118. Goble, *Beautiful Circuits*, 91, 93.

119. See Willis-Tropea, "Glamour Photography and the Institutionalization of Celebrity."

120. Cather was acquainted with the photographer who, it is generally agreed, instituted and developed glamor photography in the mid-1910s and through the 1920s: Edward Steichen, who photographed Cather for *Vanity Fair* in 1927. According to Willis-Tropea, from around 1915, Steichen's portrait photography came to be defined by its high stylization, sharp focus, and strong contrasts—indeed, not dissimilar to a "clean-cut cameo." See Willis-Tropea, "Glamour Photography and the Institutionalization of Celebrity," 263. See also Schueth, "Portrait of an Artist as a Cultural Icon." Schueth is interested in Steichen's "1927 *Vanity Fair* portrait of Cather [as] a key moment in defining Cather's iconic status within American culture" (p. 47).

121. Farnum, "The [sic] Lost Lady," sc. 109. Although 1925 appears on the cover sheet to the screenplay, it was composed in 1924. The date appearing on scenario covers are typically the date the scenario was filed.

122. Willis-Tropea, "Glamour Photography and the Institutionalization of Celebrity," 265; Shields, *Still*, 7.

123. Kaestle and Radway, "Framework for the History of Publishing and Reading," 17.

124. According to Ronning and Rosowski's Preface to the 1997 University of Nebraska Press Scholarly Edition of Cather's *A Lost Lady*, "Believing that a book's physical form influenced its relationship with a reader, [Cather] selected type, paper, and format that invited the reader response she sought. She preferred large type and wide margins" (p. ix).

125. Cather, "Novel Demeublé."

126. Merrill, "A Short Story Course Can Only Delay," 79.

127. Harris, *On Company Time*, 31. See also Madigan, "Willa Cather and the Book-of-the-Month Club," and Roorda, "Willa Cather and the Magazines."

128. Homestead, "Middlebrow Readers and Pioneer Heroines," 78. See also Jaillant, "Canonical in the 1930s."

129. Hal Waldo to Cather, 8 April 1923, the Helen Cather Southwick Papers (ms 77/08). U of Nebraska–Lincoln Archives and Special Collections, 8 April 1923). Quoted in Johanningsmeier, "Cather's Readers," 45–46.

130. Cather, "Nebraska."

131. Cather, "Willa Cather Mourns Old Opera House," 187. Cather also had an "interest in the Rin Tin Tin movie phenomenon of the late 1920s"; Swift, "Willa Cather in and out of Zane Grey's West," 2.

132. Faling, "*Lost Lady* in Hollywood," 70.

133. Cather, Contract, motion picture rights, 1929, Dec. 23.

134. Cather, "To M. Manley Aaron, November 29, 1929."

135. "On behalf of Willa Cather to [unknown recipient], [unknown date]."

136. Hampton, "Author and the Motion Picture," 224.

137. Cather, "To Ferris Greenslet, March 13, 1932"; Cather "Novel Démeublé." That Tanagra figurines were in some ways mass-produced complicates somewhat Cather's distinction.

138. Cather, "To Hugh King, Playmarket Inc, 1941."

139. The following year, Cather would express similar anxieties over radio: "I don't want to reach fifty million people. I don't write for fifty million people. I write for people who like to read with their eye and who like to reflect upon what they read. I am perfectly satisfied with my modest income and my modest audience. I certainly do not want to be advertised or thrust upon the fifty million"; Cather, "To Marjorie Ruth Hurtubise, 1942."

140. " 'A Lost Lady' Is Real Dramatic Gem."

Chapter 4

1. "The Cinema as Circulating Library," 492.

2. "Editorial: Proem," March 1911, 116; Musings of "The Photoplay Philosopher," February 1913, 130; Musings of "The Photoplay Philosopher," April 1912, 127.

3. Chion, *Words on Screen*, 124.

4. Merrill, "A Short Story Course Can Only Delay," 79. I only consider the reading of intertitles in this chapter when these comprise literary quotations. There is an abundance of very good scholarship about reading intertitles more broadly. See, for example, Chion's *Words on Screen*, and Dwyer's *Speaking in Subtitles*.

5. Bronstein, "How Not to Re-Read Novels," 78. Littau poses a cognate question in her reading of Charlotte Perkins Gilman's "The Yellow Wall-Paper" (1890): "If movement, or its correlative velocity, is a condition of modernity, and of cinematicity more specifically, in what respects does this condition also affect the reader?"; "Reading in the Age of Edison," 68. She also discusses Hugo Munsterberg's early interests in "the ways in which film motion can train the eye and brain to be attentive" (p. 71).

6. Abel and Rogers, "Early Motion Pictures and Popular Print Culture," 199.

7. Quoted in Haskar, "Moving Picture Audiences," 79.

8. "Moving Pictures as a Profession," *New York Daily Mirror*, September 12, 1908, 9; quoted in Musser, *Before the Nickelodeon*, 402. There is a lot of excellent scholarship about the role of motion pictures in training women, children and immigrants in American behaviors, thanks to its alleged universal language. See, for example, Abel, *Red Rooster Scare*, 118–23.

9. "I am the Universal Language," 27. Anthony Slide and others have speculated the poet was Julian Johnson, who wrote for silent movies. See Slide, *Inside the Hollywood Fan Magazines*, n6, 252.

10. About the "hard of hearing," see "Editorial: Proem," February 1911, 6, and Musings of "The Photoplay Philosopher," February 1913, 130.

11. Blackton, "Literature and the Motion Picture," xxvi.

12. London, "Message of Motion Pictures," 106–07, 104.

13. Musings of "The Photoplay Philosopher," February 1913, 130.

14. Lindsay, *Art of the Moving Picture*, 93.

Gunning, "Vachel Lindsay," 22. Gunning adds, "Although Lindsay had studied Egyptian hieroglyphics, he eccentrically believed that their imagistic quality allowed them to be directly understood; he claimed a layman could understand the Egyptian hieroglyphic text known as *The Book of the Dead*, if he or she had been watching enough movies!" (p. 24).

15. Hansen, *Babel and Babylon*, 78.

16. Singer, "Fiction Tie-Ins and Narrative Intelligibility," 489; Musser, *Before the Nickelodeon*, 394–95. See also Gunning, *D. W. Griffith*, 92.

17. Musings of "The Photoplay Philosopher," June 1912, 134.

18. "Answers to Inquiries," August 1911, 144.

19. Quoted in Musser, *Before the Nickelodeon*, 403. Musser's source is *Moving Picture World*, February 22, 1908, 143.

20. Musings of "The Photoplay Philosopher," March 1912, 138.

21. Musings of "The Photoplay Philosopher," November 1912, 142.

22. Musings of "The Photoplay Philosopher," March 1912, 138.

23. Gunning, *D. W. Griffith*, 94. On the narrator system, see esp. 10–30.

24. Hansen *Babel and Babylon*, 23, 25; Gunning, *D. W. Griffith*, 22.

25. Olsson, *Los Angeles before Hollywood*, 331.

26. Chion, *Words on Screen*, 110, 111, 115.

27. Olsson, *Los Angeles before Hollywood*, 334.

28. A note following on from the second reel of the Library of Congress' copy of Bosworth's film explains, "In the now lost footage, Martin embarrassed by his ignorance, attempts to educate himself, but runs out of money. He again has to go to sea. On the ship he writes the first of many stories that will be rejected by publishers. Later, back in Oakland, Martin becomes friends with Russ Brissenden, an as-yet unsuccessful anarchist poet. Martin goes with Russ to a socialist meeting. When Arthur learns of Martin's ties to socialism, he convinces his sister Ruth, to break with Martin. Meanwhile, Russ commits suicide before learning that some of his poetry has finally been published."

29. London, *Martin Eden*, 408.

30. The two relevant issues of *Cosmopolitan* are held in the Elinor Glyn Collection, University of Reading.

31. The magazine stories open with, "'*IT*' *is that quality possessed by some few persons which draws all others with its magnetic life force. With it you win all men if you are a woman—and all women if you are a man. Without it you take a chance—and are not certain of winning anyone, or of keeping him or here when won!*"; Glyn, "It," *Cosmopolitan*, February 1927, 44, and *Pall Mall*, April 1927, 6; italics in originals. This prefatory definition does not appear in the 1927 Tauchnitz volume, *"It" and Other Stories*.

32. Glyn, *Romantic Adventure*, 324.

33. It may seem oddly timed that the film *It* was released, in the United States at least, with the first installment of the two-part *Cosmopolitan* serial. It was likely Glyn had shown Paramount the story, even in its barest outline, before its publication in February 1927—how else could Paramount have produced a film attached to it? Barnett and Weedon make a similar observation in *Elinor Glyn*, 134.

34. Glyn, "It," *Cosmopolitan*, February 1927, 45, and *Pall Mall*, April 1927, 7.

35. Barnett and Weedon, *Elinor Glyn*, 138. Segrave defines product placement as "the deliberate insertion into the script of an entertainment film of a product, brand name, signage, verbal mention, and so on, for consideration," in *Product Placement in Hollywood Films*, 15.

36. Musings of "The Photoplay Philosopher," April 1912, 129.

37. Fuller, *At the Picture Show*" 133–49; Orgeron, "'You Are Invited to Participate.'"

38. Fuller, *At the Picture Show*, 135, 134.

39. McClain, "Film-Fiction," 380.

40. Fuller, *At the Picture Show*, 137.

41. "Editorial: Proem," February 1911, 5.

42. "The Motion Picture Story Magazine," May 1911, 10.

43. The winning author was Montanye Perry, who published more and more storyizations over the course of the magazine's life. Readers were also asked to nominate their favorite storyization as part of this same competition: "'Vanity Fair,' by a large margin," which Perry happened to write. "The Best Story Contest," March 1912, 168.

44. "Editorial: Proem," February 1911, 5.

45. On the gender of the magazine's Answer Man, see Slide, *Inside the Hollywood Fan Magazine*, 19.

46. According to Singer, storyizations and related motion-picture tie-ins more or less died out around 1918 because they "simply did not work to increase viewer interest, and that they may in fact hurt ticket sales, presumably because they gave away the story in advance." Singer, "Fiction Tie-Ins and Narrative Intelligibility," 495. A 1920 reader's letter, headed "A Plea for Surprise," to *Picture-Play Magazine*, laments the "hashed-over" stories on screen; this reader avoids reading storyizations so that she can enjoy in her film viewing "some surprise—some unfolding of the plot. As it is, there is so little to look forward to. You know in advance what is going to happen"; "What the Fans Think," 69.

47. Travis, *Reading Cultures*, 43. See also Fuller, *At the Picture Show*, 135.

48. Slide, *Inside the Hollywood Fan Magazine*, 12.

49. McClain, "Film-Fiction," 380. For a good consideration of gender, in particular *The Motion Picture Story Magazine*'s shift to target women readers as it pivoted from a motion-picture-story to a fan magazine; see Fuller, *At the Picture Show*, 133–49.

50. Wilinsky, "Flirting with Kathlyn," 35. Wilinsky is writing specifically of the Selig Polyscope Company and *Chicago Tribune* collaboration, *The Adventures of Kathlyn* (1913).

51. Musings of "The Photoplay Philosopher," October 1912, 140.

52. "Elaine in Picture," 87–96; Perry, "The Story of Elaine," 21–31.

53. McClain, "Film-Fiction," 382. Abel and Rogers find storyizations "were not usually taken from the films themselves, but from the script, a necessary move if the picture story was to appear in conjunction with the film's release"; "Early Motion Pictures and Popular Print Culture," 191.

54. "The Golden Supper." The storyization was replicated in the next issue of *The Motion Picture Story Magazine* (March 1911), this time ascribed, in the issue's table of contents at least, to an E. L. Martin. I refer to the earlier February 1911 publication of this story.

55. See Short, "Tennyson and 'The Lover's Tale,'" 78–84.

56. "Comments on the Film," 1478.

57. "The Golden Supper," 82. As we saw in Chapter 3, stills often contributed to the narrative confusion in the process of motion-picture story remediation, most strikingly in Hughes' "The Patent Leather Kid" in the photoplay edition of his *The Patent Leather Kid and Several Others*.

58. "The Golden Supper," 84.

59. "The Cash Prize Contest," 151–54.

60. Singer, "Fiction Tie-Ins and Narrative Intelligibility," 496.

61. McClain, "Film-Fiction," 378.

62. "The Motion Picture Story Magazine," 10. This last observation, about preserving "scenes in permanent form," recognizes what will much later become the magazine's important archival function. Storyizations, as noted in Chapter 3, are frequently all that remain of the many silent films now lost or destroyed. The Answer Man also acknowledges as much when he claims the purpose of *The Motion Picture Story Magazine* is "to render into permanent prose form the pictured action of the best plays"; "Answers to Inquiries," September 1911, 141.

63. Stamp makes a similar point about readers of serial tie-ins, *Movie-Struck Girls*, 199.

64. "Appreciation and Criticisms of Popular Plays and Players," March 1913, 125.

65. Letters to the Editor, June 1912, 164.

66. Letters to the Editor, September 1914, 167.

67. Letters to the Editor, February 1915, 169.

68. As Orgeron has written of fan magazines more broadly, they "led fans . . . to the stars themselves"; "'You Are Invited to Participate,'" 4.

69. Letters to the Editor, June 1912, 164.

70. Letters to the Editor, April 1915, 174.

71. Letters to the Editor, June 1917, 177.

72. As reported in Musings of "The Photoplay Philosopher," January 1913, 122.

73. Arguably, even the most perfunctory intertitle containing prose exposition involved plot spoiling. As Elliot has argued, we see the action and only then do we read a description of it, or vice versa; *Rethinking the Novel/Film Debate*, 91. Furthermore, as mentioned earlier, early film narratives were frequently based on news of the day or myths and fairytales and other stories well known to film viewers.

74. Lupton, "Repeat," 158.

75. Bronstein, "How Not to Re-Read Novels," 77.

76. Radway, *Reading the Romance*, 198.

77. Gray, *Show Sold Separately*, 10. On the nature of reading as always anticipatory, see also Toolan, *Narrative Progression in the Short Story*.

78. McClain, "Film-Fiction," 388. Brewer, *Afterlife of Character*, 1. While for Brewer it is readers who expand the story world, I take his concept to describe the effects of storyizations on the proliferation of narrative.

79. "The Onward March," 144.

80. Letters to the Editor, April 1912, 168.

81. As recorded in Musings of "The Photoplay Philosopher," May 1912, 127.

82. "Classified Advertising," 178.

83. Cassell, "Soundless Message," 101–02.

84. Brewster, "Expression of the Emotions," 108. Anita Loos mocked this simplistic approach to silent-film acting and viewing in her 1914 scenario "The School of Acting." As Frost writes, Loos' Professor Bunk sends up "thespians . . . taught to emote according to 'large cards'" on which is "'printed in big type the names of the different emotions.'. . . Comedy ensues when actors are shown the cards in inappropriate circumstances and cannot help but act them out"; Frost, *Problem with Pleasure Modernism*, 215.

85. Lewis, "Enemies of the Book," 2013.

86. Littau, "Reading in the Age of Edison," 77. Littau is interested in the transfer of technologies of motion into the domain of print. My own focus, here and throughout *Silent Film and the Formations of US Literary Cultures*, is on the reverse direction and on literature. Michael North describes Brown's "readies" as "a sort of modernist movie constructed of type." And "At least one such machine was actually constructed; from the photograph included in the anthology *Readies for Bob Brown's Machine* it appears to have anticipated the microfilm reader"; North, "Words in Motion," 215.

87. Brown, "Appendix," 178.

88. Bentley, *Frantic Panoramas*, 40.

89. Tie-ins did not always work to a standardized timetable. For example, regional and small cinemas may only have been able to screen a film weeks or months following the publication of its magazine tie-in. See Stamp, *Movie-Struck Girls*, 115–20.

90. Abel and Rogers, "Early Motion Pictures and Popular Print Culture," 200.

91. Shimpach, "Representing the Public of the Cinema's Public Sphere," 144, 146.

92. For an excellent account of "the interactive culture that was being generated in the magazines' pages" in the context of celebrity and fandom, see Orgeron, "'You Are Invited to Participate.'"

93. Letters to the Editor, September 1914, 164–65.

94. Letters to the Editor, September 1913, 170.

95. Letters to the Editor, October 1914, 168–69.

96. Appreciation and Criticisms of Popular Plays and Players, February 1913, 123.

97. Musings of "The Photoplay Philosopher," May 1912, 131.

98. Chion, *Words on Screen*, 111. Emre characterizes "bad readers" as those who are "socialized into the practices of readerly identification, emotion, action, and interaction"; Emre, *Paraliterary*, 3.

99. Letters to the Editor, November 1914, 164.

100. These are Bentley's terms to describe distracted reading using William Dean Howells' analogy of the three-ringed circus. Bentley, *Frantic Panoramas*, 38.

101. Chion, *Words on Screen*, 124.

102. Quoted in Travis, *Reading Cultures*, 18.

103. Ohmann, *Selling Culture*, 223.

104. Bentley, *Frantic Panoramas*, 38.

105. Ohmann, *Selling Culture*, 225.

106. Stamp, *Movie-Struck Girls*, 120; she's describing the serial tie-in.

107. Wright, "Literature and Filmland," 117.

108. Musings of "The Photoplay Philosopher," January 1914, 112.

109. Bacon, "Picture Books," 27.

110. In 1933, Cerf described Americans as "notorious seekers of short cuts to culture." Quoted in Travis, *Reading Cultures*, 22.

111. See Blair, *Reading Up*.

112. Atherton, "Circle of Time."

113. Musings of "The Photoplay Philosopher," February 1913, 132.

114. "Around the Council Table," 3.

115. Lewis, "Rambling Thoughts on Literature as a Business," 44.

116. Lewis, "Enemies of the Book," 2013.

117. Fusco, "Squashing the Bookworm," 632.

Afterword

1. Cresswell, *On the Move*, 138.

2. Rossell, "Chronophotography in the Context of Moving Pictures," 10.

3. Cresswell, "Visualizing Mobility," 12, 13, 11.

4. Wasson, *Everyday Movies*, 38, 41, 42.

5. On parks and fairgrounds, see Rabinowitz, *Electric Dreamland*; on churches and townhalls, see Field, *Uplift Cinema*.

6. Rabinowitz, *Electric Dreams*, 5; Gunning, "Cinema of Attractions," 64. Gunning is here writing specifically of "The Lumière tradition of 'placing the world within one's reach' through travel films and topicals."

7. Pryluck, "The Itinerant Movie Show," 38–9, 41.

8. Altman, "From Lecturer's Prop to Industrial Product," 75.

9. An advertisement for *The Art of the Moving Picture, Motion Picture Magazine,* February 1916, 167.

10. Hoffman, *American Poetry in Performance,* 58.

11. Masters, *Vachel Lindsay,* 124–25. Masters writes he is quoting from Lindsay's diary.

12. Lindsay, *Adventures While Preaching the Gospel of Beauty,* 14.

13. Guillory, "Tramping across America," 62.

14. "Blanche Sweet Moving-Picture Actress (After seeing the reel called 'Oil and Water.')" and "To Mary Pickford, Moving-Picture Actress," in Lindsay, *Collected Poems of Vachel Lindsay,* 172–73, 170–72.

15. The news is of "WAR, WAR,/Brother's hand against brother/WAR, WAR." This poem was first (and only ever) published in the *Chicago Herald* on August 27, 1914, and is likely Lindsay's earliest poem about motion pictures.

16. Lindsay, *Handy Guide for Beggars,* 127.

17. Lindsay, *Handy Guide for Beggars,* 191–92.

18. Kirby, *Parallel Tracks,* 1.

19. Christie, *Last Machine,* 17.

20. Altman, *Silent Film Sound,* 150–51.

21. Lindsay, *Handy Guide for Beggars,* 126.

22. McGilligan, *Oscar Micheaux, the Great and Only,* 94, 98.

23. Green, *With a Crooked Stick,* 21.

24. Micheaux, *Forged Note,* 40, 1.

25. Howells, "Man of Letters as a Man of Business."

26. McGilligan, *Oscar Micheaux, the Great and Only,* 104.

27. McGilligan's source is materials held in the George P. Johnson Negro Film Collection, 1916–1977, at UCLA. See also Koszarski, *Evening's Entertainment,* 187.

28. McGilligan, *Oscar Micheaux, the Great and Only,* 133.

29. A Micheaux Film Corporation announcement, dated January 8, 1931, about *The Exile* (1931), in Musser et al., "Oscar Micheaux Filmography," 272.

30. McGilligan, *Oscar Micheaux, the Great and Only,* 133, quoting Micheaux.

31. Chénetier, *Letters of Vachel Lindsay,* 60. But by 1916 Lindsay came to regret being "classed as an entertainer for those too busy to read books. Heaven Forbid"; Lindsay, *A Letter About Four Programmes,* 44. The copy of *A Letter About Four Programmes* I was able to gain access to is held in the library of the University of New Mexico, and it is titled exactly thus, and so differs a little from other references to this pamphlet as "A Letter about My Four Programmes"; its contents may also vary.

32. Albert Edmund Trombly, *Vachel Lindsay, Adventurer,* Lucas Brothers, 1929, 116–17; quoted in Moore, "Preaching the Gospel of Higher Vaudeville," 223.

33. Massa, "Artistic Conscience of Vachel Lindsay," 45.

34. Letter from Lindsay to Rittenhouse, January 1914; quoted in Hoffman, *American Poetry in Performance,* 61.

35. Moore, "Preaching the Gospel of Higher Vaudeville," 223.

36. Lindsay, *A Letter About Four Programmes,* 7, 4, 3, 5.

37. Lindsay, *Art of the Moving Picture,* 2.

38. Lindsay, *Collected Poems of Vachel Lindsay,* 171.

39. Lindsay, *Adventures while Preaching,* 52.

40. Hoffman, *American Poetry in Performance*, 57; Lindsay in 1923, from *The Poetry of Vachel Lindsay*, vol. 3, ed. David Camp, Spoon River Poetry, 968; quoted in Hoffman, *American Poetry in Performance*, 81; From Chénetier, *Letters of Vachel Lindsay*, 181; quoted in Hoffman, *American Poetry in Performance*, 57.

41. Canby, *American Memoir*, Houghton, 1947, 294–95; quoted in Hoffman, *American Poetry in Performance*, 71.

Works Cited

Abel, Richard. *Menus for Movieland*. Berkeley: University of California Press, 2015.

Abel, Richard. *The Red Rooster Scare: Making Cinema American, 1900–1910*. Berkeley: University of California Press, 1999.

Abel, Richard, and Amy Rogers. "Early Motion Pictures and Popular Print Culture: A Web of Ephemera." In T*he Oxford History of Popular Print Culture: Volume Six: US Popular Print Culture 1860–1920*, edited by Christine Bold, 191–209. Oxford: Oxford University Press, 2012.

Adler, Richard. "Robert E. Levy and the Film Industry." *American Philatelist* 122, no. 8 (2008): 737–41.

Adriaensens, Vito. "Winnifred Eaton." In *Women Film Pioneers Project*, edited by Jane Gaines, Radha Vatsal, and Monica Dall'Asta, n.p. New York: Columbia University Libraries, 2017. https://doi.org/10.7916/d8-zf18-vk03.

Advertisement for Vachel Lindsay's *The Art of the Moving Picture* (1915), *Motion Picture Magazine*, February 1916, 167.

Advertisement for *The Sea Wolf* (1913; dir. Hobart Bosworth). *Moving Picture World*, May 16, 1914, 920.

Advertisement for *The Woman Accused* (1933; dir. Paul Sloane). *Hollywood Reporter*, February 13, 1933, n.p.

Allen, Robert C. "Relocating American Film History: The 'Problem' of the Empirical." *Cultural Studies* 20, no. 1 (2006): 48–88.

"'A Lost Lady' Is Real Dramatic Gem." *Exhibitors Trade Review*, January 31, 1925, 51.

Altman, Rick. "From Lecturer's Prop to Industrial Product: The Early History of Travel Films." In *Virtual Voyages: Cinema and Travel*, edited by Jeffrey Ruoff, 61–76. Durham, NC: Duke University Press, 2020.

Altman, Rick. *Silent Film Sound*. New York: Columbia University Press, 2007.

"A Man's Duty." *Chicago Defender* (Big Weekend Edition), September 27, 1919, 8.

"A Man's Duty." *Chicago Defender* (Big Weekend Edition), October 4, 1919, 8.

"A Man's Full [sic] Duty." Film synopsis. Microfilm. Collection 1042, Box 52, Folder 37, George P. Johnson Negro Film Collection. UCLA Library Special Collections, University of California, Los Angeles.

Andersen, Joceline. *Stars and Silhouettes: The History of the Cameo Role in Hollywood*. Detroit: Wayne State University Press, 2020.

"Announcing Eminent Authors' Pictures." *Moving Picture World*, July 12, 1919.

"An Offer." *Competitor* 1 (January 1920): 82.

Answers to Inquiries. *The Motion Picture Story Magazine*, August 1911.

Answers to Inquiries. *The Motion Picture Story Magazine*, September 1911.

Appreciation and Criticisms of Popular Plays and Players by Our Readers. *The Motion Picture Story Magazine*, February 1913.

Appreciation and Criticisms of Popular Plays and Players by Our Readers. *The Motion Picture Story Magazine*, March 1913.

Ardis, Ann. "Making Middlebrow Culture, Making Middlebrow Literary Texts Matter: *The Crisis*, Easter 1912." *Modernist Cultures* 6, no. 1 (2011): 18–40.

Ardis, Ann. "Modernist Print Culture." *American Literary History* 27, no. 4 (2015): 813–19.

"Around the Council Table." *Authors' League Bulletin*, April 1914, 2–3.

[Article 2—No Title.] *Chicago Defender*, December 22, 1917, 7.

Atherton, Gertrude. *Adventures of a Novelist*. New York: Horace Liveright, 1932.

Atherton, Gertrude. "Agreement." 22 May 1919, Contracts and Copyright c. 1920–1944, Gertrude Franklin Horn Atherton Papers. Bancroft Library, University of California Berkeley, Berkeley, CA.

Atherton, Gertrude. "Chains of the Past." *The Woman Accused*, *Liberty* 10, no. 5 (February 4, 1933): 24–29.

Atherton, Gertrude. "Contracts and Copyright." Contract November 10 1916, Gertrude Franklin Horn Atherton Papers. Bancroft Library, University of California Berkeley, Berkeley, CA.

Atherton, Gertrude. "Noblesse Oblige." Synopsis. 13pp. Margaret Herrick Library, Academy of Motion Picture Arts and Sciences, Beverly Hills, CA.

Atherton, Gertrude. "The Circle of Time." June 3, 1931 through February 23, 1934. C-H 45, Carton 1, Drafts-Miscellaneous Transcripts (1 of 2) undated, Gertrude Franklin Horn Atherton Papers. Bancroft Library, University of California Berkeley, Berkeley, CA.

Auerbach, Jonathan. *Male Call: Becoming Jack London*. Durham, NC: Duke University Press, 1996.

"Authors for Mutual Film." *Motography* 11, no. 1 (1914): 14.

"Authors in the Movies. See Themselves in Pictures at Benefit for League of America." *New York Times*, February 20, 1914, 11.

Authors' League of America Year Books 1914 and 1915, dated "Year Ending April 1st 1915." JLE572, Jack London Papers. Huntington Library, San Marino, CA.

"Authors League to Test Copyright Law." 1913. Scrapbooks, Box 517, Jack London Papers. Huntington Library, San Marino, CA.

"Authors Urged to Write Photoplays: Universal Sends Request to Every Famous Author in the Country to Write for Screen." *Exhibitor's Trade Review*, March 7, 1925, 14.

Ayres, Sydney. "To Jack London, June 2, 1913." JL2050, Jack London Papers. Huntington Library, San Marino, CA.

Babb, Valerie Melissa. *A History of the African American Novel*. Cambridge: Cambridge University Press, 2017.

Bacon, Ralph. "Picture Books." *The Motion Picture Story Magazine*, February 1914, 27.

Baetens, Jan. "Novelization, a Contaminated Genre?" *Critical Inquiry* 32, no. 1 (2005): 43–60.

Baetens, Jan. *Novelization: From Film to Novel*. Translated by Mary Feeney. Columbus: Ohio State University Press, 2018.

Baldwin, Davarian L. *Chicago's New Negroes: Modernity, the Great Migration, and Black Urban Life*. Chapel Hill: University of North Carolina Press, 2007.

Barker, Reginald, dir. *The Italian*. 1915. New York Motion Picture. 72 minutes, silent [English intertitles]. Held in Washington, DC, Library of Congress [USW]. https://www.youtube.com/watch?v=wQgIY43c5ww.

Barnett, Vincent L., and Alexis Weedon. *Elinor Glyn as Novelist, Moviemaker, Glamour Icon and Businesswoman*. London: Taylor & Francis, 2016.

Beach, Rex. "Editor's Note." *Authors' League Bulletin*, April 1913, 2–5.

Beach, Rex. *Personal Exposures*. New York: Harper & Brothers, 1940; repr. 1941.

Beach, Rex. "Photo Plays." *Authors' League Bulletin*, June 1913, 6–8.

Beach, Rex. "The Spoilers." One-page synopsis, 1913, Folder 138, The Spoilers [1918], William Selig Papers. Margaret Herrick Library, Academy of Motion Picture Arts and Sciences, Beverly Hills, CA.

Beach, Rex. "To Hamlin Garland, September 2, 1913." Collection no. 0200, Hamlin Garland Papers. Special Collections, USC Libraries, University of Southern California, Los Angeles, CA.

Benbow, Mark E. "Birth of a Quotation: Woodrow Wilson and 'Like Writing History with Lightning.'" *Journal of the Gilded Age and Progressive Era* 9, no. 4 (2010): 509–33.

Bentley, Nancy. *Frantic Panoramas: American Literature and Mass Culture, 1870–1920*. Philadelphia: University of Pennsylvania Press, 2009.

Bentley, Nancy. "Museum Realism." In *The Cambridge History of American Literature. Vol. 3, Prose Writing, 1860–1920*, edited by Sacvan Bercovitch, 63–106. Cambridge: Cambridge University Press, 2005.

Bentley, Nancy. "Mass Media and Literary Culture at the Turn of the Twentieth Century." In *A Companion to American Literary Studies*, edited by Caroline F. Levander and Robert S. Levine, 191–207. Chichester, UK: Wiley-Blackwell, 2011.

Beranger, Clara. "The Story." In *Introduction to the Photoplay: 1929, A Contemporary Account of the Transition to Sound in Film*, edited by John C. Tibbetts, 136–57. Los Angeles: National Film Society, 1977.

Berg, A. Scott. *Goldwyn: A Biography*. London: Simon & Schuster, 2013. *First published 1989 in New York by Alfred A. Knopf and in Great Britain by Hamish Hamilton.*

Bertolini, Francesco, Adolfo Padovan, and Giuseppe de Liguoro, dirs. *L'inferno*. 1911. Milano Films. 68 minutes, silent.

"B'ham Ban on 'High School Girl' First in a Long Time." *Variety*, December 23, 1936, 13.

Birchard, Robert S. "Jack London and the Movies." *Film History* 1, no. 1 (1987): 15–37.

Blackton, J. Stuart. "Literature and the Motion Picture—A Message." *Authors' League Bulletin*, February 1914, xxv–xxviii.

Blackton, J. Stuart. "To Hamlin Garland, April 18, 1917." Collection no. 0200, Hamlin Garland Papers. Special Collections, USC Libraries, University of Southern California, Los Angeles, CA.

Blackton, J. Stuart. "Yesterdays of Vitagraph." *Photoplay* 16, no. 1 (July 1919): 28–33.

Blair, Amy L. *Reading Up: Middle-Class Readers and the Culture of Success in the Early Twentieth-Century United States*. Philadelphia: Temple University Press, 2012.

Bluemel, Kristin. *Intermodernism: Literary Culture in Mid-Twentieth-Century Britain*. Edinburgh: Edinburgh University Press, 2009.

Bohlke, L. Brent, ed. *Willa Cather in Person: Interviews, Speeches, and Letters*. Lincoln: University of Nebraska Press, 1986. Willa Cather Archive. https://cather.unl.edu/writings/bohlke

Bolter, J. David, and Richard A. Grusin. *Remediation: Understanding New Media*. Cambridge, MA: MIT Press, 1999.

Bordwell, David, Janet Staiger, and Kristin Thompson. *The Classical Hollywood Cinema: Film Style and Mode of Production to 1960*. London: Routledge, 1985.

Bordwell, David, Kristin Thompson, and Jeff Smith. *Film Art: An Introduction*. 11th ed. New York: McGraw-Hill Education, 2017.

Bosworth, Hobart, dir. *Martin Eden*. 1914. Hobart Bosworth Productions. 50 minutes, silent (English intertitles). Reels 1, 2, 5 and 6 of 6 reels, Record No.: 24049, AFI/Wright Collection, Library of Congress. Reels 3 and 4 lost.

Bosworth, Hobart, dir. *The Sea Wolf*. 1913. Hobart Bosworth Productions. 70 minutes, silent [English intertitles]. Lost.

Bosworth, Hobart. "To Charmian and Jack London, 1914 Jan 1." JL2662, Jack London Papers. Huntington Library, San Marino, CA.

Bosworth, Hobart. "To Jack London, September 15, 1913." JL 2750, Jack London Papers. Huntington Library, San Marino, CA.

Bosworth, Hobart. Telegram, October 13, 1913. Unknown recipient. JL13784. Jack London Papers. Huntington Library, San Marino, CA.

Bosworth Inc. Presents *John Barleycorn*. Four-page pamphlet. JLE1960, Jack London Papers. Huntington Library, San Marino, CA.

Bosworth Inc. [Publicity Release]. pre-1914 Carbon Copy. (Ms.) 2 pp. 4to. (typewritten). Box 1, JL JL34 Jack London Papers. Huntington Library, San Marino, CA.

Botshon, Lisa. "Anzia Yezierska and the Marketing of the Jewish Immigrant in 1920s Hollywood." *Journal of Narrative Theory* 30, no. 3 (2000): 287–312.

Brady, Jasper. "To Hamlin Garland, April 20, 1916." Collection no. 0200, Hamlin Garland Papers. Special Collections, USC Libraries, University of Southern California, Los Angeles, CA.

Brawley, Benjamin. *The Negro in Literature and Art*. New York: Duffield, 1918.

Brégent-Heald, Dominique. *Borderland Films: American Cinema, Mexico, and Canada during the Progressive Era*. Lincoln: University of Nebraska Press, 2015.

Brewer, David. *The Afterlife of Character, 1726–1825*. Philadelphia: University of Pennsylvania Press, 2005.

Brewster, Eugene V. "Expression of the Emotions." *Motion Picture Magazine*, July 1914, 107–14.

Brodhead, Richard H. *Cultures of Letters: Scenes of Reading and Writing in Nineteenth-Century America*. Chicago: University of Chicago Press, 1993.

Bronstein, Michaela. "How Not to Re-Read Novels: The Critical Value of First Reading." *Journal of Modern Literature* 39, no. 3 (2016): 76–94.

"Brooks Returns." *Chicago Defender*, August 7 1920, 4.

Brower, Jordan. *Classical Hollywood, American Modernism: A Literary History of the Studio System*. Cambridge: Cambridge University Press, 2024.

Brower, Jordan. "'Written with the Movies in Mind': Twentieth-Century American Literature and Transmedial Possibility." *Modern Language Quarterly* 78, no. 2 (2017): 243–73.

Brown, Bob. "Appendix." In *Readies for Bob Brown's Machine: A Critical Facsimile Edition*, edited by Craig J. Saper and Eric B White, 153–208. Edinburgh: Edinburgh University Press, 2020.

Brown, Bob. *What Happened to Mary: A Novelization from the Play and the Stories Appearing in the Ladies' World*. New York: Grosset & Dunlap, 1913.

Butters, Gerald R., Jr. *Black Manhood on the Silent Screen*. Lawrence: University Press of Kansas, 2002.

Caddoo, Cara. *Envisioning Freedom: Cinema and the Building of Modern Black Life*. Cambridge, MA: Harvard University Press, 2014.

Camille: The Fate of a Coquette. 1926; Barton, Ralph, dir. compiled by Barton from home movies. 33 minutes, silent (English intertitles).

Canby, Henry Seidel. "Cytherea; Review of *A Lost Lady.*" *New York Evening Post Literary Review*, September 22, 1923, 59. In *Willa Cather: The Contemporary Reviews*, edited by Margaret Anne O'Connor, 185–86. Cambridge: Cambridge University Press, 2001.

Cartmell, Deborah, ed. *A Companion to Literature, Film, and Adaptation.* Chichester, UK: John Wiley & Sons, 2012.

Cassell, R. J. "The Soundless Message." *Motion Picture Magazine*, December 1914, 101–02.

Cather, Willa. "1925: Chicago," in *Willa Cather in Person: Interviews, Speeches, and Letters Selected*, edited by L. Brent Bohlke. Lincoln: University of Nebraska Press, 1986. Willa Cather Archive. https://cather.unl.edu/writings/bohlke/speeches/bohlke.s.05.

Cather, Willa. *A Lost Lady.* Scholarly Edition. Historical essay by Susan J. Rosowski with Kari A. Ronning, explanatory notes by Kari A. Ronning, textual editing by Charles W. Mignon and Frederick M. Link, with Kari A. Ronning. Lincoln: University of Nebraska Press, 1997.

Cather, Willa. *A Lost Lady.* New York: Vintage, 1990.

Cather, Willa. *A Lost Lady.* New York: Grosset and Dunlap, 1925.

Cather, Willa. Contract, motion picture rights, 1929, December 23. MS 008, Box 2. Folder 5. Willa Cather Collected Materials. Archives & Special Collections, University of Nebraska–Lincoln Libraries, Lincoln, NE.

Cather, Willa. "Nebraska: The End of the First Cycle." *Nation*, 117 (September 5, 1923): 236–38. Willa Cather Archive. https://cather.unl.edu/writings/nonfiction/nf066.

Cather, Willa. "On the Art of Fiction." In *The Borzoi 1920: Being a Sort of Record of Five Years Publishing*, 7–8. New York: A. A. Knopf, 1920. Willa Cather Archive. https://cather.unl.edu/writings/nonfiction/nf062.

Cather, Willa. "The Novel Démeublé." *New Republic* 30 (April 12, 1922): 5–6. Willa Cather Archive. https://cather.unl.edu/nf012.html.

Cather, Willa. "To Ferris Greenslet, March 13, 1932." Houghton Mifflin Company correspondence and records, 1832–1944. Harvard University, Houghton Library, Cambridge, MA. Willa Cather Archive. https://cather.unl.edu/letters/let1100.

Cather, Willa. "To Hugh King, Playmarket Inc, 1941." Willa Cather Archive. https://cather.unl.edu/letters/let1886.

Cather, Willa. "To M. Manley Aaron, November 29, 1929." Willa Cather Archive. https://cather.unl.edu/letters/let2608.

Cather, Willa. "To Marjorie Ruth Hurtubise, 1942." Charles E. Cather Collection. Archives and Special Collections, Lincoln Libraries, University of Nebraska, Lincoln, NE. Willa Cather Archive. https://cather.unl.edu/writings/letters/let3220.

Cather, Willa. "Willa Cather Mourns Old Opera House." *Omaha World-Herald*, October 27, 1929; reprinted in Bohlke, ed., *Willa Cather in Person*, 184–87. Willa Cather Archive. https://cather.unl.edu/writings/bohlke/letters/bohlke.l.07.

Chénetier, Marc, ed. *Letters of Vachel Lindsay.* New York: Burt Franklin, 1979.

Chesnutt, Charles. "Post-Bellum—Pre-Harlem." 1931. In *Charles W. Chesnutt: Essays and Speeches*, edited by Joseph R. McElrath, Jr., Robert C. Leitz, III, and Jesse S. Crisler, 543–49. Stanford, CA: Stanford University Press, 1991.

Chesnutt, Charles. "The Negro in Art: How Shall He Be Portrayed: A Symposium." *Crisis* 33, no. 1 (November 1926): 28–29.

Chesnutt, Charles. *Paul Marchand, FMC.* Jackson: University Press of Mississippi, 1998.

Chesnutt, Charles. *The House Behind the Cedars.* 1900. In *Stories, Novels, and Essays: The Conjure Woman, The Wife of His Youth and Other Stories of the Color Line, The House*

Behind the Cedars, The Marrow of Tradition, Uncollected Stories, Selected Essays.
New York: Library of America, 2002. 267–461.

Chesnutt, Charles. *The Marrow of Tradition.* Edited by Nancy Bentley and Sandra Gunning. Bedford Cultural Editions. Boston: Bedford/St Martin's, 2002.

Chesnutt, Charles. *The Quarry.* Edited with introduction and notes by Dean McWilliams. Princeton, NJ: Princeton University Press, 1999.

Chesnutt, Charles. "To Carl Van Vechten, December 1926." In *An Exemplary Citizen: Letters of Charles W. Chesnutt, 1906–1932*, edited by Jesse S. Crisler, Robert C. Leitz III, and Joseph R. McElrath, Jr., 223–24. Stanford, CA: Stanford University Press, 2002.

Chesnutt, Charles. "To Harry C. Bloch, February 1929." In *An Exemplary Citizen: Letters of Charles W. Chesnutt, 1906–1932*, edited by Jesse S. Crisler, Robert C. Leitz, III, and Joseph R. McElrath, Jr., 246. Stanford, CA: Stanford University Press, 2002.

Chesnutt, Charles. "To Houghton Mifflin, February 18, 1921." MS 3370, Charles Waddell Chesnutt Papers. Library of Western Reserve Historical Society, Cleveland, OH.

Chesnutt, Charles. "To Oscar Micheaux, January 27, 1921." MS 3370, Charles Waddell Chesnutt Papers. Library of Western Reserve Historical Society, Cleveland, OH.

Chesnutt, Charles. "To Oscar Micheaux, January 29, 1924." Charles Waddell Chesnutt Papers. Library of Western Reserve Historical Society, Cleveland, OH.

Chesnutt, Charles. "To Oscar Micheaux, September 23, 1921." Charles Waddell Chesnutt Papers. Library of Western Reserve Historical Society, Cleveland, OH.'

Chesnutt, Charles. "To Reol, March 12, 1921." MS 3370, Charles Waddell Chesnutt Papers. Western Reserve Historical Society, Cleveland, OH.

Chesnutt, Charles. "To Robert Levy, Feb 7, 1921." MS 3370, Charles Waddell Chesnutt Papers. Library of Western Reserve Historical Society, Cleveland, OH.

Chesnutt, Charles. "To Robert Levy, Feb 18, 1921." MS 3370, Charles Waddell Chesnutt Papers. Library of Western Reserve Historical Society, Cleveland, OH.

Chesnutt, Charles. "To W. B. Pratt at Houghton Mifflin, January 20, 1921." MS 3370, Charles Waddell Chesnutt Papers. Western Reserve Historical Society, Cleveland, OH.

Chesnutt, Charles. "To W. B. Pratt at Houghton Mifflin, Feb 18, 1921 [same day]." MS 3370, Charles Waddell Chesnutt Papers. Western Reserve Historical Society, Cleveland, OH.

Chion, Michel. *Words on Screen.* Edited and translated by Claudia Gorbman. New York: Columbia University Press, 2017.

Christie, Ian. *The Last Machine: Early Cinema and the Birth of the Modern World.* London: BBC Educational Developments, 1994,

Churchill, Suzanne W., and Adam McKible, eds. *Little Magazines and Modernism: New Approaches.* London: Routledge, 2007.

"Classified Advertising." *Motion Picture Magazine*, June 1914.

Clayton, Owen. *Literature and Photography in Transition, 1850–1915.* Basingstoke, UK: Palgrave Macmillan, 2015.

Codori, Jeff. Liner notes to *Little Orphant Annie.* DVD, directed by Colin Campbell. Selig Polyscope, 1918.

Coffee, Lenore. *Storyline: Recollections of a Hollywood Screenwriter.* London: Cassels, 1973.

Collier, Patrick. *Modern Print Artefacts: Textual Materiality and Literary Value in British Print Culture, 1890–1930s.* Edinburgh: Edinburgh University Press, 2016.

Corbould, Clare. "Making the Slave Anew: History and the Archive in New Negro Renaissance Poetry." In *A History of the Harlem Renaissance*, edited by Rachel Farebrother and Miriam Thaggert, 38–54. Cambridge: Cambridge University Press, 2021.

Creekmur, Corey K. "Telling White Lies: Oscar Micheaux and Charles W. Chesnutt." In *Oscar Micheaux and His Circle: African-American Filmmaking and Race Cinema of the Silent Era*, edited by Pearl Bowser, Jane Gaines, and Charles Musser, 148–58. Bloomington: Indiana University Press, 2016.

Cremins, Brian. "Oscar Micheaux, Charles Chesnutt, and the 'Historical Novel.'" *Journal of American Culture* 25, no. 1–2 (2002): 155–60.

Cresswell, Timothy. *On the Move: Mobility in the Modern Western World*. New York and London: Routledge, 2006.

Cresswell, Timothy. "Visualizing Mobility." In *Muybridge and Mobility*, edited by Timothy Cresswell and John Ott, 9–52. Berkeley: University of California Press, 2022.

Cripps, Thomas. *Slow Fade to Black: The Negro in American Film, 1900–1942*. Oxford: Oxford University Press, 1993.

Cripps, Thomas. "The Making of *The Birth of a Race*: The Emerging Politics of Identity in Silent Movies." In *The Birth of Whiteness: Race and the Emergence of U.S. Cinema*, edited by Daniel Bernardi, 38–55. New Brunswick, NJ: Rutgers University Press, 1996.

Cummings, Denise K., and Annette Kuhn. "Elinor Glyn." In *Women Film Pioneers Project*, edited by Jane Gaines, Radha Vatsal, and Monica Dall'Asta, n.p. New York: Columbia University Libraries, 2013. https://doi.org/10.7916/d8-c8nf-en39.

Dabashi, Pardis. *Losing the Plot: Film and Feeling in the Modern Novel*. Chicago: University of Chicago Press, 2023.

Dahlinger, Charles W. "The Rising Tide of Color." *Western Pennsylvania Historical Magazine* 4, no. 2 (April 1921): 63–73.

Daigle, Jonathan. "Paul Laurence Dunbar and the Marshall Circle: Racial Representation from Blackface to Black Naturalism." *African American Review* 43, no. 4 (2009): 633–54.

Dalbello, Marija. "The Metaphysics of Replacement in Photoplay Novels of Immigration." In *On Replacement: Cultural, Social and Psychological Representations*, edited by Jean Owen and Naomi Segal, 79–89. London: Palgrave Macmillan, 2018.

Davis, Arnie. *Photoplay Editions and Other Movie Tie-In Books: The Golden Years, 1912–1969*. East Waterboro, ME: Mainely Books, 2002.

Decherney, Peter. *Hollywood's Copyright Wars: From Edison to the Internet*. New York: Columbia University Press, 2012.

deCordova, Richard. *Picture Personalities: The Emergence of the Star System in America*. Urbana and Chicago: University of Illinois Press, 2001.

Dixon, Thomas. "The Hope of the World." Photocopy of one-act play. May 5, 1924. Anthony Slide Collection. Margaret Herrick Library, Academy of Motion Picture Arts and Sciences, Beverly Hills, CA.

"'Don't Neglect Your Wife' (Goldwyn)." *Motion Picture News*, August 6, 1921, 799.

Du Bois, W. E. B. "Opinion of W. E. B. Du Bois." *Crisis* 20, no. 6 (October 1920): 261–66.

Du Bois, W. E. Burghardt. "The Negro in Literature and Art." *Annals of the American Academy of Political and Social Science* 49 (1913): 233–37.

Duffy, Enda. *The Speed Handbook: Velocity, Pleasure, Modernism*. Durham: Duke University Press, 2009.

Dunbar, Paul Lawrence. *Lyrics of Lowly Life*. Introduction by W. D. Howells. New York: Dodd, Mead and Company, 1896.

Dunbar, Paul Lawrence. "The Negroes of the Tenderloin." In Paul Laurence Dunbar, *The Sport of the Gods and Other Essential Writings*, edited by Shelley Fisher Fishkin and David Bradley, 264–67. New York: Modern Library, 2005.

Dunbar, Paul Lawrence. "The Scapegoat." In *The Heart of Happy Hollow: A Collection of Stories*, 5–20. New York: Dodd, Mead and Co., 1904.

Dunbar, Paul Lawrence. *The Sport of the Gods*. New York: Dodd, Mead and Company, 1902.

Dunbar, Paul Lawrence. *The Uncalled*. New York: Dodd, Mead and Company, 1898.

Dunbar Nelson, Alice. "Frances [sic] Party Dress." MS 0113, Box 17, F295, 7p. Alice Dunbar Nelson Papers. Special Collections and Museums, University of Delaware Library, Museums, and Press, Newark, DE.

Dunbar Nelson, Alice. "Love's Disguise." MS 0113. Alice Dunbar Nelson Papers. Special Collections and Museums, University of Delaware Library, Museums, and Press, Newark, DE.

Dunbar Nelson, Alice. "Nine-Nineteen-Nine ('9-19-'09): Motion Picture Play in Eleven Episodes." Alice Dunbar Nelson Papers. Special Collections and Museums, University of Delaware Library, Museums, and Press, Newark, DE.

Dwyer, Tessa. *Speaking in Subtitles: Revaluing Screen Translation*. Edinburgh: Edinburgh University Press, 2017.

Dyja, Thomas. *Walter White: The Dilemma of Black Identity in America*. Chicago: Ivan R. Dee, 2008.

Earle, David M. "Black Writers for the Pulps: The Case of Wallace Thurman and Harlem Stories." *Boozehounds & Bookleggers* (blog). October 6, 2015. https://www.boozehou ndsblog.com/pulps/2015/10/6/black-writers-for-the-pulps-the-case-of-wallace-thur man-and-harlem-stories.

Earle, David M. *Re-Covering Modernism: Pulps, Paperbacks, and the Prejudice of Form*. Farnham, UK, and Burlington, VT: Ashgate, 2009.

Earle, David M., and Georgia Clarkson Smith. "'True Stories from Real Life': Hearst's *Smart Set*, Macfadden's Confessional Form, and Selective Reading." *Journal of Modern Periodical Studies* 4, no. 1 (2013): 30–54.

Eaton, Mark. "What Price Hollywood? Modern American Writers and the Movies." In *A Companion to the Modern American Novel 1900–1950*, edited by John T. Matthews, 466–95. Chichester, UK: Wiley-Blackwell, 2009.

Eaton, Winnifred [Onoto Watanna]. "Butchering Brains: An Author in Hollywood Is as a Lamb in an Abattoir." *Motion Picture Magazine*, September 1928, 28–29, 110–111.

"Editor Thurman." *Crisis* 39, no. 9 (September 1932): 292.

"Editorial: Proem." *The Motion Picture Story Magazine*, February 1911, 5–6.

"Editorial: Proem." *The Motion Picture Story Magazine*, March 1911, 116.

"Elaine in Picture." *The Motion Picture Story Magazine*, February 1911, 87–96.

Elliott, Kamilla. *Rethinking the Novel/Film Debate*. Cambridge: Cambridge University Press, 2003.

"Eminent Authors Pictures Formed: Rex Beach and Samuel Goldwyn Organize Group of Famous Writers, Who Will Supervise Adaptation of Their Own Stories in Motion Picture Form." *Moving Picture World*, June 7, 1919, 1469.

Emre, Merve. *Paraliterary: The Making of Bad Readers in Postwar America*. Chicago: University of Chicago Press, 2017.

Ennis, Bert. "Them Were the Happy Days: The Vitagraph Years." *Motion Picture Classic*, October 1926, 18–19, 45.

Eptin, Charles L. *Bebe Daniels: Hollywood's Good Little Bad Girl*. Jefferson, NC: McFarland & Company, 2016.

Esmond, Irwin. "To Hal Hode, Columbia Pict. Corp., NYC, November 16, 1934." In "High School Girl," 1934, New York State Motion Picture Division License Application Case Files Casefile Number 27568, Box 303, New York State Archives, Albany NY.

Esmond, Irwin. Untitled document, June 19, 1932. In "High School Girl," 1934, New York State Motion Picture Division License Application Case Files, Casefile Number 27568, Box 303, New York State Archives, Albany NY.

Evans, Delight. "He Rolled up His Sleeves." *Photoplay* 16, no. 1 (July 1919): 50–51.

Everett, Anna. *Returning the Gaze: A Genealogy of Black Film Criticism, 1909–1949.* Durham, NC: Duke University Press, 2001.

"Exhibitors' Reports on New Releases." *Motion Pictures News*, November 6, 1920, 3529.

Fabian, Ann. "Making a Commodity of Truth: Speculations on the Career of Barnarr Macfadden." *American Literary History* 5, no. 1 (1993): 51–76.

Faling, Andrea I. "*A Lost Lady* in Hollywood." *Nebraska History* 79 (1998): 69–73.

"Famous Authors with Universal." *Moving Picture World*, September 5, 1914, 1356.

Farnum, Dorothy. "The [*sic*] Lost Lady." Scenario. Box 2. Folder 4. Final screenplay, Dorothy Farnum, 1925. MS 0008, Willa Cather Collected Materials. Archives & Special Collections, University of Nebraska–Lincoln Libraries, Lincoln, NE.

Fauset, Jessie Redmon. *Plum Bun: A Novel without a Moral.* Boston: Beacon Press, 1990.

Feaster, Felicia. "The Woman on the Table: Moral and Medical Discourse in the Exploitation Cinema." *Film History* 6, no. 3 (1994): 340–54.

"Feature the Author." *Film Fun*, September 1919, 10.

Felski, Rita. *The Gender of Modernity.* Cambridge, MA: Harvard University Press, 1995.

Field, Allyson. *Uplift Cinema: The Emergence of African American Film and the Possibility of Black Modernity.* Durham, NC: Duke University Press, 2015.

Fine, Richard. *West of Eden: Writers in Hollywood, 1928–1940.* Washington, DC: Smithsonian Books, 1993.

Fitzpatrick, Shanon. *True Story: How a Pulp Empire Remade Mass Media.* Cambridge, MA: Harvard University Press, 2022.

Fletcher, Alicia. "*L'Inferno.*" San Francisco Silent Film Festival (web page). Last modified 2019. https://silentfilm.org/linferno/.

Foltz, Jonathan. *The Novel after Film: Modernism and the Decline of Autonomy.* Oxford: Oxford University Press, 2017.

Foltz, Jonathan. "The Writing of Circumstance: Novelization, Modernism, and Generic Distress." *Modernism/modernity* 27, no. 4 (2020): 791–821.

Forster, Chris. *Modernism and Its Media.* London: Bloomsbury Academic, 2020.

"Foy Sterilization Picture Is Dull: *Tomorrow's Children* (Foy Production)." Review of *Tomorrow's Children*, directed by Crane Wilbur. *Hollywood Reporter*, May 11, 1934, 3.

"Foy Writer Arrives," *Hollywood Reporter*, February 28, 1934, 7.

"Foy's 'High School Girl' Just a Moral Preachment," *Hollywood Reporter*, May 26, 1934, 2.

"From Authors League of America, November 19, 1913." [Miscellaneous] One typed page. JLE570, Jack London Papers. Huntington Library, San Marino, CA.

Frost, Laura. *The Problem with Pleasure: Modernism and Its Discontents.* New York: Columbia University Press, 2013.

Frymus, Agata. "Black Moviegoing in Harlem: The Case of the Alhambra Theater, 1905–1931." *JCMS: Journal of Cinema and Media Studies* 62, no. 2 (2023): 80–101.

Fuller, Kathryn H. *At the Picture Show: Small-Town Audiences and the Creation of Movie Fan Culture.* Washington, DC: Smithsonian Institution Press, 1996.

Fusco, Katherine. *Silent Film and U.S. Naturalist Literature: Time, Narrative, and Modernity.* New York: Routledge, 2016.

Fusco, Katherine. "Squashing the Bookworm: Manly Attention and Male Reading in Silent Film." *Modernism/modernity* 22, no. 4 (2015): 627–50.

Gaines, Jane. "*Within Our Gates*: From Race Melodrama to Opportunity Narrative." In *Oscar Micheaux and His Circle: African-American Filmmaking and Race Cinema of the Silent Era*, edited by Pearl Bowser, Jane Gaines, and Charles Musser, 67–80. Bloomington: Indiana University Press, 2016.

Gaines, Jane M. *Fire and Desire: Mixed-Race Movies in the Silent Era*. Chicago: University of Chicago Press, 2001.

Garbutt, Frank. "To Jack London, September 10, 1914." Telegram. JL6522, Jack London Papers. Huntington Library, San Marino, CA.

Garland, Hamlin. *Crumbling Idols: Twelve Essays on Art, Dealing Chiefly with Literature, Painting and the Drama*. Chicago: Stone and Kimball, 1894.

Garland, Hamlin. *Hesper*. New York: Harper & Brothers, 1903.

Garland, Hamlin. *My Friendly Contemporaries: A Literary Log*. New York: Macmillan, 1932.

Garland, Hamlin. "Suggestions for Tinting." Item 668h, *Money Magic*, typed carbon copy, one leaf. Collection no. 0200, Hamlin Garland Papers. Special Collections, USC Libraries, University of Southern California, Los Angeles, CA.

Garland, Hamlin. "To Ince, January 21, 1913." Collection no. 0200, Hamlin Garland Papers. Special Collections, USC Libraries, University of Southern California, Los Angeles, CA.

Garland, Hamlin. Vitagraph Contract, dated June 21, 1916. Item 669, Collection no. 0200, Hamlin Garland Papers. Special Collections, USC Libraries, University of Southern California, Los Angeles, CA.

Geltzer, Jeremy. *Dirty Words and Filthy Pictures: Film and the First Amendment*. Austin: University of Texas Press, 2015.

"General Purpose of the Authors' League." *Authors' League Bulletin*, April 1913, 6.

Giles, Dorothy. "Ralph Barton: Genius Destroyed Him." *College Humor*, February 1932, 34–36, 129–31.

Glass, Loren. *Authors Inc.: Literary Celebrity in the Modern United States, 1880–1980*. New York: New York University Press, 2004.

Gleeson-White, Sarah. "Alice Dunbar Nelson at the Movies." In *Jim Crow Modernism*, edited by Keith Clark, Robert Jackson and Adam McKible. New York: Oxford University Press, 2024

Gleeson-White, Sarah. "Reading Plagiarism: Charles Chesnutt's *The House Behind the Cedars* and Oscar Micheaux's *The Masquerade: An Historical Novel*." *African American Review* 54, no. 4 (2021): 319–31.

Gleeson-White, Sarah, ed. *William Faulkner at Twentieth Century-Fox: The Annotated Screenplays*. Oxford: Oxford University Press, 2017.

Glyn, Elinor. "It." *Cosmopolitan*, February 1927, 44–49, 200–212; and March 1927, 64–67, 106–116, 120. MS 4059, Elinor Glyn Collection 1894–1955. University of Reading Library, Berkshire, UK.

Glyn, Elinor. "It." *Pall Mall*, April 1927, 6–11, 72–76, 78, 80, 82. MS 4059, Elinor Glyn Collection 1894–1955. University of Reading Library, Berkshire, UK.

Glyn, Elinor. *Romantic Adventure, Being the Autobiography of Elinor Glyn*. London: Ivor Nicholson and Watson, 1936. Internet Archive. https://archive.org/details/dli.ministry.22134/page/n5/mode/2up.

Glyn, Elinor. "Sequence Synopsis of IT by Elinor Glyn," 1926b, Elinor Glyn Collection, University of Reading, Special Collections, University of Reading MS 4059.

Goble, Mark. *Beautiful Circuits: Modernism and the Mediated Life*. New York: Columbia University Press, 2010.

Goble, Mark. "Faulkner at the Speed of History." In *The Oxford Handbook of Twentieth-Century American Literature*, edited by Leslie Bow and Russ Castronovo, 153–70. Oxford: Oxford University Press, 2022.

Goldstone, Andrew. 2021. "Modernist Studies without Modernism." OSF. September 29. https://doi.org/10.17605/OSF.IO/FRCYS

"Goldwyn Induced America's Authors to Cooperate in Their Productions on the Studio Lot." *Wid's Daily*, February 6, 1921.

"Goldwyn Makes Its Start on Advertising Campaign." *Moving Picture World*, August 30, 1919, 1304.

Goldwyn, Samuel. *Behind the Screen*. New York: George H. Doran, 1923.

"Good Production and Some Thrills to Rather Familiar Story Material: *Out of the Storm*." *Wid's Daily*, June 20, 1920, 9.

Grandy, Edwin T. "Books." *Hollywood Filmograph* 12, no. 29 (August 6, 1932): 15.

Gray, Jonathan. *Show Sold Separately: Promos, Spoilers, and Other Media Paratexts*. New York: New York University Press, 2010.

Green, J. Ronald. *With a Crooked Stick: The Films of Oscar Micheaux*. Bloomington: Indiana University Press, 2004.

Grey, Zane. *Desert Gold: A Romance of the Border. Illustrated with Scenes from the Photo Play Produced by Zane Grey's Own Company*. New York: Grosset and Dunlap, 1926.

Griffen-Foley, Bridget. "From Tit-Bits to Big Brother: A Century of Audience Participation in the Media." *Media, Culture & Society* 26, no. 4 (2004): 533–48.

Guillory, Dan. "Tramping across America: The Travel Writings of Vachel Lindsay." *MidAmerica: The Yearbook for the Society of the Study of Midwestern Literature* 27 (2000): 59–65.

Gunning, Tom. *D. W. Griffith and the Origins of American Narrative Film: The Early Years at Biograph*. Urbana and Chicago: University of Illinois Press, 1994.

Gunning, Tom. "The Cinema of Attractions: Early Film, Its Spectator and the Avant-Garde." *Wide-Angle* 8, no. 3–4 (1986): 63–70.

Gunning, Tom. "Vachel Lindsay: Theory of Movie Hieroglyphics." In *Thinking in the Dark: Cinema, Theory, Practice*, edited by Murray Pomerance and R. Barton Palmer, 19–30. New Brunswick, NJ: Rutgers University Press, 2016.

Hall, Mordaunt. "Mr. Barthelmess at His Best." *New York Times*, August 16, 1927, 31.

Halpern, Ira. "Health Care Fictions: The Business of Medicine and Modern US Literature." *American Literature* 93, no. 4 (2021): 629–54.

Hammill, Faye. *Women, Celebrity, and Literary Culture Between the Wars*. Austin: University of Texas Press, 2007.

Hammond, Mary. "The Multimedia Afterlives of Victorian Novels: The Readers Library Photoplay Editions in the 1920s." *Nineteenth Century Theatre and Film* 37, no. 2 (2010): 28–44.

Hampton, Benjamin B. "The Author and the Motion Picture." *Bookman* 53, no. 3 (May 1921): 217–25.

Hansen, Miriam. *Babel and Babylon: Spectatorship in American Silent Film*. Cambridge, MA: Harvard University Press, 1991.

Hansen, Miriam. "Early Silent Cinema: Whose Public Sphere?" *New German Critique*, no. 29 (1983): 147–84.

Harris, Donal. *On Company Time: American Modernism in the Big Magazines*. New York: Columbia University Press, 2016.

Haskar, Beth. "Moving Picture Audiences." *Motion Picture Magazine*, July 1914, 79.

Hayot, Eric. "Against Periodization; or, On Institutional Time." *New Literary History* 42, no. 4 (2011): 739–56.

Helton, Laura, Justin Leroy, Max A. Mishler, Samantha Seeley, and Shauna Sweeney. "The Question of Recovery: An Introduction." *Social Text* 33, no. 4 (2015): 1–18.

Hoberman, J. "Building an Empire." *London Review of Books* 23, no. 14 (July 19, 2001). https://www.lrb.co.uk/the-paper/v23/n14/j.-hoberman/building-an-empire.

Hoffman, Tyler. *American Poetry in Performance: From Walt Whitman to Hip Hop*. Ann Arbor: University of Michigan Press, 2011.

Holloway, Karla. *BookMarks: Reading in Black and White: A Memoir*. New Brunswick, NJ: Rutgers University Press, 2006.

Homestead, Melissa. "Middlebrow Readers and Pioneer Heroines: Willa Cather's *My Ántonia*, Bess Streeter Aldrich's *A Lantern in Her Hand*, and the Popular Fiction Market." In *Crisscrossing Borders in Literature of the American West*, edited by Reginald Dyck and Cheli Reutter, 75–94. Palgrave Macmillan, 2009.

Howells, W. D. "Mr. Charles W. Chesnutt's Stories." *Atlantic Monthly* 85 (1900): 699–701.

Howells, William Dean. "Editor's Study." *Harper's New Monthly Magazine* 72, no. 428 (January 1886): 321.

Howells, William Dean. "Introduction." In Paul Laurence Dunbar, *Lyrics of Lowly Life*, xiii–xx. New York: Dodd, Mead and Company, 1896.

Howells, William Dean. "The Man of Letters as a Man of Business." *Scribner's Magazine* 14 (October 1893): 429–46.

Hoyt, Eric. *Ink-Stained Hollywood*. Berkeley: University of California Press, 2022.

Hughes, Langston. *The Big Sea*. New York: Alfred A. Knopf, 1940.

Hughes, Rupert. "At Home in Hollywood" Typed 183-p MS (Handwritten: "Sold to Liberty Magazine." n.d.). Box 1, Collection no. 0173, Rupert Hughes Papers, USC Library Special Collections, University of Southern California, Los Angeles, CA.

Hughes, Rupert. "Contracts—Rex Beach–Goldwyn–Rupert Hughes (Eminent Authors)" 17 May 1919. Hughes, Beach and Goldwyn agreement (Stern and Reubens, 149 Broadway, NY), Rupert Hughes Papers. USC Library Special Collections, University of Southern California, Los Angeles, CA.

Hughes, Rupert. "Early Days in the Movies." *Saturday Evening Post*, April 13, 1935, 30–31, 118, 120–21.

Hughes, Rupert. "The Patent Leather Kid." *Cosmopolitan*, 80 (February 1926): 44–47, 138, 140–48.

Hughes, Rupert. *The Patent Leather Kid and Several Others*. New York: Grosset & Dunlap, 1927.

Hull, Gloria T. *Color, Sex and Poetry: Three Women Writers of the Harlem Renaissance*. Bloomington: Indiana University Press, 1987.

Hull, Gloria T., ed. *Give Us Each Day: The Diary of Alice Dunbar-Nelson*. New York: W. W. Norton & Co., 1984.

"I Am the Universal Language." *Photoplay Magazine* 15, no. 4 (April 1919): 27.

"In the matter of the application of Foy Productions Ltd and Principal Film Exchange Inc, Petitioners and Appellants, for an order pursuant to Article 78 of the Civil Practice Act—against—Frank P. Graves, as Commissioner of Education of the State of New York, Respondent, annulling the determination of the Respondent in refusing to license the motion picture, 'TOMORROW'S CHILDREN' and directing that a license for same forthwith issue." In "Tomorrow's Children (Revised)," New York State Motion Picture Division License Application Case Files, Casefile Number 28361, Box 333, New York State Archives, Albany NY.

Jaffe, Aaron. *Modernism and the Culture of Celebrity*. Cambridge: Cambridge University Press, 2005.

Jaillant, Lise. "Canonical in the 1930s: Willa Cather's *Death Comes for the Archbishop* in the Modern Library Series." *Studies in the Novel* 45, no. 3 (2013): 476–99.

James, Henry. "The Future of the Novel." In *The International Library of Famous Literature: Selections from the World's Great Writers Ancient, Mediæval, and Modern, with Biographical and Explanatory Notes and Critical Essays by Many Eminent Writers*, edited by Richard Garnett, xi–xxii. London: The Standard, 1899.

Janken, Kenneth Robert. *White: The Biography of Walter White, Mr NAACP*. New York: New Press, 2003.

Jarrett, Gene Andrew. *Paul Laurence Dunbar: The Life and Times of a Caged Bird*. Princeton, NJ: Princeton University Press, 2022.

Johanningsmeier, Charles. "Cather's Readers, Traditionalism, and Modern America." In *Cather Studies*. Vol. 10, *Willa Cather and the Nineteenth* Century, edited by Anne L. Kaufman and Richard H. Millington, 38–67. Lincoln: University of Nebraska Press, 2015.

Johnson, James Weldon. *Along This Way: The Autobiography of James Weldon Johnson*. New York: Viking Press, 1933.

Johnson, James Weldon. "The Dilemma of the Negro Author (1928)." In *The New Negro: Readings on Race, Representation, and African American Culture, 1892–1938*, edited by Henry Louis Gates and Gene Andrew Jarrett, 378–82. Princeton, NJ: Princeton University Press, 2008.

Jones, Juli, Jr. "Motion Pictures and Inside Facts." *Half-Century Magazine* 6, no. 7 (July 1919): 16, 19.

Jones, Juli, Jr. "Moving Pictures Offer the Greatest Opportunity to the American Negro in History of the Race from Every Point of View." *Chicago Defender*, October 9, 1915, 6.

Kaestle, Carl F., and Janice A. Radway. "A Framework for the History of Publishing and Reading in the United States, 1880–1940." In *A History of the Book in America: Volume 4: Print in Motion: The Expansion of Publishing and Reading in the United States, 1880–1940*, edited by Carl F. Kaestle and Janice A. Radway, 7–21. Chapel Hill: University of North Carolina Press, 2009.

Kaestle, Carl F., and Janice A. Radway, eds. *A History of the Book in America: Volume 4: Print in Motion: The Expansion of Publishing and Reading in the United States, 1880–1940*. Chapel Hill: University of North Carolina Press, 2009.

Keil, Charlie, and Shelley Stamp, eds. *American Cinema's Transitional Era: Audiences, Institutions, Practices*. Berkeley and Los Angeles: University of California Press, 2004.

Kilinski, April Conley. "Macaulay." In *Encyclopedia of the Harlem Renaissance*, edited by Cary D. Wintz and Paul Finkelman, 2:758–59. New York: Routledge, 2004.

Kilmer, Joyce. "Says New York Makes Writers Tradesmen: Hamlin Garland Laments Metropolitan Influences Which Turn Younger Literary Generation from Art to Commercial Success." *New York Times Magazine*, May 28, 1916, 12–13.

Kirby, Lynn *Parallel Tracks: The Railroad and Silent Cinema*. Durham, NC: Duke University Press, 1997.

Klotman, Phyllis. "The Black Writer in Hollywood, Circa 1930: The Case of Wallace Thurman." In *Black American Cinema*, edited by Manthia Diawara, 80–92. New York: Routledge, 1993.

Klotman, Phyllis. "Wallace Henry Thurman." In *Afro-American Writers from the Harlem Renaissance to 1940*, edited by Trudier Harris, 260–73. Detroit: Gale Research, 1987.

Koszarski, Richard. *An Evening's Entertainment: The Age of the Silent Feature Picture, 1915–1928*. New York: Scribner, 1990.

Labor, Earle G., Robert C. Leitz III, and I. Milo Shepard, eds. *The Letters of Jack London*. Vol. 1, *1896–1905*. Stanford, CA: Stanford University Press, 1988.

Langston, Tony. "Moral and Movies." *Competitor* 1, no. 2 (February 1920): 73–74.

Lederer, Susan E. "Repellent Subjects: Hollywood Censorship and Surgical Images in the 1930s." *Literature and Medicine* 17, no. 1 (1998): 91–113.

Leff, Leonard J. *Hemingway and His Conspirators: Hollywood, Scribners, and the Making of American Celebrity Culture*. Lanham, MD: Rowman & Littlefield, 1997.

Leider, Emily. "'Your Picture Hangs in My Salon': The Letters of Gertrude Atherton to Ambrose Bierce." *California History* 60, no. 4 (1981): 332–49.

Leider, Emily Wortis. *California's Daughter: Gertrude Atherton and Her Times*. Stanford, CA: Stanford University Press, 1991.

Letters to the Editor. *Motion Picture Magazine*, September 1914.

Letters to the Editor. *Motion Picture Magazine*, October 1914.

Letters to the Editor. *Motion Picture Magazine*, November 1914.

Letters to the Editor. *Motion Picture Magazine*, February 1915.

Letters to the Editor. *Motion Picture Magazine*, April 1915.

Letters to the Editor. *Motion Picture Magazine*, June 1917.

Letters to the Editor. *The Motion Picture Story Magazine*, April 1912.

Letters to the Editor. *The Motion Picture Story Magazine*, June 1912.

Letters to the Editor. *The Motion Picture Story Magazine*, September 1913.

Letters to the Editor. *The Motion Picture Story Magazine*, December 1913.

Levy, Robert. "To Charles W. Chesnutt, Feb 15, 1921." MS 3370, Charles Waddell Chesnutt Papers. Western Reserve Historical Society, Cleveland, OH.

Lewis, Jon, and Eric Smoodin, eds. *Looking Past the Screen: Case Studies in American Film History and Method*. Durham, NC: Duke University Press, 2007.

Lewis, Kevin, and Arnold Lewis. "Include Me Out: Samuel Goldwyn and Joe Godsol." *Film History* 2, no. 2 (1988): 133–53.

Lewis, Sinclair. "Enemies of the Book; Address by Sinclair Lewis at the Annual Dinner of the American Booksellers Association in New York City May 11, 1936." *Publishers' Weekly*, May 23, 1936, 2011–14.

Lewis, Sinclair. "Rambling Thoughts on Literature as a Business." *Yale Literary Magazine*, February 1936, 43–47.

Li, Stephanie. *Playing in the White: Black Writers, White Subjects*. New York: Oxford University Press, 2015.

Lichtenstein, Nelson. "Authorial Professionalism and the Literature Marketplace 1885–1900." *American Studies* 19, no. 1 (1985): 35–53.

Lindsay, Vachel. *A Handy Guide for Beggars, Especially Those of the Poetic Fraternity: Being Sundry Explorations, Made while Afoot and Penniless in Florida, Georgia, North Carolina, Tennessee, Kentucky, New Jersey, and Pennsylvania*. New York: Macmillan, 1916. Project Gutenberg. https://www.gutenberg.org/files/67947/67947-h/67947-h.htm.

Lindsay, Vachel. *A Letter About Four Programmes, for Committees in Correspondence*. Springfield, Ill.: Jeffersons Print Co., 1916.

Lindsay, Vachel. *Adventures while Preaching the Gospel of Beauty*. New York: Mitchell Kennerley, 1914. https://www.gutenberg.org/files/42252/42252-h/42252-h.htm.

Lindsay, Vachel. *Collected Poems of Vachel Lindsay: The Chinese Nightingale and Other Poems, The Congo and Other Poems, and General William Booth Enters into Heaven*. Charleston, SC: BiblioBazaar, 2008.

Lindsay, Vachel. *The Art of the Moving Picture*. New York: Macmillan, 1915; rev. 1922. Tutis Digital Publishing, 2008.

Lindsay, Vachel. "The Goodly, Strange Lanterns (in Praise of Edison's Great Invention, and in Sorrow of the News That Must Be Shown)." *Chicago Herald*, August 27, 1914. Reprinted in Dennis Camp, "Vachel Lindsay and the *Chicago Herald*," *Western Illinois Regional Studies* 2, no. 1 (Spring, 1979): 73.

Littau, Karin. "Reading in the Age of Edison: The Cinematicity of 'The Yellow Wall-Paper.'" In *Cinematicity in Media History*, edited by Jeffrey Geiger and Karin Littau, 67–87. Edinburgh: Edinburgh University Press, 2013.

Litton, Alfred G. "The Kinetoscope in *McTeague*: 'The Crowning Scientific Achievement of the Nineteenth Century.'" *Studies in American Fiction* 19, no. 1 (1991): 107–12.

London, Jack. *Hearts of Three*. New York: Macmillan, 1920.

London, Jack. *John Barleycorn*. 1913. Oxford: Oxford University Press, 2009.

London, Jack. *Martin Eden*. 1909. New York: Penguin, 1993.

London, Jack. Scrapbooks, Vols. 12, 13, 14, Box 517, Jack London Papers. Huntington Library, San Marino, CA.

London, Jack. "The Message of Motion Pictures." *Paramount Magazine*, 1, no. 2 (February 1915); reprinted in *Authors on Film*, edited by Harry M. Geduld, 104–07. Bloomington: Indiana University Press, 1972.

London, Jack. "To Frank Garbutt, September 30, 1914." JL11773, Jack London Papers. Huntington Library, San Marino, CA.

London, Jack. "To Frank Garbutt, Oct 7, 1914." Jack London Papers. Huntington Library, San Marino, CA.

London, Jack. "To Frank Garbutt, Jan 26, 1915." Jack London Papers. Huntington Library, San Marino, CA.

London, Jack. "To Hobart Bosworth, July 30, 1913." JL11031, Jack London Papers, Huntington Library, San Marino, CA.

London, Jack. "To James Sisson, Nov 1, 1914" JL13514, Jack London Papers. Huntington Library, San Marino, CA.

London, Jack. "To James Sisson, Oct 28, 1915." JL13538, Jack London Papers. Huntington Library, San Marino, CA.

London, Jack. "To Joseph Noel, September 4, 1913." In *The Letters of Jack London*. Vol. 3, *1913–1916*, edited by Earle Labor, Robert C. Leitz III, and I. Milo Shepard, 1222. Stanford, CA: Stanford University Press, 1988.

London, Jack. "To Joseph Noel, October 9, 1913." JL12955, Jack London Papers. Huntington Library, San Marino, CA.

Loos, Anita. "The School of Acting," in *Anita Loos Rediscovered*, edited by Cari. Beauchamp, 16–17. Berkeley: University of California Press, 2003.

Los Angeles Tribune, April 26, 1913. Scrapbooks, Vols. 12, 13, 14. Box 517, Jack London Papers. Huntington Library, San Marino, CA.

Louisville Times, May 1913. Scrapbooks, Vols. 12, 13, 14. Box 517, Jack London Papers. Huntington Library, San Marino, CA.

Luczak, Ewa Barbara. "Men in Eugenic Times: Wallace Thurman's Infants of the Spring and the (Im)possibility of Cosmopolitan Friendship." In *New Cosmopolitanisms, Race, and Ethnicity: Cultural Perspectives*, edited by Ewa Luczak, Anna Pochmara and Samir Dayal, 128–45. Warsaw: De Gruyter Poland, 2019.

Luczak, Ewa Barbara. *Mocking Eugenics: American Culture against Scientific Hatred*. London: Routledge, 2021.

Lupack, Barbara Tepa. *Literary Adaptations in Black American Cinema: From Micheaux to Morrison*. Rochester, NY: University of Rochester Press, 2002.

Lupton, Christina. "Repeat." In *Further Reading*, edited by Matthew Rubery and Leah Price, 153–64. Oxford: Oxford University Press, 2020.

Lurie, Peter. *Vision's Immanence: Faulkner, Film and the Popular Imagination*. Baltimore: Johns Hopkins University Press, 2004.

Madigan, Mark. "Willa Cather and the Book-of-the-Month Club." In *Cather Studies: Willa Cather as Cultural Icon*, edited by Guy Reynolds, 68–85. Lincoln: University of Nebraska Press, 2007.

"Man Afraid of His Wardrobe" (1915, American-Mustang). reviewed by T. S. Mead, *Motion Picture News*, October 9, 1915, 85.

Mann, Thomas. *Horror and Mystery: Photoplay Editions and Magazine Fictionizations: The Catalog of a Collection*. Jefferson, NC: McFarland, 2004.

Marcus, Laura. *The Tenth Muse: Writing about Cinema in the Modernist Period*. Oxford: Oxford University Press, 2007.

Massa, Ann. "The Artistic Conscience of Vachel Lindsay." *Journal of American Studies* 2, no. 2 (1968): 239–52.

Masters, Edgar Lee. *Vachel Lindsay: Poet in America*. Charles Scriber's Sons, 1935.

Matthews, Victoria Earle. "The Value of Race Literature (1895)." In *The New Negro: Readings on Race, Representation, and African American Culture, 1892–1938*, edited by Henry Louis Gates, Jr., and Gene Andrew Jarrett, 287–97. Princeton, NJ: Princeton University Press, 2007.

Maugham, W. Somerset. "On Writing for the Films." *North American Review* 213, no. 786 (May 1921): 670–75.

Mayer, Arthur L. *Merely Colossal: The Story of the Movies, from the Long Chase to the Chaise Longue*. New York: Simon & Schuster, 1953.

McCabe, Susan. *Cinematic Modernism: Modernist Poetry and Film*. Cambridge and New York: Cambridge University Press, 2005.

McClain, William. "Film-Fiction: Fan Magazines, Narrative, and Spectatorship in American Cinema of the 1910s." *New Review of Film and Television Studies* 7, no. 4 (2009): 377–91.

McGill, Meredith L. "Literary History, Book History, and Media Studies." In *Turns of Event: Nineteenth-Century American Literary Studies in Motion*, edited by Hester Blum, 23–39. Philadelphia: University of Pennsylvania Press, 2016.

McGilligan, Patrick. *Oscar Micheaux, the Great and Only: The Life of America's First Black Filmmaker*. New York: Harper Perennial, 2008.

McHenry, Elizabeth. *To Make Negro Literature: Writing, Literary Practice, and African American Authorship*. Durham, NC: Duke University Press, 2021.

McKay, Claude. *A Long Way from Home*. Edited and with an introduction by Gene Andrew Jarrett. New Brunswick, NJ: Rutgers University Press, 2007. First published 1937 by Lee Furman.

McLean, Adrienne L. "'New Films in Story Form': Movie Story Magazines and Spectatorship." *Cinema Journal* 42, no. 3 (2003): 3–26.

Mead, T. S. "Review of 'Man Afraid of His Wardrobe': American-Mustang—Three Reels." *Motion Picture News*, October 9, 1915.

Méliès, Georges, dir. *La mort de Jules César (Shakespeare)*. 1907. Manufacture de films pour cinématographes (Star Film). 3 minutes, silent.

"Menace to Culture in Cinema and Radio Seen by Miss Cather." In *Willa Cather in Person: Interviews, Speeches, and Letters*, selected and edited by L. Brent Bohlke.

Lincoln: University of Nebraska Press, 1986. Willa Cather Archive. https://cather.unl. edu/writings/bohlke/speeches/bohlke.s.06

Merrill, Flora. "A Short Story Course Can Only Delay, It Cannot Kill an Artist, Says Willa Cather." *New York World*, April 19, 1925; reprinted in *Willa Cather in Person: Interviews, Speeches, and Letters*, selected and edited by L. Brent Bohlke, 73–80. Lincoln: University of Nebraska Press, 1986.

Micheaux, Oscar. "Colored Americans Too Slow to Take Advantage of Great Land Opportunities Given Free by the Government." *Chicago Defender*, October 28, 1911, 1.

Micheaux, Oscar, dir. *The Betrayal*. 1948. Micheaux Film. 183 minutes. Lost; script held at New York State Archives (Motion Picture Scripts Collection) in Albany, NY.

Micheaux, Oscar. *The Case of Mrs Wingate*. New York: Book Supply, 1944.

Micheaux, Oscar. *The Conquest: The Story of a Negro Pioneer*. Lincoln, NE: Woodruff Press, 1913.

Micheaux, Oscar, dir. *The Exile*. 1931; Micheaux Film. 93 minutes.

Micheaux, Oscar. *The Forged Note: A Romance of the Darker Races*. Lincoln, NE: Western Book Supply Company, 1915.

Micheaux, Oscar. *The Homesteader*. Sioux City, IA: Western Book Supply Company, 1917.

Micheaux, Oscar. *The Masquerade: An Historical Novel*. New York: Book Supply Company, 1947.

Micheaux, Oscar. "The Negro and the Photoplay." *Half-Century Magazine* 6, no. 5 (May 1919): 9, 11.

Micheaux, Oscar. *The Story of Dorothy Stanfield*. New York: Book Supply Company, 1946.

Micheaux, Oscar. *The Wind from Nowhere*. New York: Book Supply Company, 1941.

Micheaux, Oscar. "To Charles W. Chesnutt, January 18, 1921." MS 3370, Charles Waddell Chesnutt Papers. Western Reserve Historical Society, Cleveland, OH.

Micheaux, Oscar. "To Charles W. Chesnutt, June 17, 1921." MS 3370, Charles Waddell Chesnutt Papers. Western Reserve Historical Society, Cleveland, OH.

Micheaux, Oscar, dir. *Veiled Aristocrats*. 1932; Micheaux Film. 48 minutes.

Micheaux, Oscar. "Where the Negro Fails." *Chicago Defender*, March 19, 1910, 1.

Miller, Rick. *Photoplay Editions: A Collector's Guide*. Jefferson, NC: McFarland, 2002.

Moore, Larry. "Preaching the Gospel of Higher Vaudeville: Vachel Lindsay's Poetic Journey from Springfield, Illinois, across America, and Back." In *Regionalism and the Humanities*, edited by Timothy R. Mahoney and Wendy J. Katz, 211–32. Lincoln: University of Nebraska Press, 2009.

Moran, Joe. *Star Authors: Literary Celebrity in America*. London and Sterling, VA: Pluto Press, 2000.

"More Eminent Author Films." *Motion Picture News*, October 25, 1919, 3145.

Mott, Frank Luther. *A History of American Magazines*. Vol. 5, *Sketches of 21 Magazines, 1905–1930*. Cambridge, MA: Belknap Press of Harvard University Press, 1968.

Murphet, Julian. *Multimedia Modernism: Literature and the Anglo-American Avant-Garde*. Cambridge: Cambridge University Press, 2009.

Murphet, Julian. "New Media Modernism." In *The Cambridge Companion to the American Modernist Novel*, edited by Joshua L. Miller, 210–26. Cambridge: Cambridge University Press, 2015.

Murray, Simone. *The Adaptation Industry: The Cultural Economy of Contemporary Literary Adaptation*. New York and London: Routledge, 2012.

Musings of "The Photoplay Philosopher." *The Motion Picture Story Magazine*, March 1912.

Musings of "The Photoplay Philosopher." *The Motion Picture Story Magazine*, April 1912.

Musings of "The Photoplay Philosopher." *The Motion Picture Story Magazine*, May 1912.

Musings of "The Photoplay Philosopher." *The Motion Picture Story Magazine*, June 1912.

Musings of "The Photoplay Philosopher." *The Motion Picture Story Magazine*, October 1912.

Musings of "The Photoplay Philosopher." *The Motion Picture Story Magazine*, November 1912.

Musings of "The Photoplay Philosopher." *The Motion Picture Story Magazine*, January 1913.

Musings of "The Photoplay Philosopher." *The Motion Picture Story Magazine*, February 1913.

Musings of "The Photoplay Philosopher." *The Motion Picture Story Magazine*, January 1914.

Musser, Charles. *Before the Nickelodeon: Edwin S. Porter and the Edison Manufacturing Company*. Berkeley and Los Angeles: University of California Press, 1991.

Musser, Charles, Corey K. Creekmur, Pearl Bowser, J. Ronald Green, Charlene Register, and Louise Spence. "An Oscar Micheaux Filmography: From the Silents through His Transition to Sound, 1919–1931." In *Oscar Micheaux and His Circle: African-American Filmmaking and Race Cinema of the Silent Era*, edited by Pearl Bowser, Jane Gaines, and Charles Musser, 228–77. Bloomington: Indiana University Press, 2016.

"Mutual News: What's Going on in the Mutual: Weekly News of the Mutual Film Corporation and Its 68 Exchanges." *Moving Picture World*, February 24, 1917, insert between 1134 and 1135.

New York State Department of Education, "In the Matter of the Appeal of Foy Productions, Ltd., from the action of the Motion Picture Division in rejecting the motion picture entitled: TOMORROW'S CHILDREN (REVISED")." In "Tomorrow's Children (Revised)," New York State Motion Picture Division License Application Case Files, Casefile Number 28361, Box 333, New York State Archives, Albany NY.

Nichols, Bill, and Susan. J. Lederman. "Flicker and Motion in Film." In *The Cinematic Apparatus*, edited by Teresa de Lauretis and Stephen Heath, 96–105. Basingstoke, UK: Macmillan Press, 1980.

Norris, Frank. *McTeague: A Story of San Francisco*. 1899. In *Frank Norris: Novels and Essays*, edited by Donald Pizer, 261–572. New York: Library of America, 1986.

Norris, Frank. "Fiction Writing as a Business." 1902. In *Frank Norris: Novels and Essays*, edited by Donald Pizer, 1170–74. New York: Library of America, 1986.

North, Michael. "Words in Motion: The Movies, the Readies, and the 'Revolution of the Word.'" *Modernism/modernity* 9, no. 2 (2002): 205–23.

Nowlin, Michael. *Literary Ambition and the African American Novel*. Cambridge: Cambridge University Press, 2019.

Ohmann, Richard. *Selling Culture: Magazines, Markets, and Class at the Turn of the Century*. London and New York: Verso, 1996.

Olsson, Jan. *Los Angeles before Hollywood: Journalism and American Film Culture, 1905–1915*. Stockholm: National Library of Sweden, 2008.

"On behalf of Willa Cather to [unknown recipient], [unknown date]." Willa Cather Archive. https://cather.unl.edu/letters/let1885.

"On Mutual Schedule." *Motography* 17, no. 15 (April 14, 1917): 778.

"Opening of the New Angelus a Notable Success." *California Eagle*, July 8, 1916.

Orgeron, Marsha. *Hollywood Ambitions: Celebrity in the Movie Age*. Middletown, CT: Wesleyan University Press, 2008.

Orgeron, Marsha. "'You Are Invited to Participate: Interactive Fandom in the Age of the Movie Magazine.'" *Journal of Film and Video* 61, no. 3 (2009): 3–23.

Osbourne, William Hamilton. "To Theodore Dreiser, Jan 28, 1915." Theodore Dreiser papers. Kislak Center for Special Collections, Rare Books and Manuscripts, University of Pennsylvania, Philadelphia, PA.

"*Pardners* by Rex Beach." *Variety*, January 26, 1917, 22.

Pavletich, JoAnn. "'. . . We Are Going to Take That Right': Power and Plagiarism in Pauline Hopkins's 'Winona.'" *CLA Journal* 59, no. 2 (2015): 115–30.

Perry, Montanye. "The Story of Elaine." *The Motion Picture Story Magazine*, June 1911, 21–31.

Petaja, Emil. *Photoplay Edition*. San Francisco: SISU, 1975.

Petersen, Christina. "The 'Reol' Story: Race Authorship and Consciousness in Robert Levy's Reol Productions, 1921–1926." *Film History* 20, no. 3 (2008): 308–24.

Petrie, Windy Counsell. *Templates for Authorship: American Women's Literary Autobiography of the 1930s*. Amherst: University of Massachusetts Press, 2021.

Pollock, Channing. "An Author in Blunderland." *Photoplay* 10, no. 4 (September 1916): 55–62, 168; reprinted in *Authors' League Bulletin*, October 1916.

Pollock, Channing. "The Author's Strike." *Photoplay* 15, no. 4 (April 1919): 31, 103–04.

Prescott, Orville. "'Books of the Times.' Review of *Red Ribbon on a White Horse* by Anzia Yezierska." *New York Times*, September 11, 1950.

Price, Steven. *A History of the Screenplay*. London: Palgrave Macmillan, 2013.

Price, Steven. *The Screenplay: Authorship, Theory and Criticism*. Basingstoke, UK: Palgrave Macmillan, 2010.

Pryluck, Calvin. "The Itinerant Movie Show and the Development of the Film Industry." In *Hollywood in the Neighborhood*, edited by Kathryn Fuller-Seeley, 37–52. Berkeley: University of California Press, 2008.

Rabinowitz, Lauren. *Electric Dreamland: Amusement Parks, Movies, and American Modernism*. New York: Columbia University Press, 2012.

Radway, Janice. *Reading the Romance: Women, Patriarchy, and Popular Literature*. Chapel Hill: University of North Carolina Press, 1984.

Ramsaye, Terry, ed. *1937–38 International Motion Picture Almanac*. New York: Quigley, 1938.

Rauterkus, Melissa. "Racial Fictions and the Cultural Work of Genre in Chesnutt's *The House Behind Cedars*." *American Literary Realism* 48, no. 2 (2016): 128–46.

Reesman, Jeanne Campbell, Sara S. Hodson, and Philip Adam, eds. *Jack London, Photographer*. Athens: University of Georgia Press, 2010.

Regester, Charlene. "Oscar Micheaux the Entrepreneur: Financing *The House Behind the Cedars*." *Journal of Film and Video* 49, no. 1–2 (Spring–Summer 1997): 17–27.

"Reol Co." *Chicago Defender* (Big Weekend Edition), March 26, 1921.

"Report of Motion-Picture Committee Year Ending April 1st 1915." Authors' League of America Year Books 1914 and 1915, JLE572, Jack London Papers. Huntington Library, San Marino, CA.

"Reprints of Shorts." *Variety Magazine*, March 3, 1926, 33.

"Rex Beach and Samuel Goldwyn Announce First Seven." *Motion Picture News*, July 12, 1919, 538.

"Rex Beach to Samuel Goldwyn, September 25, 1920." *Moving Picture World*, October 9, 1920, 758.

Robinson, Lillian S., and Greg Robinson. "Paul Laurence Dunbar: A Credit to His Race?" *African American Review* 41, no. 2 (2007): 215–25.

Ronning, Kari. "Speaking Volumes: Embodying Cather's Works." *Studies in the Novel* 45, no. 3 (2013): 519–37.

Roorda, Rebecca. "Willa Cather and the Magazines: 'The Business of Art.'" *Willa Cather Newsletter and Review* 44, no. 3 (Winter–Spring 2001): 71–75.

Rossell, Deac. "Chronophotography in the Context of Moving Pictures." *Early Popular Visual Culture* 11, no. 1 (2013): 10–27.

Rothman, Nathan L. "An Artist Unfrozen." *Saturday Review of Literature*, November 4, 1950, 13, 31.

Salt, Barry. *Film Style and Technology: History and Analysis*. London: Starword, 1992.

Salvant, Shawn. *Blood Work: Imagining Race in American Literature, 1890-1940*. Baton Rouge: Louisiana State University Press, 2015.

Sampson, Henry T. *Blacks in Black and White: A Source Book on Black Films*. Metuchen, NJ: Scarecrow Press, 1977.

Santell, Alfred, dir. *The Patent Leather Kid*. 1927. First National Pictures. 150 minutes. Held in Washington, DC, Library of Congress [USW].

Sargent, Epes Winthrop. "Photoplaywright." *Moving Picture World*, August 23, 1913, 837–38.

Schueth, Michael. "A Portrait of an Artist as a Cultural Icon: Edward Steichen, *Vanity Fair*, and Willa Cather." In *Cather Studies*. Vol. 7, *Willa Cather as Cultural Icon*, edited by Guy Reynolds, 46–67. Lincoln: University of Nebraska Press, 2007.

Schueth, Michael. "Taking Liberties: Willa Cather and the 1934 Film Adaptation of *A Lost Lady*." In *Willa Cather and Material Culture: Real-World Writing, Writing the Real World*, edited by Janis T. Stout, 113–24. Tuscaloosa: University of Alabama Press, 2005.

"Screen: A Novel in the Mill." *New York Times*, July 31, 1921, 63.

Seed, David. *Cinematic Fictions: The Impact of the Cinema on the American Novel up to World War II*. Liverpool: Liverpool University Press, 2009.

Segrave, Kerry. *Piracy in the Motion Picture Industry*. Jefferson, NC: McFarland, 2003.

Segrave, Kerry. *Product Placement in Hollywood Films: A History*. Jefferson, NC: McFarland, 2004.

Selig, William, dir. *The Spoilers*. 1916. American Film Institute Catalogue notes, Margaret Herrick Library, Academy of Motion Picture Arts and Sciences, Beverly Hills, CA.

Shail, Andrew. *The Cinema and the Origins of Literary Modernism*. New York: Routledge, 2012.

Shail, Andrew. *The Origins of the Film Star System: Persona, Publicity and Economics in Early Cinema*. London: Bloomsbury, 2019.

Shields, David S. *Still: American Silent Motion Picture Photography*. Chicago: University of Chicago Press, 2013.

Shimpach, Shawn. "Representing the Public of the Cinema's Public Sphere." In *Media and Public Spheres*, edited by Richard Butsch, 136–48. Basingstoke, UK, and New York: Palgrave Macmillan, 2007.

Short, Clarice. "Tennyson and 'The Lover's Tale.'" *PMLA* 82, no. 1 (1967): 78–84.

Singer, Ben. "Fiction Tie-Ins and Narrative Intelligibility 1911–18." *Film History* 5, no. 4 (1993): 489–504.

Slide, Anthony. "Commentary." *The Spoilers* (1914); Campbell, Colin, dir. DVD, Silent Hall of Fame Enterprises, 2016.

Slide, Anthony. *Inside the Hollywood Fan Magazine: A History of Star Makers, Fabricators, and Gossip Mongers*. Jackson: University Press of Mississippi, 2010.

Slide, Anthony. *The New Historical Dictionary of the American Film Industry*. Lanham, MD: Scarecrow Press, 2001.

Slide, Anthony, ed. *They Also Wrote for the Fan Magazines: Film Articles by Literary Giants from E. E. Cummings to Eleanor Roosevelt, 1920–1939*. Ann Arbor: University of Michigan Press, 1992.

Smethurst, James. *The African American Roots of Modernism: From Reconstruction to the Harlem Renaissance*. Chapel Hill: University of North Carolina Press, 2011.

Smith, Jean Voltaire. "Our Need for More Films." *Half-Century Magazine*, April 1922, 8.

Smith, Russell E. "The Belasco of the Motion Picture Art." *Motography* 11, no. 8 (1914): 261–62.

Sonstegard, Adam. "Visual Art, Intertextuality, and Authorship in the Golden Age of Illustration." In *The Oxford Handbook of American Literary Realism*, edited by Keith Newlin, 527-52. Oxford: Oxford University Press, 2019

Staiger, Janet. "Blueprints for Feature Films: Hollywood's Continuity Scripts." In *The American Film Industry*, edited by Tino Balio, 173–94. Rev. ed., Madison: University of Wisconsin Press, 1985.

Staiger, Janet. "'Tame' Authors and the Corporate Laboratory: Stories, Writers, and Scenarios in Hollywood." *Quarterly Review of Film Studies* 8, no. 4 (1983): 33–45.

Stamant, James. *Competing Stories: Modernist Authors, Newspapers, and the Movies*. Lanham, MD: Lexington Books, 2019.

Stamp, Shelley. *Movie-Struck Girls: Women and Motion Picture Culture after the Nickelodeon*. Princeton, NJ: Princeton University Press, 2000.

Stead, Lisa. *Off to the Pictures. Cinemagoing, Women's Writing and Movie Culture in Interwar Britain*. Edinburgh: Edinburgh University Press, 2016.

Stein, Gertrude. *A Play Called Not and Now*. In *Last Operas and Plays*, edited and with an introduction by Carl Van Vechten, 422–39. New York: Rinehart & Co., 1949.

Stein, Gertrude. *The Autobiography of Alice B. Toklas*. In *Selected Writings of Gertrude Stein*, 1–235. New York: Knopf Doubleday, 1990.

Stein, Gertrude. "To Carl Van Vechten, April 2, 1935." In *The Letters of Gertrude Stein and Carl Van Vechten, 1914–1946*, edited by Edward Burns, 422–23. New York: Columbia University Press, 2013.

Stempel, Tom. *Framework: A History of Screenwriting in the American Film*. Syracuse, NY: Syracuse University Press, 2000.

Stewart, Jacqueline Najuma. *Migrating to the Movies: Cinema and Black Urban Modernity*. Berkeley: University of California Press, 2005.

Stokes, Melvyn. *D. W. Griffith's The Birth of a Nation: A History of "The Most Controversial Motion Picture of All Time."* New York: Oxford University Press, 2007.

Stout, Janis. "The Observant Eye, the Art of Illustration, and Willa Cather's *My Ántonia*." In *Cather Studies*. Vol. 5, *Willa Cather's Ecological Imagination*, edited by Susan J. Rosowski, n.p. Lincoln: University of Nebraska Press, 2003. https://cather.unl.edu/scholarship/catherstudies/5/cs005.stout.

Swift, John N. "Willa Cather in and out of Zane Grey's West." In *Cather Studies*. Vol. 9, *Willa Cather and Modern Cultures*, edited by Melissa J. Homestead and Guy J. Reynolds, 1–20. Lincoln: University of Nebraska Press, 2011.

Taylor, Clyde. "Oscar Micheaux and the Harlem Renaissance." In *Temples for Tomorrow: Looking Back at the Harlem Renaissance*, edited by Geneviéve Fabre and Michel Feith, 125–35. Bloomington: Indiana University Press, 2001.

Tell, Dave. *Confessional Crises and Cultural Politics in Twentieth-Century America*. University Park, PA: Penn State University Press, 2013.

"Ten Writers Filmed for Use in Para. Picture." *Hollywood Reporter*, January 7, 1933, 1.

"The 'Author's Author' Voting Contest Final Results." *Authors' League Bulletin*, November 1918, 5.

"'The Barrier.'" *Film Daily*, April 4, 1926, 6.

"'The Barrier' a Success without a Big Star." *Moving Picture World*, March 24, 1917, 1956.

"The Best Story Contest." *The Motion Picture Story Magazine*, March 1912, 168.

"The Cash Prize Contest." *The Motion Picture Story Magazine*, August 1911, 151–54.

"The Cinema as Circulating Library." *Review of Reviews* 52, no. 312 (1915): 492.

"The Golden Supper: From the Poem of Lord Tennyson." *The Motion Picture Story Magazine*, February 1911, 70-85.

"The Greatest Living Authors Are Now Working with Paramount." *Photoplay* 20, no 1 (June 1921): 4.

"'The House Behind the Cedars' Shown at Royal Sunday." *Philadelphia Tribune*, December 13, 1924, 1.

"The Motion Picture Story Magazine." *The Motion Picture Story Magazine*, May 1911, 10.

"The Onward March." *The Motion Picture Story Magazine*, April 1912.

"The Patent Leather Kid (1927)." *AFI Catalog of Feature Films: The First 100 Years 1893–1993*. Last modified 2019. https://catalog.afi.com/Catalog/MovieDetails/11290.

"'The Sport of the Gods': Dunbar Feature to be Shown at the Lincoln Theatre Last Half of Next Week." *Chicago Defender*, May 21, 1921, 7.

"'The Sport of the Gods': Great Production Playing to Large and Satisfied Audiences at the Owl." *Chicago Defender*, May 21, 1921, 6.

"The Spotlight." *Baltimore Afro-American*, July 31, 1926, 5.

"Thurman Novel Sold." *Hollywood Reporter*, April 5, 1934, 12.

Thurman, Wallace. "Cordelia the Crude." In *The Collected Writings of Wallace Thurman: A Harlem Renaissance Reader*, edited by Amritjit Singh and Daniel M. Scott III, 301–04. New Brunswick, NJ: Rutgers University Press, 2003.

Thurman, Wallace. "Grist in the Mill." In *The Collected Writings of Wallace Thurman: A Harlem Renaissance Reader*, edited by Amritjit Singh and Daniel M. Scott III, 294–301. New Brunswick, NJ: Rutgers University Press, 2003.

Thurman, Wallace. *Infants of the Spring*. 1932. Mineola, NY: Dover, 2020.

Thurman, Wallace. "Negro Poets and Their Poetry." 1928. In *The Collected Writings of Wallace Thurman: A Harlem Renaissance Reader*, edited by Amritjit Singh and Daniel M. Scott III, 205–16. New Brunswick, NJ: Rutgers University Press, 2003.

Thurman, Wallace. "Notes on a Stepchild." In *The Collected Writings of Wallace Thurman: A Harlem Renaissance Reader*, edited by Amritjit Singh and Daniel M. Scott III, 235–40. New Brunswick, NJ: Rutgers University Press, 2003.

Thurman, Wallace. *The Collected Writings of Wallace Thurman: A Harlem Renaissance Reader*. Edited by Amritjit Singh and Daniel M. Scott III. New Brunswick, NJ: Rutgers University Press, 2003.

Thurman, Wallace. "This Negro Literary Renaissance." In *The Collected Writings of Wallace Thurman: A Harlem Renaissance Reader*, edited by Amritjit Singh and Daniel M. Scott III, 241–51. New Brunswick, NJ: Rutgers University Press, 2003.

Thurman, Wallace. "To Bill [William Jourdan Rapp], Saturday." In *The Collected Writings of Wallace Thurman: A Harlem Renaissance Reader*, edited by Amritjit Singh and Daniel M. Scott III, 134–35. New Brunswick, NJ: Rutgers University Press, 2003.

Thurman, Wallace. "To Bill [William Jourdan Rapp], 1929." In *The Collected Writings of Wallace Thurman: A Harlem Renaissance Reader*, edited by Amritjit Singh and Daniel M. Scott III, 141–42. New Brunswick, NJ: Rutgers University Press, 2003.

Thurman, Wallace. "To Bill [William Jourdan Rapp], Tuesday, August 13, 1929." In *The Collected Writings of Wallace Thurman: A Harlem Renaissance Reader*, edited by Amritjit Singh and Daniel M. Scott III, 156–57. New Brunswick, NJ: Rutgers University Press, 2003.

Thurman, Wallace. "To Granville Hicks, January 30, 1932." In *The Collected Writings of Wallace Thurman: A Harlem Renaissance Reader*, edited by Amritjit Singh and Daniel M. Scott III, 167–68. New Brunswick, NJ: Rutgers University Press, 2003.

Thurman, Wallace. "To Langston Hughes." In *The Collected Writings of Wallace Thurman: A Harlem Renaissance Reader*, edited by Amritjit Singh and Daniel M. Scott III, 108–09. New Brunswick, NJ: Rutgers University Press, 2003.

Thurman, Wallace. "To Langston Hughes, c. May–June 1929." In *The Collected Writings of Wallace Thurman: A Harlem Renaissance Reader*, edited by Amritjit Singh and Daniel M. Scott III, 118–19. New Brunswick, NJ: Rutgers University Press, 2003

Thurman, Wallace. "To Langston Hughes, c. January 1932." In *The Collected Writings of Wallace Thurman: A Harlem Renaissance Reader*, edited by Amritjit Singh and Daniel M. Scott III, 127–129. New Brunswick, NJ: Rutgers University Press, 2003.

Thurman, Wallace. "To Langston Hughes, February 1934," In *The Collected Writings of Wallace Thurman: A Harlem Renaissance Reader*, edited by Amritjit Singh and Daniel M. Scott III, 129. New Brunswick, NJ: Rutgers University Press, 2003.

Thurman, Wallace. "To Langston Hughes, September 1934," In *The Collected Writings of Wallace Thurman: A Harlem Renaissance Reader*, edited by Amritjit Singh and Daniel M. Scott III, 130–31. New Brunswick, NJ: Rutgers University Press, 2003.

Thurman, Wallace. "To Rapp [William Jourdan Rapp], July 1929." In *The Collected Writings of Wallace Thurman: A Harlem Renaissance Reader*, edited by Amritjit Singh and Daniel M. Scott III, 145–47. New Brunswick, NJ: Rutgers University Press, 2003.

Thurman, Wallace. "Untitled, four pages of handwritten manuscript about tubercular patients." JWJ MSS 12, ca. 1934. Pp 1 and 2, Wallace Thurman Collection. Beinecke Rare Book and Manuscript Library, Yale University, New Haven, CT.

Thurman, Wallace, and A. L. Furman. *The Interne*. New York: Macaulay, 1932.

"'Tomorrow's Children,' Dialogue Sheet." In "Tomorrow's Children (Revised)," November 24, 1934, New York State Motion Picture Division License Application Case Files, Casefile Number 28361, Box 333, New York State Archives, Albany NY.

Toolan, Michael. *Narrative Progression in the Short Story: A Corpus Stylistic Approach*. Amsterdam and Philadelphia: John Benjamins Publishing Company, 2009.

Travis, Molly. *Reading Cultures: The Construction of Readers in the Twentieth Century*. Carbondale and Edwardsville: Southern Illinois University Press, 1998.

Trotter, David. *Cinema and Modernism*. Oxford: Blackwell, 2007.

Underwood, Doug. *Literary Journalism in British and American Prose: An Historical Overview*. Jefferson, NC: McFarland, 2019.

Uricchio, William, and Roberta E. Pearson. *Reframing Culture: The Case of the Vitagraph Quality Films*. Princeton, NJ: Princeton University Press, 1993.

van Allen, Elizabeth J. *James Whitcomb Riley: A Life*. Bloomington: Indiana University Press, 1999.

van Notten, Eleonore. *Wallace Thurman's Harlem Renaissance*. Amsterdam and Atlanta, GA: Rodopi, 1994.

Van Parys, Thomas. "The Commercial Novelization: Research, History, Differentiation." *Literature Film Quarterly* 37, no. 4 (2009): 305–17.

Vidor, King, dir. *Show People*. 1928. Cosmopolitan Productions. 83 minutes, silent [English intertitles].

Volpicelli, Robert. *Transatlantic Modernism and the US Lecture Tour*. Oxford: Oxford University Press, 2021.

Waggoner, Jess. "'My Most Humiliating Jim Crow Experience': Afro-Modernist Critiques of Eugenics and Medical Segregation." *Modernism/modernity* 24, no. 3 (2017): 507–25.

Walton, Lester. "Review of *The Scapegoat*." *New York Age*, May 17, 1917, 6.

Warren, Kenneth W. *What Was African American Literature?* Cambridge, MA: Harvard University Press, 2011.

Wasson, Haidee. *Everyday Movies: Portable Film Projectors and the Transformation of American Culture*. Berkeley: University of California Press, 2020.

Watson, Jay. *William Faulkner and the Faces of Modernity*. Oxford: Oxford University Press, 2019.

"Well Known Artists of Stage and Screen." Section III, Part 7, Vol. 94, No. 174, *The Morning Telegraph* Christmas Number, New York 21, December, 1919. Rupert Hughes Papers. USC Library Special Collections, University of Southern California, Los Angeles, CA.

"Well-Known Authors Act Their Own Places in 'Movies': Amelie Rives, Booth Tarkington, George Ade, Ida Tarbell, Rex Beach, George Barr McCutcheon, and Others as Film Actors." *New York Times Sunday Magazine*, February 8, 1914, 5.

West, Dorothy. "Elephant's Dance: A Memoir of Wallace Thurman." In *Where the Wild Grape Grows: Selected Writings, 1930–1950*, edited by by Verner D. Mitchell and Cynthia Davis, 167–75. Amherst: University of Massachusetts Press, 2005.

West, Dorothy. "Odyssey of an Egg." In *The Richer, the Poorer: Stories, Sketches, and Reminiscences*, 109–16. New York: Doubleday, 1995.

West, Dorothy. *The Richer, the Poorer: Stories, Sketches, and Reminiscences*. New York: Doubleday, 1995.

West, James L. W., III. *American Authors and the Literary Marketplace since 1900*. Philadelphia: University of Pennsylvania Press, 1990.

"What Is the Matter with Your Motion Picture Scenario? By a New York Agent." *Authors' League Bulletin*, November 1918, 14–16.

"What the Fans Think: On Different Subjects Concerning the Screen, as Revealed by Letters Selected from Our Mail Pouch." *Picture-Play Magazine*, June 1920.

White, Lucien H. "Review of *The Colored American Winning His Suit*, Produced by Frederick Douglass Film Company." *New York Age*, July 20, 1916, 6.

"Why This Magazine: Announcement by the Editor." *Competitor* 1 (January 1920): 2.

Wilbur, Crane, dir. *High School Girl*. Foy Productions, 1934.

Wilbur, Crane. dir. *Tomorrow's Children*. Foy Productions, 1934.

Wilinsky, Barbara. "Flirting with Kathlyn: Creating the Mass Audience." In *Hollywood Goes Shopping*, edited by David Desser and Garth S. Jowett, 34–56. Minneapolis: University of Minnesota Press, 2000.

Williams, Erika Renée. "A Lie of Omission: Plagiarism in Nella Larsen's 'Quicksand.'" *African American Review* 45, no. 1/2 (2012): 205–16.

Williams, Tony. *Jack London, the Movies: An Historical Survey*. Los Angeles: David Rejl, 1992.

Williams, Tony. "The War of the Wolves: Filming Jack London's *The Sea Wolf* 1917–1920." *Film History* 4, no. 3 (1990): 199–217.

Willis-Tropea, Liz. "Glamour Photography and the Institutionalization of Celebrity." *Photography and Culture* 4, no. 3 (2011): 261–75.

Wilson, Christopher P. *The Labor of Words: Literary Professionalism in the Progressive Era*. Athens: University of Georgia Press, 1985.

Withalm, Gloria. "The Self-Reflexive Screen: Outlines of a Comprehensive Model." In *Self-Reference in the Media*, edited by Winfried Nöth and Nina Bishara, 125–42. Berlin and Boston: Mouton de Gruyter, 2007.

Woodley, Jenny. *Art for Equality: The NAACP's Cultural Campaign for Civil Rights*. Lexington: University Press of Kentucky, 2014.

Wright, William Lord. "Literature and Filmland." *The Motion Picture Story Magazine*, October 1913.

Wutz, Michael. *Enduring Words: Literary Narrative in a Changing Media Ecology*. Tuscaloosa: University of Alabama Press, 2009.

Yarborough, Richard. "'Introduction.' In 'Rethinking Pauline Hopkins: Plagiarism, Appropriation, and African American Cultural Production,' by Richard Yarborough, JoAnn Pavletich, Ira Dworkin, and Lauren Dembowitz." *American Literary History* 30, no. 4 (2018): e4–e8.

Yezierska, Anzia. "This Is What $10,000 Did to Me." *Cosmopolitan*, 1925, 41. Anzia Yezierska Papers. Howard Gotlieb Archival Research Center, Boston University, Boston, MA.

Yumibe, Joshua. *Moving Color: Early Film, Mass Culture, Modernism*. New Brunswick, NJ: Rutgers University Press, 2012.

Index

Printed in the USA/Agawam, MA
August 30, 2024

871898.031